KT-363-606

POP ART

P O

A

MARCO LIVINGSTONE

with 366 illustrations, 300 in colour

P

A CONTINUING HISTORY

Thames & Hudson

To Andrea and Howell on their marriage

Half-title: Andy Warhol *Shot Orange Marilyn* 1964

First published in the United Kingdom in 1990 by Thames & Hudson Ltd, 181A High Holborn, London WC1V 7QX

www.thamesandhudson.com

First paperback edition 2000
Reprinted 2002

British Library Cataloguing-in-Publication Data
A catalogue record for this book is available from the British Library
ISBN 0-500-28240-4

Printed and bound in Singapore by Star Standard Industries Pte Ltd

CONTENTS

Moderne Kunst

POP'S MATURITY

LEGACIES OF POP

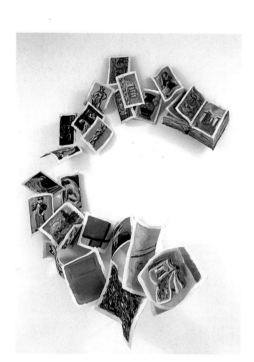

PREFACE

In the thirty years or so since Pop made its first tentative appearance in various guises, a vast literature on the movement has been generated, with especially perceptive and well documented studies on the work of individual artists. I could not have written this book without such a wealth of material at my disposal, or without the eloquent testimony of the artists themselves; I am especially grateful to all those who have so generously consented to speak to me at length about their work over the past fifteen years. Such is the volume of available material, however, that I have thought it best to refer to it only rarely. It is to the art itself, rather than to the hundreds of thousands of words already attached to it, that I have decided to address my attention.

Pop, which was not even a movement in the usual sense – since the artists did not form into groups or publish manifestos – was so extensive and sometimes so nebulously defined that here I can but trace its main course, as I see it, through the United States, Great Britain and parts of Continental Western Europe. This is not, therefore, a detailed documentation of the early exhibition history of Pop; an account of its promotion and support by dealers and collectors; a collection of essential theoretical texts by artists and critics; an encyclopaedic survey of the Pop artists from every corner of the globe who have made individual contributions to the history of the movement; an analysis of the effects of Pop art on fashion, advertising or other areas of design; or an extended study of the influence of early Pop on subsequent generations, although I touch such aspects as and when they are appropriate to my concerns. I must leave it to others to investigate those other sides of the story that are still unwritten, so that I can concentrate instead on the varied interpretations of the ideas, methods, strategies and individual works that together make up that heterogeneous, but also in some respects coherent, development in art known as Pop.

Marco Livingstone

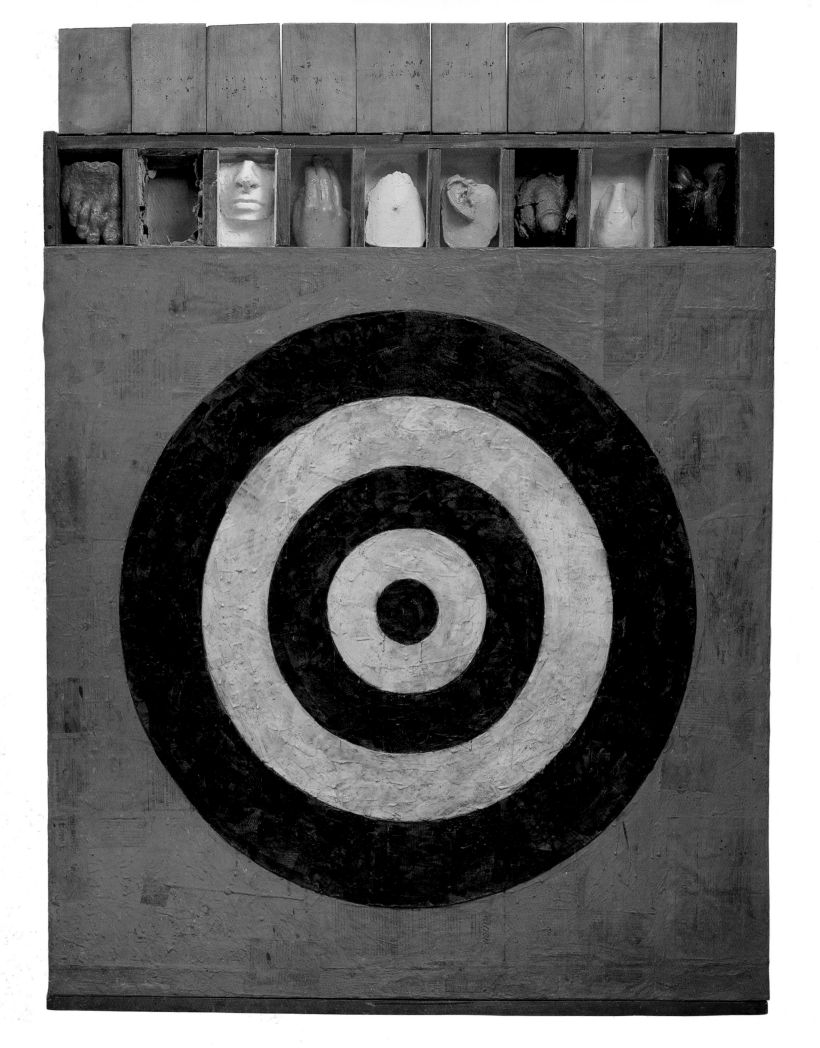

INTRODUCTION

Pre-Pop

Pop, like most art historical labels, is a convenience for critics and historians but an irrelevance and an irritant for most of the artists to whom it has been applied. Commentators in the past have often sought to establish a rigorous set of conditions by which an artist's work would qualify for inclusion under its rubric. As far as Pop painting is concerned, this generally involves the use of existing imagery from mass culture already processed into two dimensions, preferably borrowed from advertising, photography, comic strips and other mass media sources; an emphasis on flatness and frontal presentation, characteristics which in modern representational painting had come to be associated largely with naive art; an associated preference (especially in American Pop) for centralized composition and for flat areas of unmodulated and unmixed colour bound by hard edges, or for mechanical and other deliberately inexpressive techniques that imply the removal of the artist's hand and suggest the depersonalized processes of mass production; an unapologetic decorativeness; a delving into areas of popular taste and kitsch previously considered outside the limits of fine art; and a concentration on the contemporary subject-matter integral to the ready-made sources the artist has used. Similar criteria could be applied to sculpture, where the literalness and factuality could be said to involve the replication in three dimensions of familiar objects, ideally by industrial techniques rather than traditional artistic processes involving the invention and manipulation of form by hand.

Although it is useful to keep such considerations in mind, it must also be remembered that artists generally do not work so programmatically and that few have been restrained by theoretical definitions from working 'inconsistently' in accepting some assumptions and not others. Given that Pop as a whole represented an opening out of possibilities and a rebellion against a rigid set of artistic conventions, it was inevitable that its true force as a movement, and the main reason for its continued influence on subsequent generations of artists, has resided not in its codification but in a series of ideas and strategies open to constant redefinition. One of the most constant features of Pop has been its conceptual dimension, and it is in this, more than in any single visual aspect, that it has retained its most vigorous impact.

Some of the recurring characteristics of Pop cited above were anticipated in a variety of developments in European and American modernism. The basing of images on existing popular sources, for example, had precedents in the work of nineteenth-century painters such as Gustave Courbet and Edouard Manet, showing early evidence for the move from nature to culture – from romanticism to realism, from an overt subjectivity to an ostensible objectivity – most radically effected in the twentieth century by Pop.[1] The literalism of the fragments of reality from daily life incorporated into Cubist collages from

2 Kurt Schwitters *Mz 26, 41. okola* **1926**

3 Raoul Hausmann *Tatlin at Home* **1920**
4 Pablo Picasso *Baboon and Young* **1951**
5 Pablo Picasso *Guitar* **1912**

9

1 Jasper Johns *Target with Plaster Casts* **1955**

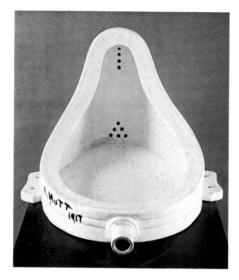

6 Marcel Duchamp *Fountain* 1917

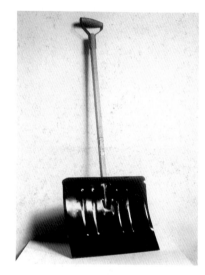

7 Marcel Duchamp *In Advance of the Broken Arm* 1915

8 Marcel Duchamp *Chocolate Grinder No. 2* 1914

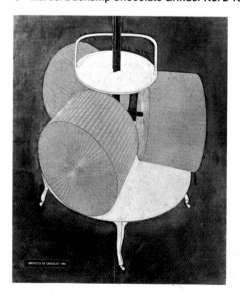

1912 also helped prepare for the use of found imagery in Pop, especially through its revision by the Dadaists: artists working just after the First World War, such as John Heartfield, Hannah Höch and Raoul Hausmann, left modern urban subject-matter in its raw state in their photomontages, while Kurt Schwitters made numerous small collages from printed ephemera and urban detritus found on the streets.[2] Such decisions by artists to site their work explicitly in the circumstances of contemporary life, which can be traced back to Courbet and the Impressionists, substantially influenced the later course of figurative art. For instance, the conscious dependence on photography to achieve a contrived casualness of composition, introduced by Degas in the late nineteenth century, gradually evolved into forms of representational painting that explicitly acknowledged their sources: notable examples include the portraits painted from snapshots as early as the 1920s by Walter Richard Sickert; the undisguised use from the 1950s by Francis Bacon of film stills, photographs by Eadweard Muybridge and reproductions of paintings for his hand-painted images; and the reliance on a 'photographic' vision, in terms either of tonal range or crispness of definition, in landscapes and cityscapes by American painters such as the Precisionists and Edward Hopper.

Cubist relief constructions by Picasso, beginning with *Guitar* (1912), not only influenced the course of abstract constructed sculpture but also helped to create the climate in which it was possible for an artist to fabricate emblems of ordinary objects and deem them worthy of contemplation. Picasso's assemblages of this period, notably *The Glass of Absinth* (1914), in which a painted bronze is surmounted by a real sugar strainer, also opened the way to the incorporation of real objects. Yet the towering example for Pop among artists working in the early part of the century was that of Marcel Duchamp, whose reputation was very much in the ascendancy again in the late 1950s.[3] His single most influential contribution was the ready-made, a mass-produced functional object removed from its original context and presented, without any physical mediation, as a work of art. After producing a sculpture in 1913 by attaching a *Bicycle Wheel* to a kitchen stool, it occurred to him in 1914 that it was enough simply to choose a manufactured item such as a *Bottle Rack*, strip it of its intended function and give it a new meaning by redefining its status.

Duchamp typically took a single object and retitled it to declare its change of function from a utilitarian purpose to an aesthetic or conceptual one, as in the snow shovel christened *In Advance of the Broken Arm* (1915); the most notorious of these, which has since paradoxically become an icon of modern art at its most iconoclastic, was a urinal which he titled *Fountain* in 1917. The generic name, ready-made, that he gave such works when he moved to America in 1915, with its connotations of industrial assembly-line production, was itself borrowed from the clothing industry, where it was used to distinguish items in standard sizes from those made to measure. Duchamp's most often quoted remarks on the ready-made were those from a talk delivered by him at the Museum of Modern Art in New York on 19 October 1961, just when the first fully realized American Pop works were beginning to be made by artists such as Warhol and Lichtenstein: 'A point which I want very much to establish is that the choice of these "ready-mades" was never dictated by esthetic delectation. This choice was based on a reaction of visual indifference with at the same time a total absence of good or bad taste...in fact a complete anaesthesia.'[4]

Although Duchamp's influence on Pop sculpture has been incalculable, the concept of the ready-made was equally important to those working in two dimensions with found material and imagery taken from advertisements, comic strips, photographs and other

printed sources. Precedents again existed in Duchamp's own production, notably the 'corrected' ready-mades such as *Apolinère Enameled* (1916–17), in which he made a few vital amendments in oil paint to an advertisement printed on tin, and *L.H.O.O.Q.* (1919), a cheaply printed reproduction of the Mona Lisa desecrated by the addition of a schoolboyish moustache and goatee that wittily confront speculations about the andro-gynous appearance of the famous but still mysterious sitter (even the title has a sexual innuendo, being a pun on 'elle a chaud au cul' – she has a hot arse). Paintings such as *Chocolate Grinder No. 2* (1914) – which he later used for his most iconographically com-plex work, *The Bride Stripped Bare by her Bachelors, Even (The Large Glass)* (1915–23) – likewise anticipate Pop in turning an ordinary functional object into a stark image con-veyed in a matter-of-fact and impersonal technique.[5]

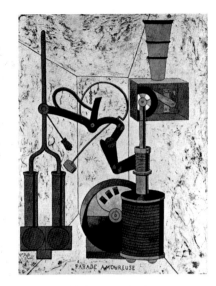

The association between machinery and human use, often with an explicitly sexual connotation, was extended by Duchamp's Dadaist colleague Francis Picabia in works such as *Parade amoureuse* (1917), which for similar reasons can be counted among the ancestors of Pop images. During the 1920s the vogue for mechanistic imagery led in various directions, all of which have some bearing on Pop. On a primarily conceptual rather than visual level, for instance, one can cite the optimistic machine aesthetic of artists associated with the Bauhaus, such as the Hungarian-born László Moholy-Nagy, whose faith in industrial processes extended beyond his choice of materials to such ideas as arranging for the manufacture of his work through instructions relayed by tele-phone; like Man Ray and Christian Schad during the same period, Moholy-Nagy also ex-perimented in the 1920s with the production of photograms, photographic images produced without a camera in the darkroom by covering the paper with real objects and then exposing it to light. Also during the 1920s, but in America, Charles Sheeler, Charles Demuth and other painters sometimes called the Precisionists conveyed images of the dynamism of modern city life not with the essentially abstract devices that had been applied to such images by the Futurists just before the First World War but by an obsess-ive rendering of surfaces. From the work of the Ashcan School and of the American Scene Painters early in the century through to the later street scenes of Edward Hopper, there was, moreover, a tradition of reflecting directly on the ways in which Americans had imposed their cultural identity directly on a previously naked and untouched environ-ment.

10 Juan Gris *Sunblind* 1914

11 Edward Hopper *Gas* 1940

The emblematic presentation of ordinary objects by Pop artists can be related to that employed in Cubist paintings such as *Sunblind* (1914) by Juan Gris, to Purist still lifes of the 1920s by painters such as Amédée Ozenfant and Le Corbusier and most directly to flat and graphically arresting paintings of 'object types' by Fernand Léger. The clear ref-erence in Léger's *Le Siphon* (1924) to modern advertising and poster design, as also in contemporary American works conceived in a similar idiom, such as *Lucky Strike* (1921) and *Odol* (1924) by Stuart Davis and still lifes of manufactured objects by Gerald Murphy such as *Razor* (1922), are also particularly apposite in relation to Pop. Although there is a great similarity, it must be noted that these are isolated examples even in the develop-ment of each of these artists and that several decades passed before such methods were regularly employed by a much younger generation as part of a consistent aesthetic.

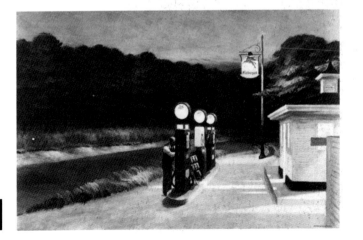

Other works with commonplace motifs represented in a straightforward and intention-ally inexpressive manner are equally tempting candidates as sources for Pop. Yet only a few paintings by the Surrealist René Magritte, such as *L'usage de la parole I* (The Use of Words I, 1928–9) – although they do anticipate Pop in their distinction between object and image and in their intentionally bland presentation in the manner of sign-painting –

INTRODUCTION

12 René Magritte *L'usage de la parole I* 1928–9

13 Gerald Murphy *Razor* 1922

14 Stuart Davis *Odol* 1924

15 Fernand Léger *Le Siphon* 1924

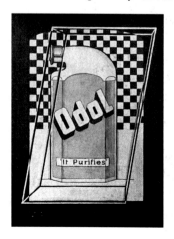
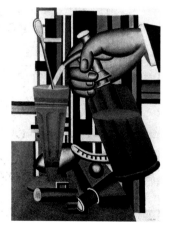

have any significant visual resemblance to Pop works. There is an affinity, too, between Pop and the collages and box constructions by the American Surrealist Joseph Cornell; *Untitled (Medici Princess)* (*c.* 1948), for instance, features found objects and photographic reproductions of a famous work of art in a construction that itself has a strong object quality, while other works use repeated images in a grid-like formation in a manner later exploited by Warhol. In contrast, however, to the insistently public imagery and large scale favoured in much Pop, Cornell's art remains essentially in the private realm of the imagination.

Nearer the time of Pop's emergence, the resemblances between the work of older artists and the first expressions of the new movement seem less accidental. Picasso's later sculptural inventions, particularly assemblages and cast bronzes incorporating found objects, such as *Woman with Baby Carriage* (1950, a bronze cast from cake pans, terracotta, a stove plate and a stroller) and *Baboon and Young* (1951), in which a toy car becomes the animal's head, are very close in spirit to what could be described as the proto-Pop work of sculptors such as Eduardo Paolozzi. A series of paintings made by Picabia during the Second World War, such as *Femmes au bulldog* (Women with Bulldog, *c.* 1940–42), deliberately confrontational exercises in squalid sexuality and kitsch, anticipate central factors of Pop in their humour, delight in self-consciously bad taste and reference to conventions from the most denigrated forms of the mass media. It would be stretching the truth, however, to refer to these paintings as Pop, given the very different circumstances in which they were made, nor could they realistically be judged influences on the movement, since it was only in the 1970s and especially the 1980s that they were first exhibited in force and made the subject of critical attention.

Any consistent lineage that one might hope to follow to the origins of Pop in the 1950s is doomed to remain largely spurious. Even the best-documented links, for example with the work of Willem de Kooning, the Abstract Expressionist painter most admired by the American Pop artists, obscure the fundamental shift in sensibility and method. While it is now well known that his paintings of women of the early 1950s were based partly on pin-up imagery and on the toothy smiles found in magazine advertisements, it is patently obvious that the Pop artists consciously opposed the bravura brushwork and exaggerated subjectivity that characterized the art of his generation. It is possible, of course, to point to formal resemblances between particular Pop works and examples of popular and folk art forms encompassing Americana, sign-painting, fairground and circus art, barge painting and even American GI art, but this again would confuse the issue, since all these forms are among those consciously referred to as sources by Pop artists. The real question is why such sources, which had been largely ignored by artists for many decades even though they were equally available, should suddenly be taken up, together with such other 'non-artistic' pictorial forms as advertising.

The tempting answer is that Pop arose from a confluence of cultural, economic and social conditions after a period of pronounced austerity during and immediately after the Second World War, and then replicated itself exponentially through the influence of one artist or group of artists on another.[6] Yet the story is far subtler and more complicated than such a glib explanation would allow. The sources of Pop and the reasons for its development are as varied and numerous as the work described by the label. The work of each artist covered here, and the situation from which it arose, has its own terms of reference. Only by allowing the story to unfold in all its detail, from the beginnings of Pop in the 1950s through its conclusive arrival in the 1960s and subsequent influence in the 1970s and 1980s, can the thrust of its development as a continuing history be laid bare.

I do not wish to pre-empt the discussion that follows by dealing here with general matters that will emerge as leitmotifs in this analysis of Pop, such as the broad differences in tone, references and formal structuring that distinguish American varieties of the movement from their counterparts in Britain and Continental Europe. Nevertheless, it is worth bearing in mind from the beginning that the imagery favoured by Pop artists concentrated much more heavily on mass-produced objects than on the human figure, and that landscapes and cityscapes made only rare appearances and even then in a wholly synthetic manner that treated the environment as a construction imposed by us onto nature.

Some of the questions that arise in unfolding the history of Pop cannot easily be answered. It is striking, for instance, that the movement, especially in its early stages, remained essentially the preserve of male artists, which cannot be explained simply as symptomatic of the general position of women in the visual arts, since the ratio of women to men is even smaller in Pop than in other movements of the period. Can this factor be caused in part by the social conditioning of women, even after the advent of feminism in the 1970s, whereby they are presumed to value intimacy and emotion over the aloofness and detachment that were essential characteristics of much Pop? It is apparent, too, that many of the artists associated with the movement are defensive about having the label applied to their work. Is this typical of the resistance of all artists to being categorized, especially when that category is commonly perceived to have enjoyed only a brief ascendancy in the 1960s? Is it that the term itself, with its identification with popular culture, pop music and mass entertainment, suggests that the art is of a low order of seriousness or intellectual acuity?

Pop artists have consistently exploited found objects and ready-made images and associated their work with mass production and other methods of creation, as if to expunge the creativity and control that had been prized for centuries in Western art. Why should anonymity and detachment suddenly be thought worthy goals, and why should these artists appear to denigrate invention, uniqueness, expressive potential and emotive content? The prevalence of such attitudes since the early 1960s can only partly be accounted a reaction against the exaggerated expressiveness and cult of personality in the movements that immediately preceded Pop in both the United States and Europe. More to the point, perhaps, is that Pop was the first full-blown return since Dada and Surrealism to a depictive art after the coming and triumph of abstraction. However pressing their desire to bring the 'real world' back into their art as blatantly and with as little ambiguity as possible, Pop artists remained acutely conscious of the historical context in which they did so. Their characteristic detachment enabled them to address themselves to the imagery they saw everywhere around them without completely submitting themselves to it, without, that is, sacrificing the hard-fought battles of modernism to which they, like their colleagues in abstraction, were legitimate heirs.

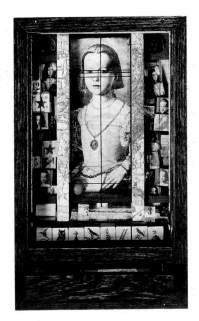

16 Joseph Cornell *Untitled (Medici Princess) c.* **1948**

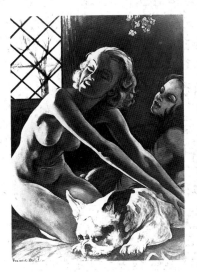

17 Francis Picabia *Femmes au bulldog c.* **1940–42**

18 Willem de Kooning *Woman and Bicycle* **1952–3**

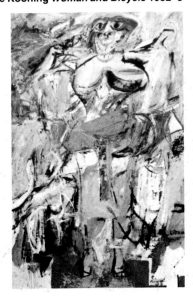

INTRODUCTION

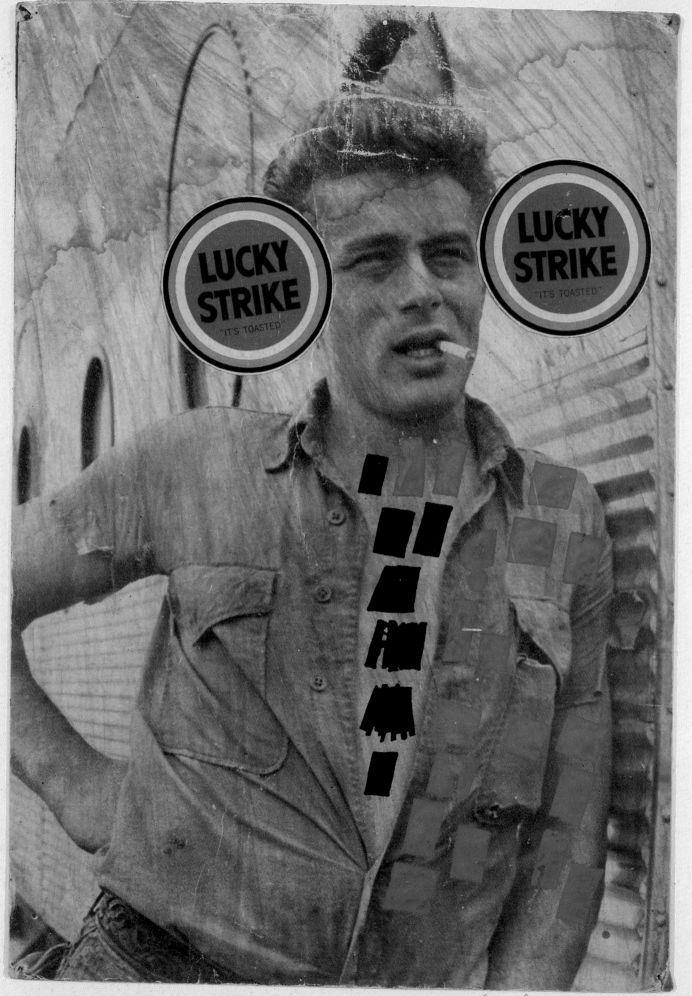

Ray Johnson 1957

COCA-COLA PLAN

Johns, Rauschenberg and American prototypes of Pop in the 1950s

Pop has come to be regarded as an art of external appearances, a resolutely post-War form of realism dedicated to the dispassionate deification of the common object and to the manipulation of images and sign systems extracted ready-made from the mass media. Its use of these media – exclusively associated with a capitalist economy – has led to its being perceived as the reflection of a materialist society saturated with images of itself and particularly of its hedonism and affluence in the post-War years. In its various forms it has been construed rather confusingly as nostalgic, celebratory, mindless and even satirical, but its supporters and detractors alike are generally agreed on one thing: that it expunged the emotion associated with the mainstream traditions of European painting and particularly the existential anxiety, intense inwardness and emphasis on spirituality, individual identity and self-communion associated with Abstract Expression-ism, the predominant American movement of the 1940s and 50s. Indeed, through to the early 1960s young artists keen to establish their identity in America had to contend with this movement's almost monolithic presence. With some of its chief representatives, no-tably Jackson Pollock and Arshile Gorky, already dead, and the remaining major figures only then beginning to enjoy the financial rewards of growing critical esteem, the style was becoming entrenched as a new mode of academicism and was being dissipated by the decorative and less robust variations of its premises practised by younger followers. What had seemed daring and outlandish only a decade earlier was beginning to look safe. The older generation's work, moreover, was becoming institutionalized as a wea-pon of cultural diplomacy in subsidized exhibitions that were toured abroad at the height of the Cold War period under the auspices of the International Council of the Museum of Modern Art.

Jasper Johns's paintings of the mid-1950s, notably his images of targets and of the American flag, had a profound impact when they appeared in his first one-man exhibition at the Castelli Gallery, New York, in January 1958. In their identification of the canvas with a flat, commonplace object, and in their apparent rejection of the attributes associated with art as an expression of personality – of the choices implicit to gestural brushwork, subjective use of colour and traditional methods of composition – these works signalled a fundamental change in definitions of art. Although they were created nearly a decade before the term Pop gained general currency, they occupy a critical position not only by virtue of their early date and formal and conceptual clarity, but also because of their widely acknowledged influence on the origins of Pop as a coherent movement in the early 1960s.

What seemed to observers of Johns's work in 1958 like shocking forthrightness and detachment, even indifference, looks altogether more personal and private to us now.

The tremulous brushwork, the layering of paint over a collaged surface of newspaper, the reticence rather than arrogance of bestowing such tenderness on the replication of a pre-existing image all seem now like the hallmarks of an intensely contemplative artist who has even retained something of the gestural expressiveness of Abstract Expressionism. Johns made no public pronouncements on his work until 1959, allowing others to draw their own conclusions, and by the time he began discussing his ideas at greater length in the mid-1960s his role in instigating Pop – even if based on misapprehensions of his motives – was a historical fact. Not until 1964 did he explain that the very idea of making the flag the subject of a painting had come to him in a dream.[1] This is not the kind of inspiration on which hard-core Pop artists were meant to rely; but by 1964 Johns had changed direction towards a greater mystery and elusiveness in elaborating his own ideas about painting, and he would have been keen to distance himself from the blatant matter-of-factness of the Pop and Minimal art he can be said to have spawned.

In *Flag* (1955) Johns relied on his choice of subject as the entire form and composition of the painting, imitating a real, man-made object closely enough to make the viewer question its presence on the wall of an art gallery, but leaving the texture of the brushwork sufficiently apparent to make it obvious that one is looking not at the real thing but at an artificial re-creation of it. Through the uneven application of the translucent wax encaustic paint one can perceive the newspapers Johns used as a porous base, introducing another element of 'reality' only to bury it beneath the surface of his own activity. The image itself is presented without comment, left open to viewers to interpret as they wish. Early commentators came to wildly contradictory conclusions about the artist's motives and the social and political implications of the subject, from accusations of chauvinism and pandering to bourgeois taste to anti-Philistine satire.[2] Johns maintained a studious silence on the matter, setting the tone for the deliberate open-endedness of later Pop art in such a way that the potential meanings of a work can be reached only through the spectator's active engagement. What at first appears to be an elimination of subjectivity emerges as a dislocation of that subjectivity from the artist to the audience.

The elaboration of the flag in other paintings by Johns established another precedent: that of appropriating as his own a motif from a generally available fund of images, with his claims to 'ownership' vindicated tautologically by the fact of its re-introduction into other works. Johns subjected the stars-and-stripes to various permutations, draining it of its normal colours (*White Flag*, 1955), presenting it as a pun on landscape and colour-field painting (*Flag on Orange Field*, 1957), emblazoning its regular pattern of horizontal bars over a four-part strip of identical photo-booth portraits (*Flag above White with Collage*, 1955), commenting on actual and illusionistic depth by creating a relief from flag canvases of decreasing size (*Three Flags*, 1958) and finally memorializing it in cast bronze (*Flag*, 1960). By such means a single motif of the utmost simplicity serves as a constant, like a scientific 'control', to examine other essential characteristics of painting. As Johns later explained, 'Say, the painting of a flag is always about a flag, but it is no more about a flag than it is about a brush-stroke or about a color or about the physicality of the paint . . .'.[3]

By the time he had painted his first *Flag* Johns had met Robert Rauschenberg, and by the end of 1955 they were living and working in the same building in New York on Pearl Street off Fulton, thus influencing each other. Although the contrast between Johns's reticence and Rauschenberg's more volatile and expansive temperament was clearly registered in the many differences among their work – between Johns's apparent subjection to the found object as a model and Rauschenberg's habit of violating or inflicting

THE FOUNDATIONS OF POP

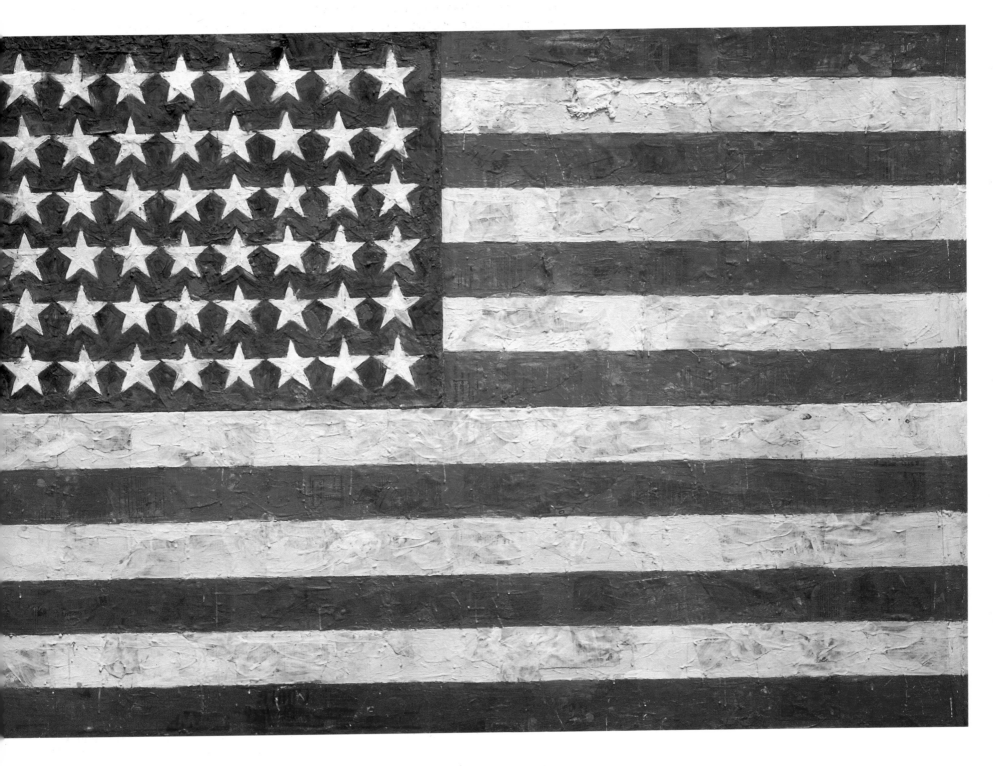

20 Jasper Johns *Flag* 1955

violence on objects for his 'combines' – both were seeking ways of incorporating fragments of reality into a visual language derived from Abstract Expressionism, in order to expand what they considered its limited frame of reference and excessive inwardness. While Rauschenberg employed the sweeping gestures and reckless drips associated with artists such as de Kooning, Pollock and Franz Kline, whom the critic Harold Rosenberg termed Action Painters, Johns appears to have taken as his model the more subdued handling of Philip Guston; Johns expunged the traces of thrusting gestural activity in Guston's heavily worked technique by choosing the more slowly worked wax encaustic instead of oil paint, spreading it as evenly as possible over the surface but with clear inflections of the brush. By presenting his surfaces as parodies of Abstract Expressionist technique, Johns implied a biting criticism of the older painters' self-indulgent tendency to view their art as self-expression rather than as a means of communication with the viewer. The air of deliberation occasioned by the patent separateness of each stroke in a Johns painting creates an impression of decelerated action, which in turn encourages the viewer to contemplate the painting both as an image and as a fabricated object.

Rauschenberg and Johns elaborated their ideas about the junction between art and life through their contact with the composer John Cage, whom Rauschenberg had got to know while studying at Black Mountain College in North Carolina from 1948. Cage thought of music as encompassing not only invented and structured sounds but also those made by the audience or audible within the environment at large. His insistence that everything was worthy of attention profoundly influenced both these painters and other artists associated with Happenings and early Pop in the late 1950s. The basis of Rauschenberg's aesthetic in collage and assemblage as early as 1950 clearly encouraged Johns with his own more tentative incorporation of objects into his earliest extant works, such as *Construction with Toy Piano* (1954), with its row of numbered wooden keys, and *Tango* (1955), a monochrome blue field concealing a music box visible only in the form of its winding mechanism near the lower edge of the canvas. Both Rauschenberg and Johns seem by this time to have become interested in Cornell's work, judging for example by Johns's use of a row of wooden boxes to contain plaster casts of male anatomical fragments in *Target with Plaster Casts* (1955).[4] It has been suggested that these life-size excerpts of human life hidden behind closed doors were cast from Rauschenberg's body, a theory that would lend support to the aura of privacy and secrecy so conspicuously at odds with the sense of exposure prompted by the target image itself.[5] When first shown in the Castelli 1958 exhibition, however, this painting attracted particular attention not for its subtlety of personal meaning but for its apparent depersonalization in the choice of subject and method of execution, and to a lesser extent for objectifying the human body as a sculptural form.[6]

As with the *Flags* it was, above all, the formal and conceptual audacity of the target image that excited other artists. Here is a painting that not only represents a subject but recreates it faithfully and without comment as if it were a found object, a man-made replica of a man-made artefact. Johns's use of the image tells us about painting, of course, not archery. The astonishing emblematic simplicity of the centred concentric bands of colour, with their resolute flatness, is heightened by our prior knowledge of the 'real' thing for which the painting serves as a stand-in. It was the apparent artlessness that critics found most shocking or audacious, leading to comparisons with the Dada provocations of artists such as Marcel Duchamp and Francis Picabia.[7] Yet the tenderness lavished by Johns on the painted surface belies any anti-art intentions. The momen-

tary confusion of identity between the painting and the thing taken as its model serves as a kind of decoy, to borrow the title of one of his later works, catching us off-guard as a prelude to heightening our perception. The apparent invitation to decisive action is immediately subverted by the painting's 'uselessness' in contrast with that of a real target; our role is limited to the relatively passive one of opening or closing the boxes surmounting the main image. Implicit in the very idea of the work having even a potential function is that of violating its sacrosanct flat surface. Finally, it is quite obviously not a manufactured object but a highly crafted painting. All its attributes as art, in other words, are exaggerated by our mental comparisons with the thing that we first took it to be.

There was a widely held view in some art circles in the 1950s that serious painting had to be abstract, that it was retrograde for artists to make reference to the outside world by engaging in representation or illusion. Johns's tactic confounded such dictates by introducing imagery – of the most extreme and deliberate banality – that simultaneously emphasized the formal values of the painting and (in the matter-of-fact duplication of an existing thing) the image as the product of a conceptual act. Every element is at once itself and a component of the painting, the literalness encompassing both its material identity and its function as a representation. Johns extended these methods in other paintings by choosing words and numbers as his subjects, playing on our acceptance of these ciphers as abstractions of concepts relayed on a flat surface and on our awareness that by definition they can be remade endlessly but never imitated. As Leo Steinberg perceptively noted in his early monograph on Johns, 'A crucial problem of 20th century art – how to make the painting a firsthand reality – resolves itself when the matter shifts from nature to culture.'[8]

Johns's concern with the painting as an object might well have led him to incorporate real objects in his paintings even without the influence of Rauschenberg. In one such work, *Canvas* (1956), he appended a small canvas seen from the back to the surface of another canvas, covering both in a layer of collage impregnated with grey encaustic paint. What could be more literal than a painting of a painting? Yet the severity of its construction makes it one of the most abstract-looking of Johns's early works, an irony further compounded by the fact that in taking an actual canvas as his subject he moved from flatness into full relief. In 1958 Johns made his first sculptures, choosing two ordinary household objects in the most standard designs he could find: a light bulb and a flashlight. Their domestic, familiar and poignantly prosaic quality are their most apparent features, exaggerated by the deference accorded them in plaster, sculp-metal, papier-mâché and bronze versions that parody the grandiloquent romantic gestures of turn-of-the-century sculptors such as Rodin and Medardo Rosso. The common household object was soon to feature as a favoured American Pop subject in sculptures – especially in Oldenburg's work – and in paintings by Warhol, Lichtenstein, Dine, Wesselmann and others.[9]

Johns evidently exploited such ordinary objects as a useful antidote to the grandiose gestures and the search for the sublime of the previous generation. They served him not as signs of mass production and capitalist culture – as would be the case for mainstream Pop artists – but again as a means of refining his concentration on art itself. These first two sculptural subjects, for instance, could also be seen as subtle propositions of a painter's obsession with light. The light bulbs and flashlights alike are temporarily extinguished, 'buried alive', rendered opaque and unfunctional, as in the case of the light bulb presented with severed wires; their textured and patinated surfaces, however, are

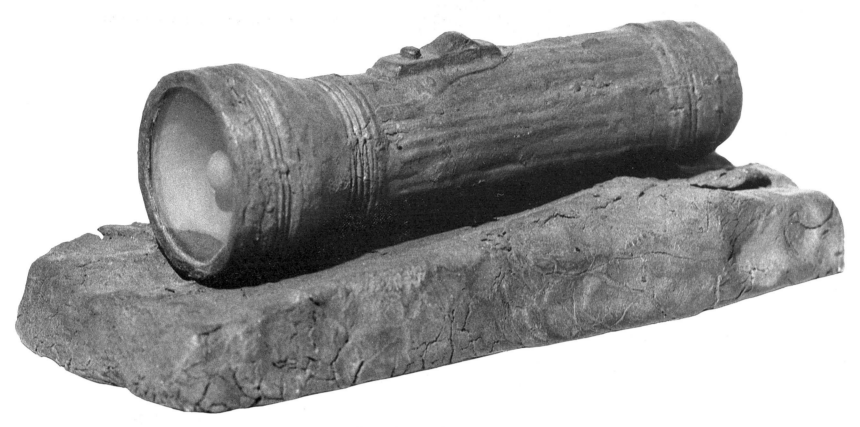

21 Jasper Johns *Flashlight II* 1958

dependent on the conditions in which they are displayed, catching all the subtleties of the light falling on them.

The influence of Johns's sculptures on the development of Pop almost certainly involved a misapprehension of his motives. This is particularly so with the two *Painted Bronze* works (both 1960), which seem most vividly to herald Pop in their replication of manufactured objects complete with boldly designed labels. The genesis of the first of these works, representing two Ballantine Ale cans, is symptomatic of what came to be regarded as a throwaway Pop attitude to inspiration: 'Somebody told me that Bill de Kooning said [of Leo Castelli] that you could give that son of a bitch two beer cans and he could sell them. I thought, what a wonderful idea for a sculpture.'[10] Having established the subject, Johns then shifted his attention to traditional artistic matters. He chose a process steeped in tradition – bronze casting – having first produced a maquette through an elaborate procedure that involved casting, fabricating, moulding, breaking and restoring. He produced only two casts of this and one of the subsequent sculpture, a Savarin Coffee can filled with painters' brushes, establishing a dialogue between the mass-produced object and its reformulation as a unique work of art. This is very different from the spirit in which Warhol, four years later, was influenced by these same works to produce his own sculptures, screen-printed replicas of cardboard cartons produced as mechanically as possible in great numbers using an adaptation of assembly-line methods. Johns's *Painted Bronze* sculptures are not, as they might at first seem, *trompe-l'oeil* replicas of manufactured objects but eulogies to the subtle interventions of the artist's eyes and hands. Close inspection yields elaborate evidence that they are hand-crafted, not machine-made, and unique. The labels of the ale cans are only fuzzily defined, their small print illegible because they are meant to be looked at rather than read. The rich

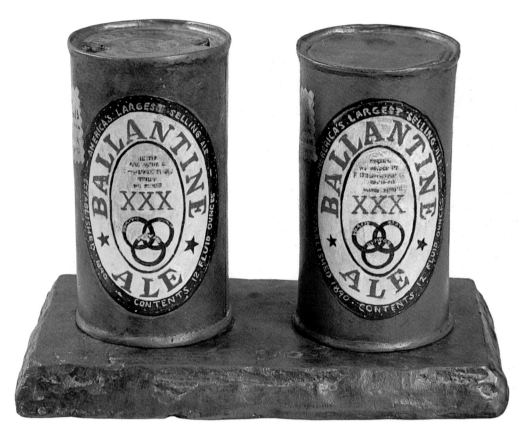

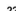
22 Jasper Johns *Painted Bronze II: Ale Cans* 1964

23 Jasper Johns *Painted Bronze* 1960

patina of bronze is clearly not the dull greyness of tin, just as the rough edges and uneven surfaces are characteristics of the fine art object and not of the regularized perfection of mass-produced goods. The repetition of the ale can as two draws attention to their 'imperfections' and differences: they are different in size, one is open and the other sealed, one plain on top and the other with an additional decoration of interlocking circles. They hint of use, of before and after, but they are rendered mute and inviolable because they are sculptures rather than the real objects they represent. Even more poignant in this respect, because of its function as the emblem of a painter's tools, is the Savarin can with its brushes permanently fixed. It is not the can for its own sake that interests Johns but its role as a container for the artist, both literally and in this context in a metaphorical sense.

The work produced in the mid-1950s by Robert Rauschenberg, like that of Johns, involved a radical re-evaluation of the status of painting that questioned in particular the most cherished assumptions underlying Abstract Expressionism. Pop Art, in its most familiar American and British forms, might never have come into existence had it not been for the alternatives the two artists proposed. Rauschenberg had participated in various group exhibitions and had held one-man shows in New York at the Betty Parsons Gallery (1951) and the Stable Gallery (1953, of his severe *White Paintings* and *Black Paintings*), but it was only towards the end of the decade that his mature aesthetic was revealed in his first one-man show at the Castelli Gallery, held in March 1958, a matter of weeks after Johns's exposure there. Equally important was his presence in the 'Sixteen Americans' exhibition organized by Dorothy Miller at the Museum of Modern Art in December 1959; this included work by Johns, Ellsworth Kelly and Frank Stella, but Rauschenberg was notable not just for his five combine paintings but for a statement that was to be as widely quoted and influential as the art itself:

24 Robert Rauschenberg *Charlene* 1954

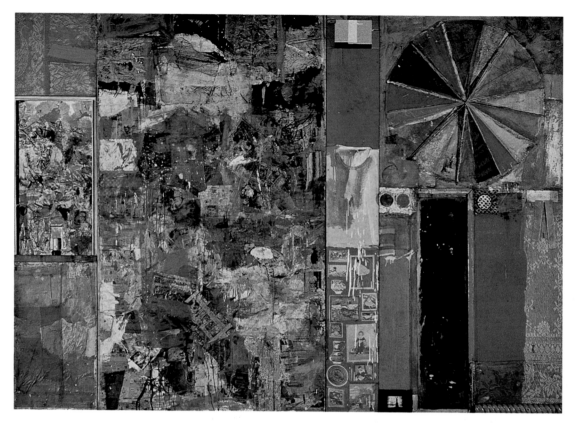

25 Robert Rauschenberg *Coca-Cola Plan* 1958

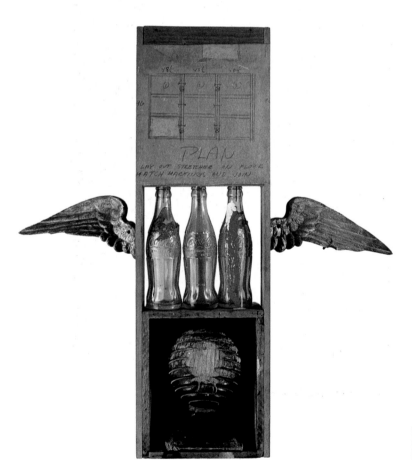

Any incentive to paint is as good as any other. There is no poor subject . . .
 Painting relates to both art and life. Neither can be made. (I try to act in that gap between the two.)

Rauschenberg's invention in the mid-1950s of a form of painted assemblage using found objects, which he christened the 'combine', evolved naturally from the collage basis of his earlier work and particularly from the red paintings begun in 1953 in which he used comic strips as a colour ground. From the time that it was first used by Picasso and Braque in the Cubist period, collage had been consistently used to bring fragments of the real world into the actual fabric of the work of art and to propose representation as an interaction between factuality and illusion. For the Dadaist Kurt Schwitters, whose work is commonly acknowledged as the most immediate model for Rauschenberg's use of collage, the medium was a way of retrieving ephemeral fragments collected in the street and of celebrating their forlorn and essentially abstract beauty of colour and texture. Rauschenberg was clearly aware of these precedents in twentieth-century art. Yet his selection of material was generally based not on formal matters but on the modern urban quality of the images, and his methods were far more aggressive than those employed by the Europeans. Such reconsiderations of collage were vital in preparing the way for the audacious dedication to found material and ready-made images that came to characterize much Pop in the early 1960s.
 In Rauschenberg's *Charlene* (1954), which in its vast, panoramic dimensions rivalled the ambitious scale favoured by the Abstract Expressionists, the surface is littered with

22

fragments of reality, including torn newspapers, reproductions of works of art, pieces of cloth and even a dismembered umbrella flattened and presented as a gigantic artist's colour wheel. Some of these samples of the artist's fund of images and materials are left in their raw state as found objects, while others are virtually obscured in dense and impulsive deposits of paint. Signs of art and life seem locked in a struggle for predominance, and beneath the chaotic surface a clear grid structure emerges as if to suggest a quest for order and a method for tabulating and compartmentalizing this confusion of data.

While Johns wanted the formal clarity of a painting to be equated with a single found object, Rauschenberg sought to accommodate the confusion of sensations and imagery characteristic of modern street life and the incessant production of the mass media. To this end he was far more prepared than Johns to appropriate ready-made images such as reproductions and photographs in profusion, creating a precedent for the use in early Pop both of found objects (as in the work of Dine and Wesselmann) and pre-processed imagery (as in the paintings of Warhol and Lichtenstein). The formal bluntness of much American Pop bears witness to Johns's influence, but Rauschenberg's use of charts and grid patterns underlying a compositional syntax of seemingly arbitrary jumps across the surface had its adherence among younger artists such as R. B. Kitaj, an American painter who himself influenced others on settling in England in 1958.

Particular devices introduced by Rauschenberg into his manipulation of found material, together with a flair for visual wit, proved rich in possibilities. One such instance can be found in *Gloria* (1956), which takes as its starting-point a newspaper story and photograph of Gloria Vanderbilt in a wedding dress, captioned 'Gloria Weds Third Time'. Three further copies of the photograph are pasted next to it, introducing a humorous visual pun. Another form of repetition – a tactic that became central to Warhol's use of images drawn from the mass media – occurs in a pair of paintings produced by Rauschenberg in 1957, *Factum I* and *Factum II*, in which the apparently spontaneous relationships of found images and casual brushstrokes are duplicated closely enough to cause confusion but with sufficient imprecision to show the uniqueness of each; even within each canvas certain elements, such as a photograph of President Eisenhower and another of a burning building, occur twice but cropped or marked to differentiate one from the other. The cult of uniqueness traditionally assumed to be the proper status of the work of art is here questioned by Rauschenberg, as Johns was to do in his ale cans of 1960, but ultimately not overturned; both artists remained too fundamentally devoted to the idiosyncracies of touch as the imprint of personality to wish to see the threat carried to its logical conclusion. This task of demystification of the artistic process, like that of depersonalization of technique, was left to the Pop artists in the 1960s as part of a more determined purge of the romantic cult of the individual.

One of Rauschenberg's most notorious works, and as influential for Pop as Johns's flags and targets of 1955, is a large combine painting, *Bed*, produced in the same year. The equation between subject and object, between the image and its presentation as a painted artefact, is here even more literal than in the works by Johns. Not only does the painting take the form of a bed, it is conspicuously made from its materials: a quilt, sheet and pillow attached to wooden supports and covered in violent gestures of paint. Its shock value at the time cannot have been limited simply to what was perceived as a provocative anti-art gesture in the use of found objects, since other works in Rauschenberg's 1958 exhibition relied on similar methods. What must have been specifically upsetting were the implications of the object itself, together with the positioning and wild

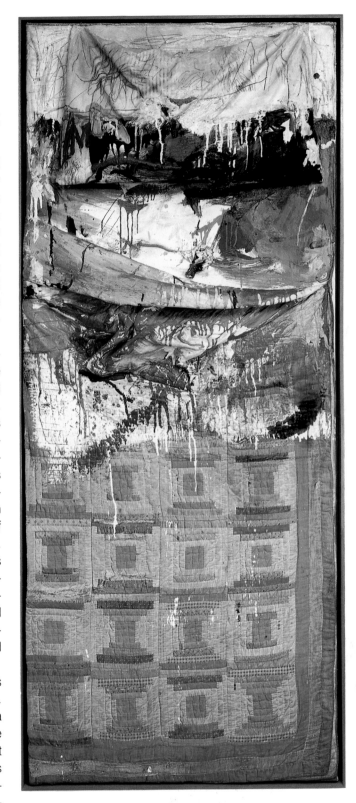

26 Robert Rauschenberg *Bed* 1955

COCA-COLA PLAN

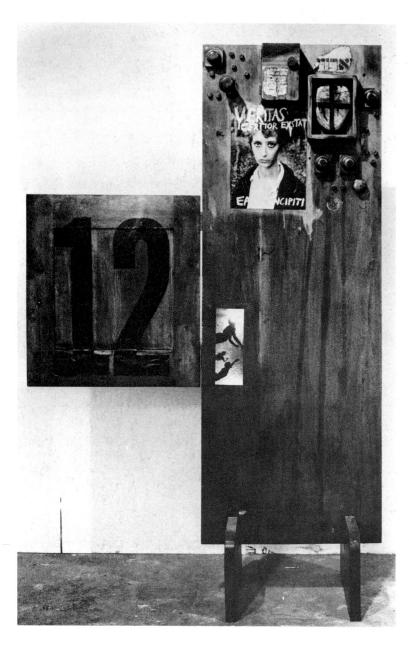

27 Wallace Berman *Panel* 1949–57

28 Robert Rauschenberg *Black Market* 1961

application of the paint over the pillow and opening into the bed, just where we would expect to find someone's head and torso. Whether read as orgasmic frenzy or as a bloody crime of passion, the connotations are unavoidably sexual and disturbingly intimate in such a public context. There was to be no place for such blatant subjectivity of emotion, either of subject-matter or painterly technique, in classic Pop art. The Pop artists, however, unquestionably learned from such works that a powerful punch could be carried by the choice of image alone, no matter how bland or unjudgmental its presentation.

In at least two works of 1958, *Curfew* and *Coca-Cola Plan*, Rauschenberg employed among his found objects one of the most instantly recognizable of twentieth-century American mass-produced artefacts: the Coca-Cola bottle. The shape of the bottle and the familiar logo emblazoned on its side had contributed vitally to the company's success in promoting its drink around the world, and by this date it had come to represent the commercial supremacy of the United States.[11] In *Coca-Cola Plan* three Coke bottles, their identity no less evident for the paint smeared across their surfaces, are encased within a free-standing tripartite construction; the central and elevated position accorded to the bottles, the presentation of the slab-like construction as a modern equivalent of an ancient stele, and the classical grandeur suggested by the outstretched wings appended to the side of the box all contribute to the commemoration of this humble but financially and symbolically powerful icon of America's economic and consequent cultural power.

The plan alluded to in the title of this work is set out in the upper register as a diagram and brief explanation for assembling the construction. It remains, of course, a rhetorical device, for the work has already been completed. In its appeal to the spectator as an active participant, however, it proposes another theme that was to gain widespread currency in Pop art of the 1960s: that of art as a form of collaborative play enacted between artist and audience, whether on a purely conceptual level (as in Warhol's *Dance Step* and *Do It Yourself* paintings) or on a more practical one (as in the changeable form of certain works by Peter Phillips, Joe Tilson, Oyvind Fahlström and others). Rauschenberg himself took the idea further in works such as *Black Market* (1961), a participation piece first shown in March 1961 at the Stedelijk Museum in Amsterdam as part of the exhibition 'Motion in Art'. Here the spectator was asked both to remove an object from the suitcase placed below the painting (in exchange for another to be deposited there) and to make a drawing of it which he or she was then to attach to one of the four clipboards on the painting bearing the same number as the object in question. This plan, too, was destined for obvious reasons to remain more an idea than a practicable arrangement, but this frustration of its intended means of operation does not negate its purpose; one could simply say that it was 'temporarily out of order'. The 'one way' arrow and car plate attached to the surface likewise play no useful role either in directing or transporting the spectator, but they have a function nevertheless as actual fragments of the street, as signs in both a literal and metaphorical sense. These, too, point the way forward to the self-consciously public language of Pop.

However central the role of Johns and Rauschenberg in preparing the ground for Pop, other American artists working in the 1950s were proceeding from similar assumptions, without necessarily wielding a direct influence. Among those working with collage and assemblage was the Los Angeles artist Wallace Berman, whose *Panel* (1949–57) was perhaps the most striking of the works shown at his 1957 exhibition at the Ferus Gallery, Los Angeles. Like Rauschenberg's, this free-standing assemblage proclaims its physi-

THE FOUNDATIONS OF POP

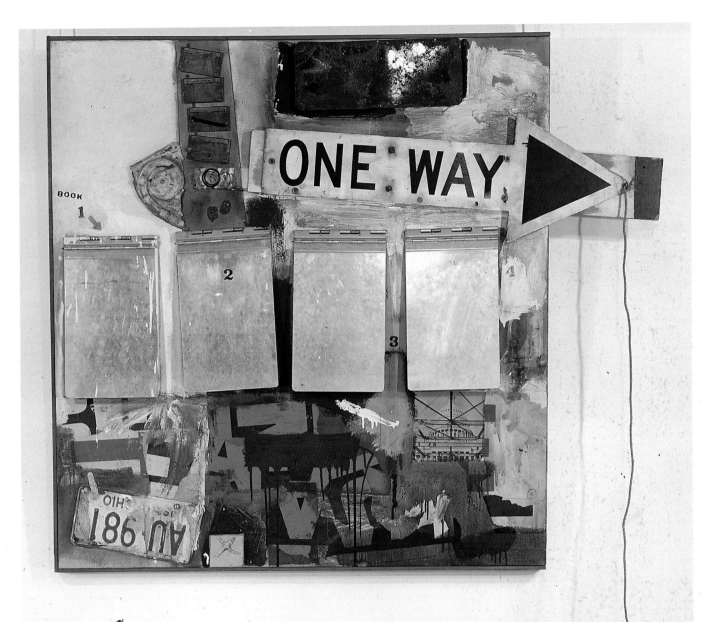

29 Larry Rivers *Cedar Bar Menu I* **1960**

30 Larry Rivers *French Money c.* **1962**

cal identity as an object both through its basic construction and by the addition to its surface of photographs, found objects and hand-painted lettering; the spectator's participation is invited by the hinged wooden door. Berman's choice of unfamiliar images and of Latin and Hebrew for his written messages contrasts strongly with the avowedly accessible material favoured by Rauschenberg. Although this work has much in common formally and in its procedures with early Pop, it remains cryptically private and thus at odds with Pop's espousal of an immediately recognizable language of signs and shared frame of reference.

Among the more established artists of the period who must also be regarded as precursors of the movement is one of the leading Abstract Expressionists, Willem de Kooning. De Kooning had remained not only committed to a form of figuration but also absorbed in the specifics of the urban environment and the mass media; in works such as *Attic* (1949) he incorporated into his paint surfaces the imprint of newspapers used to speed their drying time, and in a 1950 study for one of his *Woman* series he had gone so far as to incorporate a smiling female mouth collaged from a magazine advertisement for Camel cigarettes.[12] The hard-core American Pop artists were united in their admiration for his work, even if it seemed untenable for them to try to rival it on its own terms; he in turn was more or less alone of his generation in having any sympathy for the younger artists who found success so quickly and with such apparent lack of respect for their elders in the early 1960s.[13]

One of the figurative painters who first found direct encouragement from de Kooning was Larry Rivers, following their meeting in 1948. Rivers had worked as a jazz musician in his late teens at the beginning of the Second World War and had taken up painting only in 1945, studying first at Hans Hofmann's school in 1947–8 and from 1948 at New York University under William Baziotes and others. However immersed he thus was in the Abstract Expressionist milieu, he stubbornly resisted their emphasis on abstraction and looked instead to the work of French figurative artists including Courbet, Matisse and Bonnard. As a deliberate provocation he decided in 1953 to produce a painting of monumental proportions as an essay in the genre most despised at the time, the historic set-piece, a contemporary version of the nineteenth-century academic *grandes machines*. As if not content with flying in the face of the entire modernist tradition by taking such an aggressively retrograde step, he chose the most ridiculous and clichéd subject he could imagine, *Washington crossing the Delaware*, one that was familiar to every American child from the grandiose and much reproduced 1851 painting by Emanuel Leutze in the Metropolitan Museum of Art, New York. Rather than base his image directly on this precedent, he stripped the subject of its pomp and heroism and imagined it on a more persuasively human level, concentrating on the frailty and hesitation of the figures in making their way through a cold, inhospitable landscape. In the process the loose and gestural brushwork of the Abstract Expressionists was likewise drained of its customary exaggeratedly masculine heroism.

Washington crossing the Delaware was greeted with considerable derision when first exhibited at the Tibor de Nagy Gallery, New York, in December 1953, but its audacity in introducing a banal subject – one, moreover, with explicitly American connotations – encouraged many other painters by the beginning of the 1960s. Rivers himself was slow to follow up the implications of using a 'found subject', even though in 1951 he had produced another large painting, *The Burial*, based in equal measure on personal experience and on Courbet's 1849 masterpiece *A Burial at Ornans*. In the mid-1950s he turned his attention instead to intimate images of his family life. The occasional painting, such as

26

31 Larry Rivers *Washington crossing the Delaware* 1953

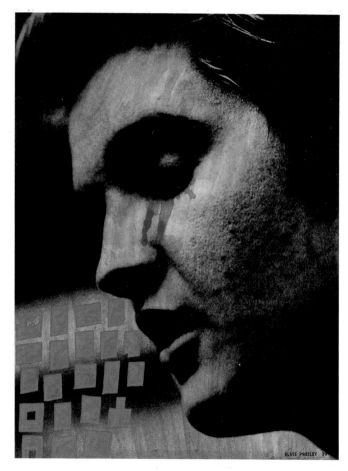

32 Ray Johnson *Elvis Presley No. 1 c.* 1955
33 Ray Johnson *Hand Marilyn Monroe* 1958

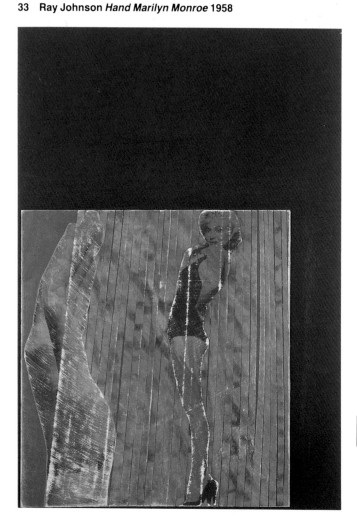

Europe I (1956), was based on old snapshots, but this was more of a convenience and a comment on the past than a conceptual gesture about the use of ready-made imagery; similarly the stars-and-stripes were introduced in fragmented form into *Berdie with the American Flag* (1955) more as colour accents than as an emblematic motif. Even his treatment of a prototypical Pop subject in *The Accident* (1957) was conditioned by his taste for episodic fragments scattered across the surface like materialized memories.

It was only in 1959, following Johns's much discussed Castelli show, that Rivers began to paint pictures explicitly based on existing material. One of the first of these, *Cedar Bar Menu I*, is a loose improvisation of the bill of fare at the Cedar Bar Tavern, then the prime meeting-place of the New York art world and particularly of the Abstract Expressionist circle; compared to Johns's deadpan mimicry of the American flag, this is a personal work exaggerated both in voluptuousness of technique and in the sly artistic references by which the partial duplication of a Ballantine Ale label is transformed into a reference to the Futurist painter Balla. Rivers's stubborn dedication to expressive brushwork was to meet with a greater response among painters in England, such as David Hockney and Allen Jones, who first came across his work in magazine reproductions in the early 1960s, than among other Americans, for whom such painterly gestures were too closely associated with the Abstract Expressionism against which they were reacting.[14] In both countries, however, the daring, wit and strong formal sense that Rivers applied to a succession of paintings based on commonplace printed objects – playing cards, cigarette packets, banknotes[15] and magazine photographs of Civil War veterans – did much to promote the attitudes and methods that were soon identified as Pop.

Such pictures by Rivers were important precursors of Pop but other artists, too, were making works that indicated a major shift of sensibility. In the mid-1950s Ray Johnson, a friend of Rauschenberg who had studied at Black Mountain College from 1945 to 1948, abandoned geometrical abstraction and produced the first of hundreds of small collages that he termed 'moticos'. Many of these consisted of fragments of newspapers or pages from magazines embellished with additional printed images, with washes of ink or with brightly coloured shapes and patterns littered like confetti as purely graphic devices. In some of these works, particularly in those based with great prescience on glamorous images of pop stars and matinée idols such as Elvis Presley, James Dean and Marilyn Monroe, Johnson appropriated mass-circulation photographs as his own inventions: an operation which in its idea, if not in its technique, prefigured the later strategies and subject-matter of Pop artists such as Warhol.[16] To a greater extent than Rauschenberg's combines, in which similar found materials were treated as compositional elements, the most extreme of these collages could be described as 'assisted ready-mades' in their presentation of an altered but otherwise intact photograph as the final work. There are clear affinities, too, with Johns's flag and target paintings made at the same time, but again with an important distinction: Johns made life-size replicas of his subjects by redrawing them, while Johnson took the literalness one step further by simply lifting his mechanically produced images intact.

Johnson's early works may indeed appear as astonishing prefigurations of classic Pop, but one must bear in mind not only that the most iconic of these collages are not necessarily the most typical of the many hundred he produced, but also that in their small scale and hand additions they remained essentially intimate and private works. *Elvis Presley No. 1* (*c.* 1955), for instance, emphasizes the tragic vulnerability of the young rock'n'roll star by the addition of red ink flowing like bloody tears from what appears to be a gouged eye. *James Dean* (1957) questions the swaggering toughness suggested by

the pose and the cigarette casually dangling from the recently martyred star's lips: black marks adorn the smooth chest visible through his shirt, like the masculine hair he conspicuously lacked; ink washes caressing the surface propose a tenderness at odds with the bravado and studied aloofness of his public image; and the circular emblems of Lucky Strike cigarettes, attached to his head like outsized earrings, enigmatically suggest both his sexual desirability and his paradoxical good fortune in attaining cult status on his death, two ways of 'striking lucky'. *Hand Marilyn Monroe* (1958), sliced into thin vertical strips and then reassembled, sanded down and covered in a hot pink wash, heightens her inaccessibility by presenting her self-consciously alluring pose as if through a veil or curtain never to be drawn back.

Wariness of the gallery system necessarily minimized Johnson's direct influence on the course of Pop art; his collages were not seen in a one-man show until 1965. By 1968, when he established the New York Correspondence School of Art, he had decided to devote himself primarily to another form, that of mail art. His collages of the 1960s and after are often fragmented and intentionally disparate in form, laden with handwritten texts, private jokes and found and invented images; poetic and highly personal, they bear only a very tangential relationship to Pop by virtue of some of their motifs and sources. Johnson remains, however, an important artist in the early development of a Pop aesthetic in America, if only for a few of his images.

Other American artists active in the 1950s similarly produced occasional works that prefigured aspects of Pop without these necessarily being central to their concerns. Jess (Collins), a Long Beach native based in San Francisco from the late 1940s, is a case in point. He worked in various media, producing paintings and more characteristically Dada- and Surrealist-influenced collages, which he termed 'paste-ups', and junk assemblages. Among the paste-ups was an eight-part series produced sporadically from 1954 to 1959 from Dick Tracy comic strips culled from the colour pages of Sunday newspapers; the choice of a witty anagram as their title, *Tricky Cad*, alerts us both to the deceit being performed and to the importance of word-play. Such tactics bear some relation to the fact that he was a close associate of the Beat poets and the companion of the poet Robert Duncan. While preserving the illusion of conventional narrative structure from the comic-strip frames, the artist has tampered with the dialogue, moving fragments of sentences from one frame into another to subvert their meaning and to disrupt the sequence of events. In their overt presentation of the comic strip as a source of found images, these collages anticipate the subject-matter of paintings produced by artists such as Lichtenstein, Warhol, Ruscha and Ramos in the early 1960s, but they were the result of quite different intentions. Seen in the context of all Jess's work, these occasional excursions into comic strips, the literature of the semi-illiterate, relate less to mass culture than to the artist's promotion of irrationality as an 'antidote to the scientific method'.[17]

Further instances of the use of comic strips and cartoon characters can be found in the work of other American and European artists before Pop if one looks for them, but when judged objectively in their context they are clearly anomalies. Philip Pearlstein's 1952 painting of *Superman*, in which the hero lurches into a stormy sky of agitated Abstract Expressionist brushwork,[18] bears as little relation to his other work as the rare use of comic-strip fragments by Kurt Schwitters in an untypical collage produced shortly before his death.[19] Three registers of comic-strip panels are placed against an orange background in Johns's *Alley Oop* (1958) but they are so concealed in paint that their presence as a collage base can only be surmised from the configurations of brushmarks that mimic their forms; the painting typifies his work not in its implicit imagery but in the dedication to

34 Jess *Tricky Cad – Case I* 1954

35 Richard Lindner *Stranger No. 2* 1958

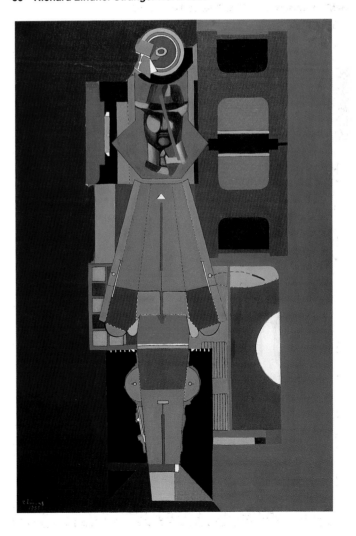

COCA-COLA PLAN

36 H. C. Westermann *The Mysterious Yellow Mausoleum* **1958**

37 H. C. Westermann *Trophy for a Gasoline Apollo* **1961**

38 H. C. Westermann *Swingin' Red King and Silver Queen* **1960**

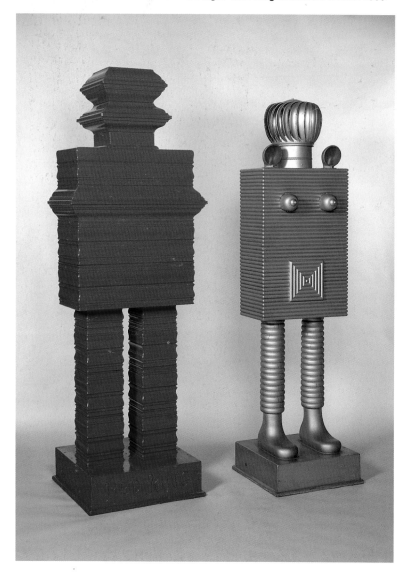

a process of revealing and concealing, a major theme of his art. Likewise Picasso in 1957 introduced the *Peanuts* character Charlie Brown into one of his fifty-eight variations on Velásquez's *Las Meninas* not in homage to the comic strip but as another means of flaunting his stylistic heterogeneity; it is but one of a variety of conflicting forms of representation, many quoting from his own post-Cubist development, that co-exist within a single picture as a demonstration of a unified attitude towards style.[20]

One must take into account, finally, those artists whose work served as a direct inspiration for certain Pop artists – in terms of formal qualities, methods and subject-matter – but who never aligned themselves with the movement. As early as the mid-1950s, for instance, the German-born painter Richard Lindner had developed a flat style and areas of vivid colour as a sophisticated rejoinder to naive or folk art, with echoes of *Neue Sachlichkeit*, of the machine aesthetic of Fernand Léger and of the poker-faced Surrealism of Magritte. While sinister psychological overtones remained paramount in his treatment of subjects involving eroticism and intimations of urban violence and anxiety, a Pop detachment became evident in paintings such as *Stranger No. 2* (1958), in which a male figure is depicted as a cut-out paper doll, a flat cipher for humanity to be assembled from ready-made components. He registered the arrival of Pop in his work from about 1963, introducing a garishness of colour into his sign-painter's technique and turning to contemporary subjects in pictures of rock guitarists, gangsters and mini-skirted and sexually provocative women. Yet Lindner's insistence on invented rather than borrowed imagery, his taste for narrative and spatial illusion, and his cultivation of an atmosphere of mystery and uncertainty all kept his work perpetually apart from the mainstream of Pop.

Equally influential yet resistant to classification was the Chicago sculptor H. C. Westermann, who made occasional inroads into Pop territory as early as the mid-1950s with his quasi-Surrealist and humorous constructions as accidental by-products of his reckless inventiveness rather than deliberate statements about common objects. Even when combining his carpentry with bold decorative patterns and found objects, as in *The Mysterious Yellow Mausoleum* (1958), his appeal was not to the here-and-now but to a world that exists fundamentally in the imagination. The mechanistic forms and brightly painted metallic surfaces of his *Swingin' Red King and Silver Queen* of 1960, an uncharacteristically large work, anticipate by two years the first robotic figures by the Scottish sculptor Eduardo Paolozzi; they were motivated, however, not by an obsession with science fiction, as in Paolozzi's case, but by a tireless desire to continually re-invent the human body in different guises. Westermann had earlier fabricated such figures as *The Uncommitted Little Chicago Child* (1957, a lovingly crafted totem shaped like a giant clothespeg), *Evil New War God* (1958, constructed from slats of brass) and *Memorial to the Idea of Man if He was an Idea* (1958, a wooden cabinet for a torso surmounted by a turretted tower as a head), and he later went on to such mutants as *Hutch – One Armed 'Astro-turf' Man with a Defense* (1976), in which the lost hand re-emerges as a threatening boxing glove in place of the figure's head. Even when using found objects or making reference to contemporary consumer items, as in *Trophy for a Gasoline Apollo* (1961), in which four overpainted Coca-Cola bottles serve as the first part of a pedestal for a miniature version of a car with absurdly large aerodynamic fins, Westermann looks askance at his culture while appearing to celebrate it. There is both affection and equivocation in such works, which in their quirky imagery and loving craft ultimately declare their dedication to the unique and personal rather than to the Pop ideal of the mass-produced and anonymous.

Among both precursors of Pop and artists later associated with the movement, it may simply be a matter of temperament that dictates whether or not the label seems appropri-

30

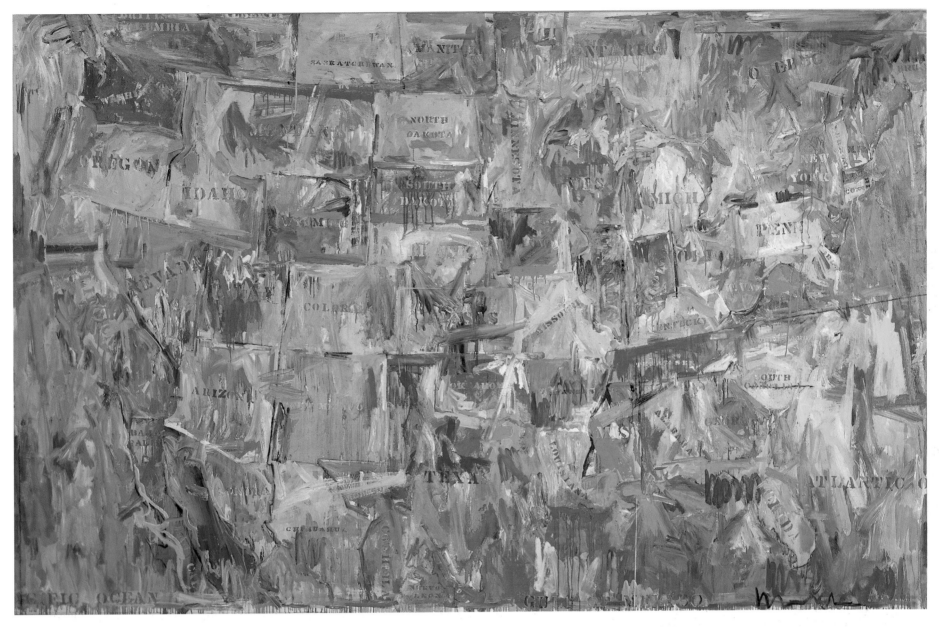

39 Jasper Johns *Map* 1961

ate in any given case, however great the influence of that person's work on the development of stylistic or conceptual strategies. Paintings by Johns that have as their subject a map of the United States, a series initiated in 1960 when he painted over an actual map given to him by Rauschenberg, herald the imminent arrival of classic Pop in their magnification of a flat and immediately recognizable image that can be taken – literally, in this case – as a sign of contemporary society. The suspicion remains, however, that as far as Johns himself was concerned, it was also a means to other ends: painting a landscape without engaging in illusions of depth or image, countering Abstract Expressionist notions of the sublime by measuring the size of a huge canvas against the far vaster geography it portrays, and deflating the pretentiousness of grand gestures by using the sweep of the brush to obliterate entire states. The very possibility of such multiple readings was to prove foreign to the theoretical underpinnings of Pop. Yet Johns's *Map*, like so many other works of the 1950s and early 1960s, set the terms that made it all possible.

COCA-COLA PLAN

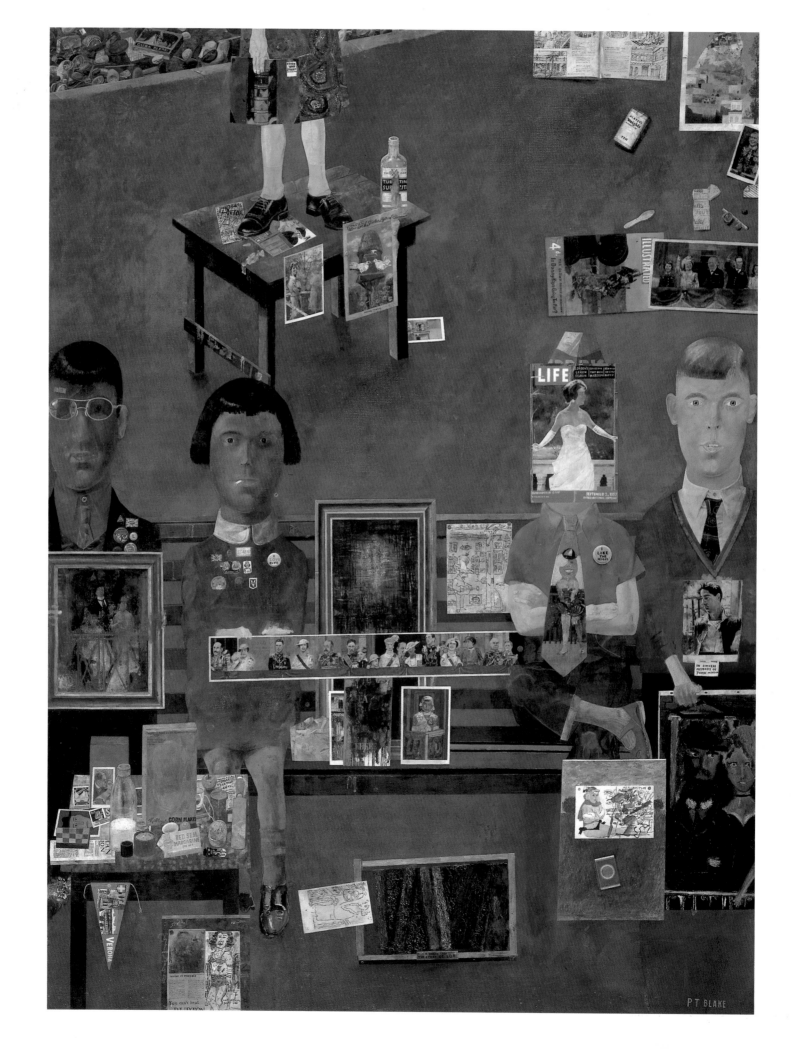

JUST WHAT IS IT?

The Independent Group and Peter Blake

Some of the earliest stirrings of Pop in England, and the coining of the term in the late 1950s, took place within a small and essentially private association of artists, architects, historians and critics who met intermittently between 1952 and 1955 as the Independent Group at the Institute of Contemporary Arts (ICA) in London.[1] Among its artist members were two who later became leading figures in British Pop, Richard Hamilton and Eduardo Paolozzi, as well as Nigel Henderson, known primarily as a photographer, the painter Victor Pasmore (a recent convert to Constructivism) and the abstract painter and sculptor William Turnbull. Also taking part were the architects Alison and Peter Smithson and several critics and historians – Lawrence Alloway, Reyner Banham and Toni del Renzio – who were voracious in their appetite for dissecting the products of mass culture, including movies, automobile design and science fiction illustration. It was Alloway who articulated the concept of a popular art/fine art continuum in order to broaden the sphere of pictorial investigation, and who is credited with the first published use of the word Pop in this sense in 1958.[2]

Few works of art that could in any way be described as Pop emerged from the Independent Group during the 1950s, which is not surprising given that what united the band was an intellectual approach to cultural and sociological issues rather than a pragmatic application of such material to the production of paintings or sculptures. Seeing themselves as consciously in opposition to what they regarded as the ivory-tower modernism of Herbert Read, who had been instrumental in founding the ICA, they helped to prepare the theoretical foundations of an involvement with popular culture that was soon broached far less self-consciously by other British artists, who were at best only dimly aware of their trailblazing path. The Independent Group meetings were virtually closed to non-members, so their ideas were disseminated primarily through specialist publications and in a series of exhibitions at the ICA and other venues, including 'Parallel of Life and Art' in 1953 and 'Man, Machine and Motion' in 1955, culminating in a thematic group show, 'This is Tomorrow', at the Whitechapel Art Gallery, London, in 1956.[3] These highly innovative exhibitions, which were conceived as thematic entities addressing such contemporary issues as the relationship between art and technology, were as ephemeral as the lectures, since their concern was to give form to particular ideas within a unified display rather than to function as collections of paintings, sculptures or photographs.

Certain images produced in relation to the Independent Group's activities, particularly by Paolozzi and Hamilton, have retrospectively come to be regarded as among the first standard-bearers of British Pop, but none of these were conceived at the time as works of art in their own right. An entire group of collages produced by Paolozzi from 1948 to

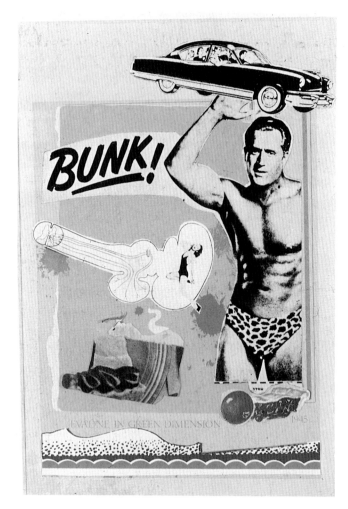

41 Eduardo Paolozzi *Bunk!: Evadne in Green Dimension* 1952

42 Eduardo Paolozzi *St Sebastian No. 2* 1957

1950, however startling they now appear as prefigurations of Pop imagery recycled as fragments from comic books, postcards, advertisements and popular magazines, were intended not as finished pictures but as scrapbook images for his own reference. Most of them were made during an extended stay in Paris from 1947 to 1949 and they reveal both the influence of Surrealism and the exotic appeal of a vast fund of American images that he had not previously encountered. Projected onto a large screen with an epidiascope, they served as the basis of a rapid-fire 'lecture' delivered by Paolozzi to his Independent Group colleagues during one of their first sessions as the Young Group in spring 1952, but it was only twenty years later that he conferred on them a new status by publishing them as a portfolio of screen-printed collage facsimiles entitled *Bunk!*.[4] One such collage, *Meet the People* (1948), even contains by coincidence what must be the earliest use of the word Pop in contemporary imagery drawn directly from the mass media.

Paolozzi, an inveterate collector and hoarder of visual material of all types, naturally found much of interest in the ephemera of his own time, particularly when it concerned an alien and resolutely modern culture that he knew only in the form of printed images. That he himself did not recognize at the time the full implications of making art from such material in its raw state can be deduced from the fact that he did not employ such methods in his work until 1962, when he made the first of a series of screen-prints on a similar collage principle. It was only later, too, that he acted on the assumption tacit in his own 'Bunk' lecture that the modern visual experience is one of constant bombardment by conflicting images and messages flashing before us in a dizzying random profusion. The elements of his transformation into a Pop artist were almost all evident in his work of the 1950s, but in separate form, and not until he began to relate his popular sources to both his imagery and his procedures did he come to adopt this new identity and to tone down the Brutalist and Surrealist trappings of his aesthetic. While teaching textile design at the Central School of Art and Design in London from 1949 to 1955, for instance, he first employed screen-printing, which was then considered a purely commercial technique; he used it not as a mechanical process or a way of appropriating the mass-media images that he collected in such abundance, but simply as another way of making marks within a system essentially derived from the aesthetics of School of Paris abstraction.[5]

In his sculptures of the same period Paolozzi had recourse to machine parts and other found objects as basic ingredients of figures constructed according to the principles of assemblage; although he left the origins of such materials clear, he presented them in ghostly form as imprints into the wax maquettes from which his unique bronzes were eventually cast, and his concern was at least as much with their rough textures as with their being found objects. His choice of a traditional technique indicated, moreover, his attitude then towards technology – a potentially dehumanizing force – which is borne out also by the fact that most of the sculptures took human form; a figure such as *St Sebastian No. 2* (1957) proclaims itself first as a contemporary martyr, a horrifying victim of a post-nuclear age, and only secondarily as a cousin to the bug-eyed monsters of science fiction films so beloved of Paolozzi and his Independent Group colleagues.[6]

Richard Hamilton's forays during the 1950s into popular sources, and in particular advertising, provide the clearest evidence of the Independent Group's intellectual and largely iconographic concern with such material. The first and most famous instance of these themes in Hamilton's work is a small collage of 1956, *Just what is it that makes today's homes so different, so appealing?*, which in spite of being completely uncharacteristic of his work of that time has become an icon of early Pop. Like Paolozzi's *Bunk!* images, it was conceived not as an independent work but as a demonstration of

THE FOUNDATIONS OF POP

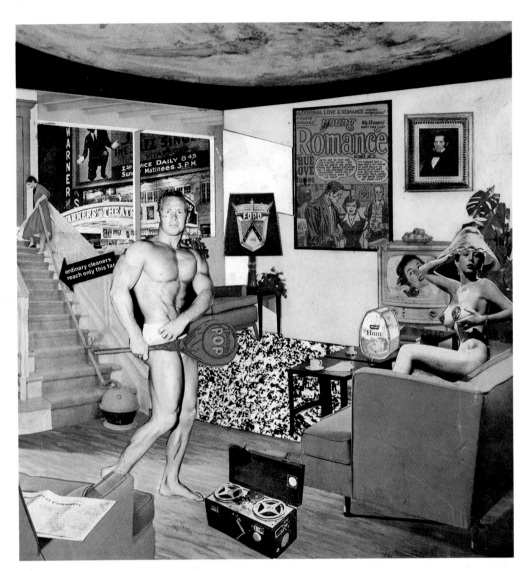

new types of imagery to be found outside the enclosed realm of fine art. It was made with a view to reproduction both as a screen-printed poster and as a page in the catalogue of 'This is Tomorrow', and it was not exhibited or treated as a work in its own right until many years later, after Pop was already an established movement.[7] The exhibition was primarily concerned with the inter-relationship of the various arts – particularly painting and architecture – and in turn with our relationship to the environment. Twelve teams, each consisting ideally of a painter, a sculptor and an architect, each devised an installation through which the spectator would walk to reach the rest of the exhibition. Hamilton collaborated with John McHale and John Voelcker on the only pavilion to make explicit reference throughout to popular culture. In their display, along with dazzling optical patterns preceding by seven years the black-and-white Op art paintings of Bridget Riley, were various ready-made elements, notably a five-metre high Robbie the Robot from the science fiction film *Forbidden Planet*, complete with flashing teeth, borrowed from the frontage of the London Pavilion cinema in Piccadilly Circus; a cinemascope billboard containing a life-size version of an already famous cinematic still of Marilyn Monroe in a billowing dress, from Billy Wilder's 1955 film *The Seven Year Itch*; and a jukebox playing the top twenty hits of the moment.

44 Nigel Henderson *Brick Lane* 1951

Even taking into account the context for which Hamilton's tiny collage was created, *Just what is it . . . ?* remains an extraordinary prophecy of the iconography of Pop. It refers to twentieth-century technology, popular entertainments and systems of modern mass communication in the form of photography, television, tape recorders, newspapers, the telephone and the cinema (Al Jolson in *The Jazz Singer*, the first 'talkie'); convenience foods, domestic appliances and advertising imagery; new forms of transport such as the automobile (the Ford insignia as a lampshade) and space travel (the aerial view of the planet disguised as the ceiling); comic books (masquerading as a framed painting); the eroticism of pin-ups and muscle-man magazines; and even an early use of the word Pop in the larger-than-life piece of American candy held up by the body-builder. Through such ready-made images Hamilton here addresses himself to modern concepts of love and leisure, to the comforts of consumerism and to the overcrowded conditions now accepted as the norm in Western society: the carpet in the picture – a detail of a high-contrast black-and-white photograph of hundreds of people on a beach – provides yet another hidden message and layer of illusion.

Musing on the exhibition in a letter to the Smithsons written on 16 January 1957, Hamilton listed the characteristics of Pop Art as:

Popular (designed for a mass audience)
Transient (short term solution)
Expendable (easily forgotten)
Low Cost
Mass Produced
Young (aimed at Youth)
Witty
Sexy
Gimmicky
Glamorous
Big Business

Hamilton was referring here to the products of mass culture to which members of the Independent Group had been turning their attention, but he also had in mind that these could become the ingredients for his own art. The Smithsons had recently published an article in which such material was seen as a significant challenge to the traditional role of the artist: 'Advertising has caused a revolution in the popular art field. Advertising has become respectable in its own right and is beating the fine arts at their old game . . . And this transient thing is making a bigger contribution to our visual climate than any of the traditional fine arts'.[8] In addition to Paolozzi, other colleagues from the Independent Group had also turned to popular culture and non-art sources, as in the photographs of shop-fronts taken by Nigel Henderson in the East End of London during the early 1950s or in the collages of food imagery from American and American-influenced magazines shown by John McHale at the ICA in 1956.[9] Hamilton was clearly in sympathy with the conclusion reached by Alloway in an article published in 1959: 'Both for their scope and for their power of catching personal feeling, the mass media must be reckoned as a personal addition to our ways of interpreting and influencing the world'.[10] Unaccountably, Alloway proved stubbornly unreceptive to the Pop aesthetic developed by Hamilton at just this time, even though he was to become one of the most vociferous champions of American Pop after his move to the United States in the early 1960s.

The conflation of American automobile styling with advertisements for a new design of bra in paintings by Hamilton such as *Hommage à Chrysler Corp* (1957) and *Hers is a Lush Situation* (1958) closely followed the themes from popular culture that became the focus of the Independent Group in 1955 under the leadership of Alloway and McHale; advertising, women's fashions, cars, consumer products and Hollywood movies were all subjected to rigorous scrutiny. Hamilton, who in his previous paintings had extended with exacting refinement the examination of perception effected by Cézanne and in Cubism early in the century, seems to have been directly stimulated in his choice of subject-matter by his colleagues' cerebral approach to the artefacts of a visual culture that seemed both alien and familiar. He began work on these two paintings, for instance, after the publication of an article by Reyner Banham on American car designs suggestively entitled 'Vehicles of Desire'. Quoting from a Buick advertisement in which 'The driver sits in the dead calm at the center of all this motion – hers is a lush situation', Banham remarks: 'This is the stuff of which the aesthetics of expendability will eventually be made.'[11] It was just such a project on which Hamilton now embarked, quoting from the presentation techniques of advertising while still availing himself of the modernist painting tradition inaugurated by Cubism as the context for such observations.

The Independent Group's stance was riddled with ambivalence: they were attracted by the vitality and inventiveness of forms of representation that were explicitly modern and free of the constraints of fine art traditions, but they maintained a critical detachment towards the plainly manipulative intentions of advertising and a scepticism about the greedy consumerism implicit in the largely American material to which they addressed themselves. They were, after all, of a generation that had experienced the austerity of the War years, a material deprivation that had survived much longer in Britain than in America; while better economic conditions were of course to be welcomed, it was difficult for them to share the naive optimism of an American Dream in which they had no part.

One of the first paintings in which Hamilton made direct use of a large range of advertising images, *$he* (1958–61), declares its scepticism in its title, which conflates the allure of women and the lure of money with a blunt frankness that no ad-man would have dared voice. Hamilton here carefully chose advertisements that promoted the joys of consumerism through an equation with feminine sex appeal, and he reinforced the sense of people objectified as commodities by treating the stylized figure and the fleshy pink refrigerator as hybrids of machinery and human form; such mutations are extended to the small domestic appliance in the foreground, which is part toaster and part vacuum cleaner. In a lengthy analysis of this painting, which he originally thought of titling *Women in the Home*, Hamilton maintained in 1962 that his intentions should not be mistaken as satirical; even though the picture might appear to be 'a sardonic comment on our society... I would like to think of my purpose as a search for what is epic in everyday objects and everyday attitudes. Irony has no place in it except in so far as irony is part of the ad man's repertoire.'[12]

Hamilton's comments notwithstanding, his concern in *$he* to decode the implicit messages of his sources, which was the visual equivalent of the new 'science' of semiology then emerging in the work of writers such as Roland Barthes, was indicative of a critical stance rather than of a neutral acceptance of such materials simply as contemporary images.[13] His reliance on a method derived essentially from Cubist collage, moreover, allowed him to present each fragment of imagery and technique as a quotation of a particular convention rather than as a measure of his own preferences or point of view. For the most part the surface sheen of his photographic sources is imitated illusionistically with

45 Richard Hamilton *Hommage à Chrysler Corp* 1957

46 Richard Hamilton *$he* **1958–61**

47 Richard Hamilton *Pin-up* **1961**

paint, but he has also incorporated two mechanically produced images as actual collaged elements pasted onto the background: a photographic enlargement of the refrigerator's automatic defrosting mechanism (as seen in the double-page advertisement from which he derived the image of the pink refrigerator viewed from high above) and a winking plastic eye brought him as a present from Germany.

The long gestation of *$he* and the considered manner in which it reveals itself were the products of an analytical approach that considered spatial and perceptual ambiguity, a technical virtuosity expressed within the context of European easel painting, and an iconographic complexity grounded equally in fine art traditions and an examination of non-art sources from the mass media. Such subtleties remained characteristic of Hamilton's highly particular approach to Pop even after the early 1960s, in striking contrast to the directness and immediacy of the American work just beginning to be made at that time from similar sources. Even when choosing a subject of blatant and deliberate vulgarity, as in *Pin-up* (1961), Hamilton interprets his sources with a refinement that subsumes them into fine art traditions.[14] The airbrushed flesh of erotic photography is metamorphosed into delicate passages of tone and colour; the figure's thrusting breasts are treated virtually as an abstract formal shape emerging from the surface into real space, so emphasizing both the sensual tactility of its skin of paint and the object quality of the picture as a whole; and the photograph of the bra, collaged to the surface, stresses the contemporaneity of the image in turn supported by the slim-line telephone, while also focussing attention on the co-existence of different pictorial languages. All these methods serve to relate a contemporary image intended for sexual titillation to the treatment of the female nude within the classical tradition, bestowing dignity on a mass-culture idiom often regarded with contempt by intellectuals and simultaneously revitalizing a moribund artistic form with the urgent intensity of its sexual charge. The exchange effected by Hamilton between two levels of culture, in other words, is presented as beneficial to both.

Concurrent with the Independent Group's knowing investigations into popular culture, as early as 1954 a young painter, Peter Blake, was producing far more innocent and straightforward celebrations of the signs and symbols of youth culture, including comic books, printed ephemera and imagery drawn from funfairs, the circus and wrestling. At the age of fourteen in 1946 he had begun studying art part-time in Gravesend, Kent, after failing the entrance examinations for grammar school. He found himself studying art almost by chance as part of a technical school course and he allowed himself to be persuaded to continue at Gravesend School of Art from 1949 to 1951 not as a painter, which he wanted to be, but as a graphic artist, which he was assured was a much more practical profession for someone who wished to earn his living from his work. The training he received in what he describes as an old-fashioned graphic design course included typography, typesetting, hand-lettering and a few lessons in such skills as wood carving, stone carving and wood engraving, all of which proved extremely useful in the pictures he began to make on a postgraduate course in painting at the Royal College of Art (RCA) in London from 1953 to 1956.

While still in his teens Blake had developed a strong interest in folk art forms as a direct consequence of the popular entertainments which were part of his working-class life from the age of fifteen: he was taken to wrestling matches and to fairgrounds, where he ignored the rides but admired the painting of the roundabouts and the decorations of the sideshows. His interest in such pictorial forms was strengthened by the fact that he was briefly taught by Enid Marx, an expert on popular and folk art through whom he was able to visit a private local collection of figureheads that also made an impression on him.[15]

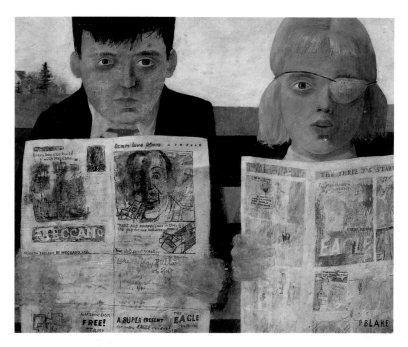

48 Peter Blake *Children reading Comics* 1954

49 Peter Blake *Everly Wall* 1959

Gravesend itself, lying on the Thames to the east of London, provided not only the visual stimulation of painted barges with stencilled lettering but Blake's introduction to what was later identified as teenage culture, for which the area was a remarkable breeding ground; he began to attend the Dartford Rhythm Club at fourteen and soon got to know about Be-Bop, hipsters and modern jazz. In Kent, therefore, Blake had already discovered a rich area of subject-matter to which he was unself-consciously attracted, as well as a popular idiom already closely associated with such subjects. As a graphic design student, moreover, he experienced no prejudice against these sources; on the contrary, he found that folk art was acknowledged in much of the graphic design being produced at that time in England, such as certain posters produced even before the War by Edward McKnight-Kauffer, Edward Bawden's posters, illustrations and promotional material in the manner of Victorian woodcuts, and the work of Barbara Jones.

On arrival at the RCA Blake found himself at odds with the highly serious tone adopted by most of the other students, although by the time he left in 1956 he had become part of a closely knit group including Richard Smith, Robyn Denny, Joe Tilson and Roger Coleman.[16] Their common interests in forms of popular culture were not, however, without a context at the RCA, as is evident from the coverage in the student magazine, *Ark*. Since the RCA placed industry and design on a par with fine art, it was natural that the editorial of the magazine's first issue in October 1950 should single out 'the elusive but necessary relationships between the arts and the social context' as a primary concern. Subsequent issues suggested possible ways by which this equivalence could be manifested in painting: for example, through Social Realism or by direct involvement with 'the pattern of contemporary life', especially through industrial arts, as a way of 'finding the right relationship between our work and the society in which we live.'[17] That Blake was not alone in his passion for traditional popular art forms was clear from the fact that an entire issue published before his arrival was devoted to Victoriana.[18] It was during Coleman's tenure as editor in the mid-1950s, however, that *Ark* became a particular forum for visual material not usually considered within the domain of art: advertising, the cinema, magazines, comic strips and cartoons were all subjected to a close examination.[19]

In spite of these common enthusiasms, Blake felt very much on his own when he painted pictures such as *Children reading Comics* (1954), both in terms of subject-matter and procedures, since he was the only one at the time to make such direct use of this type of material. The two figures were transcribed from photographs of his sister and himself as children, while the comic books in their hands were simply copied as the easiest solution. However radical the idea of filling most of the surface with a lovingly painted facsimile of pages from *The Eagle*, or of presenting the figures absolutely frontally in the manner of naive art, Blake was consciously working in an essentially academic tradition of naturalism; similarly in a small painting of 1955, *Litter*, he included fragments of printed ephemera such as cigarette packets and a Captain Marvel card, but represented them by means of a *trompe-l'oeil* realism associated with nineteenth-century painters such as the American William Michael Harnett and their academic forbears. Among more contemporary painters he felt most in sympathy with American Magical Realists such as Ben Shahn, Honoré Sharrer, Bernard Perlin and early Andrew Wyeth, whose work he knew from reproductions and from exhibitions at the ICA in 1950 and at the Tate Gallery in 1956.[20]

In retrospect Blake thinks that his real identity as an artist is as 'a straight figurative realist', but that from this central core he makes occasional 'excursions' that lead to independent groups of drawings, watercolours, wood engravings or works in other styles.[21]

40

Viewed in this way, even his original form of Pop simply constitutes an investigation into another way of making art, albeit one to which he has periodically and persuasively returned. He produced what one can consider the first of his true Pop pictures in 1955 when he turned to one of his childhood loves, the circus, both for the subject and form for a group of paintings on hardboard and panel representing such imaginary characters as *Loelia, World's Most Tattooed Lady* (1955), *Dixie, Darling of the Midway* (1955–8), *Siriol, She-Devil of Naked Madness* (1957) and *Cherie, Only Bearded Tattooed Lady* (c. 1957). Each panel is presented as if it were an actual piece of fairground art, complete with old-fashioned hand-lettering, and given a scraped, weather-beaten surface that makes it look as if it had endured decades of use in a travelling sideshow. Each painting, in other words, is conceived as an elaborate illusion of a found object; the elements in the pictures, while based on the artist's scrupulous knowledge of that particular popular art form, are invented and painted by his hand. Every detail is concocted to look as effortless and artless as possible, whether it be *Loelia's* tattooes – a clever and amusing excuse for producing an elaborate picture within a picture – or the artist's own initials, carved into the panel like the graffiti of a recalcitrant schoolboy.

The technical brilliance of the deceit practised by Blake in the circus paintings is disguised by the crudeness of his chosen language, a remarkable sacrifice that can best be understood by his intense love of his sources. In wilfully submerging his own identity in that of an anonymous art form practised over decades by unsung heroes, Blake invented, almost by accident and without any clear precedent, one of the purest forms of Pop. Although he visited some of the exhibitions mounted by members of the Independent Group, including 'Man, Machine and Motion' and 'This is Tomorrow', and by the end of the 1950s had met both Paolozzi and Hamilton, he did not attend any of their meetings and thinks he may not even have been aware at the time of the group's existence. His undisguised affection for popular art was, in any case, very different from their critical engagement with mass-media sources as a way of forging a representational art for a modern industrial age. If Hamilton took the position of a sophisticated commentator who was proud to disclose the manipulative manoeuvres of advertising, Blake happily presented himself as an innocent consumer or fan dedicated to celebrating the things that gave him pleasure.

On leaving the RCA in 1956, Blake travelled around Europe for a year on a Leverhulme Research Award to study popular art.[22] He visited Rotterdam, Amsterdam, The Hague, Antwerp, Brussels, Paris, Nice and Rome before finishing in Spain, where he joined Joe Tilson, and supplemented his already considerable knowledge of folk art and popular art forms by seeing specialist museums, attending wrestling matches and collecting not only catalogues, postcards and programmes but also other printed material such as cigarette packets. He visited all the great museums of art on the way, learning much about the history of painting, and produced a number of drawings and eight or ten small paintings, which he carried round with him from place to place.[23] Although he kept much of the material and referred to some of it in the paintings he made on his return to London, the trip simply confirmed his already strong interest in popular art and added to his fund of information.

In two large paintings begun during his last year at the RCA, *The Preparation for the Entry into Jerusalem* (1955–6) and *On the Balcony* (1955–7), both based on set subjects, Blake made the most elaborate use yet of the characteristic elements of what one could describe as his proto-Pop style: hierarchically frontal figures in emulation of the poignant awkwardness of naive and folk art; the fantasy world of childhood; pictures within pic-

JUST WHAT IS IT?

50 Peter Blake *Loelia, World's Most Tattooed Lady* 1955

tures both to incorporate contrasting styles and techniques and to suggest the power of image-making as a catalyst to the imagination; and loving, almost hallucinatory detailing of mundane fragments culled from everyday life. *On the Balcony*, completed on his return from Europe, refers to a multiplicity of sources including not only the work of other artists but also magazine covers, a postcard and photographs of the royal family, cigarette packets and other printed ephemera, all painted by hand with a scrupulous fidelity to detail.[24] The rather adult-looking children seated on a park bench literally display their enthusiasms in the badges they wear, in the pictures they hold and even in one case in the glamorous image on a hand-painted tie.[25]

Blake continued to produce figure paintings in this manner, often declaring his common bond with popular culture by the objects held by or pinned to the figures like the attributes in traditional representations of saints. Such is the jumble of badges in two self-portraits, *Boy with Paintings* (1957–9), in which he appears as an adolescent, and *Self-Portrait with Badges* (1961), in which he is grown up but clad in what became the teenage uniform of blue denim and sneakers; in the latter he holds an Elvis Presley fan magazine, again not necessarily as a declaration of his own taste but as a sign of his sense of community with the youth culture represented by the new musical form of rock'n'roll. Elvis had appeared in his paintings as early as 1957 in the form of a tattoo on the leg of *Siriol, She-Devil of Naked Madness* and in the first of his paintings to take pop music as its subject, *Girls with their Hero* (1959–62).

Pop musicians, along with film stars and pin-up images, were prominent among the subjects of a group of collage-based paintings with which Blake emerged as a fully-fledged Pop artist in 1959. In works such as *Girlie Door, Sinatra Door, Kim Novak Wall* and *Everly Wall*, all executed that year and shown at the ICA in January 1960, Blake defined a Pop aesthetic with a clarity and conviction all the more remarkable for the sudden break which it appeared to represent with the precise drawing and delicacy of touch in his previous work. In subject-matter alone these paintings introduced a rich iconography that was to characterize Pop during the following decade, particularly in Britain, including the contemporary sex goddesses of Hollywood films, pin-ups, and the stars of early rock'n'roll, pop music and other mass entertainments such as wrestling. *Girlie Door*, for instance, includes photographs of numerous contemporary stars such as Marilyn Monroe, Kim Novak, Gina Lollobrigida, Shirley MacLaine and Elsa Martinelli, with a few faces from silent films. Conventional composition is discarded in favour of an arrangement that supports the illusion of the whole image as the decorated surface of a door inside the bedroom of a sexually obsessed adolescent. A slightly later work, *Got a Girl* (1960–61), contains a strip of images of the contemporary American singers mentioned in the record by the Four Preps pinned to the upper left-hand corner: from left to right Fabian, Frankie Avalon, Ricky Nelson, Bobby Rydell and Elvis Presley (twice). In this case the images convey a narrative based on the words of the song – a lament by the singer about his girlfriend's exclusive obsession with these pop stars – so that the lyrics themselves are treated as a found object that contributes to the painting's meaning.

Blake recalls that once the term Pop had come into use in England, he interpreted it as a challenge to produce an art whose meanings would be as accessible and direct as that of popular music and other expressions of mass culture. Now he considers that the art remained too sophisticated for it to work on that level, since the formal methods that he, for example, employed in these pictures did not correspond to the popular conception of what art should look like.[26] Nevertheless, Blake's perhaps naive faith in the possibility that art could communicate with such directness helps to account both for the immediacy

THE FOUNDATIONS OF POP

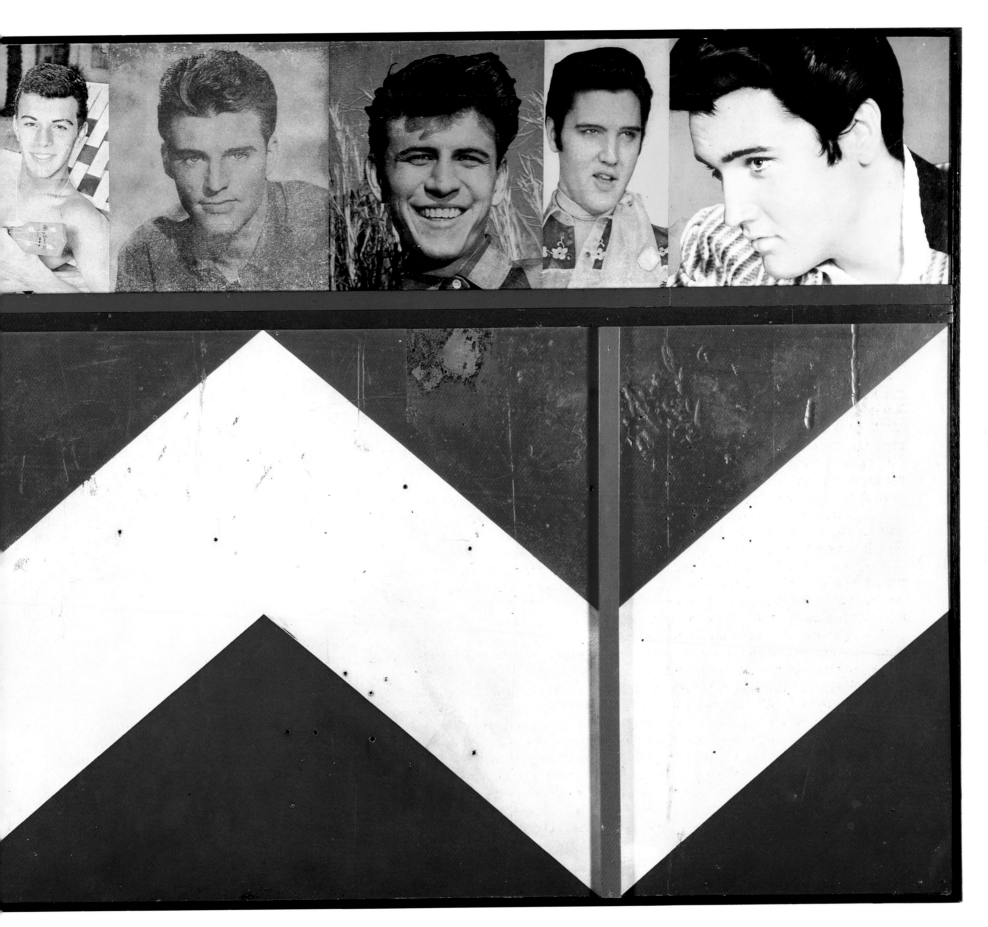

51 Peter Blake *Got a Girl* 1960–61

52 Peter Blake *Girlie Door* **1959**

with which he thrust forward his chosen imagery, allowing the pictures to speak for themselves, and an almost magical belief in each painting as the embodiment of its subject. For example, *Valentine* (*c.* 1959–60), which consists of a large heraldic heart painted bright red surmounted by expressions of affection on Victorian Valentine cards, was made as a present for Pauline Boty, a young painter at the Royal College with whom he was in love but who saw him only as a friend. His conviction that any subject was open to such treatment can be gleaned from *The Fine Art Bit* (1959), in which he dared to present as his own work hundreds of years of art history in the form of six postcard reproductions that he had collected on his travels.[27]

The main factor in this striking change, Blake readily admits, was the example of Johns and Rauschenberg, whose work he had just come to know in the form of a few reproductions. Having earlier presented his own circus paintings as illusions of found objects and having painted accurate facsimiles of photographs, postcards and other mass-produced printed matter, only a small conceptual leap was needed for him to begin to use such materials in their raw state simply as collage elements, as in Rauschenberg's combines. He also responded at once to Johns's target paintings for their equation of the painting with an ordinary object, an idea likewise implicit in his circus paintings, and he borrowed from them the device of supplementing the simplicity of the central formal design with a register of images along the top edge of the picture. In *The First Real Target* (1961) he paid homage to these works by Johns while implying, half jokingly, that he was improving on the idea by presenting his own target not as a hand-painted facsimile but in the form of an actual Slazenger archery target purchased from a sports shop.

Prompted perhaps by his friendship with painters such as Smith and Denny, Blake had long wanted to find a way to engage with abstraction without sacrificing his contact with subject-matter. Johns's targets again showed the way, since they were as formal in design as any abstraction while explicitly identified as representations of real things. One of the solutions proposed by Blake was to produce a series of *Gold Paintings* in 1959, their surfaces almost entirely covered with gold leaf so that each picture could be read either as a monochrome abstraction or as a fragment of a Japanese screen.[28] Another strategy was to bring in the overt imagery of mass-produced printed material paired with brightly coloured surfaces or heraldic patterns that are presented as real things – as fragments of walls, doors or windows – either by using actual found objects, by mimicking the object with *trompe-l'oeil* illusionism (as in *Girlie Door*), or simply by implying that the glossy surface is a section of a painted wall.

Blake's works of the late 1950s and early 1960s were radical not only in their subject-matter but, equally importantly, in their simplicity of form. He dispensed altogether in these works with his drawing skills, appropriating all the images from ready-made material such as magazine photographs and postcards which he collaged directly to the surface of another found object, such as a door, coated in bright household enamel paint. Primary colours are applied in simple flat designs with crisp edges, as in the hard-edge abstraction that was just emerging then, using different permutations of colours in vertical, horizontal or diagonal patterns that themselves originated as found images.[29] There is no sign of brushwork, just as there is no invented motif. That is to say, the paintings look like anonymous products, bearing no obvious sign of the traditional artist's manipulation of materials. It is as though Blake had removed himself entirely from the picture in order to present himself in the role of consumer, since however depersonalized these works are in technique, they are strikingly personal in conveying the passions and enthusiasms he shared with many others.

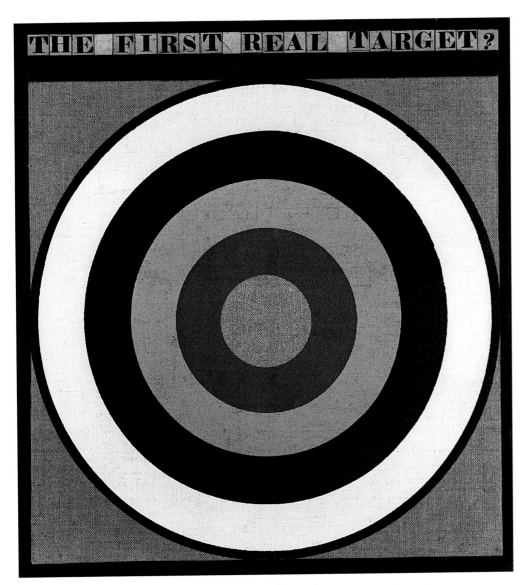

As signs of the common bonds created by popular culture, which he considered the embodiment of a collective fantasy, Blake's pictures are poignant reminders of our shared humanity. In willingly sacrificing almost all the conventional artistic techniques at which he was most adept to achieve such democratic ends, creating an authentic and personal statement by recourse to the most apparently 'ungenuine' and anonymous means, Blake discovered one of the essential paradoxes of Pop.

Each of the major artists associated with the early history of Pop in Britain was fiercely individual, preferring to establish a distinct personal identity than to band together with others as part of a group. Yet even at this early stage some of the essential characteristics that distinguish British Pop from work produced in America were coming into focus: a self-consciousness about the chosen material, manifested in the collecting instincts of Blake and Paolozzi and in the analytical tendency displayed by Hamilton and the Independent Group in general; an urge to declare a position, whether that of the enthusiast (especially in Blake's case) or of a social critic or anthropologist viewing the artefacts of popular culture as exotic, strange or alien; and a taste for narrative and anecdote. All these qualities were to remain not only in the work of these groundbreaking artists but in that of the younger British artists who followed.

BOURGEOIS TRASH

Nouveau Réalisme and precursors of Pop in Europe

The exhibition that can be credited as the first international survey of the movement that was soon labelled Pop, 'The New Realists' at the Sidney Janis Gallery, New York, in late 1962, took its title from the name of a Paris-based group, Les Nouveaux Réalistes, whose official formation had been announced two years earlier.[1] The American and British Pop artists who were emerging at the same time sought to declare their severing of ties to the past without any set communal programme. By contrast the Nouveaux Réalistes launched themselves, in typical European modernist fashion, with a manifesto by the critic Pierre Restany on the occasion of a group exhibition in Milan in May 1960, and they acknowledged their debt to an earlier avant-garde in the title of their second group exhibition, 'A 40° au-dessus de Dada' (40° beyond Dada), held in Paris in May 1961.[2] Yet in spite of presenting a united front from their inception, the Nouveaux Réalistes encompassed a disparate range of methods and intentions that crossed over into other movements and traditions, and that only occasionally touched on concerns that can retrospectively be labelled Pop.

The methods employed by a number of the Nouveaux Réalistes were a conscious development from Marcel Duchamp's concept of the ready-made, whereby a mass-produced object was presented as a work of art by virtue of the change of context and intention. For these younger European artists, it was not so much a question of presenting an object in isolation as a piece of sculpture, but of using cheap, mass-produced items, often in great quantities or with suggestions of narrative, as the raw material for assemblages and wall-hanging reliefs. The individual objects, whether they had been found discarded or purchased new, were prized for both their imagery and their specific cultural connotations: they are presented as evidence of the materialist values of post-war consumer society and of the hunger for objects stimulated by industries dependent on built-in obsolescence for their continued prosperity.

One of the French artists closest in spirit, if not in technique, to Anglo-American Pop was Arman. As early as the mid-1950s he investigated ways of producing pictures in which the individual elements were neither invented nor made by hand. His *Cachets* ('stamps'), a series of works on paper measuring in some cases more than three metres in height or width, look at first like 'all-over' abstractions in the manner of Jackson Pollock, but they consist exclusively of the imprints of rubber stamps. The earliest of these works, small in scale and printed from typographic stamps of the sort used for bureaucratic procedures, made plain their manner of manufacture through the alliance of image and technique. The more elaborate pictures of the late 1950s are generally built from repeated abstract patterns, but their greater resemblance to informal abstractions of the period make their elimination of personal touch seem even more shocking. Arman

47

55 Arman *Cachets* 1955

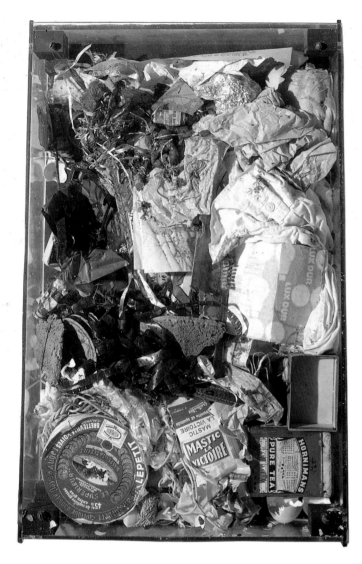

56 Arman *Petits Déchets bourgeois* 1959

57 Gérard Deschamps *Plastique à la tapette* 1961

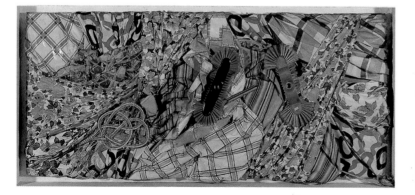

developed these ideas at the end of the 1950s in his next series of paintings, *Allures d'objets* ('traces of objects'), in which the images came from the imprints not of rubber stamps but of found objects covered with paint.

In 1959 Arman shifted his attention from the imprint of objects to the objects themselves, inventing two sculptural forms that became the basis of his subsequent work: *Accumulations*, in which he gathered together common, mass-produced objects in large quantities, and *Poubelles* ('rubbish'), which consisted of domestic detritus encased in glass or plastic boxes like flies in amber. In response to Yves Klein's exhibition 'Le Vide' (empty space) in April 1958, which consisted of the bare interior of the Galerie Iris Clert in Paris, Arman held his own exhibition in the same space in 1960, calling it 'Le Plein' (the full) and stuffing it from floor to ceiling with a vast accumulation of rubbish, so that it could be seen properly only through the gallery's window. Both exhibitions presented the gallery space as the work of art, but in exchanging Klein's empty volume for a heavy mass of discarded objects Arman made a vivid point about the basis of his work in the overconsumption of contemporary society.

Each of Arman's *Poubelles* displays an apparently random assortment of boxes, cigarette packs, pieces of clothing and other jettisoned items as if simply emptied out of a sack of rubbish. Duchamp had claimed to choose his ready-mades with complete indifference rather than with an eye to their aesthetic appeal, but in such works Arman has abnegated personal responsibility for the selection in an even more extreme manner, taking as he found them things that had been thrown away by others as worthless. Given the arbitrariness of the selection, the aesthetic pleasure afforded by particular elements – say, for example, the design of a cigarette pack – can be attributed only to the individual taste of the spectator, rather than to the artist's sensibility. Likewise any abstract beauty that we might detect in the relationships of form and colour among the casually distributed objects cannot have been predetermined, since these sculptures are not composed in any conventional sense but take shape with the aid of gravity as they are dropped into the box.

The one major way in which Arman determined the contents of his *Poubelles*, both literally and metaphorically, was in his choice of a particular category of rubbish, indicating the extent to which the meaning of these works resides in their social implications. *Poubelle menagère* (Household Rubbish, 1960), *Petits Déchets bourgeois* (Small Bourgeois Trash, 1959), and *Poubelles des enfants* (Children's Rubbish, 1960), with bits of toys and comic strips, all provide evidence of different worlds. He applied similar procedures to the closely related *Portrait-robot* series, in which the range of objects was even more specifically attuned to questions of identity and personality. Each of these consists of items of clothing and personal effects gathered together from a particular person; among the friends and associates he commemorated in this way in 1960 were Klein and the dealer Iris Clert.

It was in his *Accumulations* that Arman came closest to Pop, both in their reliance on manufactured objects and in the repetition of identical items or classes of objects as a basic operating principle. Among the objects in the first of these works were used tools, burned-out radio tubes, shoe trees, pitchers, coffee-pots, medicine bottles, watch parts, alarm clocks, cogwheels, taps and electric door-bells. Most of these he had found second-hand or abandoned, so the traces of their previous use and their present identity as functionless objects were intrinsic to their meaning; only after acquiring a second home in New York in 1963 did he begin to make more use of new objects in works constructed according to similar principles. The titles given his *Accumulations* often empha-

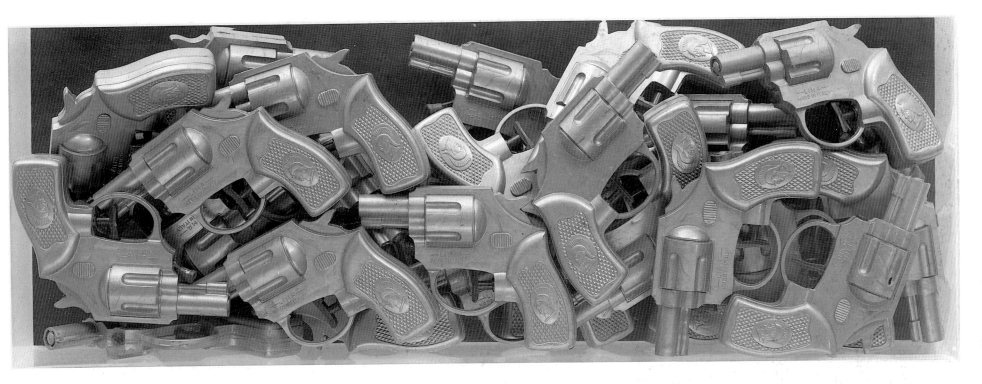

sized an element of fantasy or magic indebted to Surrealism; a coffin-like wooden box filled with partly dismembered dolls, for instance, was called *Massacre des innocents* (1961), while a free-standing accumulation of revolvers made two years later became a *Fétiche à clous* (Nail Fetish). In only a few instances are mass production or popular culture used specifically as subject-matter, as in *1 Kilo de fumée* (1 Kilo of Smoke, 1962), an accumulation of a single brand of cigarette packs, or *Boum boum, ça fait mal* (Boom Boom, That Hurts, 1960), in which toy plastic guns are presented in the context of childhood games derived from the play-acting violence of comic books and the cinema. Nevertheless, the rigorous logic of Arman's assembly-line aesthetic, in which each element is represented by the thing itself, places it at the forefront of Pop developments.

Of the other Nouveaux Réalistes Gérard Deschamps approached Arman's use of common manufactured objects in a series of assemblages made for a brief period in the early 1960s. Like Arman, he conceived of most of these works as groupings of a particular type of object – an entire series exhibited in 1961 at the Salon Comparaisons was devoted to women's underwear – but he used them primarily as elements of abstract designs rather than for their symbolic connotations or as images in themselves. In the works nearest Pop in spirit, such as *Plastique à la tapette* (Plastic with Carpet-beater, 1961), the identity of the separate objects is respected but still subordinated to the decorative role played by the juxtaposition of their shiny textures, bright colours and strong formal patterns.

Objects are made to serve fundamentally abstract ends, too, in a series of sculptures initiated in 1958 by an already established artist, César (Baldaccini), who joined the Nouveaux Réalistes in 1960 after showing the first of his *Compressions d'automobile* (Automobile Compressions) at the Salon de Mai, Paris. Superficially like the sculptures made

BOURGEOIS TRASH

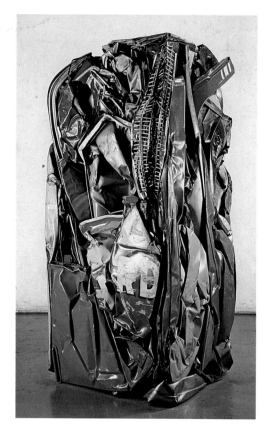

59 César *Compression d'automobile* 1962

60 César *Le Pouce* 1964–6

around the same time by the American John Chamberlain, these works were made from the battered bodies of old cars; while Chamberlain bent and twisted the components into shape, César availed himself of the mechanical crushing technique by which such massive objects were reduced to an extremely heavy block of metal scrap. As with so much of the work produced by the Nouveaux Réalistes, the transformation of identity from a functional object to one with a purely aesthetic justification was intrinsic to its meaning. Yet César's recycling of manufactured objects, however much it reveals of the production of waste by a highly industrialized society, was fundamentally geared to defining the creation of art as a physical process; by the late 1960s the *Compressions* had given way to their opposite, works he called *Expansions*, amorphous sculptural shapes reached through the hardening of expanded polyurethane poured onto a flat surface. César's rejection of artistic specialization, viewed by many critics as a questionable and controversial stance, paradoxically brings him most into line with the detached attitude towards style characteristic of Pop. Fittingly, it was this freedom of movement that later allowed him to produce his most overtly Pop sculptures, a series of monumental *Thumbs* cast in various materials including plastic, silver-plated metal and polished bronze.

Two of the other best-known artists associated with the Nouveaux Réalistes, Yves Klein and Jean Tinguely, were also only peripherally involved with issues related to Pop. Tinguely's highly inventive and often humorous motorized metal assemblages, for instance, combine elements of Surrealism and a machine aesthetic into a new form of kinetic art, while Klein's most famous works, such as the monochrome paintings in a colour he labelled International Klein Blue, precede both Minimalism and Conceptual art. In spite of their rather different interests, however, their central role in the group's activities, like that of the critic Pierre Restany, helped shape the sense of a common purpose. Each of them, moreover, was responsible for bringing into the group at least one other member who developed an aesthetic based on the common object: Tinguely introduced Daniel Spoerri, who had been his assistant; Klein invited Martial Raysse to join just as his work was beginning to address issues about the consumer society in assemblages of cheap plastic objects; and it was through Restany that the Bulgarian Christo, who had settled in Paris in 1958, first made contact with the group. Niki de Saint Phalle, like Christo, became associated with the Nouveaux Réalistes only after their signed declaration of 27 October 1960, and like him by the middle of the decade she used a highly individual visual language that took her far from the tenuous links that briefly defined the group aesthetic.

Of all these artists it was Raysse who left mass-produced articles in their most naked state as both form and content, notably in works associated with his installation *Hygiène de la vision* (Hygiene of Vision) at the Biennale des Jeunes, Paris, in 1961. His approach in works such as *Génie sans bouillir* (1960) or *Supermarket* (1961) was similar to that of American artists connected to the Fluxus group, such as George Brecht, in that he presented his inventories of humble objects in simple displays such as one might find in the most ordinary of shops; for these works of 1960–61 he favoured objects made of plastic, one of the most reviled but common contemporary synthetic materials. Raysse's reinterpretation of the ready-made was more extreme than that of any of the other Nouveaux Réalistes: he ruthlessly eliminated any sign of his physical intervention other than in the selection and pairing of objects; he limited himself to a severely restricted category of cheaply made product, which was at once austere in its bare functionalism yet attractive because of its bright colours and simple shapes; and his organizing principles, based in most cases on a kind of tabulation of samples, made even fewer concessions to tra-

61 Daniel Spoerri *Les Puces* 1961

62 Daniel Spoerri *Le petit déjeuner de Kichka I* 1960

63 Martial Raysse *Génie, sans bouillir* 1960

ditional composition than Arman's *Accumulations* of like objects, which at least included notions of repetition and grid structure.

The radical simplicity of Raysse's programme, which makes much of the work of his colleagues look conventionally anecdotal, proved intractable to further development not only by other artists but by Raysse himself. For *Hygiène de la vision* he combined similar objects with a life-size photographic image of a woman borrowed from an advertising display for Ambre Solaire suntan lotion. Elements of narrative and of the mass media made his work more generally palatable in that it began to correspond to more conventional expectations of art; by 1962 he had ceased to be close to the other Nouveaux Réalistes but had entered the orbit of Pop in a manner approached by few other Europeans. His work of the next half decade, before he again took a radical change of direction, has a central place in the development of a classic Pop aesthetic on the Continent.

Daniel Spoerri came close on occasion to Raysse's simple inventories of objects, as in *Collection d'épices* (Collection of Spices, 1961), a boxed set of three long shelves housing a range of bottled spices and condiments. He was best known, however, for his *tableaux-pièges* (snare pictures), a form of assemblage by which he would literally entrap a collection of objects as a ready-made composition by gluing them into place and then hanging the result on the wall. Typically, as in *Le petit déjeuner de Kichka I* (Kichka's Breakfast I, 1960), he would alight on the objects at a place setting at the end of a meal, so that what one might describe as the composition of the picture had been arrived at not through the artist's aesthetic decisions but through the use to which the objects had been put by someone else. As with the Kitchen Sink painters in Britain in the mid-1950s, there is a strong social undercurrent to these works as evidence of a bohemian existence that differentiates them from the more neutral stance of mainstream Pop; his longtime supporter Restany has pointed out that such works were initially conceived by Spoerri as a theatrical rendering of his miserable living conditions, a factor evident in their deliberate squalor. While Raysse referred to supermarkets, Spoerri felt more at home rendering his experience of *Les Puces* (The Flea Market, 1961) in an assemblage salvaged from forlorn objects that had long outworn their original use and beauty.

BOURGEOIS TRASH

64 Christo Look Magazine Wrapped 1964

Shortly after his arrival in Paris in 1958 Christo began to wrap found objects in canvas, cloth, plastic and other materials, at once drawing attention to their shapes and concealing their surfaces. Among the objects treated in this manner were *Packed Bottles and Cans* (1958–60), *Packed Chair* (1960), *Packed Tables* in 1961 and 1962, *Stacked Oil Drums* (1961) and *Packed Car (Renault)* (1961), followed in 1962 by works such as *Packed Motorcycle*, *Packed Perambulator*, *Package on Luggage Rack* and *Packed Portrait of Brigitte Bardot*. The mystery of objects hidden from view clearly links these works to Surrealism; a close connection has particularly been remarked upon with Man Ray's no longer extant work of 1920, now known only through photographs, *The Enigma of Isidore Ducasse*, which consisted of a sewing-machine covered with cloth and rope.

There was a Pop inflection to Christo's interest in packaging as a way of selling unseen products to consumers, particularly in the objects chosen for a group of works made in 1963, such as an adding machine, a printing machine, a supermarket cart and, in *Look Magazine Wrapped* (1964), a number of contemporary mass-circulation magazines. All these works came after Pop was already recognized as a movement, and in their more evident contemporaneity they seem to have been made at least partly in response to its precepts; in 1964, when he moved to New York, Christo made his references to the street environment even more concrete in a group of *Store Fronts* that echo Claes Oldenburg's interior installations of 1960–62 on a related theme. As early as 1961, however, Christo had proposed a project for a *Packed Public Building* in the form of a photographic collage, revealing the true scale of his ambitions with regard to the natural and built environment alike; the packaged objects that mark his brief brush with the periphery of Pop were clearly only a preparation for the massive works that he began to realize in 1961, such as *Dockside Packages* in Cologne harbour, once he had found a way of funding such grand schemes.

Niki de Saint Phalle likewise can be related to Pop only in a group of paintings and assemblages made from 1961 to 1963, in which she used found objects and referred in her imagery to city life and occasionally to the mass media. The Surrealistic fantasy and invention on which she was to build her better-known later works, particularly in league with body imagery, was already the dominant element of life-size figures such as *Large Man – Red (Munich Shot Picture)* (1962), which she assembled from a variety of objects chosen as much for their symbolic connotations as for their visual appeal; in this case tins of spray paint, model aeroplanes, toy soldiers and other ephemera are geared to conveying a stereotyped idea of 'what little boys are made of' Similarly the monster imagery prevalent in many of these works, such as *New York Alp* (1962), *Green Monster (Berlin Shot Picture)* (1963) and *King Kong* (1963, one of the rare works by her explicitly from a popular source), relates less to science fiction than to an expression of animal passions and forbidden desires. Only in a few works, such as *Coeur à la moto* (Heart with Motorcycle, 1962–3) – in which she pairs a motorcyclist in profile with an emblematic heart encrusted with a variety of heart and flower motifs, skulls and even a bust of Beethoven – does she allow a communal language to take precedence over dream imagery in a spirit approaching Pop, but even here the emphasis is largely on the personality intrinsic to her moulding of form. Ultimately this group of pictures is closest to Pop not so much in its imagery as in its partial reliance on a technique of complete detachment: colour was not applied with the brush but created by firing pellets at bags of paint suspended in front of the surface, releasing the artist from the anxiety of decision-making and presenting the spray of colour as only the result of a physical action.

65 Niki de Saint Phalle *New York Alp* 1962

66 Arman *Chopin's Waterloo* 1962

67 Yves Klein *Victory of Samothrace* 1962

In parodying techniques associated with Art Informel, the French equivalent of American Action Painting, Saint Phalle demystified the process of creation much as American artists such as Oldenburg and Dine were doing in their work of the late 1950s and early 1960s. Like these Americans, too, Saint Phalle and other Nouveaux Réalistes, notably Klein and Arman, unveiled their artistic processes in live performances. In the early 1960s, for instance, Arman made a group of works titled *Colères* (Tantrums), in which he wreaked violent revenge on objects that were then fixed to a flat surface in their dismembered form and presented as works of art, the end product of an action by which their identity was irredeemably changed; one such work, *Chopin's Waterloo* (1962), was the result of a performance held at the opening of the exhibition 'Musical Rage' at the Galerie Saqqarah, Gstaad, in 1962.

Klein, for his part, began a series of paintings in 1958 (termed *Anthropométries* by Restany in 1960) in which life-size images of female nudes were made by covering his models in blue paint and then having them press their bodies against the paper so as to leave the imprint of their breasts, thighs and torso; the performance aspect of these pictures was emphasized in a public display at a Paris gallery on 9 March 1960, during which Klein directed three nude models to the accompaniment of twenty musicians playing his *Symphonie monotone*.[3] Klein developed the literalness of this form of representation in a few works made in 1962, such as *Portrait-relief d'Arman*, in which a painted bronze that he had cast from a plaster mould of Arman's body was placed against a panel covered in gold leaf; although his use of the body here was similar to that being investigated at the same time by the American George Segal, Klein presented his fragment of reality as a heroic portrait, an icon of classicism, rather than as a materialization of an ordinary person engaged in an everyday action, as in Segal's case. In the same year Klein coated a plaster reproduction of the *Victory of Samothrace* in his characteristic deep blue, anticipating a theme that became common in Pop, that of a familiar work of art presented in the guise of a reproduction. Klein's death from a heart attack on 6 June

THE FOUNDATIONS OF POP

1962, aged thirty-four, cut short this development of ideas related to Pop at a critical moment; nevertheless his work continued to influence artists not only in Europe but in America, where he had exhibited in 1961 in both New York and Los Angeles.[4]

Much of the art produced by the Nouveaux Réalistes took the form of sculpture or assemblage, but their dedication to the found object also had its two-dimensional counterpart in the *décollages* made from layers of torn posters by Raymond Hains, Jacques de la Villeglé and the Milan-based Mimmo Rotella, and also by a German artist who was not a member of the group, Wolf Vostell. Hains was perhaps the first to make such works, which he termed *affiches lacérées* (torn posters), as early as 1949 and in collaboration with Villeglé during the early 1950s, but Rotella and Vostell independently developed a similar idiom in response to the street culture of poster art prevalent throughout Europe in the post-War years. While American and British artists were beginning to investigate the uses of popular imagery in painting, for these Europeans it seemed more natural to work directly with the materials of their immediate environment, creating essentially flat but interpenetrating layers of images derived from printed media and popular culture.

For Hains, and for Rotella in his first *décollages* of the mid-1950s, the attraction of the torn posters lay primarily in their potential for abstract designs, textures and patterns as layers were peeled away to reveal other fragments of form and colour underneath. Only in occasional works by Hains, such as *Cet homme est dangereux* (This Man is Dangerous, 1957), is a single source left sufficiently intact for it to acquire an iconic quality in terms of a legible text and image. The political dimension of this particular work, which surfaced also in various images by Hains and other artists, such as Vostell's *Ihr Kandidat . . .* (1961), indicates not a particular point of view but an almost accidental collusion between the material that happened to be to hand – such political posters were, and remain, a noticeable feature on the streets of European towns and cities – and the choice exercised by the artist from the range of images offered to him.

Towards the end of the 1950s Villeglé began to introduce imagery that was closer to Pop in its crude simplicity or in its references to mass entertainments such as the cinema. In *Angers, 21 septembre 1959*, for instance, the integrity of a single film poster is preserved by leaving enough of the image intact for it to remain legible as a continuous scene and by equating it with the contours of the picture as a whole: an approach to the picture as a real object comparable to that of Johns in America at around the same time, but with the typical insistence of the Nouveaux Réalistes on using actual found objects as their materials rather than substituting them with any form of representation. Although the impression conveyed is that of a fragment of reality wrenched from its original context and presented in an art gallery without further manipulation, the artist in fact had considerable freedom in deciding which part and how much of each layer of poster he wished to remove. In this case the notice indicating that entrance to the film is forbidden to those aged less than sixteen adds to the sense of the image as both concealing and revealing illicit pleasures, whether of sex or violence, as if they could only be glimpsed furtively through the rips in its surface.

Another work by Villeglé of this period, *14 juillet, décembre 1960*, indicates in its title the time span between the prominently featured Bastille Day poster and the making of the final picture; the weathering of the image and the sense of the picture as a record of layers of time become as much a part of its meaning as the bombardment of the innocent passerby with pieces of unrelated messages and pronouncements. Another issue that Villeglé addressed in a particularly extreme way was that of environmental scale: our apprehension that each element appears at its actual size, since it is taken ready-made

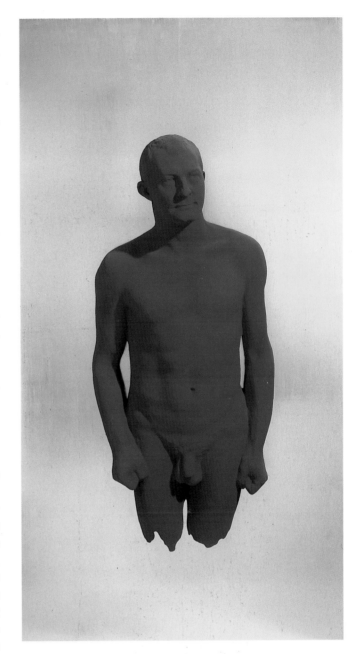

68 Yves Klein *Portrait-relief d'Arman* 1962

69 Raymond Hains *Cet homme est dangereux* 1957

70 Jacques de la Villeglé *Angers, 21 septembre 1959* 1959

from external walls of buildings, adds to the impact of works measuring as much as 3 x 8 metres, encompassing the spectator's field of vision in precisely the same way as would occur on the street itself.

Of all the *affichistes* it was Rotella who most assiduously scoured the streets for a contemporary iconography that included brand names and company logos, consumer products, film stars and equally glamorous images of politicians. Limiting his choice of motifs, like his colleagues, to those he could find ready-made on street posters, and severely restricting his relationship to this material to that of selective removal, Rotella achieved an extraordinary variety of pictorial effects that enabled him to present the products of his culture as if they were his own discoveries; however torn or distressed their surfaces, the images they contain are revealed with all their strangeness intact. Some works make subtle reference to the ubiquity of printed images, for example in the partial repetition of the image of John F. Kennedy in *Viva America* (1963), but Rotella – unlike, say, Warhol in the United States – showed little interest in presenting such material as numbing in effect. On the contrary, he was more concerned with conveying a sense of the visual stimulation afforded by a seemingly endless succession of changing images and patterns all vying for our attention.

The novelty of form that characterizes works such as *Scotch Brand* (1960) cannot disguise the extent to which Rotella has had recourse to longstanding artistic conventions and concerns, since the impact of the final image is dependent on its relationships of shape and colour and on the torn edges that constitute, in effect, a very expressive form of drawing. From the vast variety of material presented to him on his wanderings, Rotella demonstrated extraordinary discernment in his choice of iconic images, whether they be classic advertising motifs such as the Coca-Cola logo or particularly seductive media images such as the voluptuous photographic portrait of a film star, as featured in the centre of *Marilyn* (1962). Rotella's role in many cases could be described as a redesigning of an existing motif for the purpose of exaggerating its attributes; much of the visual impact of his work derives directly, in fact, from the graphic design of his chosen material, for which he clearly has an unpatronizing and unqualified respect.

Although the Nouveaux Réalistes dominated the European approach to popular imagery and industrial processes of mass production in the 1950s and early 1960s, they were not completely alone in suggesting possible avenues for an art that could be described as Pop. As early as the mid-1950s, for instance, the German painter Konrad Klapheck took for his subject domestic appliances such as typewriters and sewing-machines, which he painted in a flat, dispassionate style and presented in the manner of earlier twentieth-century advertising images. His deadpan technique, which expunged all signs of personal brushwork, prefigured much Pop of the 1960s, as did his preference for a simple, clearly defined, centrally placed image of an ordinary modern product of mass production. In presenting his machines in the form of portraits, however, and in giving them suggestions of human attributes and emotions, Klapheck demonstrated a reliance on Surrealist metaphor and fantasy that remained at odds with the fundamentally materialist aesthetic of Pop.

During the late 1950s and early 1960s the Milanese painter Enrico Baj produced two series of works in which he created the terms for what could have been a specifically European form of Pop, if only he or other painters had continued to investigate their operating principles. In a group of paintings termed *Modificazioni* (Modifications), such as *Des êtres d'autres planètes violaient nos femmes* (Beings from other Planets raped our Women,1959) and *Ninon de Lenclos e Eleonora di Navarra sorprese dal duca di Eng-*

71 Jacques de la Villeglé *14 juillet, décembre 1960* 1960

hienne e figuranti (Ninon of Lenclos and Eleanor of Navarra surprised by the Duke of Enghienne and Accomplices, 1964), he explored the limits of kitsch and of appropriated styles presented in striking opposition to each other. Starting with a blatantly sexual image of women copied with great verisimilitude from the pages of soft-porn photographic magazines, Baj introduced a second level of unreality by collaging to this surface vividly painted canvas shapes representing grotesque male figures of cartoon-like simplicity. In their excesses of bad taste, lewd eroticism and simulation of a slick bastardized realism they are rivalled only by Picabia's paintings of nudes of the early 1940s, which came to be more widely appreciated only in the 1980s.

Another series on which Baj was occupied from 1960 to 1962, a group of assemblages known collectively as *Mobili e personaggi in legno* (Furniture and Wood Inlay People),

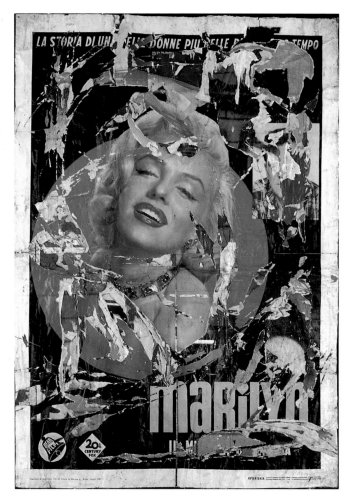

73 Mimmo Rotella *Marilyn* 1962

72 Mimmo Rotella *Scotch Brand* 1960

dispensed altogether with conventional painting methods. Although these pictures owe a clear debt to Cubist collage, with which they share a witty play on the interaction of illusion and reality, in their immediacy of impact and clarity of image they are very different from the ambiguous spatial investigations devised by Braque and Picasso. The rather humanized pieces of furniture portrayed with a simple frontality against patterned walls of domestic interiors, in works such as *Comode de style* (1961), are constructed entirely from imitation wood veneer and wallpaper. The fact that each element is assembled from ready-made materials – including some that are exactly the same as those from which the real objects would be made – is crucial to their meaning. These assemblages by Baj, so redolent of musty European interiors yet so purposeful in their deployment of found materials to convey the presence of familiar objects, are extraordinary manifestations of

74 Enrico Baj *Comode de style* 1961

75 Asger Jorn *Le Canard inquiétant* 1959

76 Konrad Klapheck *Schreibmaschine* 1955

a brief moment of an unself-conscious and specifically European form of Pop that was never really repeated or extended. The Danish Neo-expressionist painter Asger Jorn, who in 1954 had co-founded with Baj the Mouvement pour un Bauhaus Imaginiste, which remained active until 1961, also produced a group of paintings titled *Modifications* in 1959, which he exhibited at the Galerie Rive Gauche, Paris, in that year. These pictures, such as *Le pêcheur de nuages* (The Fisher of Clouds) and *Le canard inquiétant* (The Disquieting Duck), each consisted of a landscape bought in a junk shop over which he painted his own irreverent addition, often in a few crude brushstrokes simulating child art or a particularly violent sort of cartoon. The flamboyance with which he added his signature to that of the original artist in *Le canard inquiétant* calls attention to the final work as a nonconsentual collaboration between an amateur who painted for pleasure and a trained artist willingly surrendering his hard-fought expertise to the ineptitude of another painter.

In the first of two prefaces published in the catalogue to the exhibition of *Modifications* Jorn said that he preferred 'bad' painting to 'good', citing in support the gilt-framed pictures of 'lakes in forests' that enjoy such wide popular appeal, and referred to an article he had written twenty years earlier, 'In praise of Kitsch art', in which he had maintained that the greatest masterpieces were simply 'accomplished banalities' [5] These pictures, with a series of *Nouvelles disfigurations* painted over found portraits and battle scenes in 1962, were the most direct product of Jorn's involvement with the subversive theories of the Situationistes Internationales over the preceding few years.[6] Although, like Baj, he chose not to build on the aesthetic principles he established in these original works, they remain among the most vivid materializations of ideas about artistic invention, authorship and the appropriation of existing images that soon became standard themes of Pop.

THE FOUNDATIONS OF POP

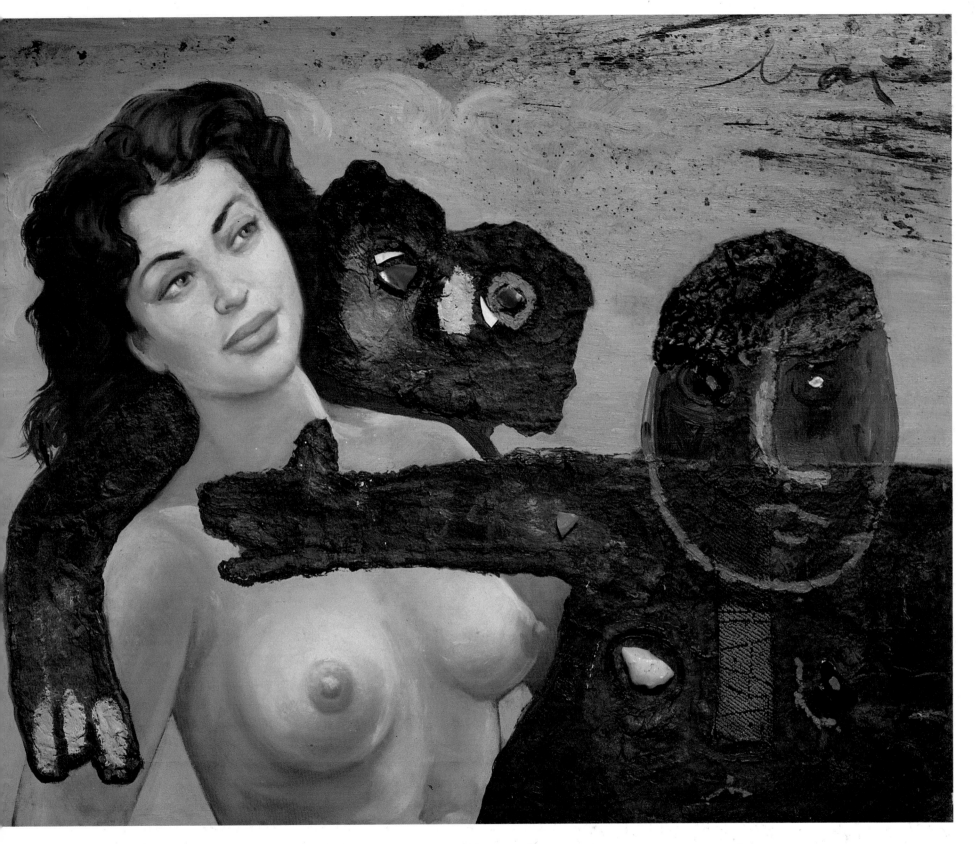

77 Enrico Baj *Des êtres d'autres planètes violaient nos femmes* 1959

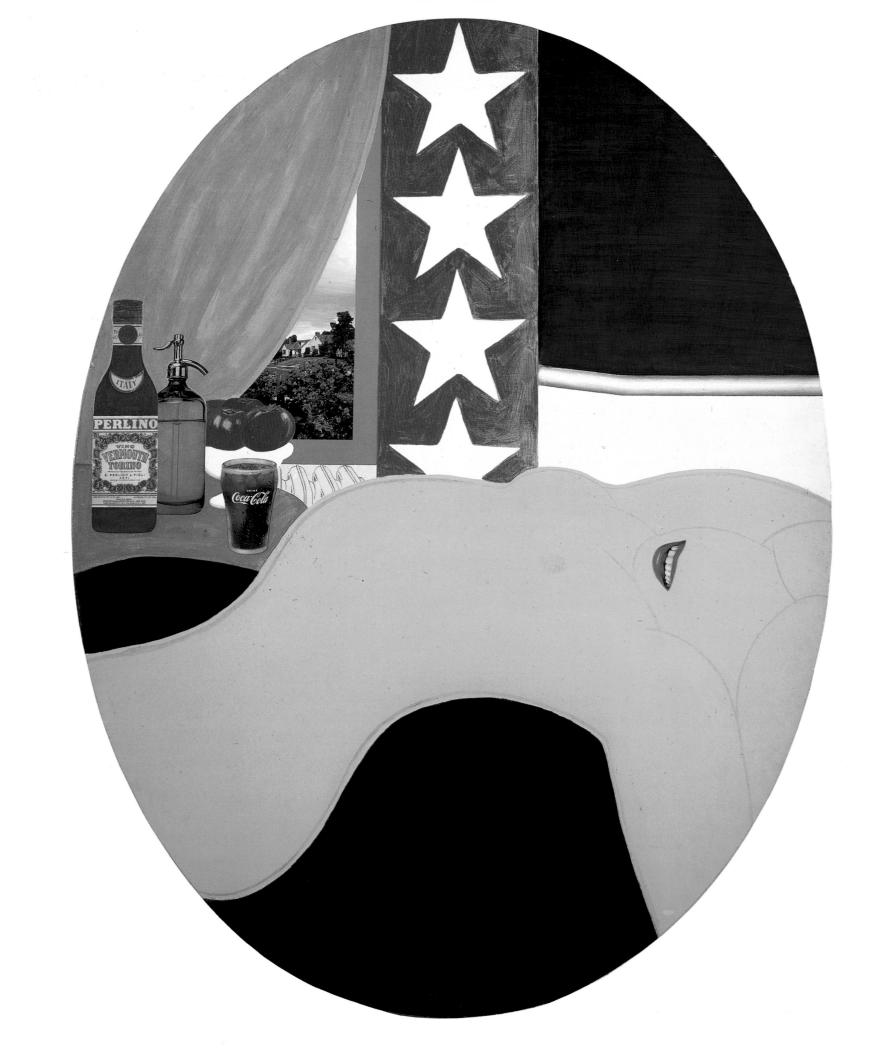

LOOK MICKEY

American Pop, 1960–62

The Pop art that emerged coincidentally and virtually simultaneously in the early 1960s from the studios of various American artists had its now generally accepted label thrust on it only at the end of 1962, in the wake of 'The New Realists' exhibition, although the term had already gained currency in England in relation to art based on similar popular sources.[1] From the moment of its appearance, however, it was recognized as a challenge and affront to the work of the Abstract Expressionists, as had already been the case with work produced in the previous decade by American artists such as Johns, Rauschenberg and Rivers. Not only was Pop blatantly representational, it also seemed to abuse the privileged status of fine art by aligning itself with kitsch and the low-brow taste of the general public.[2] It seemed indifferent and even hostile to passionately held views on uniqueness, artistic personality and originality: invention was being replaced by shameless copying from existing sources of disreputable banality, while expressiveness and the idiosyncracies of handwork were being played down in favour of uninflected surfaces that looked anonymous and in some cases even machine-made.[3]

It would be a gross simplification, however, to view American Pop simply as an overturning of the precepts of Abstract Expressionism. There was a continuity from one movement to the next, but it involved a reinterpretation of its basic principles. The emphasis on process, seen for example in the drip paintings by Jackson Pollock, was transposed into techniques associated with commercial procedures, such as Warhol's use of screen-printing and Lichtenstein's adoption of patterns of coloured spots based on the Benday dot used in the production of his source material. The 'all-over' methods of composition proposed in the late 1940s, in reaction against the traditions of European painting and to maximize the impact of a unified surface, survived in Pop through strategies such as repetition, grid formats and the equation of the entire canvas with a single found image. The large scale of the work of painters such as Barnett Newman, for whom it was a way of enveloping the spectator in a space of sublime grandeur, was transformed into the billboard images of James Rosenquist and Tom Wesselmann and into Claes Oldenburg's mock-heroic monuments to ordinary household objects.

The continuity from one generation to the next is especially apparent in the role of Happenings in the late 1950s and early 1960s as a direct mediator between Abstract Expressionism and Pop. In a much cited article originally published in 1952, the critic Harold Rosenberg interpreted the work of 'The American Action Painters' as a means of 'getting inside the canvas':

At a certain moment the canvas began to appear to one American painter after another as an arena in which to act – rather than as a space in which to reproduce, re-design,

79 Claes Oldenburg *White Shirt and Blue Tie* 1961

63

80 Allan Kaprow *Yard* 1961

81 Claes Oldenburg *The Street* 1960

analyze or 'express' an object, actual or imagined. What was to go on the canvas was not a picture but an event.

The painter no longer approached his easel with an image in his mind; he went up to it with material in his hand to do something to that other piece of material in front of him. The image would be the result of this encounter.[4]

Rosenberg's perception of such painting as the record of a kind of performance was echoed six years later, with the literalism that was to become a hallmark of Pop, in an article by Allan Kaprow on 'The Legacy of Jackson Pollock':

Pollock, as I see him, left us at the point where we must become preoccupied with and even dazzled by the space and objects of our everyday life, either our bodies, clothes, rooms, or, if need be, the vastness of Forty-Second Street. Not satisfied with the *suggestion* through paint of our other senses, we shall utilize the specific substances of sight, sound, movements, people, odors, touch. Objects of every sort are materials for the new art: paint, chairs, food, electric and neon lights, smoke, water, old socks, a dog, movies, a thousand other things which will be discovered by the present generation of artists. . . . The young artist . . . will discover out of ordinary things the meaning of ordinariness. He will not try to make them extraordinary. Only their real meaning will be stated.[5]

For Kaprow, as for colleagues such as Oldenburg, Dine, Robert Whitman, Al Hansen, Lucas Samaras and Red Grooms, live performances – using a vocabulary of ordinary gestures, in settings often composed of a jumble of objects found on the street – were a direct way of integrating art and life, of opening oneself as Cage had suggested to the randomness and beauty of things and events encountered every day.[6] Kaprow's first public performance, *18 Happenings in Six Parts*, the opening event of the Reuben Gallery, New York, in autumn 1959, was followed by further performances and temporary 'environments' in which spectators were invited into settings as chaotic as city life itself; for the exhibition 'Environments, Situations, Spaces' held in May – June 1961 at the Martha Jackson Gallery, New York, for instance, Kaprow created *Yard* from a jumble of dozens of discarded tyres through which the audience was forced to pick its way. Dine and Oldenburg used the environments they had presented at the Reuben Gallery in 1960 as the sets for their early Happenings, and they also turned some of their theatrical props or equally rough and spontaneous objects into independent sculptures or collage-based paintings. Red Grooms, whose early paintings and assemblages such as *Policewoman* (1959) are related closely in their subject-matter and improvised air to his non-narrative plays such as *The Walking Man* and *The Burning Building*, exhibited the set for one of his performances, *The Magic Train Ride*, at his one-man exhibition at the Reuben Gallery in January 1960.[7] Unlike his colleagues, however, Kaprow remained committed exclusively to ephemeral events. Although he consequently never made the transition into Pop art, his influence on the course of the movement was direct and immediate not only through his Happenings and environments, but also through his proposal of new attitudes and subject-matter and through his friendships with painters and sculptors.[8]

Dine's involvement with live events was concentrated on four Happenings held in 1960 in New York. The best-known of them, *The Smiling Workman* at the Judson Gallery, was a vividly visual piece lasting only half a minute in which Dine, dressed in an artist's smock, scrawled the words 'I LOVE WHAT I'M DOING' in huge letters of orange and blue paint

64

before drinking the remaining paint and finally hurling himself through the canvas. He was also the main actor in his other three performances: *Car Crash*, a violent subject emblematic of modern American life (which Warhol pursued in some of his most gruesome *Death and Disaster* paintings of 1963–4); *A Shining Bed*, with disturbing suggestions of animalistic sexuality; and a lighter, more humorous piece acknowledging music-hall theatrical traditions, *The Vaudeville Show*. In acting out the personal basis of art intimated in the work of the Abstract Expressionists as the product of frenzied obsessions, Dine quickly exhausted his interest in performance as too ephemeral and self-indulgent. The improvisation of art from junk found on the street, however, remained an essential element of the paintings he made in response to Rauschenberg's combines. His preference was consistently for objects rich in human associations, such as the tattered shoes and paint-besmirched shirt used in *Shoes walking on My Brain* (1960), the entangled remains of *Bedspring* (1960), or the hammers, saws and other familiar tools attached as found objects to his canvases as early as 1961. The image of the artist presented by *Green Suit* (1959), the first in a long line of his emblematic self-portraits, is the result of a series of violent acts inflicted on a man's suit that had long outworn its usefulness; yet the shredding of the trousers and the covering of the jacket in smears of colour, while implying an assault, can also be interpreted more pragmatically as the procedures of a painter. The very blankness with which such physical excesses are presented – the suit, after all, has been rehung as if it could again be worn – introduces an ambivalence towards what could otherwise be construed as an image of the tortured and wounded artist as tragic victim. If a painter loves what he is doing, as Dine's *Smiling Workman* had maintained, why should he be suffering?

Although common objects persisted as reference points in Dine's work of the 1960s, the intimacy of both his imagery and touch as a painter set him apart from the mainstream of Pop; in his case it was not simply an assertion of independence or pride to resist the application of the label to his work, but a question of a fundamentally different outlook. Dine never considered it a virtue to eliminate traces of himself by adopting anonymous images or techniques identified with mass production or consumer culture. Nevertheless, both the subject-matter and formal approach of his paintings from 1961 through to the middle of the decade – as in the Johnsian conceit of *The Red Bandana* (1961) – relate to Pop concerns that he himself had helped to establish.

Like Dine, with whom he was closely associated in the late 1950s, the Swedish-born Chicagoan Claes Oldenburg established his aesthetic through a confluence of Abstract Expressionist gesture, live performance and junk objects associated with the low life and dereliction of city streets. The environment called *The Street*, which he exhibited as part of the 'Ray Gun Show' in counterpoint to Dine's environment *The House* at the Judson Gallery from 30 January to 17 March 1960, was a chaotic profusion of decrepit materials and litter shaped and painted to represent denizens of the city immersed in urban squalor. This installation was used as the set for his first Happening, a series of thirty-two briefly illuminated scenes called *Snapshots from the City*, while the exhibition as a whole was complemented by the production of a series of crudely printed comic books by Oldenburg, Dine, Grooms, Robert Whitman, Dick Higgins and Dick Tyler.[9]

The emphasis in *The Street* on human figures, with their deliberately crude outline and rough texture, the references to graffiti and the use of cheap materials not traditionally associated with fine art, all suggest the influence of the French painter and inventor of Art Brut, Jean Dubuffet.[10] It was to his immediate environment of the impoverished Lower East Side of New York, however, that Oldenburg looked most for inspiration. The fragile

82 **Jim Dine *Green Suit* 1959**

83 **Red Grooms *Policewoman* 1959**

84　Jean Dubuffet *Touring Club* 1946

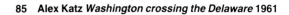

85　Alex Katz *Washington crossing the Delaware* 1961

and found materials on which he relied, such as cardboard, burlap and newspaper soaked in wheat paste, were appropriate to the down-to-earth subject-matter; they suggested that the images were materializations of fleeting glimpses snatched from the fast pace of big city life. Out of these works came painted reliefs and sculptures made of more permanent matter, such as *White Shirt and Blue Tie* (1961), painted over fabric that had been soaked in plaster and then modelled over a wire armature. At this stage Oldenburg was devoted to the human figure in all its sweaty and dynamic vulgarity, but his decision to conjure someone's presence by representing his clothing rather than his own features provides one of the first indications of his shift in favour of common objects.

For more than a year Oldenburg continued to work in malleable materials, usually muslin or burlap soaked in plaster, retaining a hand-made look still essentially derived from Abstract Expressionism. By the end of 1961, however, his imagery was already changing to include fragments of street signs, advertising logos, the American flag and typically American fast food. His new identity as Pop sculptor, first intimated in his contribution of a group of reliefs, *The Store*, to a mixed show at the Martha Jackson Gallery in May 1961, was announced by the opening in December of a one-man show with the same title at his new studio in a former store at 107 East 2nd Street.[11] The idea had occurred to him on his return to New York from Provincetown, Massachusetts, at the end of summer 1960:

I drove around the city one day with Jimmy Dine. By chance, we drove through Orchard Street, both sides of which are packed with small stores. As we drove, I remember having a vision of 'The Store'. I saw, in my mind's eye, a complete environment based on this theme. Again, it seemed to me that I had discovered a new world. I began wandering through stores – all kinds and all over – as though they were museums. I saw the objects displayed in windows and on counters as previous works of art.[12]

In this environment, and in works created immediately afterwards such as *Pastry Case I* (1962) – a selection of tantalizing life-size replicas of sweet chocolate sundaes, pies and other desserts displayed in a luncheon-counter glass case – Oldenburg addressed himself directly to the issue of consumerism, perhaps as an ironic displacement of his own ambivalence about producing saleable goods for the art market. The objects were of two types: manufactured items such as *Iron* (1961), followed by foods such as roast beef, a pair of cheeseburgers and assorted slices of pie; they were all ordinary things for daily use, designed for maximum appeal to the prospective purchaser. Oldenburg carried the gesture through to its logical conclusion, allowing visitors to take away their purchases at once and replacing the objects sold with new sculptures from stock. From February through May 1962 Oldenburg held a series of ten Happenings including *Store Days I* and *II* at the same place, rechristened the Ray Gun Theater; these introduced new subjects and images but were essentially his last major statement in the medium of live performance. Just as Dine had decided to devote himself to painting, so Oldenburg now concentrated on sculpture.

The concern with common objects that emerged as a central theme not just of Oldenburg's work but of much Pop in general was also reflected in other sculpture produced in America at this time by artists not closely identified with the movement. The free-standing painted 'cut out' figures produced sporadically by the portrait painter Alex Katz as early as 1959 cannot properly be described as Pop, but in their flat and obdurate presence

86 Claes Oldenburg *Pastry Case I* 1961–2

they have something of the deadpan solemnity of folk art forms such as painted sign-boards and cigar-store Indians. Only in one instance, *Washington crossing the Delaware* (1961), did Katz approach a full-blown Pop aesthetic by linking such techniques to a cli-chéd American subject (earlier dealt with by Larry Rivers: see Chapter 1); even in this case one must bear in mind that the cut-outs were not intended as independent sculp-tures but as the set for Kenneth Koch's one-act play *George Washington crossing the Delaware*. The cut-outs nevertheless prepare the way both for the three-dimensional figures and tableaux made by Red Grooms from 1963[13] and for the enlargement and sim-plification of Katz's own paintings at the same time in the manner of billboards, with flat areas of strong undmodulated colour, harsh tonal contrasts and severe cropping of the image.[14]

A far more spartan approach to sculpture, extending Duchamp's concept of the ready-made and acknowledging a debt also to the box constructions of Joseph Cornell, characterized the work of a loose association of artists who emerged from Cage's class in the late 1950s and who soon operated as international art provocateurs under the aegis of Fluxus.[15] George Brecht's conglomerations of found objects, in particular, pres-aged Pop in much the same way as the contemporaneous work of Arman and the Nou-veaux Réalistes. As early as 1959, in mixed media assemblages such as *Suitcase*, Brecht appropriated objects and two-dimensional images as movable elements in an elaborate conceptual game in which the spectator was invited to participate. The artist's intervention here and in slightly later works such as *Repository* (1961) lay not in any physical manipulation of the objects, but merely in their selection and organization in straightforward systems of box construction; this coupling of depersonalized form and technique with an appreciation of mass-produced objects and images as signs of con-temporary culture soon became one of the essential characteristics of American Pop.

87 Ed Kienholz *George Warshington in Drag* 1957

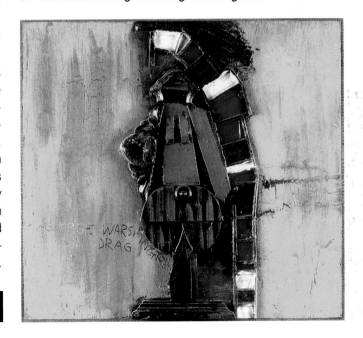

67

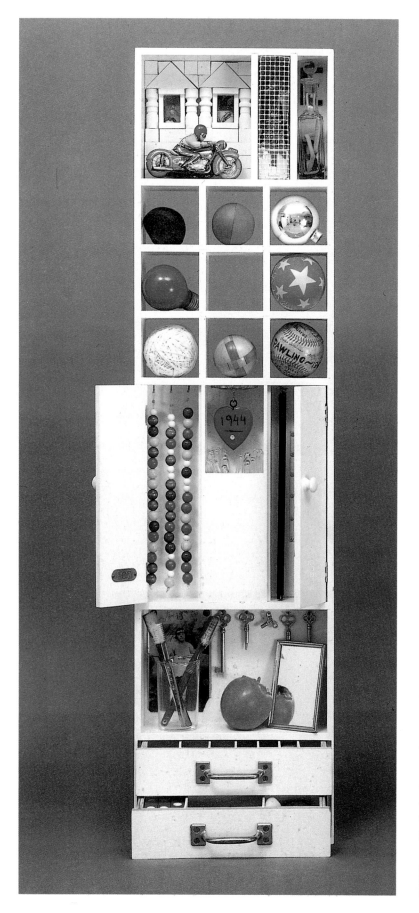

The amorphousness of the Fluxus group, their dedication to ephemeral live events and conceptual gestures, their essentially political stance and their reluctance to feed the art market with saleable commodities all militated against their acceptance by the art world network of dealers and museums; their exclusion from surveys of Pop began even before the movement had been named.[16] Nevertheless, and in spite of the sense of separateness that they themselves cultivated, one must acknowledge their contribution to the aesthetic climate that gave rise to Pop.

By 1961, when the Museum of Modern Art held a major survey exhibition 'The Art of Assemblage', an entire tradition stretching back to Picasso could be established for sculpture composed at least in part from ordinary things whose original identity was left intact.[17] Through the 1950s a form of sculpture developed that became known as Junk Art, with adherents both in Europe (such as Tinguely and Paolozzi) and the United States. Notable among the American work were hybrid figures by Richard Stankiewicz such as *Our Lady of All Protections* (1958), a whimsical construction made from pieces of scrap metal that retain their original identity while also assuming a new function as elements of an invented image. Junk Art gave rise in one direction to an essentially abstract aesthetic of mid-twentieth-century urban harshness, notably in the crushed steel sculptures devised from the late 1950s by John Chamberlain. Although Chamberlain learned much from the Abstract Expressionists – from the sculptures of David Smith as well as from the painters' use of sweeping physical gestures – a significant change of inflection was prompted by the specific associations of the rusted and fragmented car bodies that he used undisguised as his raw material. However formal Chamberlain's intentions, his choice of an archetypal symbol of American affluence, particularly when subjected to a process of such apparent violence, was not an innocent one. A typical early example, *Jackpot* (1961), was owned by Warhol, who appears to have thought of it as a car crash, perhaps helping to lead him towards the subject-matter of his own *Disaster* paintings two years later.[18]

A more explicit involvement with the imagery of junk materials was pursued in wooden relief paintings from 1954 by an artist based in Los Angeles, Edward Kienholz. Works such as the humorously titled *George Warshington in Drag* (1957), in which the first president's attire and modern transvestism are conflated in an unlikely meeting suggestive of changing social mores, were constructed from objects found in local junkyards. These led him to three-dimensional assemblages such as *John Doe* and *Jane Doe*, made in 1959 from mundane objects such as a painted perambulator, toys and mannequin parts; as their titles suggest, they are forlorn images of routine and deadened normality, of Mr and Mrs Average. A later assemblage, *Untitled American President* (1962), is a kind of bust-length portrait made from a torso in the form of a milk can painted with the stars and stripes, into which he has inserted a head and neck made from a bicycle seat as a disrespectful visual pun suggesting that politicians 'talk out of their ass', particularly when it comes to patriotism. Kienholz's open and sometimes scathing satire, directed as much to the social customs as to the politics of his country, declared a committed point of view at odds with the studied neutrality that was then emerging in Pop. His taste for visual anecdote, which soon emerged as his greatest strength in room-sized narrative tableaux, likewise set him apart from those who sought the impact of objects and images presented whole and without alteration. Nevertheless, he was as attuned to the social connotations of common objects as any of the Pop artists, and through these associations he found his own way of addressing contemporary American life.

From 1957 to 1963 Kienholz was co-director with Walter Hopps of the Ferus Gallery in Los Angeles. It was there that the city's two painters most closely associated with the origins of Pop, Ed Ruscha and Billy Al Bengston, had their first exhibitions. Painted representations of objects, rather than the things themselves, were at the root of their early work concurrent with the similar developments taking place in New York. Bengston's brief identity as a fully-fledged Pop artist in 1961 was concentrated on a few representations of the products of modern technology, specifically of B.S.A. motorcycles and their finely detailed parts, such as *Skinny's 21* and *Carburetor I*. Art and life, as far as he was concerned, were fully integrated, given his own obsession with racing motorcycles.

Even in the context of Bengston's early work his motorcycle paintings were uncharacteristically explicit. As early as 1959 he proposed a more generalized range of images with which he pursued an essentially abstract course, while still paying homage in the titles – in appropriately Hollywood fashion – to film stars and other celebrities. His first pictures of hearts in 1959–60 were dedicated to *Brigitte* (Bardot), *Kim* (Novak) and *Mae* (West); his earliest use of stacked chevrons or 'sargeant's stripes' in 1960–61 included reference to *Elvis* (the most famous rock'n'roll star in the Army) and *Tyrone* (Power); and another image he was to make his own, that of a lily, in a form resembling a bat with flapping wings, was introduced in 1960 in paintings named after a character made famous by the movies, *Count Dracula*. From Johns's work Bengston took an extreme simplicity of format, a deliberately restricted range of emblematic motifs and a scrupulous technique by which each work is treated as a decorative object as desirable and seductive as any shiny new consumer product. Although he preserved a specificity of reference in many of his titles, by 1962 he had firmly established that such motifs were purely pictorial elements within the surface design. Only in technique did Bengston continue like a Pop artist, as in his use in the 1960s of sprayed car paints on twisted sheets of aluminium, a method borrowed from the West Coast practice of 'customizing' cars.

Like Bengston, Ed Ruscha experienced Johns's work with the force of revelation when he first came across it in reproduction in 1957.[19] In his hands, however, the device of basing a painting on a ready-made image took on the blatant contemporaneity of the mass media, perhaps because in his experience commercial art and fine art had been closely entwined. In 1956 he had entered the Chouinard Art Institute in Los Angeles – known for its training of Walt Disney illustrators – in order to become a commercial artist, but he was encouraged instead by Robert Irwin and other artists on the teaching staff to devote much of his effort to painting. On completing his studies in 1960 he was employed for one year by an advertising agency on layout and graphic design, an experience he did not enjoy at the time but that he later put to good use in a series of brilliantly designed photographic books, in his work as designer for *Artforum* magazine and in the paintings of words that were to become his trademark as an artist as early as 1961.[20]

Dublin (1960), a large painting based on a small collage of wood, newspaper and ink made in the previous year, was the first by Ruscha to include a hand-painted reproduction of a fragment from a *Little Orphan Annie* comic strip.[21] This might qualify as the first Pop painting of a comic strip image, predating even those of Warhol and Lichtenstein. Rather than treating the canvas as a transposition of a single frame, however, Ruscha has isolated his material within a broad border of primed canvas and presents it at two removes, as a hand-made copy of a collage using actual objects; without benefit of comparison, there would be no way of knowing that the blue rectangle and green arrow shape that function here as formal devices are faithful versions of the weathered pieces of wood glued to the collage. A second painting from the same source executed two

89 Billy Al Bengston *Carburetor I* 1961

90 John Chamberlain *Jackpot* 1961

LOOK MICKEY

D U B L I N.

years later, consisting solely of two broad areas of vivid flat colour and the word *Annie* in its well-known typographic form, is a far more extreme statement and one that characterized Ruscha's subsequent concentration on words as found objects. To anyone familiar with the comic strip in question, the recognition factor of these joined letters is immediate, triggering memories and associations that will vary from person to person.

This conception by Ruscha of paintings as signs, both in the literal and metaphorical sense, had been stimulated by a trip to Europe from April to October 1961, during which he had produced a series of twenty or thirty works in oil on paper based in many cases on the words and images found in street signs and shopfronts.[22] When he returned to Los Angeles, a flat city of freeways and open spaces where even the architecture seems to be only an excuse to prop up enormous signs giving directions or proclaiming a product, Ruscha at once recognized his true subject. Although he continued to use imagery borrowed from the mass media or based on his own photographs of gasoline stations, it was with his paintings of words that he made his most individual contribution to Pop. In *Large Trademark with Eight Spotlights* (1962), '20th CENTURY FOX' is emblazoned in red letters drawn in perspective on a huge canvas that extends sideways like a billboard or cinemascope screen: an ode to Hollywood delivered in its own language.

Early tremors of Pop were also being registered in northern California, especially in the paintings of two friends: Wayne Thiebaud, an artist then in his early forties, and a much younger painter, Mel Ramos, whom Thiebaud had taught at Sacramento from 1953 to 1958. Thiebaud's brand of painterly realism bears comparison with that of Edward Hopper, whose reputation had grown steadily and whose paintings of sun-drenched landscapes and interiors provided an unblinking record of mid-century America.[23] From 1961 until the middle of the decade Thiebaud painted a series of pictures of ordinary objects, concentrating especially on cheap and popular foods of the sort that were consumed in huge quantities in cafeterias, diners and soda fountains across the country: hot dogs, sandwiches, a *Trucker's Supper*, slices of pie, ice cream cones and sundaes. His choice of images was explicitly American and down-market and, as he later explained, 'I think the big difference in America as compared to Europe is that the food here is the same wherever you go, even down to the napkins and salt and pepper shakers on the restaurant tables.'[24] This experience of sameness and abundance was manifested in pictures such as *Five Hot Dogs* (1961) in the form of bland repetition of a single item across a plain-coloured surface; the profusion of cakes in *Bakery Counter* (1961–2) and the rows upon rows of food shown in perspective in *Salads, Sandwiches and Desserts* (1962) implicitly carry a message of America as the Land of Plenty.

The imagery and compositional methods of Thiebaud's paintings of the early 1960s can with justice be described as Pop, but the same cannot be said for the succulent brushwork used in these oil paintings or for the use of shadows and modelling to suggest depth and volume. The fluidity of the brushstrokes, when applied to images of edibles such as ice cream, can become a metaphor for taste and consumption; the Pop literalness of the equation between motif and painted object in such cases does not, however, apply in the same way to mass-produced items such as the gumball dispensers laid out frontally in a row in *Penny Machines* (1961). Even before he turned to a more traditionally realist conception of still life and landscape, Thiebaud occupied an ambivalent position in relation to Pop. Yet the monumental dignity that he conferred on images of extreme ordinariness, isolating them against the background as if they were official portraits and caressing them with paint, suggested like the best of Pop that the familiar things we often ignore are worthy of our attention.

94 **Wayne Thiebaud *Five Hot Dogs* 1961**

opposite

91 **Ed Ruscha *Annie* 1962**

92 **Ed Ruscha *Dublin* 1960**

93 **Ed Ruscha *Large Trademark with Eight Spotlights* 1962**

95 **Wayne Thiebaud *Salads, Sandwiches and Desserts* 1962**

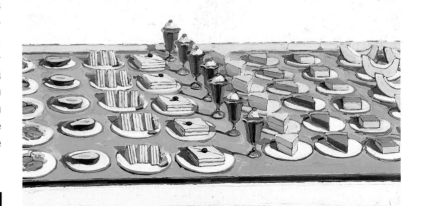

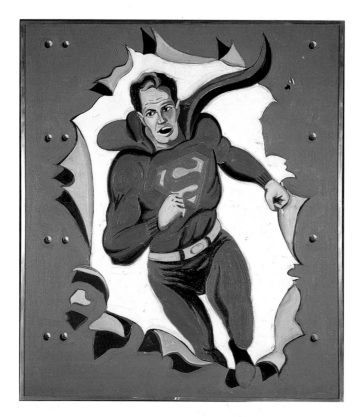

96 Mel Ramos *Man of Steel* 1962

97 Roy Lichtenstein *Popeye* 1961

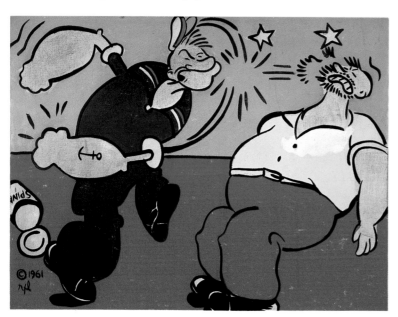

Using a painterly technique derived from Thiebaud, Mel Ramos decided in late 1961 to take as his subject the comic-strip heroes he had admired as a boy, beginning with *Superman*. He had previously painted standing figures, so in his own mind it was simply a matter of dressing them up in suitable costumes and making them large enough to give them a credible presence: 'When I saw Velásquez's work for the first time in Madrid in 1960 I really learnt something about the right scale for the human figure. This scale is slightly smaller than life for the simple reason that if you make a figure exactly life-size it looks larger. It was very important to me that the costumed heroes should be on a human scale so that they would be believable, so that they should have life aside from what they were in the comic books.'[25]

Ramos followed *Superman* with images of equally famous comic-strip characters including *Batman* and *The Flash* in 1961, bringing the series to a close in the next year with works such as *Man of Steel*, *The Trickster*, *Joker*, *The Flash*, *The Green Lantern*, *Hawkman*, *Wonder Woman*, *Dr. Midnight* and *The Phantom's Den*. He chose characters already instantly familiar but conjured their presence with lavish paintwork against brightly coloured backgrounds in characteristic poses as if he was remembering them from previous encounters rather than copying them as found objects from a single frame. His concern is with their status not as printed images but as symbols of heroism in a contemporary mythology in which good always triumphs over evil.

The early comic-strip paintings that were being coincidentally produced in New York at the same time by two artists then unknown to each other, Andy Warhol and Roy Lichtenstein, were very different in intention, although they, too, were based on well-known characters: Warhol's few works of this type, predating Lichtenstein's, were *Dick Tracy*, *Batman*, *Superman*, *Nancy* and *Saturday's Popeye* in 1960, followed by *Little King* and a second *Popeye* in 1961; Lichtenstein's first two paintings from such sources, both dating from 1961, were *Look Mickey*, featuring the Disney characters Donald Duck and Mickey Mouse, and his own version of *Popeye*.

Lichtenstein was a native of New York but had lived in Ohio from 1940, when at seventeen he began studying at the School of Fine Arts, Ohio State University in Columbus, to 1957, when he was appointed Assistant Professor of Art at the State University of New York at Oswego. From 1960 to 1964 he taught at Douglass College, Rutgers University, in New Brunswick, New Jersey, where he came into contact with Kaprow and through him attended Happenings by Oldenburg, Dine and Whitman. In the early 1950s Lichtenstein had produced a series of paintings on American themes including the cowboys and Indians of the Wild West and in 1951 even a version of *Washington crossing the Delaware* that predated Rivers's far more notorious treatment by two years.[26] Stylistically and in their whimsicality and small scale, however, they were very much the product of European modernism, with obvious debts to the work of Paul Klee and Picasso. As for so many other Pop artists, the real challenge was to produce work as powerful in impact as Abstract Expressionism, and at the end of the 1950s Lichtenstein briefly tried to meet that challenge directly in a series of untitled gestural abstractions.[27]

In 1956 Lichtenstein had produced a small lithograph, *Ten Dollar Bill*, in a jovial, cartoon-like style, and in 1958, partly to entertain his two sons (then aged two and four), he had made ink drawings of comic-strip characters such as Mickey Mouse, Donald Duck and Bugs Bunny in a loose and improvised style clearly derived from de Kooning.[28] Yet in spite of these precedents in his own work, the change in both method and sensibility implicit in the 1961 paintings *Popeye* and *Look Mickey*, both of which were gross enlargements of images printed on bubble-gum wrappers, was so striking as to announce his

new Pop style at a single stroke. This radical break with his previous work, made when he was in his late thirties, owed something to the subject-matter opened up by Happenings and even more to the formal solutions proposed by Johns's object paintings. The idea proposed by Lichtenstein was of disarming, even reckless, simplicity: to enlarge a single comic-strip image to huge proportions, making no apparent changes to the composition, drawing style or colour, and to convey it by means of a depersonalized technique of flat colour encased in black outlines that was derived directly from its printed source. Such correlations of both image and technique to a single model taken from modern mass production proclaimed the American Pop aesthetic in its most extreme conceptual form, one matched at this early date only in a few other works such as Warhol's hard-edged versions of paintings based on advertisements of consumer products.

In these first comic-strip paintings, and in the images lifted from advertisements that quickly followed, such as *Girl with Ball* and *Step-on Can with Leg*, Lichtenstein approximated the effect of newspaper printing by treating clearly demarcated areas as a thin film of rubbed colour that exaggerates the coarse grain of the canvas. The result, though it clearly referred to the properties of printed images, still seemed to Lichtenstein to be too hand-made. He wished not only to make the pre-processed origin of his motifs brutally self-evident, but to challenge fine art conventions by appropriating – as a single operation – both images and techniques deemed to be crude and unartistic. In other paintings of 1961, such as *Mr Bellamy*, he mimicked in a more systematic way the printing procedure of the Benday dot, by which tonal variations are conveyed in patterns of dots of particular size and colour density; by applying the paint through a screen perforated with a grid of identical holes, he not only obtained the desired look but literally removed his hand from direct contact with the surface, distancing himself from his own work as if it had been produced by a machine.

To a certain degree, especially at this stage, the mechanized look remained an illusion, since a certain amount of retouching by hand was necessary to iron out imperfections. But Lichtenstein clearly had no intention of abandoning his artistic control; even after the commercial success of later years, when he could have stepped up his production by employing others to execute his paintings, he used assistants only for the most mechanical tasks. What was appealing to Lichtenstein was the idea of anonymity of image and technique as a subterfuge. The paintings give the impression of being mere copies of ephemeral and tasteless material transposed only in scale, freeing the artist from having to make any decisions about such traditional matters as composition, proportion, drawing, colour or style. Yet a comparison of a Lichtenstein painting with its source reveals the complex ways in which he has manipulated the material, beginning with the careful selection of a particular image from what could have been thousands of random possibilities and extending to subtle alterations that bring into focus its abstract formal unity.

The frontal and centralized presentation employed by Lichtenstein in early paintings of domestic objects, such as *Roto Broil* and *Electric Cord* of 1961 and *Golf Ball* (1962), was of such assertive directness that it would have been dismissed in contemporary advertising as too crude and unsophisticated. In the context of painting, however, this projection of an image so as to be instantly apprehended as a whole – as a perceptual pattern or structure that in psychological terms would be labelled a Gestalt – was daring in its austere simplicity, anticipating the Minimalism of the mid-1960s. Together with an emphasis on the surface as a flat pattern of dots, brightly coloured shapes and black outlines, this fixing of the image to the centre stressed the painting as a static object.

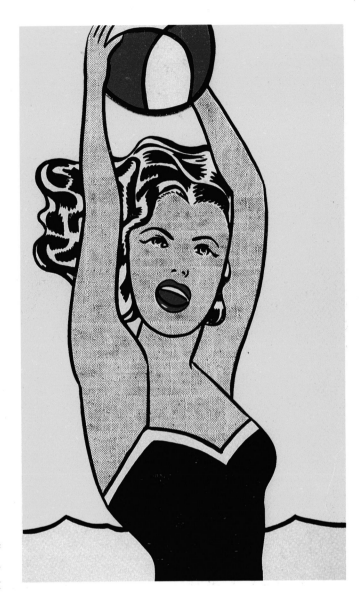

98 Roy Lichtenstein *Girl with Ball* 1961

LOOK MICKEY

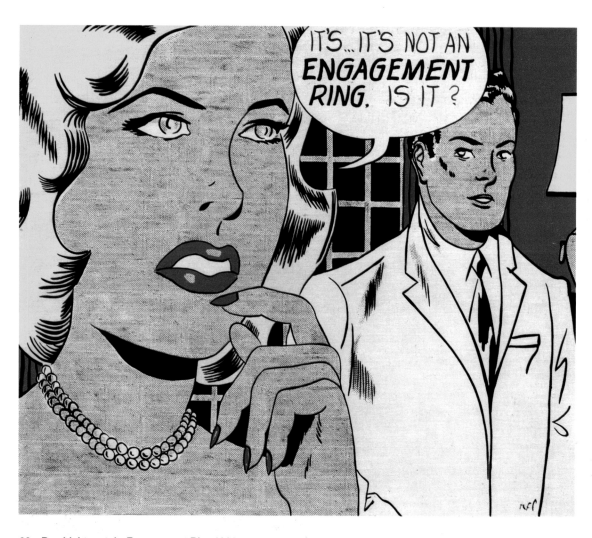

99 Roy Lichtenstein *Engagement Ring* 1961

101 Roy Lichtenstein *Look Mickey* 1961

100 Roy Lichtenstein *Step-on Can with Leg* 1961

102 **Roy Lichtenstein** *Roto-Broil* 1961

103 **Roy Lichtenstein** *Mr Bellamy* 1961

Action can only be implied, not represented, as in *Step-on Can with Leg*, a pair of canvases that are identical in every respect apart from the fact that the lid of the rubbish bin is closed in the first and open in the second. In the paintings that Lichtenstein based on Romance comic books, such as *Engagement Ring* (1961), the suggested narrative is frozen into a single frame, with a past and future that can only be surmised; the question contained within the balloon, though helping to lead us into fantasy, remains for ever unanswered.

Once he had turned to Romance comics as a source of imagery rich in potential for the dispassionate portrayal of exaggerated emotion, Lichtenstein found the images culled from such stereotypes more useful than the immediately recognizable characters he had depicted in *Look Mickey* and *Popeye*. This relative anonymity, moreover, enabled him to apply similar procedures to found images that were not themselves derived from comic books, and to bring himself into the picture in disguises that continued to insist on his absence. The well presented aeroplane pilot in *Mr Bellamy*, shown on his way to an appointment, thinks to himself: 'I am supposed to report to a Mr. Bellamy. I wonder what he's like.' It is an innocent enough image; nothing is given away with regard to the story to which it might relate. The suspicion remains, however, that the pilot might be a stand-in for the artist himself, nervously preparing to see the art dealer Richard Bellamy in pursuit of career security and success.[29]

In 1962 Lichtenstein produced a pair of pictures dedicated to two of his close associates, Ivan Karp (his dealer at Leo Castelli) and the Happenings artist Kaprow. He titled them *Portrait of Ivan Karp* and *Portrait of Allan Kaprow*, but neither painting even remotely represents the features of the man in question.[30] The two paintings, in fact, look identical in every respect, based on a single short-hand image of a suave young man of the 1950s. Lichtenstein's joke relates to the use of repetition by Rauschenberg in his two *Factum* paintings of 1957 to comment on issues of originality and identity. In taking a wilfully inappropriate stereotyped image as a stand-in for two very different denizens of the art world, and replicating it twice in a flat and inexpressive style, Lichtenstein presents in an extreme form the depersonalization of art central to Pop.

Portrait of Madame Cézanne and *Femme au Chapeau*, both of 1962, were among the first paintings in which Lichtenstein based an image directly on a picture by an illustrious predecessor, introducing the theme of art about art. Both are presented at two removes from the original. Cézanne's portrait of his wife is transposed, with significant but subtle alterations, from a diagram in a book, *Cézanne's Composition*, published a quarter of a century earlier;[31] Lichtenstein was amused by the oversimplified and paradoxical idea that a flat diagram consisting solely of a thick black outline could be used to represent the Frenchman's work, given Cézanne's insistence on eliminating contours from his paintings as incapable of suggesting the corporeal reality of the three-dimensional motif from which he was working. The author of the diagram, who on seeing a reproduction of Lichtenstein's painting threatened to sue him for breach of copyright, had unwittingly proposed a complete change of sensibility in the very act of trying to 'explain' Cézanne's work.

Picasso was a perfect target as the twentieth-century artist known to most people but commonly caricatured as producing crudely simple and childlike images of the human figure. *Femme au Chapeau*, immediately identifiable as a transposition from Picasso, is the first of many works and styles subjected by Lichtenstein to the comic-book techniques he had by then appropriated as his own. With its insistent pattern of dots and exaggerated colour, it is patently an image not of a painting but of a reproduction of a

painting. Lichtenstein plays on the distortions of the original effected in any photograph – including a change in scale, imbalances of colour and the elimination of the physicality of its surface – suggesting the extent to which our experience of art in the twentieth century is largely mediated through the printed page. Knowing that his own work would be no exception, and that we would be more likely to see it in a book than as an original on a wall, Lichtenstein delighted in features that would lend themselves well to reproduction, notably the bold primary colours in shapes clearly defined by black outlines. In less than two years, his mature aesthetic was already fully formed.

Andy Warhol, who had moved to New York in 1949 after finishing his studies at the Carnegie Institute of Technology in Pittsburgh, returned to painting only in 1960, when he was in his early thirties, after having established a formidable reputation as an illustrator in the New York advertising world. His motives for basing these paintings on comic strips or on starkly presented advertisements of consumer products were much the same as Lichtenstein's: an assault on received notions of good taste and of art as the expression of an individual's personality, coupled with a Johnsian presentation of the canvas as an object through its identification with a ready-made image.[32] Warhol's attraction to the dramatic and crudely simplified language of such material seems to have been two-fold: it was shocking to others because it was considered debased, low-brow and vulgar, and it provided a striking contrast to the sophistication of his own commercial work. His comic-strip paintings, by and large, were faithful transpositions of a single frame, but they were painted with a gestural looseness clearly indebted to the techniques of the Abstract Expressionists. He took more liberties with the image in *Popeye* (1961), one of the last of these paintings, visualizing the character and the typography that identify his name as white cut-out shapes through which we can glimpse parts of a crossword puzzle, as if we were looking through to the next page of a newspaper. Most of the rest of the canvas is covered with a flat coat of blue paint, which is allowed to drip profusely in the Abstract Expressionist manner as an ostentatious but (in this context) ironic display of expressiveness.

After seeing one of Lichtenstein's comic-strip paintings in 1961, Warhol immediately abandoned such subjects, judging that there would be too much competition between them if they continued working on similar lines and that Lichtenstein had presented such material in a more extreme and considered form by using a pseudo-mechanical technique.[33] In any case, he had already introduced other equally challenging subject-matter, including newspaper advertisements and images of mass-produced consumer products. A number of the paintings based on advertisements were given an extra edge by Warhol's choice of images that were public expressions of private embarrassments, such as *Where is Your Rupture* (1960) and *Dr. Scholl* (1960), in which a woman's finger peels back a plaster to reveal a prominent corn on her toe. *Before and After* (1960), a two-part image blithely promising the beautification of plastic surgery to the nose, and *Wigs* (1960), a display of hair styles that suggests the possibility of an instantaneous change of image, play on common anxieties about one's appearance and on fantasies about improving one's attractiveness by remaking one's image. In retrospect it is apparent that Warhol's uncanny intuitions in his choice of ready-made material owed much to the degree to which he depended on his own tastes and fears, while hiding them in the shelter of images snatched from the public sphere; it is worth noting that two of his greatest concerns about his appearance centered on his increasing baldness and on the shape of his nose, and that in the early 1950s he had taken to wearing the first of his many wigs (surreptitiously at first) and in 1956 or 1957 had had plastic surgery to his nose.[34]

104 Roy Lichtenstein *Portrait of Madame Cézanne* 1962

105 Roy Lichtenstein *Femme au Chapeau* 1962

106 Andy Warhol *Before and After 3* 1962

109 Andy Warhol *Do It Yourself (Landscape)* 1962

107 Andy Warhol *Storm Door* 1960

108 Andy Warhol *Storm Door* 1961

Like his comic-strip paintings, Warhol's borrowings from advertisements and from the labels of convenience foods, such as *Peach Halves* (1960), matched the vulgarity of their sources with a rough and ready execution, and they appeared equally contemptuous of received notions of taste and decorum. A number of the images, including *Storm Door*, were painted in two versions: one full of evident brushwork and painterly spontaneity, the other flat, linear and depersonalized. Warhol soon settled on what he called the 'cold "no comment"' paintings, encouraged by the preference expressed by people he trusted in the art world, such as Karp and the artists' agent Emile de Antonio, and by the removal of gesture that he had just witnessed in Lichtenstein's paintings.[35] Not yet as guarded in his statements as he was to become by the mid-1960s, Warhol wrote in 1960 of his first version of *Storm Door*: 'I adore America and these are some comments on it. My image is a statement of the symbols of the harsh, impersonal products and brash materialistic objects on which America is built today. It is a projection of everything that can be bought and sold, the practical but impermanent symbols that sustain us.'[36]

In his commercial work of the 1950s Warhol had used procedures such as rubber stamping images from hand-carved 'art gum', and in his drawings he favoured a transfer method by which an ink line made on a non-absorbent surface was blotted into another sheet of more porous paper, producing a printed effect that likewise gave the impression that the surfaces had barely been touched by his hand. It seemed sensible to him to use assistants as a way of increasing his productivity, assigning them basic tasks that would not depend on the autograph quality of their marks, so that work executed in part by others would be indistinguishable from his own. In contravention of passionately held beliefs about artistic ethics, authenticity and individuality, Warhol suggested the possibility that art could be made by anybody or as a collaborative venture along the lines of commercial mass production.

Warhol gave startling and vivid form to these ideas in 1962 in the last works that he painted by hand before adopting silkscreen printing: pictures based on ephemera such as matchbook covers and the sensationalized front pages of tabloid newspapers, as in *129 Die in Jet (Plane Crash)*; *Large Coca-Cola*, a stark linear portrait in black and white of a symbol of American consumerism that he had first painted two years earlier; and *Campbell's Soup Cans*, a series of thirty-two almost indistinguishable canvases of identical size painted with the aid of hand-cut stencils, each of which is one of the thirty-two available varieties of that brand. It was also in 1962 that he painted a series entitled *Do It Yourself*. Each is based on a diagram from a paint-by-numbers kit, photographed and projected onto the canvas by an epidiascope; the numbers identifying the different colour areas were produced in an even more mechanical way, as commercially available transfers of the sort that had only recently been introduced for use by graphic designers. The calculated outrage of the image, a downmarket assault on cherished notions of artistic standards, was exacerbated not only by its blatant decorative appeal but, worse, by the artist's apparent abnegation of technical virtuosity, choice and personal responsibility by limiting himself to the flat colouring-in of pre-ordained outlines. Warhol proposed an art that revealed nothing of its maker and that presented the process of mark-making not as a creative act but as a purely mechanical operation.

The equivalence of mass-produced image and technique proposed in the paintings made by Warhol and Lichtenstein during 1961–2 defined the parameters of American Pop in their purest form. During this period, however, other painters independently arrived at their own distinct contributions to the new aesthetic climate. Although much of this activity was in New York, it could not in fairness be described as a native movement.

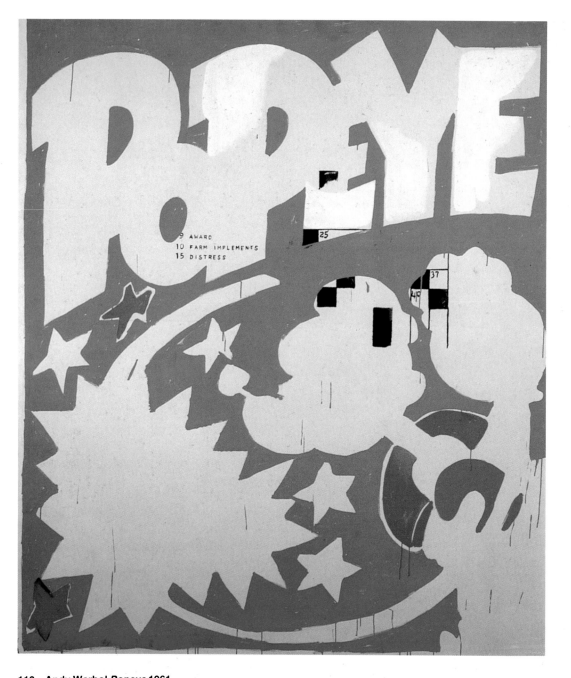

110 Andy Warhol *Popeye* 1961

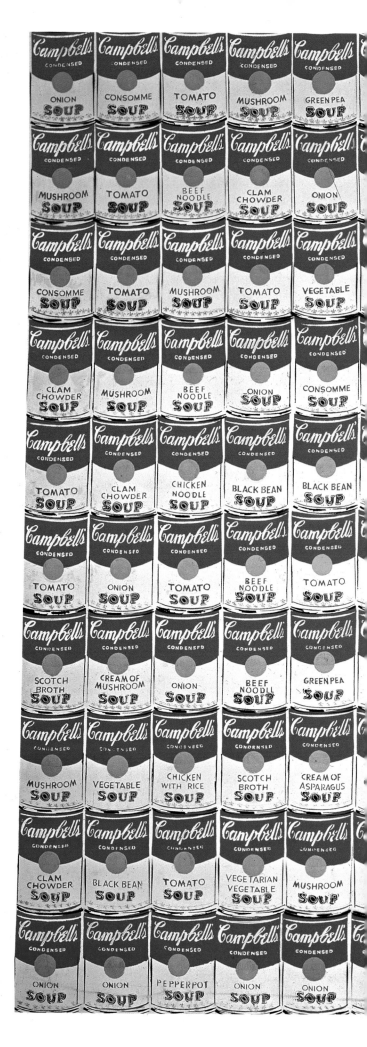

111 Andy Warhol *200 Campbell's Soup Cans* 1962

112 Peter Saul *Icebox* 1960

113 Richard Smith *McCalls* 1960

One of the first American artists to use consumerist imagery that could recognizably be called Pop, for example, was the San Franciscan Peter Saul during his extended sojourn in Paris from 1958 to 1962. In one of his earliest such paintings, *Icebox* (1960), a profusion of edible items such as one might find in a refrigerator are piled in chaotic abandon with cigarette packets, footballs, boxes labelled 'BIC', a floor lamp and a schematically rendered object identified as a 'hide-a-bed'. The items are mostly, though not entirely, of American origin, and are pictured with the reckless contours and the bright primary and secondary colours associated with certain cartoons. The circumstances of the production of this picture on the other side of the Atlantic suggest that it is a memory image of the artist's native culture, marked by an ambivalent mixture of excited affection for its vitality and of disdain for its voracious materialism and gluttony. Saul's use of a second-hand language and of images literally taken off the shelf cannot disguise an essentially passionate and emotive point of view, one that later emerged in more satirical form in his work and that confirmed his opposition to fundamental tenets of Pop.

Richard Smith, an Englishman who had studied at the Royal College of Art with Peter Blake and Joe Tilson in the mid-1950s, responded quickly and with great originality to the new mood during his residence in New York on a Harkness Fellowship from 1959 to 1961. Impressed both by Johns's paintings of familiar objects and by the centrality of composition that characterized Kenneth Noland's target-like abstractions of concentric circles, Smith produced a series of nearly square paintings that could be interpreted both as self-sufficient abstractions and as contemporary images drawn from the American mass media and from ordinary objects. Clues to their sources in general categories of things and in corporate logos can be found in the titles of paintings made in 1960, such as *Penny* and *Somoroff*, and in those produced in the following year, such as *Billboard*, *Panatella*, *Capsule*, *Revlon* and *Chase Manhattan*. Smith's references, in contrast to the humble and poverty-stricken downtown world alluded to by Oldenburg and Dine, were to the uptown affluence of Madison Avenue advertising agencies and glossy magazines. All these paintings were among those shown by him in 1961 at Bellamy's Green Gallery, where Oldenburg, Rosenquist and Wesselmann all had one-man exhibitions in the following year.

Smith's exhibition, which could with some justification be claimed as the first one-man show held by a Pop artist in New York, was impressive in its unity and in the balance achieved between an abstract simplicity of form and an image content derived from popular sources. One of the paintings shown, *McCalls* (1960), proclaims its derivation both as image and technique from a large circulation women's magazine: the sinking heart is a visual pun playing on the romantic tales that might be found in a typical issue, while the thin application of paint in vivid hues conveys Smith's delight in the superimposed layers of printed colour that he particularly associated with American magazines. Smith's painterly technique and luminous colour reveal his admiration for American colour-field painting, particularly that of Mark Rothko, but they are made more readily accessible to a non-specialist audience through their transposition into an everyday image.

Another new arrival in New York was John Wesley, who had moved there in 1960 from Los Angeles. Using a straightforward linear technique associated with such non-art sources as cartoons, comics and colouring books, he gravitated towards subjects of almost childlike innocence and fantasy, as in his pictures of animals, such as *Peacocks* (1962) or in the 1963 series of paintings based on a book of photographs of the 1932 Los Angeles Olympics that he had inherited from his father. Even when relying in such cases on existing material, it is a measure of Wesley's independence from mainstream Pop

concerns that he chose obscure and nostalgic images that had a personal significance for him rather than ones that would prompt an immediate flash of recognition in a general audience. Only on rare occasions, as in *Service Plaque for a Small Legion Post* (1962), did Wesley base a painting on a single motif of a familiar type. In spite of his insistent individuality, his particular brand of formalism – entailing a preference for silhouetted images, axial symmetry, repeated motifs, centralized composition and formats reminiscent of board games – can best be understood in the context of Pop.

An even greater formal austerity marks the work of Robert Indiana, who from 1960 concentrated almost exclusively on words and numbers as symbolically expressive but virtually abstract graphic elements. As early as 1961 he referred to himself as 'an American sign painter', two years later defining his work as 'hard-edge Pop'. Indiana decided early in his life that his mission as an artist was to represent American experience, and thus he changed his surname to that of his native state. His move in 1956 to a studio overlooking the East River at Coenties Slip, a New York district rich in historic and literary associations, provided him with the subject-matter he needed. There he also found a plentiful supply of old objects, such as wooden beams and stencils bearing the names of the industries that used to flourish in the area. All this became material for the totemic sculptures of 1960–62 in which he developed his characteristic style. One of the earliest, *Hole* (1960), is constructed entirely from found materials whose identity has been left intact, but it is also equated with a stylized male figure by means of the phallic object appended to its surface; having recognized the metaphor, however, we are returned again to a tautological literalism by which our attention is drawn to a dent in the wood prominently identified by two brightly coloured arrows and by the word 'HOLE' in huge stencilled letters.

114 John Wesley *Peacocks* 1962

The sense of community that Indiana found at Coenties Slip among abstract artists, in particular Ellsworth Kelly, had a profound effect on simplifying his formal means to strong colour contrasts and sharply defined contours. The immaculate and rigorously designed surface of Indiana's paintings of the early 1960s did not serve as a backdrop for found images, as in the work of other Pop artists, but as a clean slate on which to examine in an almost mystical way the beauty and enigmas of written language. The frequent references to America – obliquely in the paraphrasing of road signs,[37] overtly in the stencilled inscriptions – are often imbued with social concern and political criticism, as in *The Calumet* (1961), a celebration of the bonds of peace that united the native American tribes before the arrival of European settlers. Paintings such as *The American Dream I* (1961) derive both their heraldic motifs of circumscribed five-pointed stars and concentric circles and the slogans contained within them – such as 'TAKE ALL' and 'TILT' – from the surfaces of pinball machines. The pleasurable connotations of its images and accents of bright colours notwithstanding, this could hardly be described as a tribute to the American Dream; in this context the borrowed terms take on an ironic tone as reminders of the imbalances of wealth and power that are as rife in American society as in any other.

115 John Wesley *Service Plaque for a Small Legion Post* 1962

A geometric rigour and a tendency to abstraction, applied to motifs charged with social or political meaning, also characterized the work of other American artists associated with Pop. From 1962, for example, Allan D'Arcangelo – a native of Buffalo, New York, who had returned to the United States after studying art in Mexico on the GI Bill from 1957 to 1959 – developed an equally formal hard-edge aesthetic geared to maximum impact. The main features of his paintings were strong, flat areas of colour, decisive outline and a concentration on the image in its simplest and most immediately recognizable form. He thought of pictures such as *American Madonna # 1* (1962) as contemporary icons, emblematic and hierarchical in presentation. Many years later he described them

LOOK MICKEY

116 Allan D'Arcangelo *American Madonna # 1* 1962

118 Robert Indiana *The American Dream I* 1961

117 Allan D'Arcangelo *Marilyn* 1962

as 'without gesture, without brush stroke, without colour modulation, without mysticism and without personal angst.'[38] They were, however, intentionally political, as in the association here of a pin-up image with the national flag and a fragment of *American Gothic* (1930), Grant Wood's quintessential portrait of staid middle American values. Marilyn Monroe, in another painting of 1962, is presented not as a screen goddess or sex symbol but as a paper doll devoid of personality, her features draped across the right-hand panel as if waiting to be cut out and inserted into the slots indicated; a pair of scissors is helpfully provided, recalling the use of such devices by Johns, Rauschenberg and Dine but here adding to the savagery of the image.

Only after experimenting for four years with abstraction did James Rosenquist, soon recognized as one of the central figures of American Pop, produce his first works in the genre. Having spent most of his youth in Minnesota before moving to New York in 1955 to complete his studies at the Art Students League, he had particularly strong credentials as a Pop artist. Not only had he been trained as a painter, he had also gained first-hand experience in 1953 and 1954 as a painter of gasoline signs, gas tanks and refinery equipment in Wisconsin, of grain elevators in North Dakota and of billboards in the Minneapolis area; even after settling in New York, where he met Johns, Rauschenberg and other artists in 1957, he continued painting billboards in Brooklyn and Times Square, and in 1960 he also painted backdrops for window displays at some of the most fashionable department stores (as did Warhol, Johns and Rauschenberg).

The first Pop paintings produced by Rosenquist, such as *President Elect* (1960–61), which is dominated by the towering image of the newly elected John F. Kennedy, show no sign of a struggle to find his own way of painting. In retrospect it seems entirely natural for him to have used commonplace images culled from advertising and poster art and to have represented them on the grossly enlarged scale associated with billboards. He had noticed while painting his own billboards that parts of the image had looked almost abstract when he was in proximity to them, and that grandeur could be achieved with the most mundane motif when it was made to dominate the viewer's field of vision. These observations led him to adopt similar methods in his own work, where he employed a broad technique for creating large images as economically as possible and jarring juxtapositions of apparently unrelated things such as one might experience in walking or driving down a street, in flicking through the pages of a magazine or in quickly switching channels on television. Through such means, which for Rosenquist were a direct product of experience rather than a revelation he had experienced intellectually, he was able to convey with powerful impact the overloading of the senses that had become such an everyday occurrence in an urban and highly industrialized society.

Art that relies for effect on juxtapositions of deliberately unrelated motifs tends to be labelled Surrealist, but a typical Rosenquist painting such as *I Love you with my Ford* (1961) confronts us with the strangeness not of dreams but of ordinary images with which we are already familiar. In the three registers of this painting a quasi-photographic rendering of a 1950 Ford is inexplicably joined by the faces of a swooning couple and a grossly enlarged detail of unctuously synthetic tinned spaghetti. All they immediately seem to have in common is their unreality, since even the human figures are rendered in greys as if borrowed from a vast close-up on a movie screen. We are left to our own devices to connect them in other ways – by imagining, for instance, the back seat of the car as a rendezvous for the passionate lovers – if we feel compelled by force of habit to see these as fragments of a single undisclosed narrative. It is entirely up to us if we wish to do this, but the frustration we may experience in looking for such meaning should remind us

84

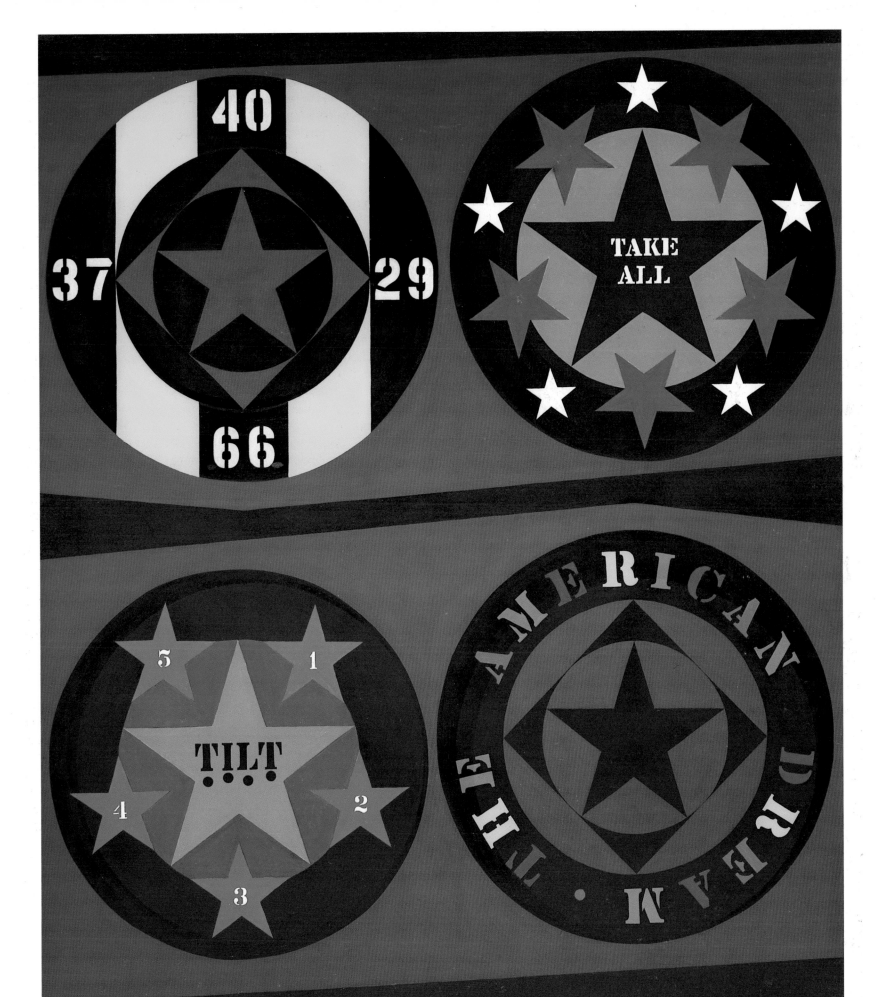

119 James Rosenquist *President Elect* 1960–61

120 James Rosenquist *I Love You with my Ford* 1961

that every section of the image – partitioned not only horizontally but also vertically by a division along the central axis – has only one function that could be described as essential: that of forming a self-contained element of a painting.

In many of his pictures of the early 1960s Rosenquist chose images that were a decade or so out of date, not to elicit a nostalgic response – they were recent enough to look merely out of fashion – but to play on their familiarity and to give them a force as thundering clichés.[39] In a country where the middle classes liked to trade in their car every year or two for a new model, an outdated model could more usefully serve as a sign for an entire way of life than one of a conspicuously new design. Other works such as *Necktie* (1961) and *Four 1949 Guys* (1962) proposed stereotyped images of American manhood in the form of anonymous pieces of standard businessman's dress, which served Rosenquist as a cipher of convention and 'normality' in much the same way as Magritte had used a bowler-hatted man.[40]

The most characteristic of Rosenquist's early paintings, such as *The Lines were Etched Deeply on the Map of her Face* (1962), employ a visual language obviously based on the presentation techniques, synthetic colour, photographic imagery and sudden shifts of scale characteristic of commercial art and particularly of billboard advertisements. In distinction from the methods of other Pop artists, for Rosenquist it was never a question at this time of basing a painting on a single existing source. It was, rather, a matter of applying a system derived from non-fine art sources to the production of paintings that were paradoxically rich in mystery. Images are often fragmented, drained of colour or made to interpenetrate, as in *Marilyn Monroe I* (1962), introducing games of perception while leaving intact their original identity. The open-endedness of interpretation, however, did not preclude the first signs of social and political concern that surfaced in works such as *Painting for the American Negro* (1962–3) and a few years later in his best-known painting, the gigantic *F-111* (1965; see Chapter 9).

For other artists whose work was critical to the development of Pop in America, domestic objects continued to prove useful in relating art to the circumstances of daily life and in draining it of excessive emotion. Having abandoned his previous involvement with live performance, Dine also began now to tone down the violence and anxiety that had characterized the paintings in which he had incorporated found objects, such as *Green Suit* (1959) and *Shoes walking on my Brain* (1960). In 1961 he painted a large, brightly oured and decorative neckerchief, *The Red Bandana*, in the form of an even bigger replica; his contribution to the Johnsian painting-as-object idea was here given a characteristically intimate inflection. Dine now maintains that he never felt part of the Pop movement, rightly drawing attention to the 'homemade look' of much of his work 'next to all these manufactured images', but for a few years from 1962 his concerns coincided sufficiently with those of other artists for him to be presented as part of these developments.[41] In 1962 he produced a series of paintings, including *Child's Blue Wall* and *The Flesh Bathroom with a Yellow Light*, that took domestic interiors as their subject and pictured the canvas surface as a literal part of an actual wall. In *Black Bathroom No. 2* (1962) Dine limited his use of the brush to a few vigorous strokes surrounding a shiny new sink attached to the centre of the canvas, as if he were engaged in an activity no more artistic than the redecoration of his bathroom.

Such a provocative incorporation of real objects into a number of Dine's works on domestic themes attracted much attention, appearing to some commentators as an anti-art gesture in the tradition of Duchamp. For Dine, however, it was a way of making art more 'real' through its direct relationship to day-to-day experience, and through the identifi-

121 James Rosenquist *The Lines were Etched Deeply on the Map of her Face* 1962

122 James Rosenquist *Painting for the American Negro* 1962–3

123 James Rosenquist *Marilyn Monroe I* 1962

cation of an object not by its simulacrum in paint but in the form of the thing itself. Using a real thing, in his view, was also a way of 'gaining someone else's mystery' and of adding a layer of the world's history to the image.[42] Similar reasons motivated him to begin using hammers and other ordinary tools in paintings such as *Five Feet of Colorful Tools* (1962). Such implements had a personal association for him from the hardware shop run by his grandfather in Ohio, but more important was the fact that they were conceived as extensions of the hand for the performance of particular tasks. The making of a painting, as Dine dared to suggest, was in many respects similar to the construction by hand of any other object. His identification of the artist's tools with those of the craft worker, made clear here by the bright paint with which he has coated them and by the silhouettes he has formed by using them as templates, becomes a statement of faith about the artist as a working member of society.

Domestic references and an intimate tone were also characteristics of the work made around this time by another native of Ohio, Tom Wesselmann. Wesselmann first sensed his vocation as an artist when he was drafted into the army in 1952 at the age of twenty-one; dissatisfied with the regimented life, he began drawing satirical cartoons about it and soon found such pleasure in the activity that he decided to become a professional cartoonist. At the end of his service three years later he attended his first formal art classes under the GI Bill at the Art Academy of Cincinnati, continuing his studies in New York from 1956 to 1959 at Cooper Union. In 1959 he began producing small collages of female figures in interior settings, introducing in rudimentary form the methods as well as the subject-matter that were to sustain and define his Pop works of the 1960s. He made

88

124 Jim Dine *Child's Blue Wall* 1962

125 Jim Dine *Five Feet of Colorful Tools* 1962

126 Jim Dine *The Red Bandana* 1961

his first *Little Great American Nudes* in 1960, pairing figures reminiscent of Matisse's paintings with hand-drawn stars and flags, decorative patches of cloth (signifying furniture, cushions and wall coverings), and bits of colour photographs of such national stereotypes as the Statue of Liberty or a portrait of George Washington by Gilbert Stuart.

These early pictures by Wesselmann admit frankly their debts to tradition. At least one collage was derived directly from a device favoured by the fifteenth-century Netherlandish painter Hans Memling, by which an interior is pierced by a distant view glimpsed through a window; two collages of 1960 pay homage to Matisse and Bonnard, the two modern French painters most closely associated with a sensuous representation of the nude female form.[43] Yet even these tentative experiments were evidently of their time, in their incorporation of explicitly American and contemporary imagery from ready-made material, and they were also intensely personal in their eroticism, which according to the artist originated not in sex magazines but in the circumstances of his own life on the dissolution of his first marriage.[44]

The first large picture by Wesselmann, *Great American Nude # 1* (1961), based directly on a collage of the previous year, was followed by other mixed-media and collage paintings of boldly simplified but erotically suggestive reclining nudes in a domestic set-

ting. In this and subsequent works in the series, such as *Great American Nude # 30* (1962), a hand-painted and increasingly flat and schematized figure is set into a specific environment defined by photographs and other printed material glued directly to the surface so as to heighten the physical presence of each element. Wesselmann later maintained that he used such fragments of ready-made material as a purely practical solution, as he felt unable to paint them with the precision he required. The very directness and literalness of the procedure, however, by which things are used as signs for themselves in the precise form and size in which they are found, was soon to make him one of the most rigorous of the major American Pop artists. By the end of 1962 he was updating the still-life tradition by reference to commercial presentation techniques, lifting images of consumer items directly from advertisements so as to use them as the prime elements of mixed-media reliefs such as *Still Life # 24*. In the ostentatious and garish commercialism of their imagery, in their aggressive assault into the third dimension and in the severity of their depersonalized surfaces, they are among the most accomplished products of early Pop and harbingers of the even more mechanical phase to come.

In retrospect the works produced by American Pop artists as late as the end of 1962, when the label first gained general currency in the United States, seem tentative and almost reticent by contrast with the far more aggressive stance soon adopted by many of the painters and sculptors associated with the movement. Yet even at this stage their introduction of machine-made objects and of imagery from advertising, comics and other products of the mass media seemed shocking, and the old-style avant-garde was quick to recognize the challenge that they presented to long-cherished concepts of originality, authenticity and expressiveness. As a sense of group identity took hold, so the artists began to respond to the unspoken challenge of their peers to take their work to ever greater lengths of depersonalization, vulgarity and bad taste. Pop, in other words, was coming of age.

127 Tom Wesselmann *Great American Nude # 6* 1961

128 Tom Wesselmann *Still Life # 24* 1962

THE ARTIST THINKS

The Royal College of Art, 1959–63

During the 1950s in Britain artists such as Hamilton, Paolozzi and Blake had begun to create the terms for British forms of Pop that were either more openly celebratory or more critical of their sources in mass culture than was the case with their American counter-parts. Yet Pop emerged as a coherent movement in the country only with the arrival of a group of younger artists on the occasion of an exhibition of student art, 'The Young Con-temporaries', held in London in February 1961. On the advice of Lawrence Alloway, one of the jurors of the exhibition, a group of painters from the Royal College of Art decided to present a united front at this annual display by re-hanging the entire show shortly before the opening so that all their work could be seen together. They were in the fortunate pos-ition of having one of their number, Peter Phillips, as president of the organizing commit-tee, and another painter who had been on the same course, Allen Jones, as its secretary. Both had begun their postgraduate degree in painting in the autumn of 1959, with other artists whose work they hung in the same room – the American R. B. Kitaj, David Hockney and Derek Boshier – and one year before another painter, Patrick Caulfield, whom they also welcomed into their ranks.

By the time Caulfield left the RCA in 1963 any lingering sense of unity among these painters was more professional than stylistic, particularly as Jones had been expelled in the summer of 1960, Kitaj had left when his GI Bill grant ran out a year later and the others had all gone their separate ways on graduating in 1962. Between 1960 and 1962, however, the characteristics uniting their approach were sufficiently strong for critics to speak of a 'Royal College style'. Among the most notable features were the use within a single picture of contrasting idioms and images plucked from disparate sources, a form of representation at once immediately legible but anti-illusionistic, and an openness to a wide range of sources including, but not limited to, mass-produced objects, diagrams, advertisements, photographs and other material previously considered outside the realm of fine art. Among the appropriated stylistic elements were devices from abstract painting, although admiration for their rigorous design was often tempered by an exam-ination of their potential as agents of communication when used in a more accessible representational context. Current issues – such as flatness, the painting as object and the shaped canvas – were voiced by equating format with image in Kitaj's tackboard-like, collage-based paintings; in the allusions by Hockney and Boshier to consumer pro-ducts such as packets of tea or matchboxes; in Phillips's derivations from pinball machines and funfairs; in Jones's shaped canvases representing the sides of moving buses; and in Caulfield's decision to adopt the flat graphic style of the sign-painter.

The major outside influences on these painters included the recent work of American artists such as Johns, Rauschenberg and Rivers, which they knew almost exclusively

130 R. B. Kitaj *Erasmus Variations* 1958

131 R. B. Kitaj *Specimen Musings of a Democrat* 1961

from a few reproductions, and that of the English painter Blake, who soon got to know some of the younger students as friends.[1] In spite of their contact with Alloway, they were all too young to have known about the Independent Group's activities in the mid-1950s, and only Jones was even in London at the time that the exhibitions organized by them took place.[2] In his introduction to the 'Young Contemporaries' catalogue, moreover, Alloway conspicuously avoided using the term Pop in relation to their work, noting instead that, 'For these artists the creative act is nourished on the urban environment they have always lived in.'[3]

Among the students themselves Kitaj, who enjoyed considerable independence at the College as an American under the GI Bill, arrived with a clear programme for his own art; not only was he five years older than the others, he had also studied in New York and Vienna and had experience of a wide range of modern European and contemporary American art. He had strong intellectual and literary inclinations and saw himself as a latter-day Surrealist (with a particular liking for Max Ernst's illustrated books collaged from Victorian engravings), but he also took an informed interest in Abstract Expressionism and in the work of American artists only slightly older than himself, notably Rauschenberg. Although he was never comfortable with the Pop label, since he based his works on arcane sources from literature, iconographic studies and political history rather than on the ephemera of popular culture, in the absence of any real sympathy from the staff he became something of a mentor for his fellow students. As early as 1958, in works painted while studying at the Ruskin School of Drawing and Fine Art in Oxford, Kitaj devised his practice of basing motifs on found images painted in borrowed styles in such a way that their meaning was an accumulation of their previous history.

One of Kitaj's first such works, *Erasmus Variations* (1958), was transcribed from a reproduction in a book illustrating fragments of doodles made by the philosopher Desiderius Erasmus.[4] By reformulating these scribbles in a technique reminiscent of de Kooning, Kitaj made a connection between the Surrealist concept of automatism as a method of unleashing the unconscious and the Abstract Expressionist use of painterly gesture as a sign of the artist's personality. He continued to quote from printed images as a means of investigating their multi-layered meaning in the paintings made during his two years at the RCA. In several works of 1960–62, including *The Bells of Hell* (1960), *The Red Banquet* (1960) and *Reflections on Violence* (1962), he devised figures in the manner of American Indian pictographs as reproduced in an 1893 Smithsonian Institution study in which they were defined as a form of picture-writing capable of 'expressing thoughts or noting facts.'[5] The structure itself of certain paintings was presented as intrinsic to their meaning, as in *Specimen Musings of a Democrat* (1961), in which conventional compositional methods and illusionistic space were ignored in favour of a flat diagrammatic layout reminiscent of paintings by Rauschenberg but derived in this instance from an alphabet table devised by the thirteenth-century Catalan philosopher Ramón Lull.[6]

However different his intentions were from those of Johns in his target and flag paintings or of Rivers in *Washington crossing the Delaware* (1953), Kitaj's individual use of found imagery and quotations of style and technique proved immediately appealing to others because it provided an open-ended system that could be applied as logically to any other existing material. His conviction, moreover, that an artist should declare himself in his choice of subject-matter was a welcome invitation to abandon purely formal issues or the tired art school categories of still life, landscape and figure painting in favour of a language of signs directly rooted in the circumstances of the artist's life.

The images of consumer products that appear in a few of David Hockney's student pictures as evidence of the terms of his daily life, such as the frontal images of tea packets in *The First Tea Painting* (1960) and *The Second Tea Painting* (1961), led him to be identified as a Pop artist, but like Kitaj he was quick to deny the appropriateness of the label. He took Kitaj's advice about finding a personal subject- matter in a series of paintings that proclaimed his vegetarianism, his interest in the poetry of Walt Whitman and Constantine Cavafy, and above all his sense of identity as a young homosexual. Although he made it plain in his work that his prime interest was already in the human figure, he did engage in a presentation of the painting as object in a specifically Pop way in a series based on playing cards in 1960–61 and in his equation of the contours of a shaped canvas of 1961, *Tea Painting in an Illusionistic Style*, with a tea packet shown in isometric projection.[7] Familiar consumer products were incorporated, moreover, in 'homosexual propaganda' paintings such as *The Most Beautiful Boy in the World* (1961), in which a young man is shown wearing a flimsy négligée, as a humorous way of stressing the ordinary, everyday quality of situations that might otherwise have appeared strange and threatening. In another painting of this series, *The Cha-Cha that was Danced in the Early Hours of 24th March 1961*, an advertising slogan accompanies the image of a young man clutching a woman's handbag and dancing with wild abandon for the artist's pleasure; its incomplete message, 'penetrates deep down/gives instant relief from', provides a crude but amusing *double-entendre* about the artist's sexual designs on his handsome subject.

Although Hockney, like his fellow students, was affected by the recent work of American artists such as Johns and Rivers,[8] his concern with style as an element that could be called forth at will was derived more from Kitaj and from two Continental artists, Picasso and Jean Dubuffet. The Picasso retrospective held at the Tate Gallery in 1960, and in particular the later works shown, revealed to him the possibility of using apparently conflicting idioms and of making reference to a variety of sources within a single picture so long as they were held together by a consistent attitude towards style.[9] From Dubuffet, whose work was also exhibited in London in 1960, he took the idea of representing the human figure in the apparently fixed languages of child art or graffiti.[10] In works such as *We Two Boys Together Clinging* (1961) Hockney was able to use such methods to confront subjects that might otherwise have been too shocking in their intimacy, making private impulses public through an apparently anonymous visual language and presenting written messages of urgent sexuality – drawn in this case from both low-life and high art sources, from the scribbled notes on the walls of public toilets and from the poetry of Whitman – as if he were merely recording graffiti glanced in passing.

Such a detached attitude towards style, whatever its derivation, was itself indicative of the extent to which Hockney's early work was conditioned by ideas central to Pop. When the various threads of his student work come together, as they do for example in *I'm in the Mood for Love* (1961), the result is pure Pop. The derivation of the title itself, from the popular song written by Jimmy McHugh and Dorothy Fields, establishes the tone of the picture, one of several painted by Hockney in the autumn of 1961 to memorialize his first visit to New York that summer. America is presented as a place of optimism and sexual satisfaction; the words inscribed on the rather devilish figure, 'QUEENS UPTOWN', refer both to a direction on one of the New York subway lines and to the prospect of meeting other openly homosexual men in Manhattan, while the skyscrapers are both emblems of the city's aggressive self-confidence and phallic symbols promising the orgasmic frenzy alluded to in the title. The figure and architecture are conceived in a simple childlike

132 David Hockney *Tea Painting in an Illusionistic Style* 1961

THE ARTIST THINKS

133 David Hockney *The Most Beautiful Boy in the World* 1961

134 David Hockney *I'm in the Mood for Love* 1961

idiom and the entire image is contained within the format of a travel calendar as a witty means of avowing its quality as a diary recording a fragment of his own life.

A personal commitment to subject-matter is a distinguishing feature of the art produced in the early 1960s by the RCA painters, all of whom were then barely in their twenties, in contrast to the more ambivalent or critical stance adopted towards contemporary material by older artists such as Hamilton in England or Warhol and Lichtenstein in America. Such is the case even with the work of Peter Phillips, who from his second year at the RCA revealed himself as the most severe practitioner of the Pop aesthetic in Britain, since the images and formal methods he adopted were derived straight from the formative experiences of his teenage years, entailing not only his technical training and artistic influences but also the youthful working-class enthusiasms to which he referred so openly in his pictures.

The training Phillips received from the age of thirteen at a school of applied arts, the Moseley Road Secondary School of Art in Birmingham, predisposed him to the craft-like techniques and formal geometries with which he was to make his name as a Pop artist; rather than starting with a romantic conception of art or painterly procedures, he learned such practical disciplines as painting and decorating, sign-writing, heraldry, silver-smithing, graphic design, architectural illustrations and technical drawing. After moving to the Birmingham College of Arts and Crafts in 1955 he decided to become a painter and worked briefly in a social realist idiom, drawing the local factories and workers on strike, as a way of responding to life in the industrial district in which he had grown up. On graduating in 1959 he received a scholarship that enabled him to spend the summer in Paris and Florence, Venice and other Italian cities studying Italian Trecento and Quattrocento painting, in which his interest had been whetted by his visits to the Pre-Raphaelite collection at the Birmingham City Art Gallery. In the flat, hieratic and formalized paintings of artists such as Giotto and Cimabue he found an unexpectedly sympathetic artistic frame of reference for the exacting procedures in which he was already so well versed.

In the summer of 1960 Phillips painted a large canvas, *Purple Flag*, in which he synthesized his practical skills and his intuitive response to Italian pre-Renaissance painting with an open expression of his enjoyment of funfairs and the game of pinball. All that survived from his first-year experiments with Abstract Expressionism at the RCA was a conviction about working on a large scale that would encompass the viewer's space and field of vision and assure a powerful presence for the painted image.[11] Having realized that a gestural handling of paint did not suit him, he decided to return to the more 'controlled' methods with which he was already familiar. The overriding influence on *Purple Flag* is clearly that of Johns, but Phillips has translated Johns's flat heraldic motifs in terms of his own experience, displaying a row of targets as if they were part of a game in a funfair booth and literally recording the change of context by filling the top half of the picture with an image of the Union Jack drained of its normal colours.[12] The smaller motifs incorporated in the lower half of the painting, including a grid of coloured squares with an arbitrary sequence of numbers and the image of an American football player painted from a photograph, establish an alternative time scale. As in early Italian altarpieces, in which predella panels establish a narrative complement to the starkly formal central image, implications of movement are here introduced in a static and strictly controlled format. This device soon became a standard feature of Phillips's work, for example in the invented comic-strip sequence as a row of images along the lower edge of *Wall Machine* (1961) or in the striptease freeze-shots of *For Men Only – Starring MM and BB* (1961), in which each image is framed by a panel of polished wood.

96

135 Peter Phillips *Purple Flag* 1960

Purple Flag and other works of 1960–61 incorporated contrasting techniques within a single painting, containing each change of pace within a demarcated subdivision. *One Five Times/Sharp Shooter* (1960) also carries further the amusement arcade imagery and the intuitive juxtapositions of images from unrelated sources, here a row of targets with actual holes punched in them, a grid of selected numbers, a diagrammatic representation of a sleeve pistol, and what appears to be a hare, half-obscured by a cancellation mark, muttering the curious phrase 'JUST THE THING FOR TAXIDERMISTS AND BATMEN'. By the end of 1960 Phillips had begun to seek additional information to use in his paintings and to devise as many ways as possible of formulating an image without recourse to conventional artistic forms of representation. Several works, such as *War/Game* (1961), feature images from comic strips. In other paintings, such as *For Men Only – Starring MM and BB*, he used images derived from photographs, either transcribed faithfully by hand (as in the row of stripper images) or simply collaged to the surface, as in the portraits of Marilyn Monroe and Brigitte Bardot from the colour pages of mass-circulation magazines. Diagrammatic representations of machines feature in works such as *Motorpsycho/Tiger* (1961–2), which includes a sectional drawing of a motorcycle engine. In a few small works the images are taken from commercially available stencils (as in *Racer*, 1962) or from a repeated printed image inserted intact as a collage element – for example in *Philip Morris* (1962), a painting very similar in format to works by Blake such as *Got a Girl* (1960–61). Yet another solution used in some works involved the use of printed transfers, as in *Motorpsycho/Club Tiger* (1962), in which such an image of a tiger in profile is applied over an enlarged copy of it painted by hand.

These and other strategies by Phillips, by which images appropriated from already existing sources are presented with a machine-like depersonalization, were based on a match between source and technique that was unsurpassed in its logic in British Pop of the early 1960s. Apart from Blake, the only painters working as rigorously at the time on similar lines were Americans such as Warhol and Lichtenstein, whose work was not to be seen even in New York until 1961. The very format of Phillips's paintings of the early 1960s, derived in many instances from the designs of board games, pinball machines and games of skill, was a vital component of works presented as if they were machine-made objects. Such references, moreover, were intrinsic rather than incidental to their meaning as open invitations to the spectator's involvement.[13] Each picture itself, rather than just the individual elements it contains, is to be regarded as an *Entertainment Machine*, to borrow the title of one of Phillips's most accomplished paintings of 1961. One such work in this genre, *Burlesque Baby Throw* (1961), includes four metal rings pinned to the surface as if in readiness for the next contestant. A painting of the following year, *Distributor* (1962), makes actual the possibility of our physical participation in the final form of the work by having a row of panels that can be moved by hand from side to side to reveal other images underneath. These permutations are alluded to by the punning title, which refers also to the motor part – a device in petrol engines for relaying high-tension voltage to the sparking plugs in the sequence of the firing order – depicted in grey in the centre of the picture. The stakes here are high: winning bears the promise of a seductress reclining in anticipation, while losing is signified by a stand-offish seated figure. The international road sign placed along the picture's central axis, a triangle containing an exclamation point, provides a vivid warning of the 'other dangers' that lie in wait for all those involved in games of sexual fantasy and seduction.

The pin-up transfers used in the upper register of *Distributor* as ready-made motifs led Phillips to seek other girlie images in a similar style, which he transcribed in enlarged

form in paintings made in 1963, such as *Four Stars* and *Gravy for the Navy*. Both the title and image of the latter were taken from a drawing by the illustrator Vargas published in *Esquire* magazine. Phillips had a particular preference for such images not because they dated from the 1940s but because they corresponded in feeling to other images he had been using, which seemed to him neither real nor unreal. With its axial symmetry, repeated and compartmentalized images, insistent frontality, glittering surfaces and eccentric format, the pattern of framed images of seductive women in *Four Stars* has much in common with the presentation of haloed attendant angels to a fourteenth-century Madonna. Using gloss paint in bright primary and secondary colours to decorate the surface of a picture whose shape stresses its identity as a constructed object, Phillips has produced a design as formally resolved as that of the pre-Renaissance altarpieces he admired and yet as vibrant and modern as that of pinball machines.

Phillips painted his Pop pictures at home rather than in the studio provided for him in the College, since he had been berated by staff and threatened with expulsion during his first year for painting huge abstractions. Such was the outcry from his tutors when the new work was first seen that he was forced to transfer in his third year to the Television School, although he continued to spend most of his time painting. All the artists in this group were seen as troublemakers because of their excessive independence; even Hockney, who was recognized as a star pupil, was threatened with expulsion in April 1962 because he had deliberately refused to comply with the work demanded by the General Studies course, but to save embarrassment the authorities eventually relented, awarding him a pass for that subject and the Gold Medal for painting for his year. Allen Jones was not so fortunate: at the end of his first year, in the summer of 1960, he was expelled from the RCA as an example to others and forced to return to Hornsey College of Art, north London, where he had studied from 1955 to 1959, to do a two-year teacher training course.

However traumatic these events were for the students, the hostility they encountered from their tutors also convinced them about their work as a joint enterprise. Such was the case even for Jones, who remained on friendly terms with his former colleagues, especially with Phillips. In the autumn of 1960, during his first term back at Hornsea, he painted what must count as one of the earliest examples of Pop to have emerged from his group at the RCA, *The Artist Thinks*. The picture refers to popular sources both in the use of a cartoon 'thinks' balloon that fills almost the entire surface above the stylized self-portrait head, identifying the apparently abstract marks as the products of the artist's subconscious, and in the derivation of the green hill-like forms from the buttocks of a pin-up photograph as a private sign of his erotic obsessions. The vivid complementary colour contrast of red and green that gives the picture its optical vibrancy relates, like the post-Cubist treatment of the head, to his interest in the work of the French Orphist painter Robert Delaunay, just as a subsequent work, *The Battle of Hastings* (1961–2), echoes the composition of the *Improvisations* painted shortly before the First World War by another pioneer of abstraction, Vasily Kandinsky.

Jones remained firmly involved in his subsequent work with issues of abstraction and colour theory but he began to address himself to recognizable imagery based on sources already processed into two dimensions. One of the first such works, *The Battle of Hastings*, used a diagram he had made as a teaching aid to explain the position of Harold and the opposing forces during the 1066 battle. His use of a diagram he had drawn himself, rather than one he had found ready-made, distinguishes the process here from the more depersonalized system devised by friends such as Phillips. Never-

136 Peter Phillips *For Men Only – Starring MM and BB* 1961

137 Peter Phillips *Distributor* 1962

THE ARTIST THINKS

138 **Allen Jones** *The Battle of Hastings* 1961–2

140 **Allen Jones** *The Artist Thinks* 1960

139 **Allen Jones** *Second Bus* 1962

theless Jones's map-like source fulfilled a similar function, distancing him from his subject-matter, allowing a great range of information within a single picture, and creating a unified formal structure that eliminated the apparent arbitrariness of compositional decisions. The sequence of motifs spread across the bare canvas also provided an opportunity for referring to contradictory pictorial languages, including Kandinsky and Klee, hard-edge abstraction (the heraldic shields) and colour stain painting (the stripes in the upper right), and Dubuffet in the cartoon-like figures represented as floating through the space.

In 1962 Jones produced a series of shaped canvases representing the sides of red London buses in movement. Like *The Battle of Hastings*, they were prompted by a classroom exercise he had set his students, in this case a specifically Pop notion of relating the object quality of the painting to a particular subject. In paintings such as *Second Bus* Jones took up the idea of the shaped canvas as a container that could define the subject through its outline, so that flat images could be scattered across the surface without the necessity of engaging in conventional forms of description. Two small canvases with target-like motifs of concentric circles could thus signify the bus's wheels as seen in profile, with the rhomboid shape of the main canvas leaning leftwards to imply the movement of the vehicle without contradicting the formal quality of the painting as a static object with a decorated surface. The male commuters pictured on the upper deck of the bus are shown as stereotyped torsos, each one a headless suit-and-tie, and the interior of the bus is glimpsed as if in a cut-away view. The mixture of contradictory idioms and pictorial conventions within the context of a formalized object, marking these works as some of the most achieved examples of the 'Royal College style', is given a characteristic Jones twist in the updating of Futurist ideas about the representation of movement in terms of the still images of painting. In their allusions to urban life, and specifically to the commuting that was then part of his daily existence as a teacher, these bus paintings again reveal the extent to which Pop subject-matter was perceived by these artists as intrinsic to the circumstances of their lives.

As early as 1961 another painter who was part of the 1959 intake at the RCA, Derek Boshier, made a particular point of incorporating references to images from his immediate environment, which he saw as encompassing all the information he could glean from the mass media, as well as ordinary objects he might encounter in a routine day. He had first dedicated himself to explicitly contemporary subject-matter while still a student at Yeovil College of Art in Somerset, taking as his model the work of the Kitchen Sink School, about which he also wrote his student thesis. During his first year at the RCA he became interested in much more formalized images based on given objects. Stimulated by discussions with other students about flags and the work of Johns, but without apparently having seen reproductions of Johns's own paintings of the American flag, in 1959 he painted a small picture, *Flagmap*, as a variation of the Union Jack turned on its side. Soon afterwards he produced several paintings based on Ludo-boards and chess-boards, such as *Airways*, *Yellow Cross* and *Blue Cross*, which he showed at the 'Young Contemporaries' in 1961.[14] These were followed by his most blatant equation of a painting with an ordinary printed object, *Airmail Letter* (1961), copied by hand down to the detail of the stamped postmarks as areas of smudged paint. The formal device of alternating bands of colour, similar to those employed by Blake in his paintings of 1959–61, is here given an extremely literal reading as a motif found on an envelope. The degree of abstraction in which Boshier was able to engage, combined with the choice of a square format and of a gross enlargement of a simple found image, suggest an awareness of the paintings

141 Derek Boshier *Airmail Letter* 1961

143 Derek Boshier *England's Glory* 1961

142 Derek Boshier *The Identi-Kit Man* 1962

made in New York during 1960–61 by another RCA graduate, Richard Smith.[15] Smith's references to popular sources were still oblique, but the connection made by Boshier between abstract form and the image of a real object was explicit and in that sense much more an overt Pop statement.

Still basing his paintings on familiar ready-made motifs, Boshier in 1961 began deliberately to disrupt their formal autonomy in order to explore narrative and symbolic possibilities through his choice of images and subject-matter. He became particularly involved with political issues and with the loss of individualism in consumer society, a question discussed at length in a number of books Boshier was then reading by authors such as McLuhan, Vance Packard and J. K. Galbraith.[16] Boshier explained in the television programme *Pop Goes the Easel!*, filmed by Ken Russell in February 1962, that he used American images 'not because I'm in love with them but because of their symbolic meaning – the way that Americanism has crept into the social life of the country'.[17] The subject-matter of his paintings began to include political events such as the Bay of Pigs crisis in Cuba of 17–19 April 1961, which he commemorated almost immediately in a small painting, *Situation in Cuba*; ethical questions such as that of the death penalty, another topical issue to which he referred in a painting of 1961, *Caryl Chessman*;[18] the explorations of space conducted in a competitive spirit by the Americans and Russians, which he recorded in light-hearted paintings such as *The Most Handsome Hero of the Cosmos and Mr Shepherd* and *I wonder what my Heroes think of the Space-Race*, both executed in 1961 when reports of the flights by Yuri Gagarin (12 April) and Alan Shepard (5 May) were still fresh in the news; and what he regarded as the insidious infiltration of American culture and commercial interests into Europe to exert political dominance over other countries, which he took as the subject of paintings such as *Pepsi-Culture* (1961).

In several of these paintings Boshier used flag imagery for purposes that were as much symbolic as formal. In *Situation in Cuba*, for instance, the Cuban flag is invaded by the stars-and-stripes, while in *England's Glory* the matchbox from which the picture takes its title is shown as if being slowly eaten by the same symbol of American national identity, with the Union Jack clouded over elsewhere in the picture. In *Caryl Chessman*, a small painting conceived as a rephrasing of the American flag onto which he has imposed a profile portrait of the executed prisoner in the top register, Boshier created a specifically American image of martyrdom and brutality. For the space paintings he relied on maps as found images that dominate the events presented within the spectator's field of vision. Against a grid-like view of constellations in *The Most Handsome Hero of the Cosmos and Mr Shepherd* he has drawn trajectory diagrams of curved arrows representing the movement of the figures; these lines of force are complemented by long quotations in the manner of comic strips conveying the astronaut's comments on taking off, which he copied straight from newspaper accounts. In *I wonder what my Heroes think of the Space-Race* disparate styles, events and personages – Lord Nelson, Abraham Lincoln and the recently deceased American rock'n'roll singer Buddy Holly, all people admired by the artist – are brought into play in a re-enactment of American and Russian attempts at world domination in outer space; the departure of a rocket is represented lower right in a sequence of four images apparently based on photographs, while an astronaut is depicted in the form of a line drawing and Nelson as a close-up view of his image on Nelson's Column, in imitation of the kind of photographic collage that would be found on a tourist postcard.

The best-known Pop works by Boshier, a series of *Toothpaste Paintings* executed in the first half of 1962 as he finished at the RCA, took as their premise the covert methods

144 Derek Boshier *The Most Handsome Hero of the Cosmos and Mr Shepherd* 1961

used in modern advertising to influence the unwary consumer. Packard had written of advertising men as 'symbol manipulators', and McLuhan had observed that archetypal commercial images function as 'cluster symbols' which, when analysed, yield multiple layers of meaning.[19] Having previously referred to Kellogg's cereal packets in paintings such as *Special K* (1961) and to the Pepsi Cola logo in pictures such as *Pepsi-Culture* and *Sunset on Stability* (1962), Boshier now used a new brand of toothpaste, Signal, that had just been introduced with the gimmick of red-and-white striping as a means of capturing new customers. *The First Toothpaste Painting* is also the most general in terms of meaning, showing a man swallowed up by the products of contemporary technology that have grown to monstrous proportions now out of his control. Visual puns are used even more explicitly in a later work in the same series, *So Ad Men became Depth Men*, the imagery and title of which were borrowed from chapter three of Packard's *The Hidden Persuaders* (1957). The use of 'conditioned reflex' and 'triggers of action' by market researchers investigating the subconscious factors that motivate people to purchase particular products are given a humorously literal form by Boshier, who illustrates the construction of the ideal mass-man's torso from 'triggers' presented in the form of pistols.[20] The main figure in *Identi-Kit Man* (1962) has been so taken in by the company's

sales ploy that he has turned into toothpaste himself, his spinelessness giving him no protection against the further abrasive action that is already beginning to rub him out of existence; his lack of an individual identity is further emphasized by the separation of his head from his torso, by the implication that he is just a piece of a jigsaw puzzle, and by the small tumbling figures that accompany him like a row of cut-out paper dolls.

Other ubiquitous advertising images of the period were handled by Boshier in paintings such as *Drinka Pinta Milka* (1962), but his work took many turns after he left the RCA and subsequently bore only a tangential and intermittent relationship to Pop.[21] One other artist from the RCA who shared Boshier's narrative, political and sociological approach to contemporary images from the mass media, Pauline Boty, produced only a small number of paintings before her tragically early death from leukaemia in 1966. A close friend of Blake and a student in the stained glass department at the RCA from 1958 to 1961, Boty can be said to have become a Pop painter only in 1963, when she painted a series of pictures based on photographic images of public figures including Marilyn Monroe (*The Only Blonde in the World*) and other movie stars (*Monica Vitti Heart* and *With Love to Jean-Paul Belmondo*) as well as politicians such as John F. Kennedy and Fidel Castro (*Cuba Sí*). In *Scandal 63* she represented Christine Keeler (as shown in a photograph taken by Lewis Morley) and other protagonists of the Profumo Affair, the sex-and-spy scandal which had brought down the British Conservative government that year. Other works alluded to funfair imagery, as in *54321*, and to romantic subjects seen from a specifically female point of view. In *My Colouring Book*, for instance, she illustrated the lyrics of a pop song then in the charts as a series of separate images detailing a sense of loss and loneliness; accompanying the lines 'THESE are the arms that Held Him and Touched Him & lost HIM Somehow COLOUR Them empty noW' is a picture of a blonde girl with her arms around the neck of a man pictured simply as a white silhouette.[22] Boty was the only woman painter associated with British Pop, and for this reason her approach to popular subjects and motifs remains of interest even though her fatal illness prevented the possibility of any real development at the most critical point in her career.[23]

Patrick Caulfield had met Boshier and Jones before beginning his course at the RCA in 1960 but because of his retiring personality and resistance to the idea of being part of a group or movement he never felt that Pop was a suitable term to describe his own work. On the whole he avoided using blatantly contemporary images from popular culture, preferring to explore standard subjects such as landscapes, interiors and still lifes that are so traditional as to seem not only corny and old-fashioned but also timeless. He looked for inspiration mainly to the great European modernist painters of the early twentieth century, such as Léger and Gris, and in 1963 he even painted *Portrait of Juan Gris*, basing the head on a black-and-white photograph of the artist and the body on that of a friend who posed for him wearing a suit.[24]

The preference shown by Caulfield for an impersonal manner of painting, identified specifically in his case with the flat graphic style of the sign-painter, was supported by an unlikely variety of sources including the blandly painted pictures of Magritte, postcard reproductions of ancient Minoan frescoes and the hard linear technique of Léger's American protégé Stuart Davis.[25] Davis's treatment of architectural subjects and still lifes based on modern commercial packaging is perhaps the most overtly popular and contemporary of Caulfield's artistic sources. While he greatly admired Johns's manipulation of the flag and target as 'finite' images, he felt that for himself it would be impossible to follow the 'absoluteness' of Johns's initial choices by working with a similar range of motifs; in their place he favoured images of objects that were generalized in terms of their use

145 Derek Boshier *Swan* **1962**

146 Pauline Boty *Scandal 63* 1963

148 Patrick Caulfield *Leaving Arabia* 1961

147 Patrick Caulfield *Engagement Ring* 1963

and not confined to any specific period of time, such as flowers, jugs, vases, bottles and glasses, all of which had a long history in painting but also a more recent lease of life accorded them by Cubism.

In presenting his images as clichés that correspond to the most commonly held conceptions about art, Caulfield was of course subscribing, in his own way, to a Pop attitude in retrieving beauty and value from subjects and images that seemed hopelessly mundane. In the first works in which one can recognize Caulfield's characteristic style, moreover, such as *Leaving Arabia* and *Upright Pines* of 1961, his presentation of ordinary images as familiar objects from his immediate environment was very close to the systems then being employed by Phillips and Boshier. They remain among the clearest expressions of a Pop aesthetic in all his work. *Upright Pines*, for instance, was based on a weighing machine by the bus-stop near his home in Shepherd's Bush, London; the pattern repeated across its surface was taken from a soap packet. One version of *Leaving Arabia*, reminiscent of board-game designs in its heraldic and brightly coloured pattern, was among several pictures to contain cut-out images of great formal simplicity in order to draw attention to the painted surface as a decorative coating of a physical object; in this case the repeated representations of a snow-capped mountain in ever-diminishing size humorously allude to the spatial recession implied in the title, while fixing the images bluntly and irrevocably to the painted background.

Until 1965 Caulfield painted exclusively on hardboard with glossy oil-based household enamel paints, as a way not only of emphasizing the object quality of his pictures but also of bringing them into a familiar sphere of daily life by ridding them of high art pretensions. The apparent impersonality of technique and image in works such as *Engagement Ring* (1963), in which Caulfield ruthlessly dispensed with the expected signs of the artist's intervention – such as brushwork, composition, invention, tonal values and in this case even colour – gives the pictures an air of finality and objectivity as crafted artefacts. The assertiveness both of the presentation methods and of the linear language used here evidently resemble sign-painting as an early manifestation of advertising: the diamonds are proffered to us by the thrusting projection of the ring and by the insistent repetition of a stylized diamond at each junction of the vertical/horizontal grid. By such means a familiar object is treated in a formalized manner as if it were a symbol, its importance insisted on by its isolation in the centre of the design, but no specific symbolic content is advanced. As in Léger's concept of the 'object type', we are drawn to contemplate the powerful presence of an otherwise ordinary thing because of its unexpected beauty and also because we identify with its purpose in our lives.[26]

Caulfield's reluctance to employ aggressively contemporary images that would suggest a kind of life alien to his own circumstances, and his particular antipathy to American motifs, soon led him to investigate subjects that seemed impossibly romantic or escapist, as in *Still Life with Dagger* (1963), one of several works of 1963–4 to include Islamic and Turkish artefacts.[27] Exotic subject-matter gave him an opportunity to express his ambivalence towards the European traditions of painting that he saw as discredited but of which he nevertheless felt his work was a part. Faced with the task of producing a transcription of a famous work of art as part of his final-year coursework at the RCA, he painted *Greece expiring on the Ruins of Missolonghi, after Delacroix* as the most unfashionably passionate source he could imagine. Basing his picture on a black-and-white reproduction, he invented the colour and conceived this archetypal image of Romanticism in the hard linear terms of political propaganda posters, contradicting the essence of Delacroix's painterly style in order to exaggerate the emblematic quality of its imagery.

149 Patrick Caulfield *Christ at Emmaus* 1963

150 Patrick Caulfield *Greece Expiring on the Ruins of Missolonghi, after Delacroix* 1963

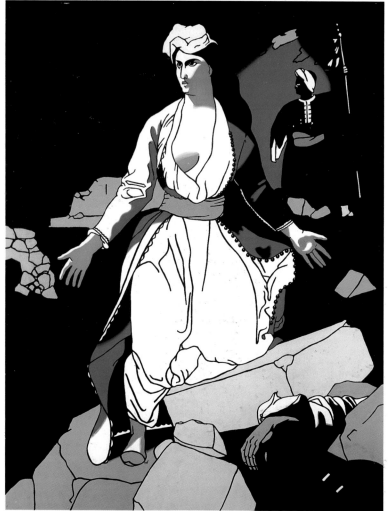

However consciously Caulfield reacted against what he interpreted as Pop imagery in the work of other artists, he seems if anything to have been more predisposed than his colleagues to making the most from the least promising material. One of his most successful early forays into exoticism, for instance, *Christ at Emmaus*, was painted in compliance with a final-year project at Easter. Faced with two set subjects that he found equally uninteresting – 'Christ at Emmaus' or 'Figures in a High Wind' – he decided that he might as well combine the two into an image that he describes as 'Christ at Emmaus slightly in the wind'. For the equestrian figure he used a painting by Delacroix and for the decorative border a suitably debased and dessicated source of Middle Eastern imagery, the design of a packet of dried dates. As in much of Caulfield's work, the same strain of fantasy by which he seeks to escape into the past leads him back to the mundane reality of the present moment and his immediate circumstances. Lured by European fine art traditions but recognizing the impossibility of engaging sincerely with methods that seem no longer appropriate, he examines his own romantic impulses with a self-effacing irony that brings the grandest gestures down to the most banal level, lending his pictures a comic poignancy that makes them, paradoxically, among the most personal, intimate and affecting works in all Pop.

Each of the painters who studied at the RCA in the early 1960s demonstrated a remarkable facility for pursuing a personal range of imagery, subject-matter and techniques with which to establish a separate and immediately recognizable identity. The conviction with which they explored similar ideas, methods and sources, however, did much to es-

tablish Pop in Britain as an influential movement and in so doing helped also to create a context for the work of older artists, including former members of the Independent Group, such as Hamilton·and Paolozzi, and former RCA students, notably Blake, Smith and Tilson. Blake's new friendship with Phillips, Boshier and Hockney, for instance, co-incided with some of the clearest statements of his own Pop aesthetic, such as *Captain Webb Matchbox* (c. 1960–61), a painted free-standing object conceived as an enlarged transcription of a familiar artefact, and *Toy Shop* (1962), an assemblage of toys and other ready-made objects encased in a brilliantly coloured shopfront made from actual doors and windows bought from a demolition site.[28]

151 Peter Blake *Captain Webb Matchbox c.* 1960–61

In the summer of 1961 Richard Smith returned to London after a two-year stay in New York where he had produced paintings in which he applied the language of formal abstraction to familiar artefacts, company logos and the colour printing of mass-circulation magazines. He, too, seems to have been heartened by the work of the younger artists and by the interest they showed in his art, for in 1962 he began to make much more direct reference in his pictures to popular sources, to the presentation techniques used in advertising and to the packaging of consumer products. One small and uncharacteristically representational picture of this period, *Slot Machine*, is a rough-hewn and colourful construction presented as a non-functioning one-armed bandit, with its four cylinders lined up to display identical images of hearts as if someone had just won the jackpot. In several works, such as *Nassau* (1962), he alluded to theatrical spotlights largely as formal devices that allowed him to suggest spatial recession in the context of a flat surface design and to present the image both as something specific and as a large abstract colour wheel. Motifs are often shown in extreme close-up, a technique derived both from the cinema and from billboard advertising, by which ordinary products are presented as monumental and lusciously desirable.

The overriding concern demonstrated in Smith's works of 1962–3 was, in fact, with the packaging of commodities and with the role of their surface design in selling the product hidden inside. The titles of works painted in 1962, such as *Package*, *Product* and *Flip Top*, provide a clue to the reading of the image, but it was in 1963, in paintings such as *Staggerly*, that the previously oblique references to cigarette packs were brought into the open both as an image and as the primary component of the painting's structure; in this case the repeated motif, shown as if zooming towards us by means of a simple presentation technique of increasing scale, seems to have given rise to the eccentric shape of the canvas support itself. The thrusting and aggressive methods employed by advertisers for consumer seduction led Smith in the same year from such shaped canvases to three-dimensional wall-hanging constructions again based on cigarette packs, such as

152 Peter Blake *Toy Shop* 1962

Surfacing, *Alpine* and *Piano*. The largest and most blatantly representational of these works, *Gift Wrap*, in which the two monumentalized cigarette packs are so massively sculptural in form as to cast deep shadows on the painted background, represents Smith's most extreme engagement with Pop: consumer imagery is here directly allied to methods derived from advertising. The delicate balancing act between his attraction to colour and form as self-sufficient elements and his interest in relating them to recognizable aspects of mass culture was again resolved in favour of a greater degree of abstraction on Smith's return to the United States for another stay from 1963 to 1965. Although references to popular culture and common objects continued to appear in his work, after 1963 they were largely submerged in more purely formal concerns.

Another artist who changed the direction of his work around 1960–61 was Joe Tilson, who had arrived at the RCA a year before Blake and two years before Smith. He, too, was

153 Richard Smith *Gift Wrap* 1963

154 Richard Smith *Slot Machine c.* 1961–2

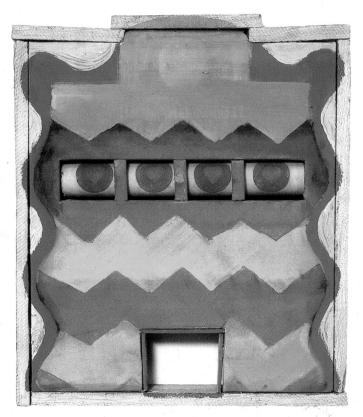

almost certainly encouraged by the sense of group identity of the younger artists whom he was then getting to know. With his friends Smith and Denny he had undergone the influence of American abstract painting in the late 1950s, an experience that had a permanent effect in his taste for large scale, bold colour, simplification of form, frontality and centralized composition. In 1960 he made the first of a series of wooden reliefs, making direct use of the carpentry skills he had acquired as a teenager. Such constructions became increasingly formalized during the next year, with the thin sawn planks integrated into a continuous surface in simple patterns and basic geometric shapes. In *For Jake and Anna* (1961), one of his earliest Pop works, he introduced into this still rather austere system elements that were to become integral to his mature aesthetic: bright primary and secondary colours, fragments of imagery and stencilled lettering. Dedicated to his young son and daughter, whose names appear on the front, this is one of the first instances when he clearly rooted his work in the personal circumstances of his life or in deeply held convictions, which he was soon to do as a matter of course.

In its boldly simplified structure composed from cheerfully decorative components of standard size, *For Jake and Anna* clearly alludes to children's toys and building blocks. References to games as an unpretentious means of inviting the viewer to participate directly occur also in many other works by Tilson of this period, such as *Astronaut Puzzle* (1963). *Key Box* (1963), with its keyhole enlarged to Alice-in-Wonderland proportions, is a characteristic example of another aspect of his work by which word and image are associated in various and usually very direct ways. In this case the word KEY completes the image of a vacant keyhole; in *Lucky Six* (1963) the word SIX accompanies the three faces of a die showing three, four and five; in *Oh!* the title word is placed immediately below two huge exclamation marks painted as if they were solid forms seen in perspective; in *Secret* the middle two letters are obscured by a huge painted finger covering a pair of lips in a hushed gesture; while in the *Zikkurat* series begun in 1963 the word used to

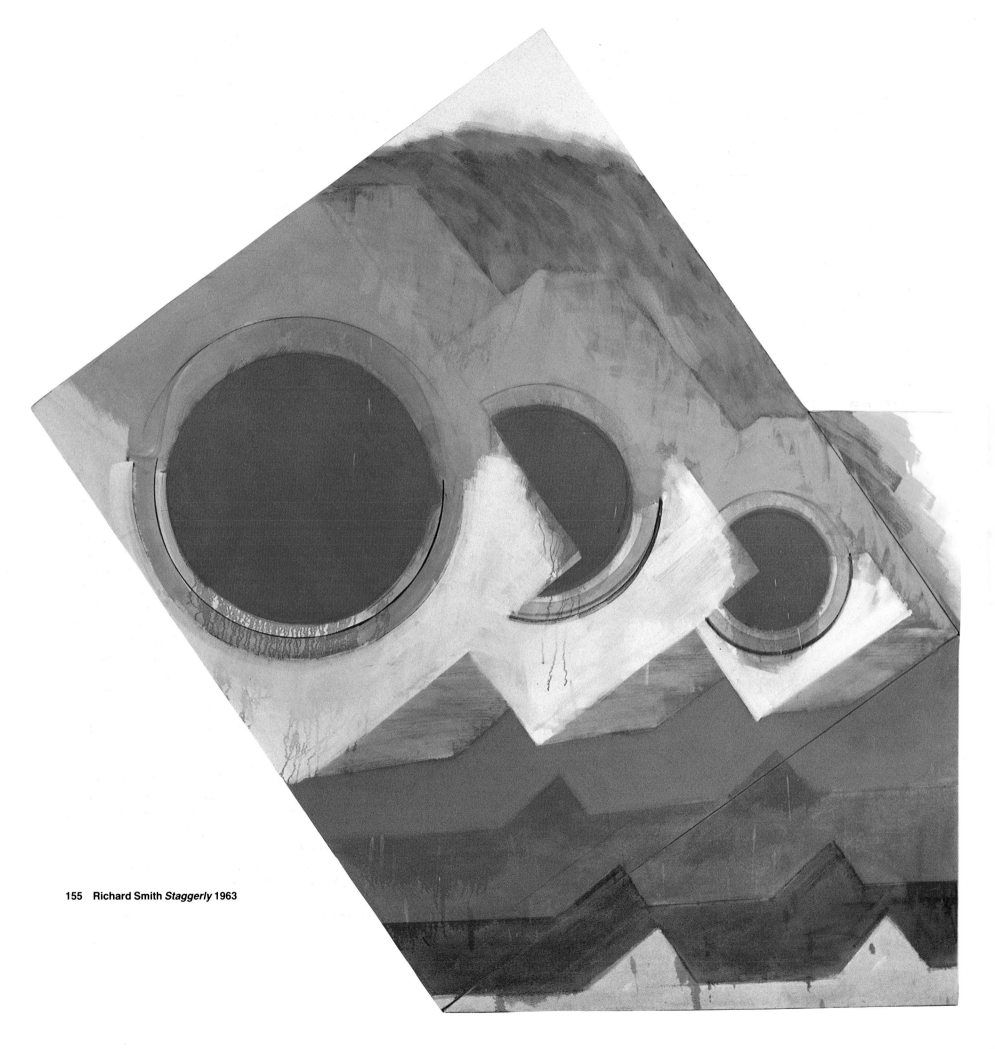

155 **Richard Smith** *Staggerly* 1963

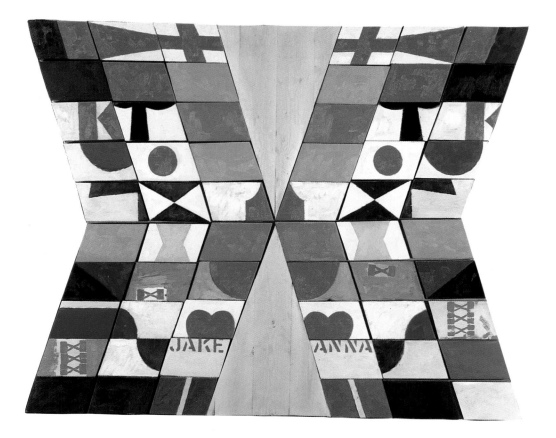

156 Joe Tilson *For Jake and Anna* 1961

158 Joe Tilson *A–Z Box of Friends and Family* 1963

157 Joe Tilson *Key Box* 1963

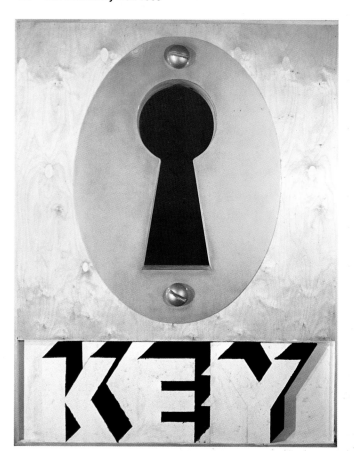

identify the stepped form is subjected to an increasingly abstract treatment, so that by 1967, in works such as *Zikkurat 7*, the individual letters are expressed as patterns of coloured circles. Tilson continued through the 1960s to explore not only the relationship between simple images and their linguistic equivalents, but also a range of formally appealing motifs with a long history, such as mazes and spirals, through which he began to relate his own contemporary artefacts to other cultures and to the transcendental, spiritual and mystical themes that eventually took him away from Pop in the early 1970s.

Tilson's wooden constructions of the early 1960s were his most personal contribution to the language of Pop, but he and his wife Jos also affected the course of the movement by hosting informal gatherings at which artists were introduced to each other and ideas were exchanged. It is thus fitting that one of the works that has acquired particular resonance for this period of British Pop is Tilson's *A-Z Box of Friends and Family* (1963), a construction in which he included specially commissioned samples of works by many of his Pop colleagues. Among the miniaturized pictures are works by Peter Blake (B), David Hockney (D), Eduardo Paolozzi (E), Allen Jones (J), R. B. Kitaj (K), Peter Phillips (P), Richard Hamilton (R) and Richard Smith (S), and by other artist friends including Clive Barker (C), who was then just beginning to make a name with his Pop sculptures. A version of one of Tilson's *Zikkurats* occupies the Z box and a full list of the participants is helpfully concealed behind the box marked Q (for Question mark).[29] Within its logical and straightforward grid-like structure, *A-Z Box* brings together the disparate intentions of Tilson and his colleagues into something resembling a unified movement. This collaborative work, which captures the artists in their first maturity just before many of them changed direction, was perfectly timed. More than a quarter of a century since it was assembled, it remains one of the most suggestive icons of British Pop.

192 ONE~DOLLAR BILLS

American Pop, 1962–4

In America, as in England, a sense of common purpose among Pop artists was most evident around 1962–3, and by this time a consensus was already emerging about which artists were the major figures. Among those working in New York, Warhol, though still struggling to find a gallery to represent him, was producing some of the most influential art. Traditional assumptions about the uniqueness and expressive potential of art had been questioned in a particularly disturbing way in his use of repetition and a semi-mechanical method in his *Campbell's Soup Cans* and other images of mass-produced products in 1962. Through the identification with consumerism and assembly-line methods of production, he implied that this ironing out of personality and individual identity was a peculiarly modern and American condition that he accepted without passing judgment on its desirability. His refusal to declare a clear position on the matter was symptomatic not so much of a mindless and amoral indifference, as some of Warhol's critics have assumed, as of his recognition that assembly-line production, while dehumanizing, was also imbued with a grandeur and an inspiring efficiency. Among his last such works to be painted by hand with the aid of stencils were slightly later monumental variants of his soup cans, such as *Big Torn Campbell's Soup Can (Vegetable Beef)* (1962), in which the labels were ripped to reveal corroded metal surfaces in mock-Expressionist angst.

While continuing to work with similar subjects, Warhol found a much simpler and more direct way of replicating an image by using a photo-mechanical process, that of silk-screen printing. He applied the process first to paintings representing rows of dollar bills or two-dollar bills, ordering a screen to be made from a hand-drawn facsimile of a banknote (as the laws on counterfeiting forbade their photographic reproduction) and then using it as a standard unit to be printed one by one on a strict grid system. For Warhol, as for the Minimalists and other artists during and after this period, the grid itself – as a pure expression of serial repetition that dispensed with relational methods of composition – functioned as a sign for modernism in the context of abstract and representational painting alike. The procedure used by Warhol in the dollar-bill paintings was rich in irony: not only was he literally printing money, matching the technique to its subject, he was also drawing attention to the status of art itself as a mere commodity, 'money on the walls'. The buying and selling of contemporary art, and especially of American art, was for the first time becoming big business in New York. Other artists continued to speak of their transcendental and spiritual ambitions. Warhol, by contrast, blandly but shockingly avowed the more worldly monetary transactions that others cared about just as passionately but preferred not to admit to publicly. What may have seemed at the time to be cynicism on Warhol's part could as accurately be described as brutal honesty.

160 Andy Warhol *192 One-Dollar Bills* 1962

161 Andy Warhol *210 Coca-Cola Bottles* 1962

162 Robert Rauschenberg *Estate* 1963

With screen-printing Warhol had finally found a way of eliminating altogether the distinguishing personality of brushwork, at the same time satisfying his professed desire to make himself into a machine, registering images as a mere film of colour on the canvas surface. Repetition was a useful tactic for emptying his mind, freeing him to respond intuitively (often to subjects or ideas proposed to him by other people) and leaving him open to happy accidents and chance effects; early visitors to his studio remarked on his disconcerting habit of playing the same pop song over and over again at high volume as he worked. Paradoxically, it was through such seemingly mindless repetition that Warhol proposed his own concepts of transcendence, involving a heightening of perception through concentration on minor variations of apparently identical things. *210 Coca-Cola Bottles* (1962), for instance, is based on a repeated image of three bottles laid out in strict row formation, but one soon becomes aware of the variations in colouring and later of a few deliberate and puzzling disruptions of the repeat pattern. What appears at first to be self-evident gradually asserts itself as an object requiring close and intense scrutiny.

From the hand-cut screens it was only a small step to Warhol's adoption in August 1962 of photo-screens as his preferred method. With hindsight his use of the medium has come to look primitive and still hand-made but at that time any use of machinery in the production of art seemed technologically sophisticated. The process was also taken up in 1962 by Rauschenberg, apparently following Warhol's example, although in his case it also came logically from the transfer drawings from newspapers that he had been making since the late 1950s.[1] The technique served the two artists in different ways. For Rauschenberg, in paintings such as *Estate* (1963), it supplied another texture and painterly effect as well as a fund of images of urban life and the mass media; he used both found photographs, including reproductions of works of art, and his own street photographs (many taken from his studio window), and he re-used screens in different combinations from one painting to another. His work of the 1960s was rich both in its formal inventiveness and iconographically. Images of space travel, street life, sport, famous faces, art and advertising – all jostling against each other in a visual free-association – added to the repertory of Pop subject-matter. In contrast with the wilful depersonalization and formal directness of Pop, however, Rauschenberg's work came to look increasingly personal and private, with a preference for compositional improvisation, sensitivity of touch and metaphorical use of imagery. The process of layering characteristic of Rauschenberg's work, both in his use of overlapping painted and printed images and in his increasing predilection in the 1970s and 1980s for translucent materials, dictated the slow and mysterious manner in which his paintings yielded themselves to the viewer. However much respect he and Johns continued to command, both artists appear to have almost deliberately moved away from the mainstream concerns of Pop just as the movement was becoming established.

For Warhol the photo-screen provided a bald and immediate method for appropriating an image; it was easy to use, capable of indefinite reproduction, and all the more attractive for its mechanical nature.[2] The screens were produced commercially by coating them with light-sensitive material and then exposing them to a projected black-and-white photograph. Among the subjects for the first paintings produced by him in this way in 1962 were film stars such as Troy Donahue (*Troy Diptych*), *Warren* (Beatty) and *Natalie* (Wood), for which he used images selected from the collection of publicity shots he began to form as a child.[3] These were not arbitrary images of famous people but emblems of their beauty, glamour and star quality that they and the film studios had chosen to represent them to their public. The prominent signatures on some of these pho-

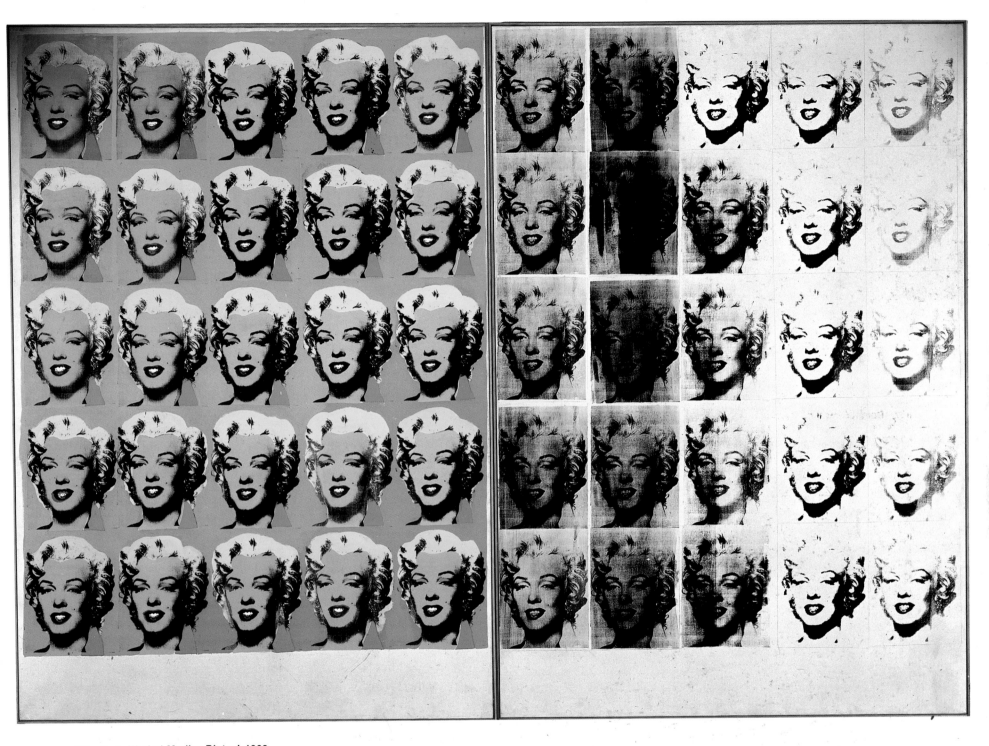

163 Andy Warhol *Marilyn Diptych* 1962

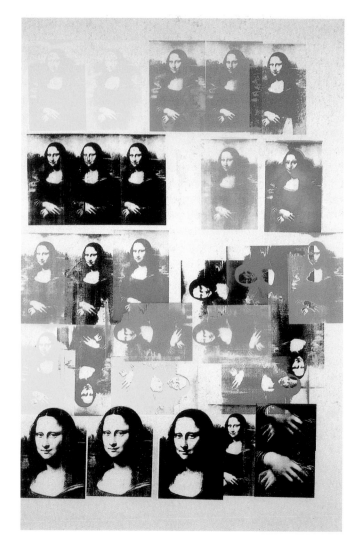

164 Andy Warhol *Mona Lisa* 1963

165 Andy Warhol *Most Wanted Men No. 11, John Joseph H.* 1964

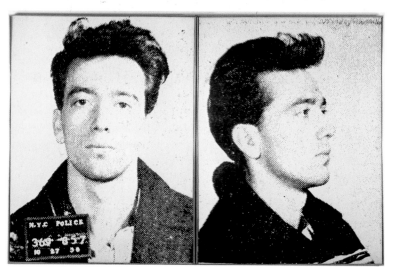

tographs, such as those of Beatty and Donahue, function both as the sitter's official seal of approval of the image and as a doomed attempt to personalize it with writing that itself is mechanically reproduced. Donahue's name and image are printed 95 times in *Troy Diptych*, as if in a frantic denial of the single artist's signature that we would once have expected in confirmation of the work's authenticity as the product of the artist's hand. The insistent presence of the sitter's name in his own writing draws attention to the painter's physical absence already effected in his choice of a mechanical technique.

Warhol had an uncanny gift for selecting motifs from the glut of visual information characteristic of a modern industrial society overwhelmed by consumer products, newspapers, magazines, photography, television and the cinema. He was particularly astute in realizing that our over-exposure to images in the public domain, whether of famous faces or horrific events, gradually divests them of any apparent emotion and at the same time gives them their iconic power by engraving them in our memory through the force of repetition. A painting such as *Marilyn Diptych* (1962), one of a number based on a publicity still by Gene Kornman for the 1953 film *Niagara*, confronts us with the depths of our ignorance of a star whose face we may have seen countless times; we respond to her glamour and beauty, but as her suicide in August 1962 suggested, these may simply have constituted a mask that concealed her humanity and vulnerability. The nature of the screen-printing technique, in Warhol's deliberately casual hands at least, subjects the single image to countless variations: sometimes it is over-inked, sometimes under-inked, occasionally it is smudged or partly obliterated by the hardening of ink in the screen before it is cleaned. Those heads printed over stencilled colour areas corresponding to her skin, hair, make-up and collar introduce further surface changes to a motif presented as theoretically immutable and impassive. It is as though we are being shown fifty different faces of Marilyn encompassing her ultra-feminine sexuality and coquettish eroticism, her fears of aging and loss of beauty, her suffering and her ultimate self-destruction as she fades into memory as a goddess of the silver screen.

The meaning of his work was never explained by Warhol in this way; it may be that any such interpretation says more about ourselves, about our own need for understanding, than it does about the artist or his intentions. These images are, after all, only marks made on a surface with mechanical aids. Yet the tactical avoidance of clear-cut meaning raises questions about his motives. Was his purpose to draw attention to himself through mystification, ensuring that he and his work remained enigmatic and inscrutable and consequently the object of continuing curiosity, or did he genuinely wish to democratize art by involving others in its interpretation as well as in its making? The system devised by Warhol for producing the paintings enabled him to hand over at least part of their execution to others, mimicking the division of labour used in assembly-line production. In theory the pictures could physically be made by anybody following his instructions; much of the screen-printing was carried out with the help of an assistant, Gerard Malanga, whom he employed from June 1963 to August 1967 and again from September 1968 to November 1970.

The sources and processes referred to in the production of Warhol's paintings are made explicit in their technique and form alike, as in the direct correlation between the grid formation of separate panels in *Ethel Scull Thirty-six Times* (1963) and the strips of cheap photo-booth portraits from which the images were printed. The status of this painting as a commissioned portrait – the subject was the wife of the influential Pop art collector Robert C. Scull – is made apparent by Warhol's willingness to allow the sitter to display herself as she thinks fit, not just in the act of photographing herself but in the

hanging of the separate components into any permutation rather than according to a set plan. Another work of the same year, *Mona Lisa (Colored)*, deals explicitly with our experience of works of art in the form of reproductions in Warhol's separation of the repeated image into the black, magenta, yellow and cyan employed in the four-colour process of printing; the choice of the most reproduced painting of the Renaissance was particularly timely, as it was much in the news when loaned in February 1963 to the Metropolitan Museum in New York.

The factory production methods underlying both Warhol's technical procedures and his subject-matter of consumer items – or, more precisely, their packaging – were brought to a logical conclusion in 1964 with a series of sculptures replicating cartons used for the delivery of factory-produced goods to supermarkets. Choosing the most ordinary and familiar designs that he could find – *Brillo Box (Soap Pads)*, *Campbell's Box (Tomato Juice)*, *Heinz Box (Tomato Ketchup)* and *Del Monte Box (Peach Halves)* – he had dozens of boxes constructed out of plywood which he and Malanga painted with an undercoat in a colour matching the cardboard before screen-printing facsimiles of the original designs to each side of the box in the colours of the original. The step-by-step efficiency of the process imitated, as far as possible, the methods that would have been used to make the cartons themselves; once out of Warhol's studio, the Factory, and into the gallery (the market place) they could be displayed in different configurations, singly, laid out in rows or stacked as they might be in a warehouse. Both Duchamp's readymades and Johns's *Painted Bronze* sculptures of 1960 were evident prototypes. Whereas Duchamp had taken manufactured objects as he found them and Johns had stressed the hand-made uniqueness of his traditionally cast bronzes, Warhol used 'unartistic' mechanical procedures to produce large numbers of virtually indistinguishable items.[4] The simplicity of the gesture was disarming, especially given the questions raised about the distinction between original and copy, the degree of manipulation of form required for an object to constitute a sculpture and the status of a work of art both as a physical manifestation of an idea and as a commodity.

However strict the logic of Warhol's process, the first-hand accounts of colleagues and assistants testify to his deliberate exploitation of casual effects and 'mistakes' as an essential part of his aesthetic.[5] The technical imperfection is poignant evidence of his own human fallibility. Moreover, he clearly gravitated towards tragic and sensationalized subject-matter, as in his choice of Jackie Kennedy in her role of grieving widow after her husband's assassination and in the *Death and Disaster* series initiated in 1963 with enlargements of bleak and gruesome press agency photographs of car crashes, race riots and electric chairs starkly printed in black against backgrounds of vivid colour. Warhol's handling of such subjects asks us to consider whether we can fully appreciate their horror given the extent to which they are part of our daily intake of images, interspersed with entertainment and hard-sell consumerism. Violence is as constant a presence in Warhol's art of the 1960s as it was in American life itself during that decade. The role-playing fantasy of Elvis Presley's cinematic pose as a tough-looking gun-slinger, as memorialized in Warhol's 1963 series, is treated as no less real than the emblems of thuggery and corruption screen-printed from FBI photographs of criminals in the *Most Wanted Men* series of the following year. Morality aside, fame and notoriety are indistinguishable, since the net effect of both is to stand out from the crowd, to make a mark on the world. Given Warhol's well documented insatiable hunger for fame, it seems indisputable that his choice of such subjects was far more carefully considered than his own casual pronouncements might lead one to believe.

192 ONE-DOLLAR BILLS

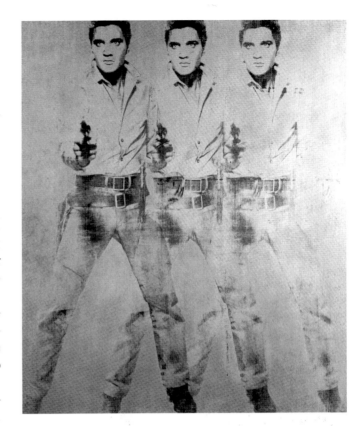

166 Andy Warhol *Triple Elvis* 1963

167 Andy Warhol *Brillo Box (Soap Pads)* 1964

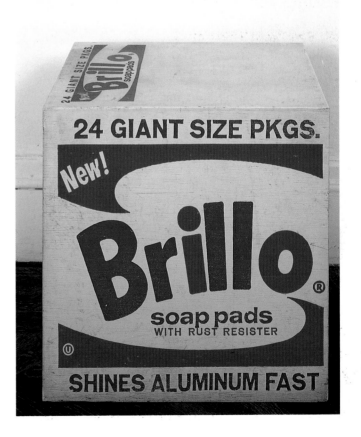

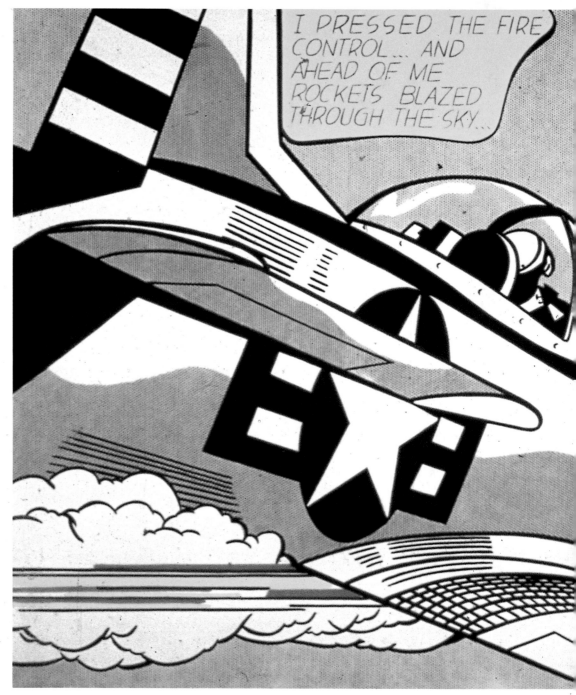

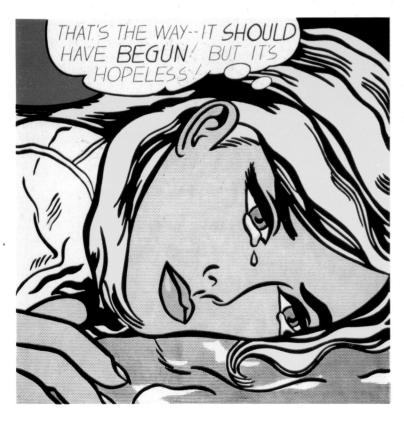

168 Roy Lichtenstein *Hopeless* 1963

The shift in Warhol's work from banal to more emotionally charged imagery, counteracted by a more exaggeratedly mechanical and depersonalized technique, was parallelled in the paintings of this period by Lichtenstein. For him it was a case of subtle adjustments to his formal language, combined with new preferences in his source material for the masculine violence and aggression of war comics and the feminine emotional traumas of romance comics. The more systematic application of a technique combining black outlines, flat areas of a severely limited range of colour, regular patterns of Benday dots and bold lettering makes for a seamless surface that seems to have been achieved without effort or anxiety. The combination of forthrightness and detachment

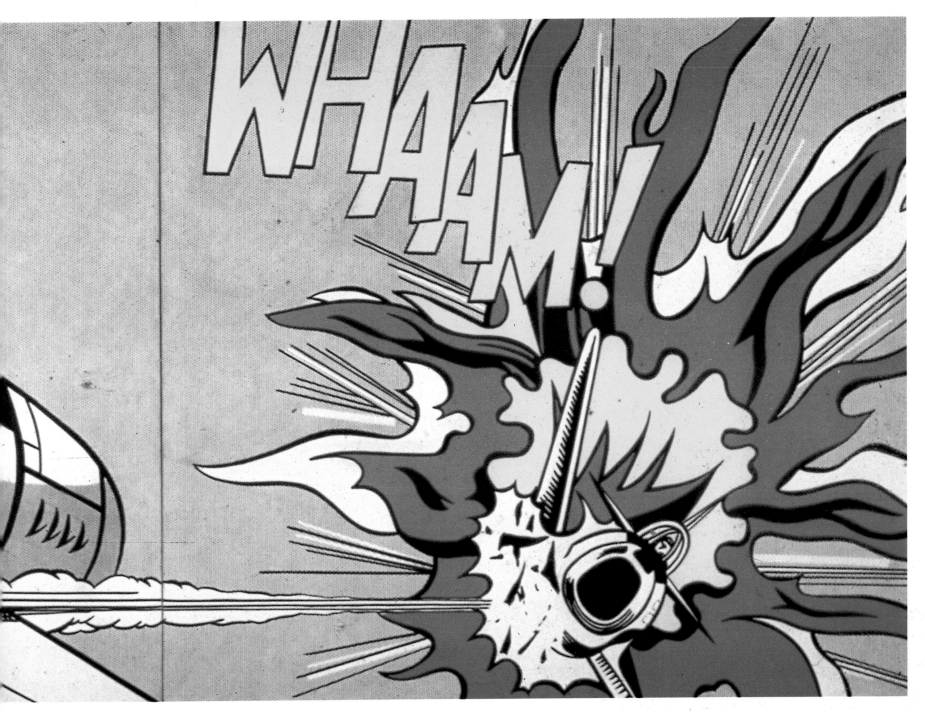

169 Roy Lichtenstein *Whaam!* 1963

allows the artist to deal with troubling emotions and desperate situations without appearing to succumb to them: a painterly equivalent, one could say, of a stiff upper lip.

Lichtenstein first used war imagery in 1962 in single-frame paintings such as *Blam*, in which a pilot is shown ejecting from his exploding aeroplane, and *Takka Takka*, in which blasts of ammunition are accompanied by a long and ridiculous caption that describes a lurid narrative not seen in the picture itself: 'THE EXHAUSTED SOLDIERS, SLEEPLESS FOR FIVE AND SIX DAYS AT A TIME, ALWAYS HUNGRY FOR DECENT CHOW, SUFFERING FROM THE TROPICAL FUNGUS INFECTIONS, KEPT FIGHTING!' By the following year, in paintings such as the two-panel *Whaam!* (1963) and the three-panel *As I Opened Fire* (1964), he increased the im-

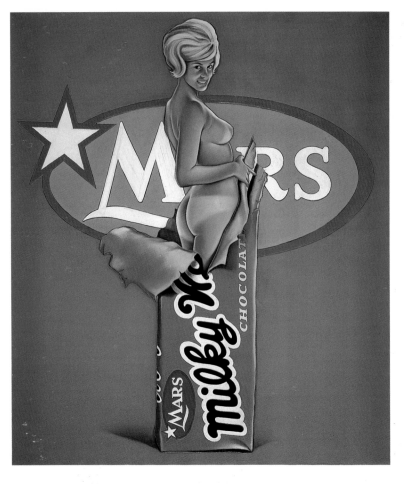

170 Mel Ramos *Candy* 1965

172 Mel Ramos *Señorita Rio* 1963

171 Tom Wesselmann *Bathroom Collage # 3* 1963

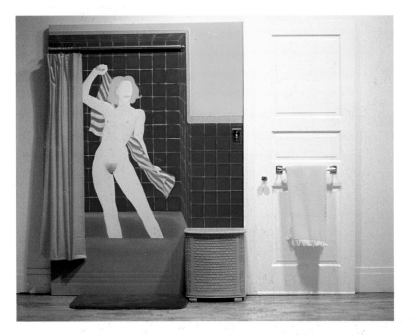

pact of the imagery by working on a larger scale, concentrating on a single event or image conveyed in an immediately recognizable form, and highlighting the sequence of action by presenting it in before-and-after separate panels. The outsize bursts seen, for example, in the right-hand panel of *Whaam!* soon became the subject of independent paintings such as *Varoom!* (1965) and of enamel on steel *Explosion* reliefs in the same year. In these works the violence of the subject-matter is plainly directed towards art itself: the paintings picture the surface as great holes surrounded by shattering fragments, an even more pronounced assault on the 'integrity of the picture plane' than that proposed in Johns's targets of the previous decade, while the reliefs paradoxically present disintegrating matter by means of solid, hard-edged and reflective materials. However much one might wish to read this group of pictures as a political comment on the American industrial-military complex, Lichtenstein has said that his motives remained essentially pictorial.[6]

Romance comics had been Lichtenstein's source material for some of his earliest Pop pictures, such as *Engagement Ring* (1961), but as with the war subjects it was only in 1963 that these images were treated as a definite genre within his work.[7] Paintings such as *Hopeless* (1963) typically take as their subject a blond girl of stereotyped prettiness in a state of advanced lovesickness or despair; the gulf between the supposed depth of her emotion and its dispassionate rendering, in this case by means of huge and frozen tears, exposes the artificiality of the fiction while acknowledging the real impact that it can have on an audience willing to suspend its disbelief.

Female characters had featured among some of the paintings derived from comic strips by Mel Ramos in 1962, and they became his primary subject in the following year. The first of these, such as *Señorita Rio* (1963), retained both the thickly painted surface of his earlier pictures and the open dependence on a comic-strip source, but they also announced the voluptuously sexual imagery that soon became the salient feature of his work. He now began to rely largely on photographs, including images both of stars such as Marilyn Monroe and Jane Russell and of the anonymous women displaying themselves on the pages of girlie magazines, and under the influence of the medium he adopted flatter areas of colour combined with a tonal rendering of the figure influenced also by Vargas and other illustrators of the 1930s and 1940s. The paintings Ramos made in 1963 were mostly of invented and scantily clad characters, such as *Pha – White Goddess* and *Roma*, whose names are displayed in prominent lettering behind them.

The voyeuristic nature of Ramos's imagery was made explicit in the *Peek-a-boo* series of 1964, in which female nudes were viewed as if through giant keyholes, an idea borrowed from a 1940s postcard.[8] His paintings became increasingly fearless in their vulgarity and poor taste, as in *Candy* and other paintings from 1965 in which provocatively posed nudes are shown flaunting giant-sized consumer products with a lip-smacking gusto that few advertising agencies would have dared to entertain. They mock the strategies used to sell products to men anxious to proclaim their virility, as typified by the women draped over objects on calendars intended for the workshops of car mechanics. Much of this irony has been lost in the wake of the feminist movement, and the pictures have suffered accordingly. Lichtenstein spoke at the time of his desire to make paintings that seemed so awful that no one would hang them, but he turned bad taste on its head in pictures of consummate elegance. Ramos, by contrast, flaunted his art as kitsch devoid of intellectual pretension but with an earthy humour that remains its saving grace.

The sensuous eroticism that had emerged in Wesselmann's work of the early 1960s became pronounced by 1963 in mixed-media works such as *Bathroom Collage # 3*.

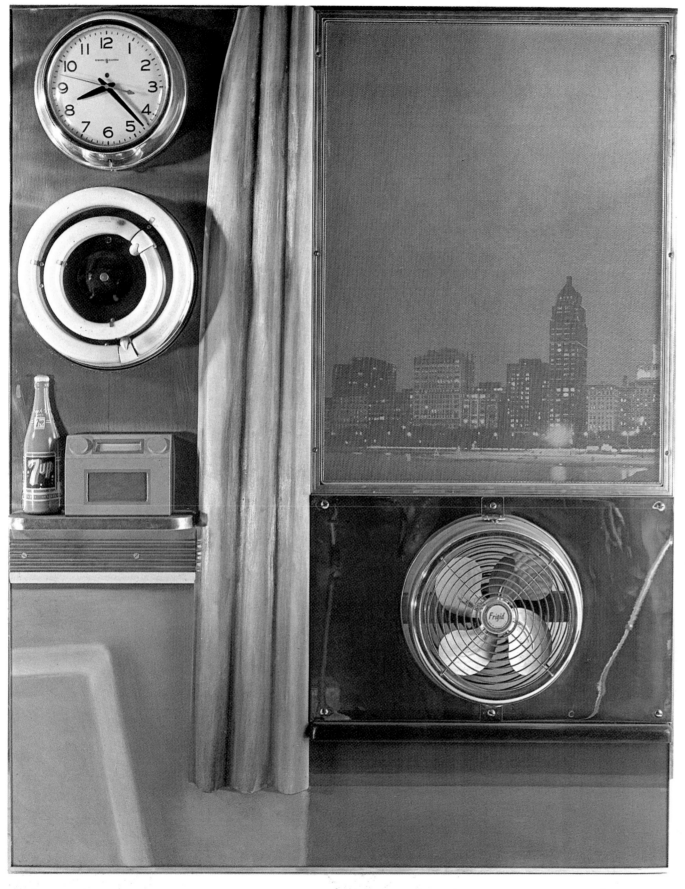

173 Tom Wesselmann *Interior # 2* 1964

174 Tom Wesselmann *Still Life # 33* 1963

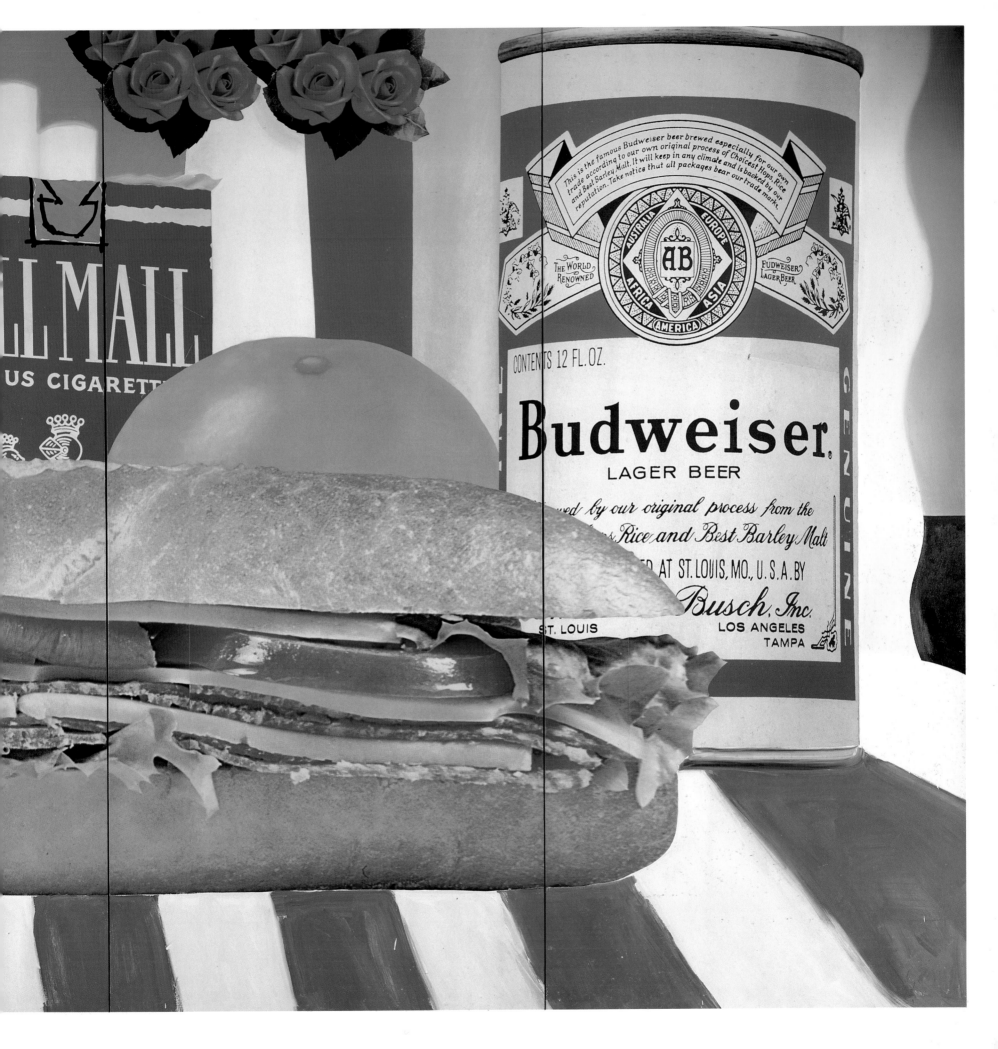

175 James Rosenquist *Lanai* 1964

This was achieved both through the hardening of the contours of the figure and through its frank and full-frontal presentation in ordinary domestic situations. Earlier treatments of similar subjects, for example by Degas in the late nineteenth century, had seemed shockingly honest at the time in their seemingly casual glimpses of unposed nudes spied in the act of washing themselves. Degas's women remain aloof and inaccessible, however, by contrast with Wesselmann's figure, who openly and without embarrassment acknowledges our presence as she towels herself dry. The actual door, towel rail, towel, shower curtain, clothes hamper and rug that are part of the relief add to the physical presence of the life-size figure even though it is almost the only element painted on the flat surface rather than incorporated as a real item.

Objects and printed images of objects from the mass media continued to occupy Wesselmann's attention in works such as *Still Life # 33* (1963) and *Interior # 2* (1964), in which he dramatically reinterpreted the traditional themes ironically referred to in the titles. Rosenquist had introduced billboard scale and imagery into his paintings of the early 1960s, but Wesselmann now developed the idea in an even more extreme and literal form by adapting the principles of his own earlier collages to the grossly enlarged dimensions of street advertising. He has not simply approximated billboard effects in his

126

176 James Rosenquist *Win a New House this Christmas (Contest)* 1964

monumental representations of a beer can, cigarette pack and overstuffed sandwich in *Still Life # 33*; the images are actual pieces of advertising posters glued onto three large backing boards into a composite arrangement and supplemented by simple painted designs to complete the overall effect of a continuous surface. The final image, measuring approximately 3 x 5 metres, has a grandeur exceeding even that of its sources, since in a gallery or museum the spectator inevitably experiences the picture from nearby as an overpowering presence, rather than seeing it quickly in passing as would be the case with an actual billboard.

Works by Wesselmann using real and functioning objects, such as the clock, fan and fluorescent light in *Interior # 2*, can be related to earlier combines by Rauschenberg that had used similar devices. There is, however, an essential distinction to be made between the uses of such material in the work of these artists. The two unsynchronized electric clocks in Rauschenberg's *Reservoir* (1961), one set at the time the painting was begun and the other at the time of its completion, draw attention to the artist's process as a system enclosed within the work itself; in an earlier work, *Broadcast* (1959), three radios concealed in an essentially abstract paint surface provide a cacophony of found sounds in the spirit of John Cage as fragments of reality beyond the artist's direct control. By con-

192 ONE-DOLLAR BILLS

127

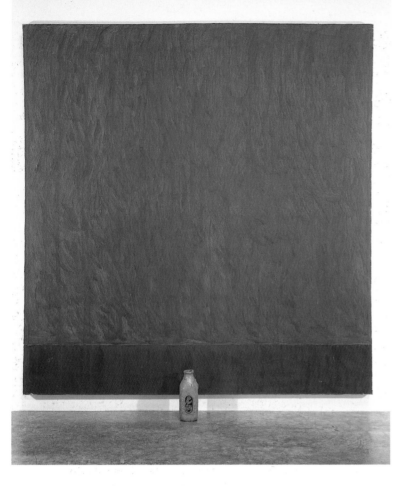

177 Joe Goode *Untitled* 1962

178 Joe Goode *The Most of It* 1963

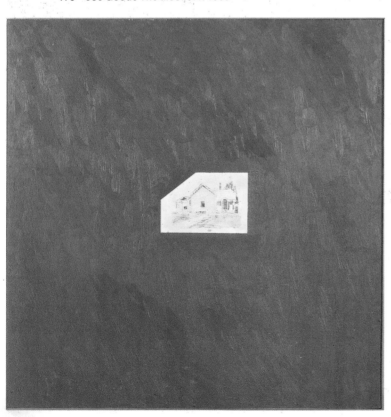

trast, Wesselmann's work, and others of the same year which incorporated working radios and other manufactured objects purchased for the occasion, betrays no sign of traditional artistic manipulation; the ready-made items are simply fixed into position in formalized relationships so that the image as a whole appears to be an actual part of a modern interior.[9] The industrial objects intruding into our space in such works insist on the harsh materiality of their presence and serve as reminders of the here-and-now: clocks tell us the actual time; fans blow air into our faces; and radios are tuned to local stations, broadcasting the popular songs of the moment or the latest news. In *Interior # 2* there is only one major element, the imagined view through the window, that serves as a two-dimensional sign rather than as a literal stand-in for what it represents, but even this is mediated through an existing photograph of the city skyline.

American Pop artists had each worked in considerable isolation in 1960–61, but from 1962, when they began to exhibit together and to know each other on a more personal basis, cross-influences and a common sense of purpose became more evident.[10] Rosenquist's use of the language and scale of billboards may have influenced Wesselmann, but the more overt display of advertising imagery in paintings by Rosenquist such as *Lanai* (1964), together with the synthetic colour and more mechanical technique of painting, suggests that he may have been prompted in turn by the greater depersonalization and consumerism effected by his colleague. With the exception of his occasional overtly political work, however, and of the rare single-image paintings based on photographs or advertisements, such as *Win a New House this Christmas (Contest)* (1964), for Rosenquist the contemporaneity of an image often seems almost incidental. *Lanai*, for instance, would make little sense if analysed in terms only of its title (the name of an island in central Hawaii) or of its conjunctions of images of tinned peaches, a shiny new car, a female nude crouching by a swimming pool and a broken pencil. The specific way in which their textures are rendered – as syrupy, metallic, photographic and hard-edged – must be assumed to be a factor in what they represent, as does the sequential experience that unfolds for the viewer when walking from one side to the other of the massive painting itself. Judged in this way, *Lanai* becomes a meditation on the senses, particularly of touch, taste and sight.

Shared references and similarities of imagery and technique in the work produced by American Pop artists in the first half of the 1960s, when the movement seemed most clearly defined, have been taken as evidence of identical goals. The resemblances, however, are often superficial or fortuitous, masking contradictory impulses and concerns. For example, the southern Californian artist Joe Goode, who like his friend Ruscha was from Oklahoma, figured in the early history of Pop not only because he was seen as part of a tight-knit group but also because he referred in his paintings to contemporary images such as suburban housing and to ordinary objects such as milk bottles and (in his later sculptures) to staircases. In general, however, his work displays neither an interest in social commentary nor a will for anonymity of technique.

Far from glorifying consumerism, Goode's use of milk bottles in works such as *Untitled* (1962) appears to be a way of drawing attention to a confrontation between the material world and the spiritual. The bottle has been emptied of its contents and covered with paint, reversing the expected relationship between the container and the liquid and also obscuring the clear view that would normally be offered through the glass. The modulated colour brushed onto the canvas surface behind the bottle provides a space for contemplation as unobstructed as an open horizon, with the positioning of the bottle in front of a horizontal band of darker colour encouraging such an interpretation of the envelop-

ing atmosphere of colour as an equivalent of a limitless landscape. This metaphysical reading is further encouraged by the alteration of the surface of the machine-made bottle by the artist's hand, drawing attention to people's need to impose themselves on their surroundings. Paintings of 1963–4, such as *The Most of It*, in which a small pencil drawing of a suburban house is collaged to the centre of a canvas painted as an expanse of a single colour, are more readily interpreted as signs of the isolation of suburban life.[11] The contrast between the diagrammatic line drawing and the tenderly brushed surface that creates a no-man's-land around it suggests that Goode's ultimate concern is not with the cultural implications of contemporary American life or architecture but with the individual's struggle to express his or her identity in the face of bland conformity.

The suburban experience alluded to in the work of other Pop artists, including that of Ruscha in Los Angeles and D'Arcangelo in New York, was not confined to any particular geographical location but was part of American life in general. The *Highway* series D'Arcangelo inaugurated in 1963 deals explicitly with this sense of the endless road as nowhere and anywhere. Nature is no longer experienced directly by most of us, but seen instead as a kind of backdrop past which we travel from one like place to another. In the five-panel series *U.S. Highway 1* (1963) a narrative measuring time and distance is established along the lines of a sequence of film stills, so that we see the landscape as if from a moving car: we approach a gasoline sign, then glimpse it from the side, then face a blank stretch of road before seeing another identical sign ahead, giving us the impression through repetition and sameness that we are back where we started.

Every element of D'Arcangelo's pictures, whether man-made or natural, is treated as part of a single bland and uninflected surface, so as to bring into relief our separation from the natural world. Distance is represented by a system of one-point perspective

179 Ed Ruscha *Noise, Pencil, Broken Pencil, Cheap Western* 1963

180 Ed Ruscha *Standard Station, Amarillo, Texas* 1963

recognized by all of us from illustrations of roads and railway tracks in basic drawing manuals, adding to the banality of the image. By thus conceiving his roads both as flat and as implicitly spatial, while maintaining a uniform intensity of colour, D'Arcangelo asks us to visualize the American landscape in a symbolic rather than descriptive form. In subsequent works real objects are introduced as a way of stressing both the physical immediacy of the painting in conveying experience and the illusion with which we willingly comply; in *Crossroads* (1964) a rear-view mirror carries a painted image that we accept as a reflection of the stretch of road behind us, while in *Barrier* (1964) a real wooden fence painted with dazzling stripes prevents us from proceeding further towards the imaginary space alluded to on the picture plane behind.

Of all American Pop artists, none explored the strange attraction of the suburbs and the open road more avidly than Ruscha in drawings, paintings, screen-prints and especially photographs. The series of books he began publishing privately in 1963 remains unparallelled as a photographic documentation of contemporary American architecture, particularly of southern California, which is meant to be viewed in passing from a cruising automobile.[12] The first of these, *Twenty-six Gasoline Stations*, recorded a return journey from Los Angeles to Oklahoma as a series of bland and interchangeable landmarks on Route 66, an interstate highway which itself had become an almost mythic symbol of American life.[13] Other artists associated with Pop sometimes used the camera in gathering together material for their paintings, as in Rauschenberg's stockpiling of images for screen-printing or in Warhol's use of Polaroids for the commissioned portraits that became his main source of income as a painter during the 1970s, but Ruscha was alone at that time in presenting photographs as independent works.

Ruscha's photographic sequences of seemingly bland but rigidly structured images of the built environment can thus rightly be regarded as the only work in the medium to emerge from Pop but their influence was largely outside the movement, first on Conceptual art and in the 1970s on the work of the 'New Topographics' photographers such as Robert Adams and Lewis Baltz. He himself applied the deadpan descriptiveness of his gasoline station photographs to several of his most blatant Pop pictures, beginning with a large painting, *Standard Station, Amarillo, Texas* (1963); in its wide format, exaggerated one-point perspective and imagery of searchlights and triumphant signs, this glamorous homage to the service station as the temple of the twentieth century closely follows the pattern of his 1962 painting *Large Trademark with Eight Spotlights*. In 1965 Ruscha produced a series of pencil drawings of Los Angeles apartment blocks that bear comparison with the contemporaneous paintings of the city's rigorously geometric architecture made by Hockney after he first settled in the city in 1964.

Other works by Ruscha in 1963, such as *Flash* and *Noise, Pencil, Broken Pencil, Cheap Western*, consist of a colour field in which a single word is paired with a found printed image culled from popular culture – the folded-up colour comics section of the *Los Angeles Times* or the cover of *Popular Western* – hand-painted with the scrupulous accuracy and definition of a photograph. In *Noise* . . . we are left to our own devices to establish the connection between the prominent word and the three images, all of which seem to be escaping from each other towards the canvas borders, leaving vacant the central area; does the noise refer to the sound of the shoot-out expected in any western, or simply to the snap of a breaking pencil across the vast silence that separates the two writing instruments from each other? The perspectival presentation of the word itself provides a visual equivalent of a sudden sound trailing off into a mere murmur. Ruscha had already realized that the suggestiveness of language, especially when it is both seen

181 Allan D'Arcangelo *U.S. Highway 1 – No. 3* 1963

and heard, could be a subject in itself, and shortly after producing his pencil drawings of apartment blocks he devoted himself almost exclusively to the pictures of words for which he remains best known.

In paintings such as *Eat/Die* (1962), a large two-panel picture each half of which consists of a single word in a white circle on a flat coloured background, Indiana continued to employ words and basic geometric forms as his standard motifs for a heraldic art that was visually austere but poetically evocative of experience. As in Ruscha's case, it occurred to him that fragments of ordinary language could be used as equivalents of found images, as visual signs that were already dense with associations both for himself and for each viewer. The apparent simplicity of Indiana's use of words and elemental shapes, giving his paintings the blatant immediacy of road signs, attracts our attention while continuing to yield essentially private messages slowly as an interaction between the artist and viewer on a one-to-one basis.

The formal strictness of a multi-partite shaped painting such as *The Demuth American Dream # 5* (1963), involving an elaborate system to support the numerical symbolism of threes and fives, is intrinsic to the picture's layering of meaning. It consists of five separate panels arranged in cruciform plan as two intersecting sets of three. Each contains a circumscribed five-pointed star and three 5s in diminishing size, with the four outer panels containing a single word repeated five times within the perimeter of the circle. The date 1928 on the central panel refers to that of Charles Demuth's precisely rendered but mysterious painting *I Saw the Figure 5 in Gold*, on which the imagery of Indiana's picture was based, and to Indiana's year of birth, a coincidence that reinforced the private meaning of his decision to paint his own response to it in 1963, his thirty-fifth year. The insistent repetition of the numbers 3 and 5 elaborates the hypnotic recurrence of the 5 as it approaches the picture plane in Demuth's picture, which itself was based on a poem, 'The Great Figure', by William Carlos Williams. This spiralling of reference adds to the reverberation of the image, but Indiana has employed a language that is bold and direct, both visually and verbally, so that each viewer may also relate to the picture in terms of his or her own experience. Four verbs are repeated with a mantric intensity: DIE, EAT, HUG, ERR. They speak of facts of existence, physical and emotional needs, and human failings. Private concerns, having been made public, once again become internalized by the viewer in the act of looking at the picture.

While already distancing himself from Pop, Dine continued to investigate ways of integrating the private with the public in his work, notably in the series of emblematic self-portraits he initiated in 1964. Rather than represent his features as studied from life, he chose to picture himself in the schematized form of a bathrobe he had seen in a hand-drawn advertisement in the *New York Times*; the fact that he neither owned nor wore such a garment compounded the irony of a self-portrait that lacked head, hands and body. *Palette (Self-Portrait No. 1)* (1964) and the variant images that followed have a Pop wit in the artist's removal of himself from the picture, but there is also a pronounced ambivalence about them, given that we are asked to imagine the painter as occupying the dressing gown even if we can't see him.

There is a persuasive logic to Dine's idea: since any representation can on one level only be a stand-in for the real person, a found image of a masculine torso provides just as useful a sign for his presence as a faithful rendering of his features, particularly as these pictures were conceived as emblems of himself as a painter. The outlined figure in his first self-portrait of 1964, only partly covered in a coat of red paint, is presented against a huge palette shape, suggesting that the artist himself, rather than just the colours with

182 Robert Indiana *The Demuth American Dream # 5* 1963

192 ONE-DOLLAR BILLS

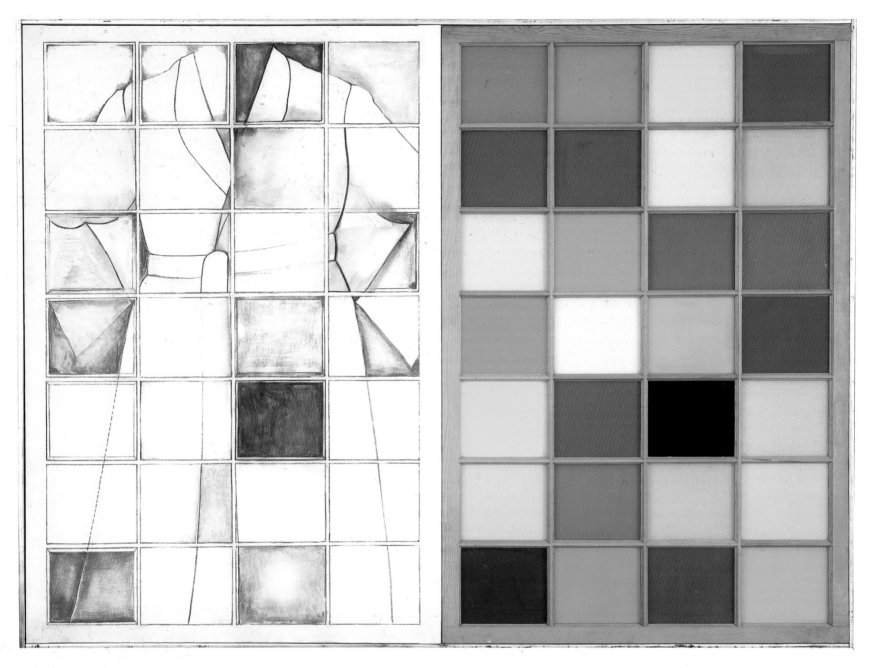

183　Jim Dine *Self-Portrait Next to a Colored Window* 1964

which he covers the surface, is the material with which he makes his art. A subsequent painting, *Self-Portrait next to a Colored Window* (1964), pairs a black-and-white rendering of the bathrobe with a panel of squares in vivid hues presented in the manner of a colour chart; the two panels are of equal size and both are subdivided into the same grid of small squares, again proposing the equivalence between the artist and his materials and the possibility of seeing one through the other.

Like Dine, Oldenburg remained faithful to the human emphasis of his earlier Happenings even after his preferred subject-matter shifted from the figure to man-made objects. His full transition into one of the most eloquent and single-minded practitioners of Pop was marked by his first one-man show at the Green Gallery in autumn 1962, an uptown, upmarket venue with a clean white space for which he created his first larger-than-life

sculptures out of soft materials such as canvas or vinyl filled with kapok. The home-made look and expressive handling of materials that characterized his previous objects in plaster were replaced by more anonymous coloured surfaces and by more craft-like, if not totally mechanical, processes; the gargantuan three-dimensional replicas of ordinary objects such as an ice-cream cone or a slice of cake were stuffed and stitched together like cushions or pieces of furniture, and the cloth was sewn by his wife, Patti, leaving open the possibility of his sculptures being manufactured by others under his direction.

All the objects shown by Oldenburg at the Green Gallery were re-creations of things intended for human consumption and human use, essentially food and clothing. The anthropomorphic appearance of the larger sculptures such as *Floor Cone* – which in its softness, weight, size and responsiveness to gravity is very much like a phlegmatic person lying prone – owes much to the artist's recognition that people tend to make objects in their own image. The interchangeability of object and figure, moreover, is also traced by him to his experience as an apprentice reporter for the City News Bureau in Chicago from 1950 to 1952. He had visited the homes of recluses on several occasions and had noticed their tendency to hoard particular objects in vast numbers; the impression he formed of objects as a substitute for people was later confirmed for him by psychoanalytic literature, in which a fascination with things is deemed to represent a sense of loss.[14]

By including some of the earlier life-size objects from *The Store*, such as his *Two Cheeseburgers, with Everything* (1962), in the same space with grossly enlarged versions of similar items, Oldenburg drew attention to the transformational power of size alone. The preference he had already developed for an ambiguity of shape, so that one class of object was endowed with the qualities of another, could be further exploited by the process of abstraction and metamorphosis he had observed taking place when something was magnified in size or scrutinized at a very short distance: it begins to lose some of its original identity and to look like something else. The characteristic works that Oldenburg began to make at this time, such as *Floor-Burger (Giant Hamburger)* (1962) or *Soft Fur Good Humors* (1963) can thus only incompletely be described as materializations of a childlike gluttonous fantasy, as comments on the presentation techniques and ridiculous claims of hard-sell advertising, as reflections of the exaggerated scale of American architecture, or as affectionate monuments to the transient culture of his adopted country. Like the best of Pop, their effect is to awaken us to the strangeness of the ordinary, to present the most routine encumbrances of our daily lives as almost miraculous apparitions. Things that we take for granted, such as a public telephone, are seen as if for the first time when their outlines are reiterated with the utmost fidelity but in an unexpected form; in *Soft Pay-Telephone* (1963) the shapes and relationships of the constituent parts are openly displayed, but the object as a whole has also taken on the forlorn and sagging appearance of an aging face, reminding us of its function as a go-between for human beings.

However great Oldenburg's concern with form and process, his reluctance to limit himself to any particular technical innovations or to engage in abstraction for its own sake was made abundantly clear with his major work of 1963, *Bedroom Ensemble*, displayed as a complete installation at the Sidney Janis Gallery in January 1964. He spent eight months with his wife in Los Angeles researching, planning and supervising the fabrication of this mock version of a motel interior that is both funny and nightmarish in its clash of patterns, kitsch taste and claustrophobic discomforts. It is an elaborate web of deceit in which every material masquerades as another, in which nothing works (not even the mirror), and in which the disproportionate perspectives built into the furniture induce a

184 Claes Oldenburg *Floor-Burger (Giant Hamburger)* 1962

185 Claes Oldenburg *Soft Fur Good Humors* 1963

186 Claes Oldenburg *Soft Pay-Telephone* 1963

sense of unease and nausea. Everything is for show – including the bed, which is hard – in a grotesque but unerringly accurate parody of the crippling obsession with appearances to which we may all be prey, but none more so than the American middle classes.

Bedroom Ensemble marked a new turn in Oldenburg's work in the explicit association between the manufactured items displayed and the system of industrial production by which specialists made the objects according to his instructions. In limiting his role to that of designer, he removed himself from the process of fabrication even more thoroughly than Warhol was to do with his *Brillo Boxes* and other sculptures in the following year. Henceforth Oldenburg designed as many as three variants of a single object – a 'soft' version, a soft version drained of colour (which he termed a 'ghost' version) and a 'hard' version – to call attention to the transformed identity of the object and to the process and materials by which it has been called into being. The lessons of manufacture by proxy were also to serve him in good stead for the large-scale commissioned projects that occupied him almost exclusively after 1969.

Bedroom Ensemble bears comparison with furniture sculptures fabricated around the same time by Richard Artschwager, who had trained as an artist with Amédée Ozenfant in New York in 1949–50 but who had operated a furniture factory in New York from 1955 after taking up cabinet-making to support himself. By 1962 Artschwager was already beginning to find ways to bring together his training as an artist with the practical skills and know-how he had acquired in industry. In 1964 he produced the first of his sculptural representations of furniture conceived in basic block-like forms covered in a veneer of synthetic material, formica, that was particularly prevalent at the time in mass-produced easy-to-clean furniture and kitchen fittings. Like the objects in Oldenburg's *Bedroom*, Artschwager's sculptures represent things of daily use at something like their normal scale, but which deny their function. After producing about thirty shipboard altars in the space of a year it had struck him that their function was as much to serve an idea as to fulfil a practical purpose: 'I was making something that, by definition, is more important than tables or chairs – that is, an object which celebrates something.'[15] He was ready now to eulogize both the signs of his culture and art as the triumph of idea over utility.

The austere simplicity of the cube shape that defines a work such as *Table with Pink Tablecloth* (1964) led Artschwager to be associated with Minimalism, a movement just emerging at that time, but his identification of the form with an ordinary object of everyday use was clearly imbued with the Pop aesthetic. Although Artschwager was both designer and fabricator of his objects, his decision to limit himself rigorously in these sculptures to industrial materials that could be purchased ready-made enabled him to eliminate any signs of his manual involvement. The self-proclaimed illusion of his image, moreover, by which the box seems transformed into a thin-legged table covered with a crisply ironed tablecloth, lies explicitly on the surface as part of the synthetic veneer from which it is composed. Just as formica was devised to be a practical material that could mimic other substances such as wood or stone, so Artschwager's sculpture was its artistic equivalent: efficient and artificial, an art of surface and honest deceit.

Artschwager's sculptures are disquieting in the way they combine their insistent physical presence as objects with the evidence of their own disappearance as images that exist only as mirages on the surface. The same can be said of the paintings he began to produce in 1964, such as *Untitled (Tract Home)*, which characteristically take as their subject standard types of contemporary American architecture as displayed in real estate advertisements. Synthetic, industrial materials are once more vital elements of the equation. All the pictures are painted with acrylic on the hard but textured surface of celo-

187 Claes Oldenburg *Bedroom Ensemble* 1963

tex, giving them a manufactured look that supports the anonymity of the building types displayed. The faithful transcription of the photograph into an enlargement of the rubbed grey surface of its newsprint source, plainly presented as a mere skin of colour, brings a disembodied quality to the image. Such works have much in common with Pop, especially in the impersonality effected by the combination of a found mass-produced image and a pseudo-mechanical technique. In their sombre colour schemes, however, their implicit engagement with illusionism and spatial depth, their air of contemplation and their sideways glances at contemporary culture as something strange and alien, they remain outside the strict perimeters of the movement: not quite Pop, not quite Minimal, not quite Conceptual, but a significant contribution to the iconography and formal language of the 1960s.

192 ONE-DOLLAR BILLS

188 Richard Artschwager *Untitled (Tract Home)* 1964

189 Robert Watts *Stamp Machine* 1961

Given the importance of common objects to the Pop aesthetic, it is one of the anomalies of the movement that sculpture did not figure more prominently in its development. It was, moreover, Fluxus artists such as Brecht and especially Robert Watts who took a Pop literalism to its extreme by presenting as their own work mass-produced contemporary articles associated with commmerce. Watts's stamp and pen dispensers of 1961 cannot be seen solely as distant relations of Duchamp's ready-mades, although the parentage is indisputable, because of the explicitness of their contemporary designs and of their function in releasing mass-produced objects in exchange for money. As with the paintings of *S&H Green Stamps* produced in 1962 by Warhol, or the images of money painted not only by Warhol but by Rivers, Phillip Hefferton and other artists associated with Pop, Watts in his sculptures uncomfortably drew attention to the status of art as a mere commodity. His life-size *Chrome Fruits and Vegetables* (1964), cast from the actual objects, were meant to be displayed in their appropriate crates, complete with marked prices, as if they were as dispensable and replaceable as the produce in a grocery shop. Related works include *Whitman's Assorted Chocolates* (1963–4). By presenting the art object as a facsimile of something real rendered useless, Watts expressed with clarity one of the fundamental propositions of Pop, by which the artist's task is to represent the juncture between shared experience and its expression in the form of a generally recognizable sign.

A more whimsical form of Pop sculpture was cultivated in the early 1960s by Marisol (Escobar), a Paris-born artist of Venezuelan parents who had settled in New York in 1950;

by 1962 she was closely associated on a social level with Pop artists, especially with Warhol, who like her was showing his work through the Stable Gallery. Her involvement with the movement was largely circumstantial, since the folkloric aspect of her early assemblages in wood and terracotta remained the salient characteristic of her art even when she turned to humorous portraits of popular figures conceived as larger-than-life toys for adults; her good-natured depiction of *John Wayne* (1962–3) as a harmless cowboy play-acting on a cut-out hobby-horse is dependent for its appeal on the quality of the artist's invention and handcrafting of the object, concerns that were far removed from mainstream Pop. Her occasional incorporation of found objects gave a Pop inflection to her more traditional aesthetic, notably in *Love* (1962), in which a human head of indeterminate sex, depicted in fragmentary form in plaster, is shown as if drinking from a real Coca-Cola bottle placed in its mouth. The title, which could refer either to the popularity of America's best-selling bottled drink or to the sexual act proposed by the insertion of a phallic shape into the mouth, supports the provocative ambiguity of the image. The explicit contemporaneity of this emblem of oral gratification has assured its place in the early history of Pop, but it remains a special case in the work of an artist essentially concerned with an affectionate rendering of the foibles of human personality.

The sculptures of the human figure that George Segal began making in 1961 also differed from Pop in fundamental ways; their hand-made look, their solemnity and sincerity of emotion, and their passionate identification with lonely and outcast members of so-

192 ONE-DOLLAR BILLS

192 **Marisol** *Love* 1962

194 **George Segal** *Cinema* 1963

193 **George Segal** *Woman shaving her Leg* 1963

ciety are all signs of a humanity and unequivocal social conscience very much at odds with the anonymity and ambiguity cultivated by most of the artists aligned with the movement. Yet Segal may have been prompted by the use of plaster casts of anatomical parts in Johns's most celebrated *Target* paintings of 1955. His links with Pop, moreover, go back to its origins in the Happenings of the late 1950s and particularly to the work of Kaprow, whom he had met in 1953. Through Kaprow Segal became aware of Cage's ideas, which he credits with confirming his desire to bring the 'real world' into his work in opposition to its exclusion by the Abstract Expressionists. Kaprow's Happenings, moreover, the first of which took place in 1958 on Segal's chicken farm in New Jersey during a picnic attended by associates of the Hansa Gallery, suggested the possibility both of working on an environmental scale and of using human figures engaged in ordinary actions as his basic sculptural material.

In the late 1950s Segal had treated the human figure in large paintings and in expressive and fragmented sculptures made of plaster and chicken wire. Two unrelated occurrences in 1961 finally impelled him to produce the first of the sculptures for which he became known, in which human figures cast from life are shown engaged in mundane activities in contemporary and often explicitly urban architectural settings. One was a visit to the Mark Rothko retrospective at the Museum of Modern Art: it struck him while watching visitors moving in front of the closely hung paintings in the small rooms of the exhibition that people had never looked more attractive than when set against the enveloping bands of colour, suggesting to him a possibility for transcending the limitations of abstraction without denying its validity as an expression of emotion through colour and form. The second factor was his discovery of a new type of medical bandage (brought to his class one day by a student married to a chemist), which he found could be soaked in plaster and thus become a sculptural material for taking casts of the human body.

Segal realized that the human figure itself could be a found object, replicated to actual size but treated as a general sign for a person – a shell of white plaster recording a particular pose or action – rather than as a specific portrait of an identifiable sitter. In July 1961 he produced his first work using this system, *Man at a Table*, for which he was his own model, with his plaster effigy seated on a real chair at an actual table. The interaction of Segal's subsequent figures with found and manufactured objects, including such historically specific things as pinball machines and modern bathroom fixtures, together with his fabrication of more complex settings from such materials, brought his work closer to Pop in 1962–3 in terms both of procedure and subject-matter. In works such as *Cinema* and *Woman shaving her Leg* (both 1963) and *The Gas Station* (1964) he not only added to the iconography of the movement but also found a way of treating the urban environment itself as part of the substance of his art, proposing a powerfully immediate identification between his chosen subject-matter and its resolution in sculptural terms.

As the mainstream Pop painters referred to material that had already been processed into two dimensions as a way of reintroducing imagery of contemporary life without engaging in illusionism, so Segal created its three-dimensional equivalent through his use of casts from real people and of actual pieces of furniture and architecture. That he chose to place such methods at the service of his humanitarian concerns, thus gradually removing him from the general ethos of the movement, was a mark of his personality and of his need to declare his moral position with regard to his subject-matter. His discoveries, however, like those of his colleagues more engaged with notions of anonymity sometimes bordering on brutality, were to have further repercussions on the development of Pop.

138

MODERNE KUNST

European Pop, 1960s and after

Pop was destined to remain essentially a movement of the English-speaking world and even more specifically of the United States and Britain. Even in Canada, where artists such as Michael Snow, Joyce Wieland and Greg Curnoe produced works closely related to Pop from the early to mid-1960s, the movement failed to take hold with the same conviction, perhaps partly because of their problematic relationship to both British and American culture, which Canadians tended to perceive as an insidious imperialistic influence that constantly threatened to subjugate their own sense of identity. Further away and for similar reasons, Pop ideas sometimes appeared in a form so substantially different that they were almost unrecognizable as part of the same movement. As one of the most widely reported trends of the post-War period, and one moreover that appeared just as the glossy international art magazines began to proliferate, Pop was quickly disseminated throughout the world by means of countless reproductions; these improved communications, together with increasingly easy travel from one country to another, soon encouraged the existence of numerous variations of Pop as far afield as Latin America and Japan.[1] Even the most inventive of these artists, however, were restricted to working within the terms of a transplanted movement or to commenting on a culture that was not their own.

By definition, Pop could flourish only in a highly industrialized capitalist society, and there was therefore no immediate counterpart to the movement in the Soviet Union, in Eastern Europe or in Communist China. In Japan, where a rapid expansion of industry and consumer culture following the Second World War provided a sympathetic context for a native Pop style, the artists most closely involved during the 1960s, such as Shusaku Arakawa and On Kawara, seem to have felt compelled to develop their work in other directions in order to resist following prototypes foisted on them from outside. Only the graphic designer Tadanori Yokoo, whose brilliantly garish and congested posters were conceived as deliberate confrontations between the style of traditional Japanese woodblock prints and images or idioms imported from America and Europe, was able to make a virtue of the situation, extending the terms of Pop by reinterpreting them from an explicitly foreign and contemporary vantage point.

Pop never developed as a coherent movement on the European Continent, although a number of artists separately contributed significantly to the expansion of its terms during the 1960s. Chief among these was Martial Raysse, who by 1962 had moved beyond his Nouveau Réaliste assemblages of found objects towards a more specifically pictorial style in which such objects were subservient to flat, mechanically derived images in bright artificial colours. In September 1962 Raysse was invited to take part in an exhibition at the Stedelijk Museum in Amsterdam, 'Dylaby (Dynamisch Labyrint)', which

196 Martial Raysse *Souviens-toi de Tahiti, France en 1961* 1963

141

made explicit the concept of the room-sized installation as a participatory setting that had been explored during the previous few years by Americans such as Dine and Oldenburg and in British exhibitions such as 'This is Tomorrow' (1956) and 'Place' (1959).[2] For this occasion Raysse recreated the carefree holiday atmosphere of his native French Riviera in an elaborate environmental work titled *Raysse Beach*, which was reassembled in November as his first one-man show in New York.[3] In it he made use of numerous forms of representation that were drawn equally from the processed images of the mass media and from the merchandise of mass production: life-size photographic images of women, enlarged from the pages of fashion magazines and tinted in bright colours, were placed among real objects (including beach toys, a plastic swimming pool and a juke-box), in a setting conspicuously labelled with a neon sign.

Raysse continued to use such procedures in subsequent works on similar themes. His images of glamorous women, generally taken from the pages of fashion or film magazines, were presented as a photographic or screen-printed surface which he then selectively coloured with garish hues of acrylic paint in flat areas. In works such as *Souviens-toi de Tahiti, France en 1961* (Remember Tahiti, France in 1961, 1963) the blatant artifice of these methods was countered by the incorporation of real objects such as a beach ball and parasol, leaving the viewer, however, in no doubt about the identity of the scene as a materialization of pure fantasy. Raysse's reliance on mechanical methods of image production made seductive by the addition of colour has much in common with the system devised at the same time by Warhol in America, although Raysse added colour as a final decorative layer while for Warhol it was a base over which he screen-printed his images in black.

Unlike Warhol, moreover, who exploited the indefinite reproducibility of the image as a way of commenting on the numbing repetitiveness of modern life, Raysse used such methods largely to suggest a disembodied quality for motifs that were destined to remain unattainable mirages. Like other European Pop artists and in distinction from most American Pop, Raysse involved himself with narrative and expressed an emotional commitment to his subject-matter. Although he produced a few portraits of film stars, including Sophia Loren and Marilyn Monroe in 1963, mostly his models for works such as *Fille aux sept couleurs* (Girl with Seven Colours, 1963) were anonymous. They are shown engaged in ordinary actions – looking in a mirror, posing for a photograph, spreading suntan lotion on their skin – or are presented as symbols of explicitly contemporary notions of beauty, complete in some cases with beehive hairstyles. The manic cheerfulness of image and colour alike is occasionally unmasked as a mere veneer behind which there lurks a potentially destructive desperation. A painting of 1963, in which a reclining model spread over three panels smiles broadly as she sweeps back her hair for the camera, is titled *Soudain l'été dernier* (Suddenly Last Summer) after the 1959 American film in which a young woman sees her homosexual cousin raped and murdered by a group of men on a beach; even in such apparently idyllic circumstances, Raysse implies, the most sinister impulses of human nature continue to operate.[4]

Similar methods were applied by Raysse to reinterpretations of well-known works of art, which he presented as outlandishly lurid reproductions updated to a notional idea of current popular taste. *Made in Japan: tableau turc et invraisemblable* (Made in Japan: Turkish and Improbable Picture, 1964) displaces the foreground group of figures from the most famous version of Ingres's *Le bain turc* (1859–63) into a setting even more flamboyant in its exoticism than that of the original; the title alludes to the unlikely meeting of cultures both in the nineteenth-century source itself and in the international dissem-

197 **Martial Raysse** *Fille aux sept couleurs* 1963

198 **Martial Raysse** *Made in Japan: tableau turc et invraisemblable* 1964

ination of the image in crude colour reproductions destined for a huge audience who would be unlikely ever to see the original painting.[5] Another painting conceived on similar principles, *Tableau simple et doux* (Simple and Sweet Picture, 1965), was made by Raysse as a cut-out photographic montage of an equally famous painting in the Louvre, François Gérard's Neo-classical masterpiece *Psyché recevant le premier baiser d'Amour* (Psyche receiving Cupid's First Kiss, 1798); preserving the essential contours of the image so that it can be recognized immediately, Raysse has brutally discarded its refinement of hue and paint quality, availing himself instead of heightened colour, a hard and mechanical surface, real objects and the glare of neon in order to exaggerate the erotic titillation of the subject freed of its veneer of 'fine art' respectability.[6]

Having introduced neon into his work in *Raysse Beach*, Raysse continued to use this explicitly urban and synthetic material as a form of homage to the artifice of modern city life in which – thanks to electricity – even night can be turned into day. Perhaps the most memorable of these works, because of its iconic simplicity of image and the mesmeric effect of its programmed sequence of coloured light, is *America, America* (1964). The outlined form of an upraised hand clutching a torch, a free rendition of the most prominent symbolic detail of the Statue of Liberty, is humorously turned into a jazzy gesture as streetwise and hip as the snapping of a musician's fingers to an irresistible rhythm. In other neon works, such as the free-standing sculpture *Aurore IV* (Dawn IV, 1966), he represented the Statue of Liberty's crown in a halo of light as an excuse for abstraction still based on his observation of a familiar and symbolically powerful object.

Raysse's wholehearted embrace of a Pop aesthetic came to a rather abrupt end in 1968, during the period of great political ferment that found its most acute expression in a succession of student riots in Paris and other cities. Disenchanted with the commodification of art – that is to say, with the very machinery of capitalism that had been so central to the meaning of his work since the beginning of the decade – he temporarily abandoned painting for a form that lent itself more directly to narrative, film-making, just as Warhol had done in America. When he returned to painting in the early 1970s his work had changed almost beyond recognition from an aggressively contemporary and urban art to one celebrating nature and tradition. However much he may himself have turned his back on his early work, his important place in the history of European Pop remains assured.

Another French painter who developed his own form of Pop in the early 1960s was Alain Jacquet, initially in a series of paintings based on the decorative format of board games; among the earliest of these were three variants of *Jeu de Jacquet* (Backgammon Game, 1961), which punned on his own name. These were among the works exhibited by him at the '2ᵉ Biennale de Paris' at the Musée d'Art Moderne de la Ville de Paris in 1961, where they were shown next to Raysse's *Hygiène de la vision* installation. Although Jacquet liked the work of the Nouveaux Réalistes he never became close to the group, not only because most of them were about ten years or more older than he but because he preferred to work within the terms of modernist painting. He immediately felt close, however, to Raysse, who was similar in age and who by this time was working more as a painter than as a sculptor. They became friends and the two most important representatives in France of an idiom that could accurately be described as Pop. Yet it was only in 1963, when British and American Pop began to be shown in Paris, that Jacquet came across other art with which he felt sympathetic.[7]

Jacquet was self-taught as a painter, but he had studied architecture briefly in 1960 at the Ecole des Beaux-Arts in Paris and as a Frenchman was aware of new trends such as

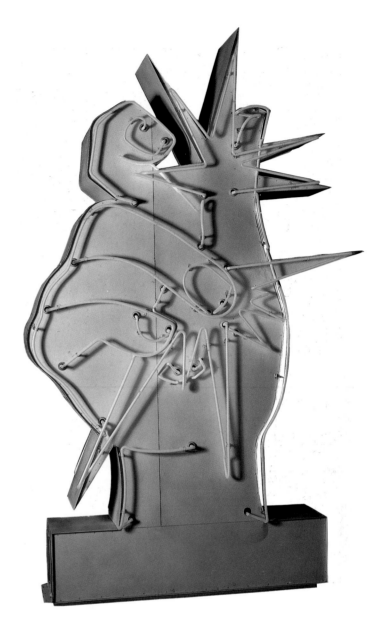

199 Martial Raysse *America, America* 1964

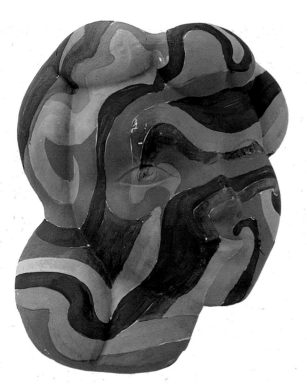

200 **Alain Jacquet** *Camouflage tête de femme* 1962

201 **Alain Jacquet** *Naissance de Vénus* 1963

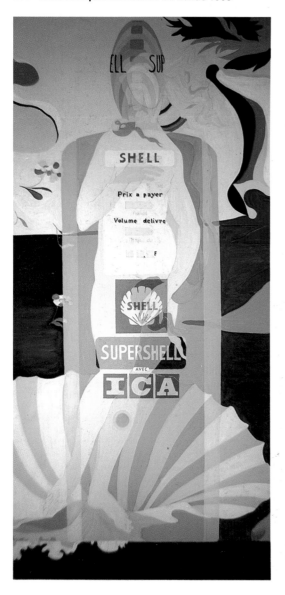

semiology earlier than most of his counterparts in English-speaking countries; many of the early critiques published about his work in France set it into the context of this philosophical method of analysis. Although it was more a question of being involved with similar ideas than with a desire to illustrate them, the works he produced during the first half of the 1960s were consequently as highly conceptual as those produced anywhere during that period. In 1962 he began a series of paintings entitled *Camouflages*: each is of a hand-painted rendering of a reproduction of a famous work partly obscured by a blatantly contemporary image or crude abstract pattern. Many were based on Renaissance masterpieces by artists such as Uccello, Botticelli and Michelangelo, but he also used modern artists (including Klimt, de Chirico, Mondrian and Picasso) and in one instance an early form of popular art, the *images d'Epinal*, in a portrait of Napoleon. In one of the first of the series, *Naissance de Vénus* (Birth of Venus, 1963) Botticelli's idealized vision of feminine beauty is brutally overlaid with the image of a Shell petrol pump, as if to overpower the fresh smell of a natural breeze with the toxic fumes of modern industry; he referred to this particular brand because the company's name and motif provided a punning contemporary counterpoint to the shell in the Botticelli.

Through such oppositional devices Jacquet suggested the extent to which cultural differences and the distance of time act as a screen between us and the great art with which we are familiar mainly in the form of reproductions. He also applied the system to contemporary images and specifically to American Pop motifs. In 1963 he painted *Camouflage Jasper Johns*, in which a flat, hand-painted rendering of Johns's *Three Flags* relief of 1958 is interwoven with the image of the RCA Victor dog and gramophone; the inscription, 'La voix de son maître' (His master's voice) refers not only to the standard phrase accompanying the motif but to Johns's already unassailable position as a contemporary master. In the same year Jacquet also paid homage to paintings such as *Roto Broil* (1961) by Lichtenstein, whom he had not yet met and whose work he knew only in reproduction. The most extreme of all the camouflage paintings, *Peinture Souvenir* (1963), was a rendering six metres wide of Lichtenstein's *Hot Dog* (1962). Painted in a number of separate panels and sold section by section at ten francs each, its guiding principle – at once structural and commercial – prefigured that of Rosenquist's *F-111* (1965).

This notion of camouflage – which, perhaps coincidentally, resurfaced as the subject of one of the last series of paintings made by Warhol shortly before his death in 1987 – was also applied by Jacquet in 1962–3 to a group of sculptures representing mostly female heads and torsos. One such work was painted over a plaster reproduction of the Venus de Milo purchased by him in the Louvre; another consisted of a reproduction of the head of Andrea del Verrocchio's equestrian portrait of Bartolommeo Colleoni with a superimposed image of a girl urinating, copied from a children's book. Several heads of 1963 were included in Jacquet's first one-man show in New York, at the Alexander Iolas Gallery in February 1964. It was at the opening of this exhibition that he met Lichtenstein, who seems to have returned Jcquet's compliments by producing his own series of female heads in 1965, although he chose glazed ceramic as his medium and rendered his stereotypical women in his characteristic style of flat colour, black outline and Benday dots.

A central concern of Jacquet's early work was the gradual dissolution of a motif that could still be read because of our previous knowledge, and it is for this reason – rather than for an essentially parodic intent – that so many of his pictures of the early to mid-1960s were based on familiar images from the history of art. The increasing complexity of the stages by which he removed a particular motif from its original context was

indicated by his anamorphic treatment of a painting-by-number rendition of Leonardo's *Last Supper*. In 1964 he painted an extended series of variations of Manet's *Déjeuner sur l'herbe* of 1865, in which he introduced a new way of working that extended the ideas he had been exploring during the previous two or three years. His choice of starting-point was clearly carefully considered, since Manet's painting, executed almost exactly a century earlier and occupying a critical position in the development of modernism, was itself based on a reproduction of a painting by another major artist; just as Manet had brought up to date a group of figures from Raphael's *Judgment of Paris*, as engraved by Marcantonio Raimondi in 1510, so Jacquet now rephrased Manet's painting using his own friends as models and the contemporary equivalent of engraving – photography – as his intervening medium.[8]

Jacquet thought of his role in these works as that of a film director, placing his actors in a set and then photographing them, the only major difference being that he was producing a still rather than a moving image. In order to obtain a particular quality of surface and to make direct use of his photographic source, he decided to avail himself in these pictures of a mechanical process, screen-printing. Having made the screens, there seemed to him to be no good reason to produce only one painting, since it was possible to print almost indefinitely from them, so he produced dozens of variations in various sizes and formats. He regarded each work, however, as a separate object – like one of many variants of a new model of car – rather than as part of an edition, and unlike Warhol he did not repeat the image in a single work.

Although in 1965 Restany devised the term Mec Art (from Mechanical Art) to describe works by Jacquet and other artists (including Rotella, the Belgian Pol Bury and the Greek Nikos) based on the appropriation of photographic images, Jacquet maintains that while he was happy to use mechanical procedures he was not obsessed by them. He liked the simplicity of the process but was prepared to use other methods to achieve a similar fragmentation of an image derived from photography. Some paintings, for instance, were done with rollers and stencils; others, if they were very large, such as a 6 x 18 metre version of Velásquez's *The Rokeby Venus* (1650–51), had to be painted by hand, but he considered the process to be no less mechanical since it was also based on a pre-ordained system that simply had to be carried through to its conclusion. His interest in screen-printing was not in a machine-like perfection or anonymity for its own sake, but in the perceptual ambiguities made possible by the superimposed patterns of colour. This was particularly the case in the *Déjeuner sur l'herbe* series and in subsequent works based on a similar photographic recreation of other well-known paintings in a contemporary guise, such as *La Source* (1965), a parody of the 1856 picture by Ingres in the Louvre. If viewed from too short a distance, the image gives way to abstract dots of different colours; if seen from too far away, the outlines begin to look fuzzy and the image again begins to break down. Only from a particular distance, depending on the size of the painting and of the elements from which it is composed, does the motif begin to approximate the clarity of definition of its photographic source.

The intertwined themes of Jacquet's Pop works – that of the ambiguity of vision and of the dialogue between what is 'fake' and what is 'authentic' – gradually took him into more purely conceptual areas and away from Pop imagery. His involvement with surface led him to make a group of sculptures using the language of braille, a tactile equivalent of the dot patterns that had featured in his paintings. In 1968 he produced works such as *Parquet* (Floor) and *Sacs de jute* (Burlap Sacks), which consist respectively of a plank covered in a veneer of fake wood and of bags made from a cotton cloth printed with a

202 **Alain Jacquet** *Le Déjeuner sur l'herbe* **1964**

203 **Alain Jacquet** *La Source* **1965**

145

PASTORALE_

204 Hervé Télémaque *Pastorale* 1964

205 Bernard Rancillac *Private Diary of a Foot* 1965

rough pattern imitating burlap. In their artifice they highlight the relationship between invention and reality, between the art object and the prosaic thing that it resembles in such an uncanny manner.[9]

From 1969 Jacquet made his home more in New York than in Paris, but if it was a shared sense of purpose that had taken him to America, his relative isolation there as a Frenchman seems only to have encouraged him to move further into his own investigations and to abandon virtually all vestiges of his early Pop manner. He returned properly to painting in the early 1970s with a series based on photographs of the planet Earth taken from outer space; the appeal of the subject, which could be described as landscape writ large, lay as much in the fact that such images had only recently become available as in the suggestion of an alliance between art and science. His most overt later involvement with Pop themes occurred when he reverted in 1988 to the *Déjeuner sur l'herbe*: taking as his starting-point the same colour photograph that he had used for his 1964 screen-printed variations, he replicated the image on a canvas measuring 1.98 x 2.7 metres using a newly available process of four-colour laser printing by computer, so that the resulting work could be described accurately as both a painting (since it consists of a layering of colour on canvas) and a photograph.[10] Such marriages of processed images and mechanical techniques, while avowing Jacquet's Pop credentials, were destined to remain exceptions in his later work.

A great variety of Pop-related work emerged throughout Europe from 1964 to 1970, gathered together in thematic exhibitions such as 'Mythologies Quotidiennes' (Everyday Mythologies, 1964), 'La Figuration narrative dans l'art contemporain' (Narrative Figuration in Contemporary Art, 1965) and 'Bande dessinée et figuration narrative' (The Comic Strip and Narrative Figuration, 1967).[11] As the terms suggest, the Europeans by and large used contemporary images – even those from comic strips, the cinema and other mass-media sources – as starting-points for forms of narrative painting that were in many respects at odds with the essentially static and emblematic quality of mainstream Pop in America and Britain.

Hervé Télémaque, one of the best-known and most influential of these Continental painters who emerged in the early 1960s, exemplifies the distance between such work and that of the few others, such as Raysse and Jacquet, whose art can be placed more squarely within the context of Pop. Télémaque quickly progressed from the private imagery and quirky cartoon-like inventions of his early paintings such as *Portrait de famille* (Family Portrait, 1963) to a more overtly Pop idiom in works such as *Pastorale* (1965), in which familiar images are conveyed in clean outlines and flat areas of unmodulated colour. In his characteristic outlined images of objects and figures, however, he remained interested above all in relaying mysterious conjunctions of fragmented motifs, and as such can be said to have developed a form of late Surrealism couched in an apparently neutral and impassive language derived from Pop.

Comic strips were also referred to in the early works of another Frenchman, Bernard Rancillac, but in place of the single frame and deliberate disruption of narrative content in paintings by Americans such as Warhol, Lichtenstein and Ramos, he was specifically interested, in pictures such as *Private Diary of a Foot* (1965), in exploiting the format for its story-telling possibilities. In his subsequent works he, too, moved closer to Anglo-American conceptions of Pop, notably in a series of paintings on contemporary political themes – with reference to the Vietnam War, to the Cultural Revolution in China, to the Palestinian struggles and to the American Black Panther Party – that he made in the late 1960s and early 1970s. Flatly executed in the bright, synthetic colours of acrylic paints

146

and with the pronounced tonal contrasts and frozen gestures of their obviously photographic sources, these paintings have the stark immediacy and plain legibility of mass-produced political posters. Although the propagandistic tone of these works is presented as an attribute of the found material from which Rancillac culled his imagery, the impassioned identification with particular causes introduced a subjectivity of purpose that again was at odds with the apparent neutrality cultivated in most mainstream Pop.

Pop entered the vocabulary of the Spaniard Eduardo Arroyo or the Italian Valerio Adami, for example, primarily as a stylistic element. In Adami's early paintings such as *L'ora del sandwice* (Sandwich Time, 1963) he had employed a fractured and expressionist comic-strip technique similar to that of Télémaque, but by the mid-1960s he had developed his characteristic language of forms in which a strong black outline encased flat areas of vivid colour. His essentially graphic technique, derived in some measure from the work of Lichtenstein and Caulfield, was primarily used, however, to convey parts of mysterious and sometimes disturbing episodes, as in *Gli omosessuali – Privacy* (The Homosexuals – Privacy, 1966).

For others, such as the Germans Gerhard Richter, Konrad Lueg, Sigmar Polke, Peter Klasen and Wolf Vostell, the Icelandic Errò, the Swiss Peter Stämpfli, the Spanish artists of Equipo Crónica (Chronicle Team) or the Frenchman Jacques Monory, imagery and technique were more firmly grounded in popular mass-produced sources. For example, Monory's *Meurtre* (Murder) pictures of 1968, his first sustained series of paintings, make clear their derivation from the cinematic conventions of *film noir* detective movies through their imagery and photographic technique alike. All these pictures were painted in an essentially monochromatic blue, a painterly equivalent to the dense black tonalities of 1940s films, as a means of stressing their artifice in conveying an imaginary scene; onto this surface, however, Monory placed real mirrors riddled with bullet holes as a way of involving the spectator as an unwitting accomplice and of introducing a fragment of reality, of the here-and-now, into an otherwise invented situation.

The use of mirrors for such purposes was probably suggested to Monory by the work of the Italian Michelangelo Pistoletto, who as early as 1962 had attached realistic representations of life-size figures to reflective steel plates so that the environment in which the picture was hung – including the image of the spectator gazing at the surface – was as much a part of the work as the marks actually on that surface. From 1964 he used photographic representations of people, silk-screened on tissue paper, to achieve an even more exacting illusion of reality. Although Pistoletto was primarily involved with issues of perception, his use of mechanical procedures to heighten the literalness and factuality of his images brought his work within the realm of Pop, as did his belief in the artwork as a collaborative venture between artist and audience.

As early as 1962, in works such as *Marilyn Monroe (Marilyn Idolo)*, Vostell had begun to manipulate the found images used in his *décollages* by partly obliterating them in smears of paint in the manner of Rauschenberg. By 1965 he was using photographs, silk-screened photographic images and real objects as a means of juxtaposing and layering found images in works such as *Car Crash* (1965–7), where the horrific nature of the subject-matter is held in abeyance by its co-existence with the sweet colouring, abstract textures and decorative pattern that first attract one's eyes to the surface. In other works of this period, such as *Wir waren so eine Art Museumsstück* (We were a Kind of Museum Piece, 1964), he likewise combined mechanical or semi-mechanical techniques with a variety of media images, here a newspaper headline, photographs of street fighting and a repeated image of Lee Harvey Oswald being assassinated.

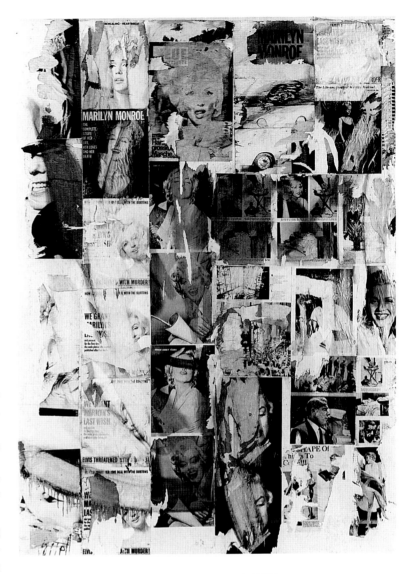

206 Wolf Vostell *Marilyn Monroe (Marilyn Idolo)* 1962

207 Valerio Adami *Gli omosessuali – Privacy* 1966

209 Wolf Vostell *Car Crash* 1965–7

208 Michelangelo Pistoletto *Vietnam* 1965

210 Gerhard Richter *Verkündigung nach Tizian (343/1)* 1973

211 Gerhard Richter *Terese Andeszka* 1964

By these means he arrived at a sense of the apparently random violence of life in the 1960s. Klasen also incorporated rather mechanistic renderings of real objects in his pictures, and sometimes even the objects themselves, but generally he did so in order to heighten the sexual connotations of the images of women featured as his primary subjects; although his works of the late 1960s closely resemble certain aspects of American Pop, his art remained at odds with the impassive stance of its prototypes because of its fetishistic tenor.

Like Vostell, Richter and Lueg each relied on blatantly photographic images, although they replicated them in paint in wholly different ways: Richter , as a painter of extraordinary facility, used conventional brushes to approximate the surface of slightly out-of-focus black-and-white photographs, while Lueg exaggerated tonal contrasts to achieve a poster-like immediacy of image. In the mid-1960s Polke, who like Richter and Lueg was a student at the Staatliche Kunstakademie in Düsseldorf, also devised a quasi-mechanical system for replicating colour photographs in his oil paintings, using superimposed patterns of dots reminiscent of half-tone printing. In 1963 they invented the term Capitalist Realism to describe their ironic embrace of materialism; it was a deliberate echo of the official Socialist Realism of the Communist states, as both Polke and Richter were from East Germany. It was only in the most general ways, however, that the work of these three artists could be taken as part of a common assault on the conventions of representational painting. All three were regarded in the early literature of Pop as minor followers of the movement, if they were mentioned at all, but Richter and Polke emerged in the 1970s as among the most important post-war painters in Germany Lueg gave up painting and under the name Konrad Fischer became a powerful dealer in Düsseldorf, where from 1970 he gave one-man shows to both Richter and Polke.

In some of his earliest photographically derived paintings, such as *Terese Andeszka* (1964), Richter dutifully copied not only the found image but also the accompanying fragments of text – in this case, one presumes, part of its caption in a magazine – as a way of acknowledging that the motif has been lifted entirely from a printed source. Similar methods were used by him in other paintings of this period, such as *Ferrari* (1964) and *Grosse Sphinx von Giza* (The Great Sphinx of Giza, 1965), which also conform to a classic Pop conception of appropriated images conveyed in an impersonal machine-like technique evocative of their mass-produced origins. By and large, however, Richter did not base his paintings on photographs already familiar to a wide public, as was the case with Warhol's film-star portraits or grisly disasters. Instead he favoured more ordinary private snapshots, at once intimate in their origins and anonymous in that their protagonists can be recognized only by the few people directly involved in the photography.

Shortly after this extended series of paintings Richter produced a group of pictures radically different in appearance – abstracts based on simple grids, such as *Sechs Farben* (Six Colours, 1966). More precisely, they were paintings that appeared to be abstract but were in fact representations, on a grossly enlarged scale, of another type of printed found object: commercial colour charts. Such swings in the appearance of his work, based on the application of strict principles to different types of material, remained a constant feature of Richter's art. After painting a series of canvases conceived explicitly as recreations of past masterpieces viewed through the filter of photographic reproduction, such as *Verkündigung nach Tizian (343/1)* (The Annunciation, after Titian, 1973), he concentrated on two separate groups of pictures. Moving deftly from an apparently conventional realism in highly detailed and atmospheric landscapes to abstract

paintings of coloured, textured surfaces, he insisted with great subtlety on the conceptual continuity of works in such seemingly opposite styles.[12]

The landscapes painted by Richter in the 1970s and 1980s, always starting from photographs, are characterized not by the crispness of detail sought by the Photorealists but by a surface of disembodied colour in which the identity of the image is lost when viewed from nearby; only when seen from a distance or in reproduction does the image begin to come into focus and to achieve its full mimetic purpose. The 'abstracts', which can more properly be described as pictures of abstractions, work in a similar way. At first, they appear to be painted impulsively with broad sweeps of the arm in the Neo-expressionist manner then current, but the individual marks, when scrutinized, emerge as the result of careful deliberation, with the same fuzziness of photographic enlargement characteristic of his landscapes. Placing photography always at the centre of his debates about the function of representation in painting, Richter elaborated an increasingly sophisticated stance that remained clearly rooted in the principles and methods of his Pop works of the 1960s.

While evading the constrictions of a single style, Richter maintained an elegance of conception and delicacy of touch at all times. By contrast, Polke declared his freedom from a traditional conception of fine art by addressing himself to the most undignified pictorial conventions he could find and by mimicking them with a crudeness and brutality that was extreme even by the standards of American Pop. More than a decade passed before early paintings by him such as *Plastik-Wannen* (Plastic Tubs, 1964) and *Liebespaar II* (Couple II, 1965) could be appreciated as anything more than badly painted and misguided responses to Pop. Both these works have a deliberately rough and unfinished look that seems even more alarming because of the apparent effort that has gone into composing their obviously unworthy elements into a pleasing decoration. We are shown, for instance, that the plastic tubs have first been carefully outlined against their flat coloured backgrounds, and that thought has been given to the rigorous geometric design of the surface and to the disposition of the images as coloured shapes. Given this evidence of planning, the apparent ineptness of the result is shocking, with the unconvincing and inconsistent modelling and a patent refusal even to secure a clean, unsmudged edge for the pink and blue areas against the unprimed canvas. The fact that one of the tubs and an entire rectangle have been left unpainted suggests that the artist himself – by all appearances a rank amateur – has given the picture up as a bad job. Yet the painting parades its shoddiness with a mixture of pride and arrogance, and from this most unpromising and banal subject-matter and crudeness of technique Polke has contrived to present cheap artefacts with a dignified presence within a simple but somehow alluring decorative scheme.

Liebespaar II looks similarly bungled, with its truncated figures, anatomical distortions, inconsistencies of scale, crude tonal contrasts, insensitive paint handling and puzzling mixtures of technique. As a demonstration of what can go wrong it could hardly be bettered. Are the blotches of red and yellow paint along the left edge meant to represent a curtain, or should they be taken as the impatient marks of a painter in the middle of a tantrum about to destroy an unsatisfactory result? If neither possibility ultimately seems convincing, this is because we know from the context that the marks have been placed there deliberately as part of an overall strategy in assaulting conceptions of good taste and 'finish'. To read anything else into them, to imagine even momentarily that they might be evidence of a haphazard process by which the picture has been called into life, would be to assume a different authorship for the work. An idea intrinsic to much Pop has been that of

212 Sigmar Polke *Palmen* 1964

213 Sigmar Polke *Moderne Kunst* 1968

Moderne Kunst

214 Sigmar Polke *Berliner* **1965**

a collaboration between low and high culture; Polke has simply taken this to an extreme by subjecting his artistic identity so completely to the conventions of bad painting that it is possible to forget that he remains in control and that such astonishing coarseness has been deliberately pursued in order to taunt us.

Influence is often a question of misunderstanding – sometimes deliberately – someone else's intentions. The strength of Polke's work, which he carried through to his far more sophisticated paintings of the 1970s and 1980s, seems to have originated in his will to take American Pop artists, especially Lichtenstein, at their word. In an interview published in November 1963 Lichtenstein explained that 'Pop Art looks out into the world; it appears to accept its environment, which is not good or bad, but different – another state of mind. "How can you like exploitation?" "How can you like the complete mechanization of work? How can you like bad art?" I have to answer that I accept it as being there, in the world.' Noting that he had developed his concept of Pop out of a desire 'to get a painting that was despicable enough so that no one would hang it', Lichtenstein said, 'The one thing everyone hated was commercial art; apparently they didn't hate that enough either.'[13] In retrospect, however, it appears that Lichtenstein, for whatever reason, could not bring himself to make work that did look 'despicable'. Even when basing his pictures on the crudest of sources, his innate elegance of draughtsmanship and sensitivity to surface aestheticized them and returned them to a level that could be recognized as high art. Polke, testing the theory to the limit, had no such compunctions. Much of his 1960s work in particular is genuinely raw and ugly, and paradoxically it is this willingness to abandon the last vestiges of good taste and skill that gives these pictures their power and strange attraction today.

From 1963 to 1969 Polke worked intermittently on a series of paintings based on the pseudo-mechanical replication of photographs: the generic term he used was *Rasterbild* (screen-picture) because of the way in which the image is reconstructed by a grid of coloured dots suggesting a grossly magnified half-tone reproduction. The procedure clearly relates both to Lichtenstein's use of the Benday dot and to Warhol's assimilation of media photographs through photo-silkscreens, as was also the case with the hand-painted copies of newspaper photographs made in 1963–4 by the British artist Gerald Laing. The media images Polke used for these paintings were often deliberately bland and uneventful. Some, like *Junge mit Zahnbürste* (Boy with Toothbrush, 1965), indicated sources in advertising; others, such as *Berliner* (1965), *Bunnies* (1966, depicting a group of four Playboy 'bunnies') and *Dublin* (1968, an anonymous street scene that could as easily represent any other city), allude to the kinds of images in magazines and newspapers which we might easily flip through every day without noticing. The cumulative sense conveyed is of a world so familiar that we hardly take any notice of it; whereas Warhol favoured the instant recognition and glamorous attraction of portraits of the famous or the dramatic potential of cataclysmic scenes of violence, Polke's media-derived pictures present a distinctly low-key vision of modern ennui.

Another type of picture with which Polke concerned himself from 1964 to 1971, the *Stoffbild* (fabric picture), also constituted a reaction to Pop strategies with found material. Each of these pictures, such as *Palmen* (Palms, 1964), was painted on a piece of cloth chosen for its decorative pattern and used as a stereotypical 'modern art' background against which to place an equally trite pattern or image. While thus extending the notion of the painting as a real object established by Johns and other Pop artists, Polke shifted attention to the element of parody so as to challenge the belief in invention and authenticity that still prevailed among the avant-garde. These and other 1960s works by Polke,

215 Sigmar Polke *Plastik-Wannen* 1964

216 Equipo Crónica *Latin Lover* 1966

217 Eduardo Arroyo *With Deference to Traditions* 1965

such as the slapdash travesty of gestural abstraction prominently and disrespectfully labelled *Moderne Kunst* (Modern Art, 1968), declared in no uncertain terms his belief that an artist could best become free of the limitations of style by making knowing reference to every pictorial convention available without seeming to subscribe to any with sincerity. Taking his cue during the 1970s from the late work of Picabia, in which contradictory conventions jostle against each other with uneasy humour, Polke was increasingly instrumental in preparing the way for an attitude that became second nature to many artists during the 1980s. If the history of world art was to become an artistic mega-store from which assiduous shoppers could pick and choose as they pleased, such a consumerist notion of style itself as an expendable commodity would have been unthinkable without the supermarket mentality that emerged from Pop in the work of artists such as Polke.

Similar tactics were employed by other European artists during the 1960s, such as the Spanish group Equipo Crónica. This partnership, consisting of the painters Rafael Solbes and Manuel Valdés, was formed in Valencia in 1964 after an exhibition of contemporary Spanish art in which they had both taken part; they continued to work together until Solbes died in 1981. The very idea of working collaboratively, with the personality of each artist subjugated to the identity of their jointly produced work, was evidence of their predisposition to the tenets of Pop. One of their earliest works, a large linocut entitled *America! America!* (1965), is an ambivalent homage to Pop art and popular culture: within a grid format of squares 5 rows high and 4 rows across they placed 19 identical profile heads of Mickey Mouse, with the randomly selected twentieth space occupied by a simplified image of an atomic mushroom cloud. In following the serial format of Warhol's work and the cartoon images favoured by Lichtenstein and other American painters – in this case, the Walt Disney character that, more than any other, had come to symbolize American culture – they built on the strengths of both the style and the motifs while also turning them satirically against themselves.

With *Latin Lover* (1966) the Equipo Crónica created a more affectionately kitsch classic Pop image. The uncanny similarity of this male head to that in Polke's *Liebespaar II* of the previous year, whether directly related or simply due to their shared reference to a stylized and outdated form of depiction, demonstrates the extent to which the language of Pop had by this early stage become an international one, although *Latin Lover* has a specifically Spanish inflection. By showing a stereotyped figure perceived as representing their own culture, and by setting his boldly delineated and colourful profile against an equally absurd exotic landscape of swaying palm trees, moonlit waters and a sky studded with five-pointed stars, they direct their irony equally against their self-image and against the misapprehensions of foreigners.

The Equipo Crónica made much play from the late 1960s on parodies of art historical styles and on particular works familiar to a general public from reproductions. They shared such methods with Eduardo Arroyo, a slightly older painter whose disdain for the rigidity of standard styles was exemplified in early pictures such as *With Deference to Traditions* (1965), where a rural landscape of banal picturesqueness is changed into three equally trite schemes of pointillism, geometric abstraction and an impastoed expressionism reminiscent of the late work of Maurice de Vlaminck. As early as *Mi padre Velásquez* (My Father Velásquez, 1964), Arroyo had dipped into the well of art history as a source of images with which he could define his own situation, and in 1967 he produced canvases such as the punningly titled *España te Miro* (Spain I am watching You), in which he caustically parodied the work of one of Spain's most venerated modern painters, Joan Miró.

Like Arroyo and like the Icelandic painter Errò, much of whose prolific production consists of outlandish meetings of art historical or other found sources conveyed in a bold but homogenized poster-like technique, the Equipo Crónica used a wide range of past art as seen in reproduction to emphasize that they felt marginalized as artists but that the entire history of art was nevertheless as available to them as to others. This state of affairs – by which their own position is presented as both a predicament and an advantage – was one context for Europeans to work persuasively within Pop terms. In the work of Equipo Crónica, such references were drawn initially from Spanish high culture at the time of their country's political ascendancy in the seventeenth and eighteenth centuries, for example from Velásquez, El Greco and Goya. Then they gradually turned their attention to the succession of styles in the twentieth century, refering to Cubism, Expressionism and other movements, punctuated by raids on specific images by such major figures as Cézanne and Picasso. In 1969 they produced an entire series based on Picasso's *Guernica* (1937) – which had long since acquired an iconic status as an outcry against the Spanish Civil War – to explore the transformation of an image and its meaning.

218 Errò *Venus* 1975

The Swiss artist Peter Stämpfli produced his first Pop paintings in 1963, such as *Glacière* (Refrigerator) and *Chaussure de luxe* (Luxury Shoe), choosing a banal object as displayed in the most unimaginative of advertisements and painting it with no apparent refinements of composition in an exaggeratedly bland technique. Although his methods and choice of imagery suggest an awareness of Warhol, Lichtenstein, Wesselmann and the use of enlargement and close-ups by Rosenquist, one may also cite a specifically European source for his adoption of the methods of the sign-painter: the work of Magritte, as suggested specifically in *Bond Street* (1964), in which a man's hand is shown lifting a bowler hat. Stämpfli became progressively involved with gross enlargement and with a mechanical and impersonal surface, for example in *Rouge Baiser* (Red Kiss, 1966), a shaped canvas 2.4 metres wide representing a pair of female lips, apparently predating the first of Wesselmann's pictures in a similar format.[14] After painting larger-than-life fragments of front and rear views of cars in 1966, he treated such images on an ever extending scale to arrive at a genuine and almost unbearable level of banality.[15]

The variety in European Pop could not be better exemplified than by the contrast between Stämpfli's paintings – in which a single contemporary image, virtually meaningless in itself, is presented in its most immediately recognizable form on a gigantic scale – and the preference demonstrated by the Swedish artist Oyvind Fahlström for a complex fragmentation of form and imagery that allows his works to be experienced only slowly and in ever changing permutations. Born in Brazil to Swedish and Norwegian parents, Fahlström moved to Sweden in 1947 at eighteen and settled in New York in 1961 but continued to make frequent visits to Sweden and to spend summer holidays in Italy. Although he became a close friend of Oldenburg, Fahlström never fitted comfortably into the mainstream of American Pop in spite of his reference to comic-strip imagery and techniques of drawing in paintings such as *Sitting . . . Six Months Later (phase 4)* (1962) and *Performing K.K. No. 2 (Sunday Edition)* (1963–4), one of several works based on the character known as Krazy Kat. As in the case of painters working in France, such as Télémaque and Rancillac, Fahlström appears interested not so much in the stylistic potential of such sources, or even in their identity as signs of contemporary culture, as in their narrative potential. Many of these early paintings were conceived as 'variables', with a number of the elements attached to the surface only with magnets so they could be moved by the spectator to create new pictures whose final form could never be fixed.

MODERNE KUNST

219　Peter Stämpfli *Caprice* 1968

220　Peter Stämpfli *Gala* 1965

221　Oyvind Fahlström *Performing K. K. No. 2 (Sunday Edition)* 1963–4

In slightly later works such as *Roulette, Variable Painting* (1966) Fahlström introduced photographs and other ready-made materials while still stressing the role of the spectator as an active participant and the relationship of the elements as constantly in flux. The diversity of the imagery used in *Roulette*, and the sense of randomness that pervades much of the material's organization, relates Fahlström's work more to traditions of Dada and Surrealist collage than to Pop, with which he was associated by circumstance rather than design. The single aspect in which Fahlström most clearly developed one of the standard principles of Pop was his dedication to collaboration, particularly in assemblages such as *The Little General (Pinball Machine)* (1967) and *World Politics Monopoly* (1970), which he conceived explicitly on the lines of board games and games of skill for teenagers. If the work of art was presented by him, however, both as the product of his

222 Arman Vénu$, Poupée dollars 1970

223 Marcel Broodthaers Casserole et moules fermées 1964

own play and as an invitation to the spectator to play with him, the implicit partnership and mutual dependence of artist and audience also carried with it a moral and political responsibility. This was reflected not only in his references to the Cold War and to the power struggles between one country and another, but more generally in the idea that only through our active and ceaseless involvement are we able to exercise any control over our lives and our environment.

The progress of Pop ideas in later Continental art, as in its American and British counterparts, continued to return to the common object and to the question of reproduction. Arman, who of all the Nouveaux Réalistes remained most faithful to the system of recycling mass-produced objects that had characterized the first incursions of Continental artists into Pop territory, remained particularly well placed to elaborate such themes. After settling in New York in 1963 he tended for his 'accumulations' to favour newly purchased objects rather than used ones, as had often been the case in his Paris work. In *Vénu$, Poupée dollars* (Vénu$, Dollar Doll, 1970) he also began to use moulded containers in transparent polyester, rather than simple box-like shapes, to establish a relationship between the outer image – here identified literally with human skin – and the internal contents. This equation between feminine beauty and commercial exploitation formed part of a series in which a youthful female torso was given a specific and often sexually charged identity. In *Venus of the Shaving Brushes* (1969), for instance, sexual union is suggested through the alliance of feminine smoothness and masculine beards, while in *Cold Petting* (1967) the body is filled with mannequin hands that appear to be groping her thighs and breasts from within, an even more disturbing image of penetration and invasion. The connotations of these images, although rooted to some extent in Surrealism, demonstrated unequivocally the continuing flexibility of purpose in Pop strategies.

Pop did not develop in as consistent and linear a fashion on the Continent as in the United States or Great Britain. While English originators of the movement such as Blake, Hamilton and Phillips and the mainstream American Pop artists such as Warhol, Lichtenstein, Rosenquist, Oldenburg and Wesselmann continued to build systematically on the principles of their early work, some of the Europeans who conformed most closely to the tenets of classic Pop, such as Jacquet and Raysse, had moved in very different directions by the end of the 1960s. Yet Pop, sometimes in a drastically revised form, remained an important force in European art. It was, for instance, a visit to a Segal exhibition in Paris in 1963 – followed almost immediately by seeing work by Dine, Lichtenstein and Oldenburg – that led the Belgian Marcel Broodthaers to produce his first art objects just before his fortieth birthday.[16] The immediate impact that Pop had on him is evident in the announcement for his first exhibition, held at the Galerie St Laurent, Brussels, from 10 to 25 April 1964, in which he declared with provocative wit: 'I, too, wondered whether I could not sell something and succeed in life . . . Finally the idea of inventing something insincere crossed my mind and I set to work straightaway.'[17] Among the first such works was *Casserole et moules fermées* (Casserole and Closed Mussels, 1964), in which he filled a real pot owned by his family with mussel shells supplied by a restaurant. Although there is a Surrealist aspect to the absurdly high stack of shells fixed into place under the casserole lid, the image – representing a Belgian national dish as common and popular as the American hot dog or British fish and chips – was presented incontrovertibly as an emblem of (European) mass culture.

In the twelve years until his death in 1976 Broodthaers developed a highly personal way of making art allied to Conceptual art and rooted in a European tradition of philo-

224 Oyvind Fahlström *World Politics Monopoly* 1970

sophical enquiry exemplified by two artists, Duchamp and Magritte, who became his most important models. In a production that was astonishingly varied in form – including assemblages of objects or photographs, hand-written and printed texts, drawings, books and editioned prints incorporating reproductions of works of art and other found images – Broodthaers nevertheless continued to examine themes of reproduction and replication, of originality and authenticity, that were central to Pop and that constituted some of its most important legacies.

RANDOM ILLUSION

British Pop from the 1960s to the 1980s

The course taken by British Pop artists during the 1960s was in many cases far more idiosyncratic than that followed by their American counterparts. Although an impersonality of technique and a range of images based directly on found sources or on known popular forms characterized Pop of this period on both sides of the Atlantic, British artists in general were reluctant to engage with the increasingly mechanistic procedures employed by the Americans and preferred to choose their subject-matter with a mixture of affection and irony rather than with a matter-of-fact neutrality and detachment.

The wilfully old-fashioned image presented by Patrick Caulfield in *The Artist's Studio* (1964) vividly demonstrates his suggestive ambivalence about the contemporaneity of his work in relation to both art history and the expectations of an audience with fairly fixed ideas about modern art. Laid out before us are various clichéd images of modernism and of the painter's vocabulary and materials: a red artist's palette occupies the central position, accompanied by a standard biomorphic design, geometric shapes and hard-edge pictorial devices and set against an exotically decorated pot and a Mediterranean harbour view. In the lower-right corner of the picture, which is conceived as a frieze-like sequence in a format reminiscent of decorative murals, is a scribbled line that one takes to be the artist's signature. The blatant artifice of this illegible flourish helps to give the game away, for this of course is meant to be recognized as a kind of cocktail of 'modern' pictorial elements with strong echoes of 1950s kitsch design.

Every feature of *The Artist's Studio* betrays its falseness: for example, the coloured rectangles clearly have no function except as decorative devices and a palette would be of no use to an artist working with gloss paint in large flat areas of unmodulated colour. Although one would not know without being told that certain details were derived from unlikely sources – the horizontal blue band was taken, for example, from a postcard of a Minoan fresco, while the black biomorphic swirls and spots came from an insignificant detail on a cheaply printed colour advertisement – it is plain enough that we are being presented with a debased form of modernism reminiscent of 1930s abstractions.[1] The Mediterranean view, presented at an angle and framed by a linear border along the top and right-hand side so that it is obviously a picture within the picture, corresponds to a common and by that time anachronistic conception of an artistic locale; the sketchy notational style with which it is depicted, moreover, complete with ragged 'spontaneous' brushmarks in different colours, itself corresponds to a stereotyped and bastardized notion of modernist technique ultimately descended from the Fauvism of French painters such as Dufy. By presenting all the elements in the painting, including the signature, within quotation marks, Caulfield disclaims responsibility for them except as components of his own highly synthetic composition. Paradoxically, it is through this removal of

226 Patrick Caulfield *The Artist's Studio* 1964

225 Patrick Caulfield *After Lunch* 1965

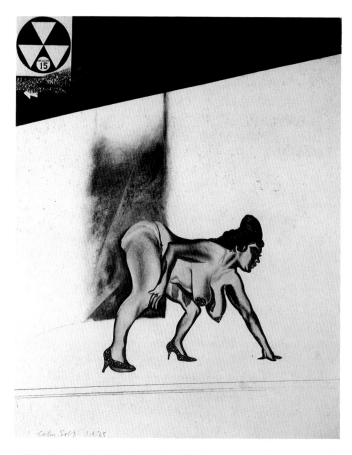

227 Colin Self *Fall-out Shelter 5. She's got everything she needs, she's an artist. She don't look back* 1965

228 Colin Self *Two Waiting Women and B58 Nuclear Bomber* 1963

himself and denial of invention that he makes the picture his own as an artefact unlike any seen before, giving a new life to apparently outworn motifs and procedures reconstituted with considerable panache and affection.

Although British Pop of the early 1960s emanated primarily from the RCA, similar assumptions also underlay the work of young artists such as Colin Self, who studied at the Slade School of Fine Art, London, from 1961 to 1963 with, among others, Terry Atkinson. Inevitably Self got to know Hockney and the rest who were at the RCA during the same period, but he was never completely comfortable with the Pop label because of its implied celebration of modern materialist society. For him Pop represented both a specifically working-class rebellion against obscurantism – British art schools in the 1960s were, it should be noted, the training ground for John Lennon, Pete Townsend, Keith Richards of the Rolling Stones, Ray Davies of the Kinks and numerous other pop musicians who did so much to define the period and the aspirations of their generation – and, as he put it, 'the first movement for goodness knows how long, to *accept* and reflect the world in which it lives' in its open embrace of twentieth-century iconography.[2]

Self's work of the 1960s was generally explicitly dark in mood, however, compared with that of other Pop artists. Convinced about the planet's imminent destruction by nuclear war, he saw his task as one of leaving a record of a violent society brought to its end by its inability to harness constructively its own technological inventions.[3] At once fascinated and repelled by man's aggressive and competitive instincts, he gave form to his anxieties in obsessively worked drawings in ballpoint pen, such as the *Mortal Combat* series initiated in 1963 with *Wrestlers*. In many of these he used the death struggles of animals, such as a *Snake and Eagle (Mortal Combat No. 4)* (1966) or *Lion killing Zebra (Mortal Combat No. 6)* (1966), as metaphors of the aggressive and self-destructive forces that rule human behaviour. Another memorable set of drawings made in the mid-1960s, mainly as a result of visiting New York, was called *Fall-out Shelter*, in which he used an unconventional combination of pencil, coloured pencil, fluorescent paper and glitter to create a stark and foreboding atmosphere. He borrowed the title for one of the best of these, *She's got everything she needs, she's an artist. She don't look back* (1965), from the opening lines of a Bob Dylan song released earlier that year, 'She Belongs to Me', which continues: 'She can take the dark out of the night-time And paint the day-time black'.[4] Self is now at pains to clarify that his intentions were not misogynous but that his rather brutal treatment of the figure arose from observing the odd behaviour of some of the city's lonely people, the fall-out shelter signs he saw on the streets and the political tensions of the period.

Although Self described himself as 'a compulsive collector of photos' on the publication in 1968 of a portfolio of etchings, *The Power and Beauty Series*, based on found images, his decision to work primarily as a draughtsman and on a traditional small scale must be understood to express his abhorrence of the dehumanizing influence of technology. Favouring the most ordinary pencils and pens which anyone could buy in local stationers, he lavished an extraordinary amount of detail on subjects sometimes chosen specifically because they seemed unworthy of this virtuoso treatment, such as a hot dog or an empty armchair. His 'beautiful technique', as he explained in the typed notes accompanying his one-man exhibition in 1965, was meant to be 'near to sarcasm . . . over-loving to the point of becoming vulgar'.[5] Like the more mainstream Pop artists, Self devoted considerable attention to common objects, which he considered had the same individuality and presence as the people by whom they were made and for whom they were intended. Among the most haunting of his early pictures are those of ordinary arm-

POP'S MATURITY

chairs and sofas, sometimes with his wife or other figures, drawn with a hallucinatory intensity against bare backgrounds; they are often unnerving in their extreme perspectives and spatial distortion.

The best-known works and those that sit most easily in the context of Pop are Self's *Cinema* drawings of the mid-1960s, in which he brought together the quintessential modern architecture of cinema interiors with images of glamorous and seductive women cloaked in the trappings of fashion. The subject itself was suggested partly by an American film he had seen in 1959 or 1960, and also by a six-week stay in Los Angeles in 1962.[6] In a typical example, *Cinema 3* (1964), the highly worked figure drawn with sharp pencils is placed in an environment almost entirely simulated from a collage of marbled and coloured papers, bringing an uneasy atmosphere even to these apparently more neutral images. Self's temporary disguise as a Pop artist must be understood in the context of his notes for the 1965 exhibition, in which he recorded that television was popularized in the 1950s as a perfect tranquillizer to calm people's fears during the 'knife edge living' of the Cold War period. Popular entertainments, he suggested, were forms of escape that were invented in order to counteract 'weapons, warfare, broken laws and other causes of degeneration'. So, although he used certain types of imagery and a style of presentation associated with Pop, Self's work was essentially opposed to Pop's seeming detachment, moral, intellectual and emotional, from the world it showed.

As early as 1963 Self also produced sculptures with a purposeful brutality in both their imagery and methods, deliberately concentrating on 'what wasn't the domain of the sculptor up till the point I came along'.[7] Among the earliest such works were polished metal aeroplanes and submarines partly covered in leopard-skin, which he describes as 'hybrid' objects 'conceived to emphasize the deadliest aspects of a nuclear machine of destruction with the most fearsome associations of predatory animals'. Such themes were carried through to later sculptures such as *Handley Page 'Victor' B.I. 'V' Class Nuclear Bomber & Missiles* (1965), sprayed entirely in a sinister black, and *The Nuclear Victim* (1966, now fittingly housed in the Imperial War Museum, London), a metaphorical self-portrait as a naked and mutilated girl representing his own '7-year journey . . . through a Nuclear Winter of Non-Being'. Even the most innocent looking of his sculptures, like the chrome-plated *Vase of Flowers (Roses)* (1964) – an early example of a technique also taken up around this time by Paolozzi, Clive Barker and others – had apocalyptic overtones. 'My idea of chromium plate . . . was that every sculpture up till my vase of flowers was about its own mass, weight, structure, stress, composition – AND ITS OWN CONTAINED SURFACE. I reasoned that if I made a sculpture and chromium-plated it, the ultimate anarchy could happen to sculpture because it then *wouldn't* "have" a surface. Its surface would be the reflection of everything else around it. It would symbolise my state of NUCLEAR NON-BEING!'

Self was too concerned with a personally motivated subject-matter and with an almost frantically restless inventiveness for his work to be contained for very long within Pop. He began to think of all his pictures, sculptures and ceramics as 'works of fusion' through which he explored an extraordinary variety of ways of making art in order to proclaim his personality as the product of multiple interests and identities. This very idea of working in different styles chosen at will for their significance in a particular context, however, can be viewed as the legacy of a Pop attitude, particularly as he included what he called 'People's Art', which encompassed all the artefacts through which those not trained as artists have responded to the world.[8]

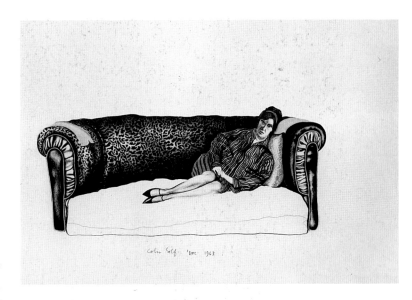

229 Colin Self *Margaret on a leopard-skin sofa* 1963

230 Colin Self *Vase of Flowers (Roses)* 1964

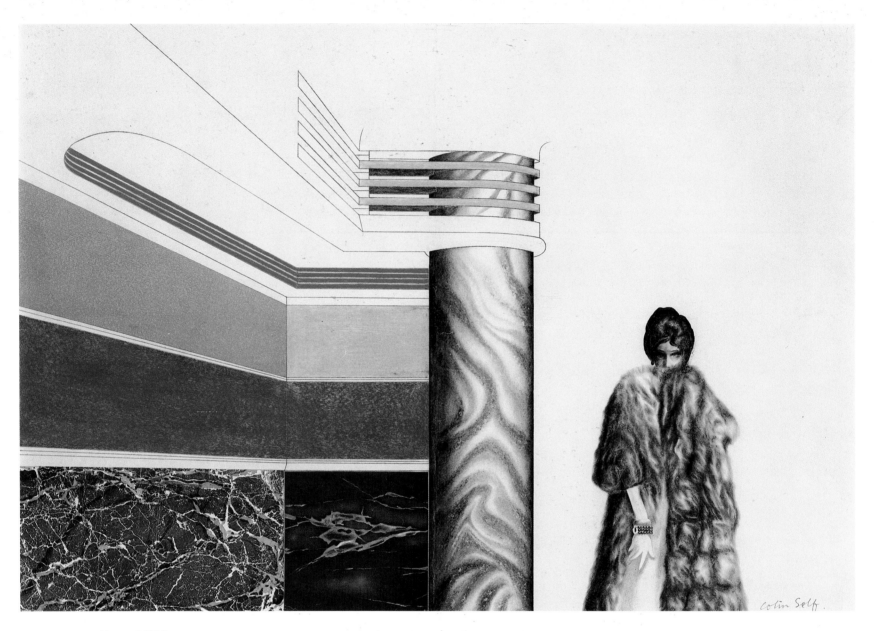

231 Colin Self *Cinema 3* 1964

232 Eduardo Paolozzi *The City of the Circle and the Square*
1963/66

This appetite for images, styles and procedures was shared by Paolozzi, who was unable to limit himself for long to a system that could comfortably be labelled Pop. The contemporary iconography and references to machinery proposed in the collages and sculptures made by him from the late 1940s to the end of the 1950s, when he was involved in the Independent Group's analytical investigations into popular culture, emerged with a dazzling clarity in the robot-like, machine-made totemic figures he began producing in 1962, such as *The Bishop of Kuban*. Paolozzi's temporary transformation from latter-day Surrealist to Pop artist, particularly in these metal works bolted and welded together by specialists from standard parts ordered as ready-made manufactured units, was completed by his decision in the mid-1960s to give them glossy industrial finishes or to paint them in bright primary colours.[9]

In their rigorous amalgamation of imagery, formal values and processes from modern industry, such works by Paolozzi represent the essence of his short-lived but vigorous

233 **Nicholas Monro** *Martians* 1965

235 **Nicholas Monro** *Sand Castles* 1966

234 **Eduardo Paolozzi** *The Bishop of Kuban* 1962

Pop style. Among the pieces he repainted were *The Bishop of Kuban*, given a coat of a single colour, and several aluminium sculptures of 1963 whose component parts were picked out three years later in dazzling colours, such as *Wittgenstein at Casino*, *Diana as an Engine* and *The City of the Circle and the Square*. All these – a mechanized portrait of a modern philosopher, a contemporary counterpart of a Roman goddess and a non-functioning machine presented as if it were just about to spring into action – are among the most effective of his icons of the machine age. By 1965 Paolozzi had abandoned such overt imagery, at least for the time being, and had begun to explore a more abstract formal language in works still fabricated in industrial materials such as painted and polished aluminium, stainless steel and chromed steel. Although he continued to employ processes and to conceive of many works as entities composed from interlocking fragments, he never again demonstrated such a sustained involvement with Pop in his sculptures.

Science fiction, one of Paolozzi's perennial concerns, featured also in the work of Nicholas Monro, who with Paolozzi, Jann Haworth and Clive Barker was one of the few British artists associated with Pop in the 1960s to work exclusively in sculpture. Unlike Paolozzi's, however, there is nothing mechanical or futuristic about Monro's celebratory, jokey and affectionate references to popular entertainments, comedians, and toy-like animals. Monro's friendly *Martians* (1965), half-frog, half-human, with the rubbery joints of children's toys, cheerfully send up not only the more ridiculous excesses of science fiction but also, more seriously, the prejudices we hold against the unknown, the unfamiliar and the foreign. Of this work, one of his first groups of figures – modelled in clay, cast by him in fibreglass and painted in garish colours – Monro recalls that he and the collector who purchased it, Alan Power, approached Bendy Toys in the hope that they would mass-produce them. As he later explained, the subject-matter was consciously popular: 'The conventions, the clichés, the myths, platitudes and norms by which we judge, and by which we in turn are judged. The starving artist, the mad inventor, the absent-minded professor, and so on, and so on.'[10]

Together with a wry and affectionate humour, Monro brought to Pop sculpture a selection of subjects from the realm of juvenile fantasy: stylized animals that belong more to the nursery than to the wilds of nature (*Reindeer*, 1962, *Ducks*, 1963, *Red Squirrels*, 1963, *Falling Giraffes*, 1963, *Sheep*, 1968), grossly enlarged toys or home-made objects (*Yachts*, 1967), fictional figures (*Mad Hatter*, 1971, and *White Rabbit*, 1972, from *Alice in Wonderland*, *Quasimodo*, 1966, *Dude Cowboy*, 1976, and the larger-than-life *King Kong*, 1972), entertainers, clowns and comedians (*Douglas Fairbanks Jr*, 1967, *Morecambe and Wise*, 1977, *Coco the Clown*, 1979, *Grimaldi*, 1979). In one of his most engaging early works, *Sand Castles* (1966), he poked fun at the sculptor's task in a characteristically self-effacing way, by identifying his invention of form with a clichéd version of the ephemeral fantasy constructions made by children all over the world. His *Money Bags* (1965), a comic-book visualization in three dimensions of sacks of loot, is a vivid measure of his disdain for the vulgar accumulation of wealth, an attitude which is very much part of his refusal to court career success or the approval of the art world.

The full extent of Monro's irreverence towards the antics of so-called mature adults, and of the appealing madness of his imagination, was manifested in his later groups of life-size figures such as the six couples that make up *Latin American Formation Team* (1970) or the ludicrous and ungainly participants of *Waiters Race* (1975). Like Caulfield, a friend from the time they were both students at the Chelsea School of Art, London, Monro consistently favoured apparently worthless and over-used subjects – themes

POP'S MATURITY

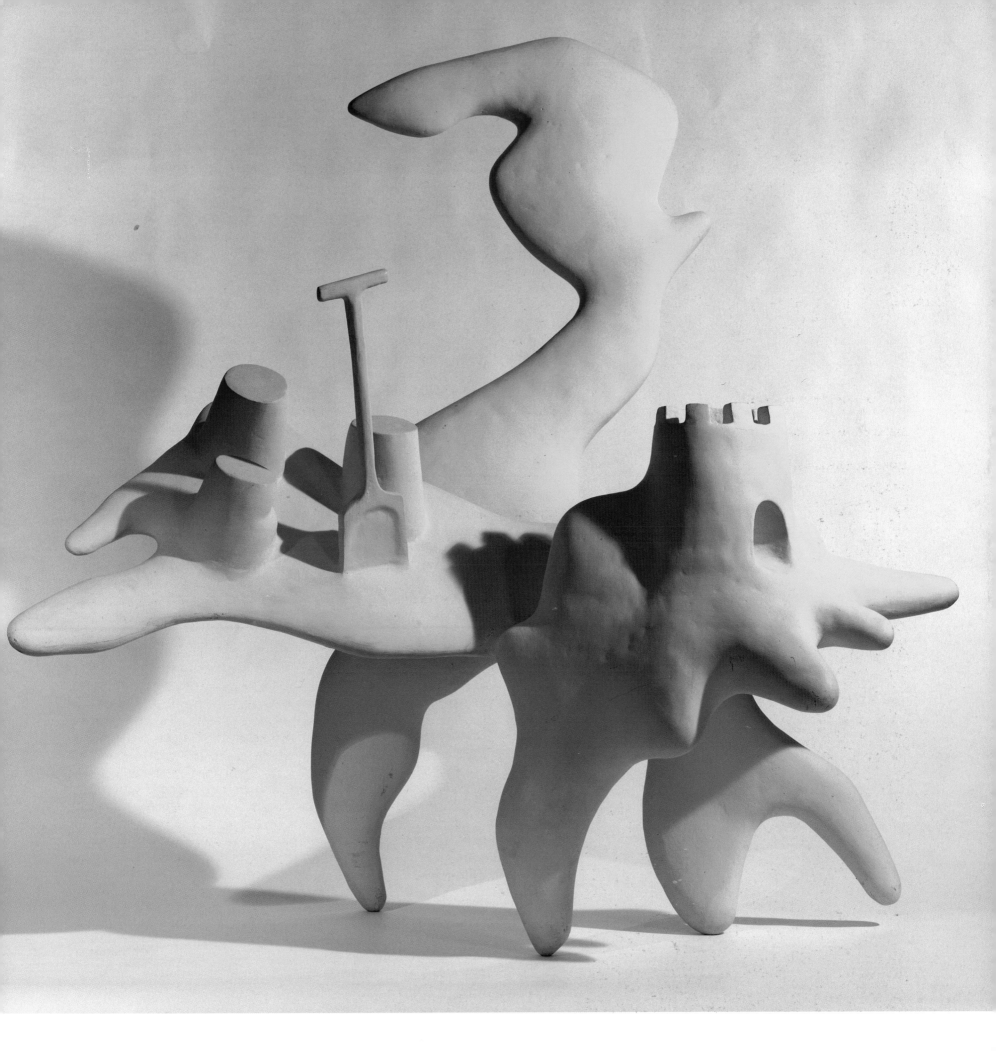

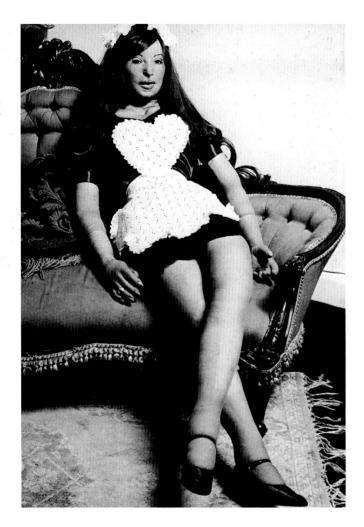

236 Jann Haworth *Maid* 1965–6

237 Jann Haworth *Mae West Dressing Table* 1965

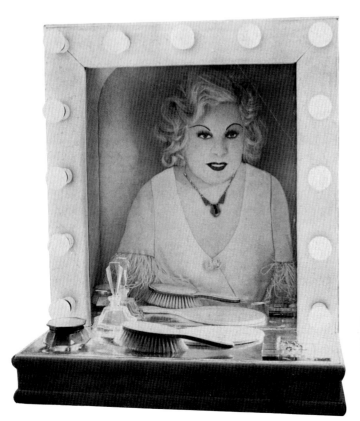

which to many ambitious artists would be beneath contempt – as a vehicle for an ironic but forgiving probe into modern culture. The degree of stylization to which he subjected his figures and objects, cast in fibreglass and then coated in a single bright colour or genially decorative pattern, also bears comparison with Caulfield's standard means during the 1960s. In 1978 he produced a group of studies of Max Wall – a favourite English music-hall comedian who was also an impressive actor – to celebrate a man who, like Monro himself, has embraced life with a humour enriched by pathos and a strong sense of the absurd.

A light-hearted touch also characterized the cloth sculptures made by the Californian Jann Haworth on settling in London in 1962, where she spent one year at the Slade on a non-diploma course in painting. Like the Canadian Joyce Wieland, who from the mid-1960s also used Pop imagery in stitched cloth works presented as wall-hanging quilts,[11] Haworth brought a specifically feminine perspective to a predominantly male domain in her choice of subject-matter and especially in her use of procedures associated with 'women's work'. Although the handcrafted, sometimes folksy, look of Haworth's art places it somewhat at the periphery of mainstream Pop, her Pop subject-matter encompassed her occasional treatment of common objects in soft form, suggesting the influence of Oldenburg, such as a *Charm Bracelet* made in two versions in 1963: one in the form of a gold satin quilt, the other in all-white calico more than three metres in length. Another quilted work, *L.A. Times Bedspread* (1965), took the comic-strip section of an American newspaper transcribed in grossly enlarged form, with the contours of the bedspread identified with the edges of a double-page spread; the images in the individual strip-frames are discernible only as ghostly contours, all colour having been expunged, but they are clearly labelled with the familiar titles of the strips from which they were copied. A faithfully transcribed advertisement for a pink telephone is literally 'dropped in' as a jarringly realistic note within a surface that otherwise seems virtually abstract in its reticence.

It is for her life-size figures of stuffed cloth, however, that Haworth remains best known. In the earliest she chose ordinary people presented in a stereotyped form, such as *The Old Lady* (1962–3) and her elderly companion *Frank* (1963), who were displayed seated next to each other when first exhibited in 1963,[12] or particular types of Americans recalled from her adolescence, such as a *Cheerleader* (1963, followed in 1968 by an equally empty-headed *Surfer*, southern California's male equivalent). These were succeeded by more elaborate tableaux such as *Maid* (1965–6) and subjects associated with her native Hollywood, as in a bas-relief of *Mae West, W. C. Fields and Shirley Temple*. In *Mae West Dressing Table* (1965), the blonde bombshell is shown as if reflected in her mirror, with an expectant look on her face, reinforcing the impression that we have just burst in unexpectedly on her and that she is confronted by our presence as much as we are by hers. Haworth shared with Peter Blake, whom she married in 1963, an interest in famous people.[13] One of the most vivid and certainly the most widely seen expressions of this concern took the form of their collaborative cover design for the Beatles' *Sergeant Pepper's Lonely Hearts Club Band* album in 1967, for which Haworth supplied and set up the sculptures and painted the photo enlargements of the crowd of celebrities pictured on the front.[14]

Of all the sculpture produced in Britain during the 1960s under the aegis of Pop, it was Clive Barker's that took to the most extreme conclusion ideas about the machine aesthetic and assembly-line production. While still at school in Luton, a small city north of London, he had begun attending art school in the evenings. He continued training as a

painter at Luton College of Technology and Art from 1957, but he abandoned the five-year course after only two years because it failed to meet his expectations; he particularly disliked the sculpture class, finding his teacher uncommunicative and taking little pleasure in manipulating clay with his hands. Aged only nineteen and uncertain whether he should move to London, Barker worked for eighteen months on the assembly-line of the Vauxhall car factory.[15] He remembers being impressed by the sight of enormous skips filled with chrome-plated lamps and by the pleasure, at the end of each day, of seeing shiny new cars lined up in the parking lot.

In retrospect Barker recognized that this spell in a factory was his most important formative influence, however subconscious its effects on his art might have been at the time. The materials with which he made his first sculptures in 1962–3 were those with which he had had direct contact at Vauxhall Motors: leather and chrome-plated metal. A perfectionist by nature, he found himself producing sculptures that were as shiny and glamorous as the engineered products he had earlier helped to make, which he fabricated with recourse to a division of labour and specialist skills on the same logical and efficient principles of the assembly line. He remembers that while still working in the factory it struck him that it would be wonderful if art could be made in the same way, since he enjoyed seeing the finished product but felt frustrated by the effort and failures of conventional studio methods.

Barker married Rosemary Bruen, who had been a fellow student at art school, in March 1961 and moved with her to London. There he was offered a place at St Martin's School of Art but he decided he could not face another three or four years at art school. Instead he took a job in a jewelry and pawnbroker's shop on Portobello Road while continuing to paint and see friends in the art world such as the abstract painter John Plumb, who had taught him in Luton; Alloway, whom he met through Plumb; the artist, writer and collector Roland Penrose, the main driving force at the ICA; and Blake, whom he met in about 1958 at an opening at the New Vision Centre and with whom he immediately became fast friends. After briefly experimenting with abstraction under the influence of Clyfford Still, in the wake of the 1959 exhibition of American painting at the Tate Gallery, he started building up the surface with materials such as polyfilla so that they eventually became almost like wall-hanging reliefs. These led in 1961–2 to works made from corrugated card, which were hung at right angles to the wall, and to a few pictures made from found objects, such as a billiards scoreboard that he painted black.

With his intuitive response to ordinary objects and his willingness to be inspired by the most unlikely and banal sources, Barker was naturally predisposed to Pop ideas even before he would have thought of applying the name to his own art. Stimulated by the publicity over an apparently trivial matter, the centenary of the zipper, which he regarded as a marvellous modern invention, he produced a few drawings of small squares with zips on them and by 1962 translated the idea into a screen-printed painting of three enormous zips laid out frontally in a simple formation. Although he did not pursue this early foray into screen-printing, which appears to predate the first use of the medium in paintings by Warhol and Rauschenberg in America, his reliance on a specialist technician to simplify the actual production of his work had immediate and lasting repercussions on his aesthetic.[16] As he was already in the habit of having the stretchers for his paintings made from his sketches, he decided to ask his carpenter to make some boxes instead, to the particular dimensions indicated on his drawings. These were then taken to an upholsterer to be covered with two layers of leather, with the uppermost surface pierced by a working zip. Among these *Zip Boxes* of 1962, his first Pop works, was at least one that

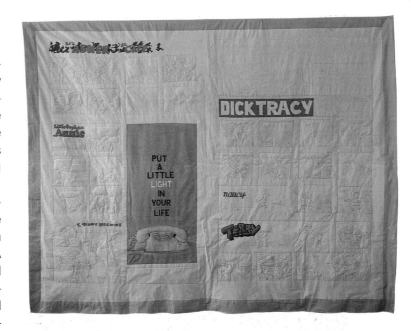

238 Jann Haworth *L.A. Times Bedspread* 1965

239 Clive Barker *Van Gogh's Chair* 1966

241 Clive Barker *Art Box II* 1967

240 Clive Barker *Splash* 1967

included the word ZIP in prefabricated letters purchased at Woolworth's, a device prob-ably borrowed from Blake's work.[17]

Although he had enjoyed handling paint, Barker discovered that he no longer felt the need for physical contact with his work. Spending the days in a job that did not especially interest him, he found a way of making art so that it would just materialize without any great expenditure of labour or effort on his part, as if he were daydreaming the objects into existence. His experience in a factory made it seem perfectly reasonable to him that his input as an artist should be limited to the concept and that others with specialist skills be asked to fabricate his objects according to his instructions. When he began to use chrome in 1964, beginning with *Two Palettes for Jim Dine* – one covered in leather, the other chrome-plated – it was obvious that the only sensible course was to get the work done by the best technicians he could find; his later chrome pieces were all plated at the Juno Plating Company (a subsidiary of Rolls Royce), and any welding was also done by specialists. When he began using neon in 1964, initially in two leather-clad works with the word 'EXIT' (as glimpsed in darkened cinemas) and two others with the words 'WAY OUT', he again simply took actual-size drawings of the lettering he wanted to a fabricator who bent the glass to the required shape and fitted the transformers to put them into oper-ation; two of these flashed on and off to particular frequencies, while the others remained permanently lit.

The extreme impersonality of Barker's sculptures, in the choice and handling of ma-terials and in that they were made for him by other people, place them among the most rigorous works in British Pop. Through their defiance of the Puritan work ethic, it took some years for them to be accepted as art by all but a small coterie that consisted essen-tially of his dealer Robert Fraser and a few collectors. A three-week visit to New York in April 1966, however, convinced Barker of the validity of his procedures, not because of any specific influences – he saw little sculpture during his trip – but because anything seemed possible there.[18] Nevertheless, his knowledge of the work of American artists such as Johns, Warhol and perhaps even Artschwager must have helped confirm his direction. On his return to London he completed a group of works that constituted his most sustained statement as a Pop artist when shown at the Robert Fraser Gallery in 1968 and at the Hanover Gallery the following year.[19] The majority of these sculptures were plated in chrome, which attracted him for its reflectiveness: an inert substance ani-mated by passing spectators and by the colours and other objects in the environment where the sculpture is displayed.

Among Barker's works of 1966–9 were facsimiles of objects encountered in everyday life, including buckets, a newspaper in chrome-plated brass, a ball of string, Coca-Cola bottles cast in bronze and chrome-plated, and his father-in-law's set of false teeth; objects with a slightly more exotic or aggressive identity, such as *Victorian Fruit*, cowboy boots (including a pair entitled *Rio – Homage to Marlon Brando*, 1968) and hand gren-ades; allusions to art and artists, as with a pair of painting boxes in chrome-plated steel or gold-plated brass (*Art Box I* and *II*, 1967), followed in 1969 by his first *Life Mask of Francis Bacon*; and artefacts conceived as materializations from the work of famous painters such as van Gogh, Magritte (*Homage to Magritte*, 1968–9, a chrome-plated bronze representing a pair of laced boots ending in human toes), Picasso, Morandi and Soutine. Of these tributes to favourite painters the most Pop were the chrome-plated bronze *Van Gogh's Chair* (1966) and the bronze *Van Gogh's Sunflowers* (1969), both of which pre-sent images that have entered the public domain through incessant reproduction, by which the aura of the originals has been replaced by their status as icons of modern art.

242 David Hockney *A Hollywood Collection: Picture of Melrose Avenue with an ornate gold frame* 1965

243 David Hockney *Two Boys in a Pool, Hollywood* 1965

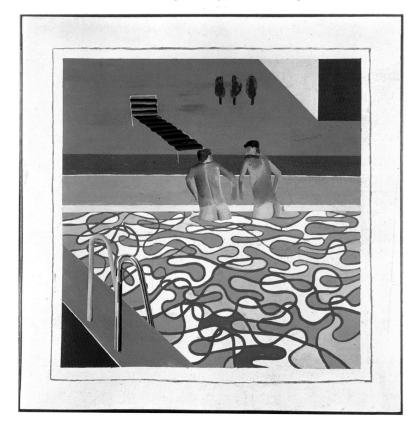

Barker did not consider that his replicas of real objects were extensions of Duchamp's ready-mades, since he had the components specially made. Such was the case with the casting of brushes, tubes of paint and other items in the *Art Boxes* (although the palette and box itself were fabricated from cut-out sheets), a tactic which in rendering them useless and passive compounded the irony of a sculptural representation of the tools of a painter. Similar methods were employed in *Homage to Soutine* (1969, assembled from casts of the separate components of an actual shutter and from a cast of a frozen rabbit's carcass bought at the butcher's) and in various sculptures of Coca-Cola bottles (transformed from clear vessels into reflective sculptures).

In Duchampian terms these works by Barker could thus be regarded as assisted ready-mades, but only in one group of sculptures, those of buckets, did he use real objects in the final piece. In *Splash* (1967), for instance, he bought a cheap galvanized steel bucket, removed its galvanized surface, chrome-plated it and filled it with a large number of individually plated ball-bearings as static visualizations of water dripping from a tap. As he later recalled, he was as likely to be inspired 'by just driving along a street, going into a sweet-shop, seeing a waitress carrying a tray with knives and forks on it' as by other art; he was particularly struck in New York by 'the American commercial activity of displaying and packaging expensively even the most ordinary domestic objects' and was amused by the idea of lavishing the most glamorous treatment he could imagine on the most prosaic of consumer goods.[20] By thus making the object beautiful and precious, he allowed it to retain its original identity while presenting it at one remove from ordinary experience as a sign for another level of reality.

The incorporation of ideas from American art in Barker's work was symptomatic of the interplay that was beginning to take place by this time between the forms of Pop on either side of the Atlantic. Three of the painters who had helped establish Pop as a movement at the RCA in the early 1960s found themselves living in the United States for extended periods by the middle of the decade. From the end of 1963 to June 1967 Hockney was in Los Angeles, with brief stays in Iowa, Colorado and San Francisco, while Jones lived in New York from 1964 to 1965. Phillips was also in New York (on a Harkness Fellowship) from 1964 to 1966, travelling extensively by car across America with Jones in 1965 and collaborating with another British exile, Gerald Laing, on a sculptural project in 1966 before returning to Europe, where he settled in Switzerland; he never again lived in England and as a consequence was rather excluded from a history in which he should have been recognized as a central figure.

The experience of living in America had immediate consequences on the art of each of these painters. For Hockney the lure of southern California and specifically of Los Angeles – with its open spaces, rectilinear architecture, sensuous way of life, vivid light and bright colour – proved overwhelming, and he began to move towards a more naturalistic form of representation based on photographs and on drawings made directly from life. A Pop artifice remained in his use of distancing devices, such as the illusionistic frames in his six colour lithographs, *A Hollywood Collection* (1965), which he conceived as an instant collection of standard types of pictures for a Hollywood starlet: a landscape, a cityscape, a still life, a portrait, a nude and even a *Picture of a Pointless Abstraction framed under Glass*. In his paintings of this period, such as *Two Boys in a Pool, Hollywood* (1965), he alluded openly to his reliance on photography by presenting the image as a hugely enlarged transcription of a snapshot, complete with white border in the form of a bare canvas edge; these pictures, the first in which he used acrylic paint, also marked a severe change from the textural paint surfaces of his earlier oils to a flat, unin-

POP'S MATURITY

flected and depersonalized surface that parallelled the disembodied gloss of his photographic source.

In such ways Hockney continued to be affected, even in his more naturalistic phase, by methods of working and of representing reality that were associated with Pop, basing his pictures on material already processed into two dimensions and continuing to rely on a high degree of stylization even when he was apparently most intent on mirroring a particular environment as neutrally as possible. Nevertheless, Hockney's assertion of tradition, not only in his references to artists such as Piero della Francesca but more generally in his insistence on drawing from life as the root of his art, distanced him increasingly from the tenets of Pop. With one major exception, *Early Morning, Sainte-Maxime* (1968–9), a painting transcribed from a colour photograph he had taken on his travels, Hockney stopped well short of the mechanistic reliance on the camera that characterized a development from Pop, Photorealism, which he himself may have helped influence. Perhaps it was mostly in his subject-matter, particularly the hedonistic life of southern California, that Hockney continued to work within terms that could plausibly be described as Pop. In general, however, his later work – with Kitaj's one of the most affectingly personal in contemporary art – lay resolutely outside the movement.

If America helped turn Hockney away from Pop, for Jones the experience of New York appears to have had the opposite effect, for it was precisely in 1964–5 that he moved from a painterly to a harder and more graphic form of representation and from a gentle eroticism to a more fetishistically charged subject-matter with strong overtones of popular sexual illustration. Following his 1962 *Bus* paintings, in 1963 he had produced further shaped pictures in which he joined an octagonal canvas to a rectangular one to represent such subjects as a *Marriage Medal* or parachutes. In many of these, and in other works such as *Hermaphrodite* (1963) and his 1964 lithographs *Concerning Marriages*, he represented a man and woman in stereotyped form fusing into a single image. His choice of subject was both a private celebration of his own wedding just before leaving Britain and a metaphor for the creative act as a meeting of male and female qualities, an idea he had derived from his reading of Jung and Nietzsche.[21] In *Wunderbare Landung*, for example, an entwined couple is shown floating earthwards below a billowing parachute, the sensation of vertiginous movement being associated explicitly with the sexual act.[22] Even more overtly sexual was a painting made to exactly the same format, *Falling Woman* (1964), in which the genitals of a woman with stockinged legs are seen voyeuristically as if through a keyhole.

On a visit to New York in 1964 Hockney remarked to Jones on the resemblance between his recent hermaphrodite paintings and a specific illustration in a fetish magazine. Jones was intrigued and began to collect this kind of illustration as source material for his paintings, appreciating it both for 'the vitality of this kind of drawing of the human figure, which had been produced outside the fine art medium', and for its elimination of all 'extraneous line or information'.[23] Such images served him directly for some pictures painted on his return to England, which were exhibited as a group at Arthur Tooth, London, in 1967. Each of these works, such as *First Step* (1966), *Wet Seal* (1966) and *Sheer Magic* (1967), pictures a life-size fragment of the female anatomy tightly encased in latex or rubber – whether just a foot and calf or a complete pair of legs – with a stiletto-heeled shoe shown as if resting on a plastic shelf that juts out from the lower edge of the canvas. The illusionistic modelling of the anatomy, together with the detailed rendering of the folds in the tautly stretched synthetic material, adds to the sexual charge of the image by concentrating attention on both its tactility and fetishistic associations.

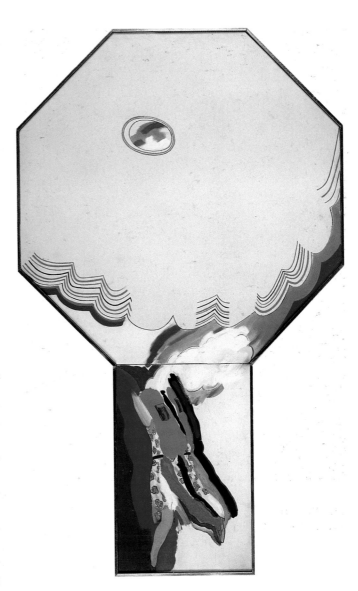

244 **Allen Jones *Wunderbare Landung* 1963**

245 **Allen Jones *Sheer Magic* 1967**

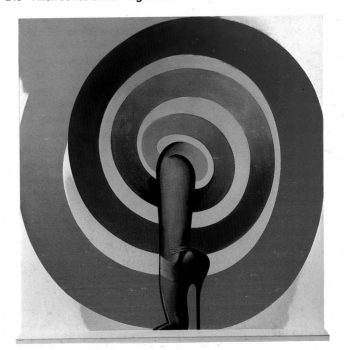

RANDOM ILLUSION

173

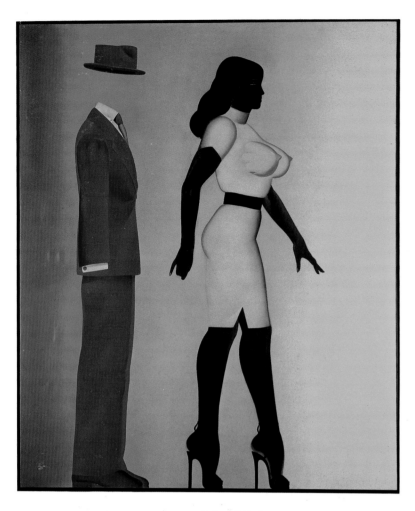

246 **Allen Jones** *Maid to Order III* 1971

Jones continued to employ exaggerated images of sexuality in his later paintings; his closest counterparts in the United States in this respect were Lindner and Wesselmann, both painters whose work he admired. In Jones's three *Maid to Order* canvases of 1971 he reinterpreted his earlier theme of the male and female duality within each person by direct reference to transvestism; seen in sequence, a stereotyped man is shown undergoing a complete change of identity as he sheds his suit and tie for a tightly belted and heavily bosomed dress that seems to have a life of its own. It was in a set of three painted fibreglass sculptures in 1969, however, that Jones gave the most vivid form to such subject-matter. For each of these cast fibreglass figures, modelled in clay under his direction by a professional sculptor, Dick Beech, he pictured an illusionistically rendered life-size woman in the posture of a piece of furniture: *Hatstand*, *Chair* and *Table*. Clothed in thigh-high leather boots and bondage-wear manufactured to the artist's specifications by a London firm, Atomage (specialists in such sexual apparel), and complete with glamour-girl wigs and eyelashes, these images of female passivity and submissiveness were meant to shock, and so they did.[24] Although they aroused the wrath of the feminist movement which was emerging at that time, the artist's intention was not to encourage violence against women or to speak of their domination by men but simply to elicit a direct emotional response from every viewer in order to circumvent the preconceptions usually at work when people look at art. However much he may have miscalculated the way they would be interpreted and the anger they would arouse, the strength of feeling still stirred by these works provides clear evidence that Jones succeeded in his stated ambition. In distinction from the lusciously painted pictures that again came to dominate his work in the later 1970s and 1980s, these exaggerated embodiments of femininity, made by proxy to eliminate any expressionist or direct physical involvement on his part, remain Jones's most extreme statements as a Pop artist.

The British painter whose commitment to Pop was most vividly confirmed by living in America was Phillips, who on moving to New York in September 1964 developed even more ruthless variations on the imagery and procedures he had proposed when a student at the RCA in the early 1960s. Having made the decision at an early stage that he would take images exactly as he found them, reasoning that whatever had stimulated his imagination could operate in a similar way for the spectator if integrated into the painting in the same form, he had begun by 1963 to photograph and project such material so that particular motifs could be employed with a greater freedom: they could be enlarged to any size, reversed or combined in unexpected ways with other images. Such methods were used in a major painting executed shortly before he left for America, *AutoKUSTO-Motive* (1964), a shaped canvas from which a brightly decorated and almost full-size car juts aggressively into our space. This was the first work in which Phillips explicitly referred to an American invention, customizing, which individualized cars of otherwise standard design and suggested their potential for speed by purely pictorial means. The appeal to Phillips was strong, for it was an equivalent of the artist's own process of painting a canvas – in the dual sense of decorating a surface and of creating illusions – adapted to the requirements of a utilitarian object.

Before leaving for New York Phillips produced a series of precisely worked-out drawings as detailed blueprints for a group of paintings, complete with the necessary slides, since he wished to leave nothing to chance when undergoing such a major disturbance in his living and working conditions. Seven of these eight *Custom Paintings* were made in America, the last completed in 1967 after his move to Zürich. Cars and car parts feature prominently in each of these pictures in combination with unrelated elements drawn from

247 **Allen Jones** *Chair* 1969

an increasingly wide variety of sources: labyrinths, diagrams of nuclear power stations and of a nineteenth-century distillery, heraldic patterns from Battersea funfair, pin-ups, and an array of dazzling abstract patterns and geometric devices. Of even greater significance than their imagery, however, was the fact that they were painted with a mechanical tool associated with illustration and photographic retouching, the airbrush, which he had long wanted to acquire and which he now could afford. Having eliminated the most obvious kind of handwork from his paintings as early as 1962 and having begun to use spray-paint in London, he was able now to produce an absolutely flat painted surface that looked pristine, glossy and machine-made. More than ever before, Phillips's work took on the character of painted collage, with the homogeneity of technique and seamless continuity of surface neutralizing the sudden ruptures of images drawn from such diverse sources.

RANDOM ILLUSION

248 Peter Phillips *Custom Painting No. 4* 1965

249 Peter Phillips *The Random Illusion No. 3* 1968

250 Peter Phillips *Art-O-Matic Cudacutie* 1972

The system Phillips devised for the *Custom Paintings* was elaborated by him until the mid-1970s. Using oil paint mixed with Magna – which curtailed the drying time and thus made respraying more convenient – he first painted in the backgrounds, having marked off the image areas with masking tape and tissue paper. Designs such as the moiré pattern in *Custom Painting No. 4* (1965) were invented, sprayed in blocks with stencils he cut himself. The more detailed areas were then painted in with the aid of projected slides. The shiny metallic surfaces, which provide an other-worldly ground similar to that of the gold leaf on icons, were painted with regular artist's quality silver oil paint.

Phillips's time in New York confirmed his desire to take his aesthetic to an extreme of banal and aggressive contemporaneity on an ever larger scale. His move to Switzerland did not deflect him in the least from this course. In screen-prints such as his *PNEUmatics* portfolio and in his *Random Illusion* paintings (both 1968) he explored the idea of producing groups of related pictures, each utilizing the same categories of imagery, the same format and the same basic approach. The types of motifs used in the paintings – diagrams of molecular structures from the pages of *Scientific American*, invented grid patterns, predatory birds drawn by the nineteenth-century American artist John James Audubon, motor engines and machine parts – were selected, as always, with a view to their strangeness when juxtaposed.

These ideas were developed by Phillips from 1972 to 1974 in an extended series of small *Compositions* and *Select-O-Mat Variations*, in which he suggested that the individual elements were like interchangeable machine parts and that in principle any combination of motifs could be tailor-made to the requirements of a particular (art) consumer; on the final page of his 1972 retrospective catalogue he went so far as to include an advertisement announcing his willingness to produce pictures to order on just such terms, 'Introducing the portable, or everything goes' with such subtle irony that the desired commissions failed to materialize.[25] Phillips appeared to court cynicism because of the apparent indifference with which he manipulated his found images, but the intensity of his brand of Pop continued to be derived from the paradoxical relationship between his randomly organized and anonymous material, on the one hand, and the emotional response they elicited both for the artist in planning the picture and, in turn, for the viewer in looking at it. Given that the largest paintings, such as *Select-O-Mat Techtotempest* (1971) and *Art-O-Matic Cudacutie* (1972), measure up to five metres in width, reproductions of them cannot begin to convey the perceptual and intellectual disorientation engendered by their dazzling and contradictory patterns, spatial devices and disembodied floating images presented to our eyes with an unnatural clarity.

A notion of collaboration was inherent to Phillips's concept of Pop, not only in his use of images invented by others and of techniques taken from commercial art but also in the role accorded the spectator, who is encouraged to make his or her own sense of juxtapositions not grounded in logic. Wishing to take this idea further, in 1965 Phillips approached Gerald Laing in New York, with the idea of working together. Laing had produced his first Pop paintings in 1963 while still at St Martin's, London, where he studied from 1960 to 1964. His first subjects included the film stars *Anna Karina* and *Brigitte Bardot*, whose images he took from newspaper photographs which he transcribed by hand to vastly enlarged dimensions by painting dots of various sizes in black onto a ruled grid against a white background; the image of Anna Karina as a prostitute in Jean-Luc Godard's 1962 film *Vivre sa vie*, for example, was enlarged from a height of $1\frac{1}{2}$ to 144 inches so that it was endowed with the larger-than-life monumentality of a billboard. The process adopted by Laing in such works clearly related both to Warhol's screen-printing

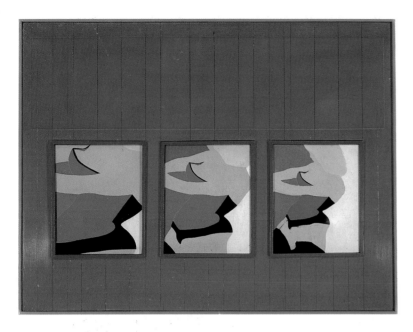

251 Anthony Donaldson *Strip Board* 1962–3

252 Anthony Donaldson *Hollywood* 1968

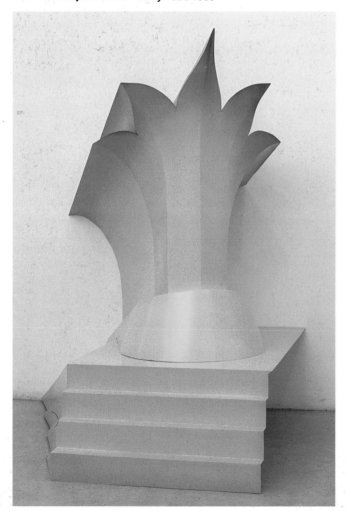

of newspaper photographs and to Lichtenstein's hand-stencilled approximations of the Benday dot used in the printing of colour comics on newsprint. Laing regarded his system, however, not as a mechanical way of blowing up a printed image but as a practical device for producing a hand-painted enlargement of a half-tone photograph that would also preserve a sense of the abstractness of the marks as self-sufficient patterns.

Laing first visited New York in 1963, during which time he worked briefly as Indiana's assistant. On finishing his studies in London the following year, he moved to New York at the invitation of the dealer Richard Feigen; he remained there until 1969, thus producing all his Pop works in an American rather than British context. Having introduced accents of colour as large flat shapes or as repeated or interlocking patterns into his otherwise austere black-and-white grids as early as 1963, he now became increasingly involved with formal and perceptual issues linked to images of individuals made glamorous by their profession, such as astronauts, skydivers and the drivers of drag-racers. Many of these works, such as *Skydiver VI* (1964) and *Deceleration I* (1964), were conceived as shaped canvases in separate sections, a device by which he was able both to suggest the dynamism of his subjects and to employ contrasting languages – one fairly literal in its rendition of an image, the other a far more formalized and abstract treatment of positive and negative shapes or strict geometrical patterns – clearly separated from each other by the divisions between one section and another.

It was with such works that Laing was occupied when he was approached by Phillips about collaborating. They first considered producing a painting together but decided instead to form a market research company, Hybrid Enterprises, with the aim of producing an art object determined by the demands of the informed consumer. They constructed two kits containing samples of colours, patterns, shapes and materials – from canvas, paint, wood and fabrics through to modern synthetic and industrial materials such as plastics and metals – and devised a questionnaire with which they interviewed 137 critics, collectors and arts administrators in various cities, including New York, London, Chicago and Los Angeles. The results were designed to be fed into a computer, but this proved difficult because of their inexperience in framing the questions; they also admit that the choices given were not as wide as they would have liked: for example, interviewees were offered the choice between 'abstract' or 'figurative' although there was no practical way of incorporating specific imagery. Such minor hiccoughs did not greatly concern them, since their main interest was in seeing the concept through. The resulting editioned sculpture (1966) – incorporating aluminium, plexiglass and a fluorescent tube within a wedge shape, the striped pattern at the side producing a chevron image with the aid of its reflective metal surface – was, as Laing himself later acknowledged, 'an assemblage of trendy 60s notions'.[26] The high sales for *Hybrid* (the Fogg Art Museum at Harvard University was one purchaser) neatly completed the project, but it remains an ambiguous statement about the relationship between the artist and the audience for whom the work is intended. Even Phillips and Laing fail to agree about it, Phillips seeing it as an amusing gesture about the art world but Laing going much farther in acknowledging it as a satirical attack on the manipulativeness of the art market.[27]

Both Laing and Phillips continued making similar sculptures after *Hybrid*, and both participated in the 'Primary Structures' exhibition at the Jewish Museum, New York, in 1966, at which Minimalism made its first great impact. Immediately afterwards, however, Phillips returned to painting, whereas Laing became increasingly dedicated to abstract sculpture from 1965; after leaving New York for the north of Scotland in 1969 he eventually returned to a representational language bordering at times on a traditional aca-

demicism, but he never again engaged with the themes or methods of his short-lived Pop period. He came to see his early works as 'endorsing the technological optimism of the early 1960s at a time when all things seemed possible, and that man would be able to dominate his environment and solve all his problems through science. This hubris was soon to end in disillusion.'[28]

Another English artist who was similarly only briefly involved with a pure form of Pop was Anthony Donaldson, who studied at the Slade, London, from 1958 to 1962, at the same time as Colin Self although not part of his social circle. Many of his first Pop paintings included cinematic references, with figures repeated in fragmented form as if they were freeze-frame close-ups; he often traced his images from photographs and then transferred them to canvas with stencils for a clean edge that would leave no obvious trace of a personal drawing style. His approach was essentially decorative, with flat shapes arranged symmetrically or in repeated patterns and with sequences of static images sometimes suggesting a narrative development, as in *Strip Board* (1962–3), whose title alludes to strip-tease, film strips and to the fact that it is painted on a hardboard panel. The title of one of his best-known works, *Take Five* (1962) an expression used on film sets to indicate a short rest period, likewise affects our reading of the postures adopted by the women in the upper register.

Although Donaldson's early works fit comfortably into the mainstream of Pop both in their subject-matter of pin-ups and racing cars and in their references to packaging, poster design, photography and cinema, he introduced a new twist on such motifs in the fibreglass sculptures he began making in 1968 at the end of his two-year stay in Los Angeles on a Harkness Fellowship. In *Hollywood* (1968), for example, an exotically shaped motif reminiscent of a fragment of Art Deco cinema architecture is mounted on a pedestal in the form of a staircase. From this near-abstraction he returned in 1970 to an overtly sexual treatment of the female figure, this time in sculptures made of fibreglass, lacquer and paint, such as *Gold'n'Green* (1970), which represent nudes slightly under life size. Overshadowed by Jones's notorious furniture sculptures of 1969, Donaldson's work escaped the disapprobation of feminists and continued in a similar vein, although in later bronzes such as *Three* (1984) he turned to a miniature scale reminiscent of the 1960s tableaux by the American sculptor Robert Graham.

While Pop continued to attract new adherents, some of the most sustained statements of the aesthetic were made in the 1960s by artists who had laid its foundations in the previous decade. Peter Blake, for instance, continued to produce pictures of pop musicians such as *Bo Diddley* (1962) and *The Beatles* (1963–8) and introduced further themes from popular culture in separate series on wrestlers and strippers. As with his circus pictures of the 1950s, he again worked within well defined conventions, those of wrestling posters and images in girlie magazines, but in almost every case invented his own characters rather than basing his pictures entirely on given sources. With one exception, *Masked Zebra Kid* (1965), the wrestlers were all imaginary figures rather than portraits of real people.[29] In *Kamikaze* (1965) the masked wrestler whose stage-name is prominently displayed along the lower edge is given a Japanese identity through various associations; these include a toy model of the kind of plane used by Japanese pilots on suicide missions during the Second World War, a set of framed photographs of such pilots with their national flag, and a traditional warrior's mask over which he has placed a replica in fabric (made by Haworth) of the wrestler's mask.

The concern shown by Blake for different forms of picturing was increasingly evident not only in his use of such a variety of systems within a single picture but also in the diver-

253 Gerald Laing *Anna Karina* 1963

254 Gerald Laing *Deceleration I* 1964

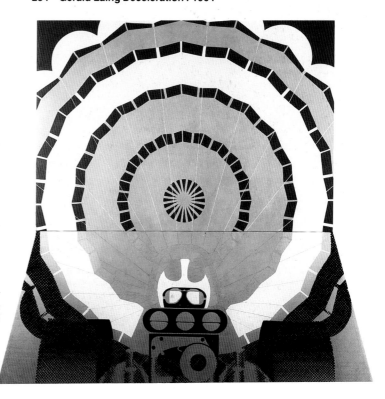

255 Peter Blake *Tarzan Box c.* 1965

256 Peter Blake *Masked Zebra Kid* 1965

gence of his methods from one work to another, as if to suggest that he had multiple identities as an artist. In 1965, for instance, he began work on one of his largest and most ambitious straight figurative paintings, *Portrait of David Hockney in a Hollywood-Spanish Interior*, which maintained a link with Pop in its imagery and subject-matter but not in its relatively naturalistic technique, yet he also produced one of his most overt Pop sculptures, *Tarzan Box*, conceived like the dioramas in natural history museums or the penny entertainments associated with the amusement arcades on Victorian piers. Using plastic toys and other found materials, he has created a miniature tableau in which every imaginable event of a Tarzan movie is amusingly incorporated into a single action-packed scene: a crashed plane, a rapacious lion, an over-active gorilla, a fearsome warrior with spear poised over a frightened Jane, and Tarzan himself about to swing from a rope in time-honoured fashion. With a characteristically generous and humble spirit, Blake continued to find ways of proposing serious artistic questions. Under the guise of humour and a shared memory of a childhood entertainment which is likely to have spurred our own fantasy and imagination, *Tarzan Box* constitutes a provocative artistic gesture in disclaiming the sculptor's traditional manipulation of materials, while subtly proposing a new definition for sculptural composition through the precise arrangement of found objects in a delimited space.[30]

Blake was rare among Pop artists in seeking to reintegrate his art into the popular culture from which it sprang, thanks primarily to the fact that he continued to work occasionally as a graphic designer and to think such illustration a form of expression as respectable and worthy as painting or sculpture. He made his greatest stride into mass acceptance in 1967 with the cover design for the Beatles' *Sergeant Pepper* album, and in the same year he produced a multiple printed on tin, *Babe Rainbow*, which was produced in vast quantities and initially sold for as little as £1 on street markets.[31]

Collage-based pictures and assemblages from popular ephemera and other found materials were still produced by Blake on an occasional basis, notably in a series of *Souvenirs* intended as gifts for other artists,[32] but from the late 1960s he returned essentially to the 'figurative realism' that he still regarded as the core of his work. This was particularly the case with the pictures of fairies and literary subjects with a strong Victorian flavour that he produced after 1969, when he settled with his wife in the countryside at Wellow, near Bath, until their separation ten years later. After this period as a member of the self-styled Brotherhood of Ruralists, an association of artists founded in 1975,[33] he moved back to London and began using once again some of the urban themes of his earlier work. He made a conscious and witty return to the images and methods of his classic Pop works for an exhibition held in Tokyo in 1988, 'Déjà vu', which he conceived as a post-modernist statement about his own work, producing both new variations on particular types and second versions of specific works, as in *The Second Real Target, 25 Years Later* (1988).[34] With these pictures he demonstrated the continuing vitality of his brand of Pop while bringing his own history as a Pop artist full circle.

Within a few years of his first tentative inroads into popular sources in the late 1950s, Richard Hamilton had staked out the territory that made him one of Britain's most inventive and committed Pop artists. Often working in series, as in a group of 1962 works spurred by a headline about male fashion in *Playboy* magazine, *Towards a definitive statement on the coming trends in men's wear*, Hamilton devised countless ways of relating images, themes and techniques derived from the mass media. For instance, he produced a set of variations on concepts of masculinity and male beauty by making inspired connections between different types of men who had in common a glamorous and wholly

contemporary identity that made them admirable role models; seen as a group, President John F. Kennedy, helmeted American footballers and astronauts all become tokens of a forward-looking male perfection, explicitly identified with fashion and the classical ideal in the third painting in the series, *Adonis in Y-fronts*. In this work, translated into Hamilton's first editioned screen-print the following year, a muscleman derived from a photograph is given the perfectly contoured torso of *Hermes* by Praxiteles (as reproduced in *Life* magazine) and clothed in a tee-shirt or jersey copied from a photo-spread in *Playboy*.

Hamilton's satisfaction with this print, made in collaboration with Christopher Prater at the Kelpra Studio, London, led him not only to translate many of his most important Pop paintings of the 1960s into the medium but also to encourage others to take it up. A portfolio of screen-prints commissioned in 1963 from twenty-four artists selected by Hamilton, published the next year by the ICA, introduced many British Pop artists to screen-printing. Blake, Boshier, Caulfield, Hockney, Patrick Hughes, Jones, Kitaj, Paolozzi, Phillips, Smith and Tilson were included; Gordon House, who had already experimented with it, also took part, along with a number of other abstract artists.[35] Hockney disliked both the print he produced, *Cleanliness is next to Godliness*, and the mechanical nature of the process, preferring the handworking of traditional etching and lithography, and he never returned to the medium. Many of the others, however, were immediately attracted to the possibilities it held for disseminating their images to a wider public and for producing a perfect finish that showed no sign of the artist's hand. The opportunity for collaboration with a master printer such as Prater, who had the technical expertise and sensitivity to translate the most complex and vague ideas into a pragmatic solution, was also an incentive to many to produce further screen-prints. Prater's creative contribution as an equal collaborator is beyond dispute and must be recognized as a major force in this phase of British Pop history. Similarly, American print studios such as The Tamarind Lithography Workshop (founded in 1960 by June Wayne in Los Angeles), Tatyana Grosman's Universal Limited Art Editions (established in 1957) and Ken Tyler's Gemini G.E.L. (founded in Los Angeles in 1966) and Tyler Graphics (which he established in the mid-1970s after leaving Gemini) were instrumental in the print boom that did so much to disseminate Pop in the United States.[36]

Caulfield was alone among the major British Pop artists in using screen-printing entirely as a way of translating images he had invented and painted by hand, rather than as a device for making direct use of found material through its photographic reproduction; it was also very suitable for the dense colour, flat images encased in black outline, and uninflected surfaces that were essential to his aesthetic as a painter.[37] He produced some of his most important works in this medium, notably the 1973 book of twenty-two screen-prints entitled *The Poems of Jules Laforgue*, rather than regarding it as a purely commercial strategy for reaching a larger market. Nevertheless, all the artists who produced a sizeable number of editioned prints found themselves caught up in the sudden demand for such work which started idealistically as a way of democratizing the collecting of art but soon became another tool for the financial exploitation of the market.

For artists such as Phillips and Tilson, who were interested in industrial processes or in surfaces that looked mechanically produced, screen-printing was a logical way of integrating photographic or other found images. Tilson's quintessential Pop works of the mid- to late 1960s were largely dependent on this and associated processes: among the most notable examples are *P.C. from N.Y.C.* (1965), an enlargement nearly two metres wide of a fold-out postcard, a monumental photographically derived print of an ephem-

257 **Richard Hamilton** *Adonis in Y-Fronts* 1962

258 **Joe Tilson** *P.C. from N.Y.C.* 1965

259　Joe Tilson *Transparency, The Five Senses, Taste* 1968–9

261　Eduardo Paolozzi *Moonstrips Empire News: Formica-Formikel* 1967

260　Joe Tilson *Page 16, Ecology, Fire, Air, Water, Earth* 1969

eral souvenir itself printed from photographs of New York at its most awe-inspiring; the 1968–9 series *Transparency: The Five Senses*, screen-printed on acrylic sheets vacuum-formed to the shape of grossly enlarged 35mm transparencies; and paintings and constructions incorporating images screened on canvas, such as *Page 16: Ecology, Fire, Air, Water, Earth* (1969–70). Tilson, Kitaj, Phillips and Paolozzi also found the medium ideally suited to collage methods of composition and to images based on existing material. Such was Kitaj's most overtly Pop exploitation of the ready-made, his 1969 portfolio of fifty screen-prints based directly in most cases on favourite book covers, *In Our Time: Covers for a small library after the life for the most part*. Kitaj also found the medium invaluable in the 1960s as a kind of visual diary of his ideas, since his slow methods of painting would never have allowed him to produce such a wealth and variety of pictures in such a short time; but by the mid-1970s he had come to reject nearly all his screen-prints as slight and inconsequential works, in spite of the wide admiration expressed for them by others.[38]

In the hands of an inveterate collector of printed ephemera such as Paolozzi the medium was an almost instant method of reprocessing favoured images in sometimes startling combinations. His portfolio of screen-prints, *As is When* (1965), remains among his major statements in a Pop idiom. Based loosely on the life and writings of the Austrian philosopher Ludwig Wittgenstein, prints such as *Wittgenstein in New York* were presented as projections of the ideas and sensations of two minds – that of Paolozzi and his subject – in an explicitly modern context.[39] In subsequent portfolios, such as *Moonstrips Empire News* (1967, a set of one hundred prints housed in a coloured perspex box), *Universal Electronic Vacuum* (1967), *Zero Energy Experiment Pile* (1969–70) and *General Dynamic F.U.N.* (1970, fifty prints conceived as the second part of *Moonstrips Empire News*), Paolozzi elaborated an iconography of Pop that was without parallel in its sheer diversity and intuitive brilliance, encompassing everything from scientific diagrams to the most pedestrian advertisements by way of Mickey Mouse. In 1972 he published some of his earliest scrapbook images as *Bunk*, a box containing forty-seven facsimile reproductions (screen-printed, lithographed and collaged) of collages made from 1947 to 1952.

Screen-printing gave Hamilton a way both of reinterpreting themes and images he was exploring in paintings and of enlarging the technical vocabulary of the paintings themselves, since he began to use the process to incorporate fragments of imagery in compositions that were mainly collaged from different sources. In *Interior I* (1964), for instance, one of a pair of paintings in which he deftly manipulated the evidence in a still from a 1940s film, *Shockproof*, the desk in the foreground was collaged from Fablon (a self-adhesive plastic, available in a simulated wood finish, used for kitchen surfaces), while the film's female lead, Patricia Knight, is literally placed into the space in the form of an image screen-printed directly onto the primed panel before any of the surrounding images were painted. The actress's portentous presence as a monochromatic but physically immediate full-length figure heightens the sense of unease in this elaborate web of deceit, in which every image has the quality of a warning or a clue and even the space itself conspicuously fails to conform to logic.[40] To the left of the figure is a small piece of a real mirror that serves to incorporate the space in which we are standing into that of the picture and to suggest that we are also willingly colluding in whatever sinister event is about to take place.

Following his first trip to the United States in October 1963, during which he visited the Marcel Duchamp retrospective at Pasadena,[41] Hamilton painted *Epiphany* (1964) as a

262 Eduardo Paolozzi *Wittgenstein in New York* 1965

263 R. B. Kitaj *In Our Time: Four in America* 1969

conscious act of homage to the directness, immediacy, 'audacity and wit' of the American Pop that he first saw in some depth at this time. On first showing this painting in London in 1964 he remarked, 'The thing that impressed me was their throwaway attitude to Art – a point of view which the European with his long tradition of the seriousness of culture (not even Dada was that carefree) could hardly achieve.'[42] A vastly enlarged transcription of a cheap and vulgar badge he had purchased in the Venice area of Los Angeles, it is marked by a simplicity of form and method decidedly at odds with the multilayered ambiguity that characterizes most of Hamilton's work; this is the only instance in which he made a direct equation, as Johns had done, between an ephemeral object and its painted depiction.

Although *Epiphany* conforms more closely than almost any other example of Hamilton's art to his own 1957 prescription for Pop – in that the button depicted could be described as popular, transient, expendable, low cost, mass-produced, aimed at youth, witty, sexy, gimmicky and glamorous – his own comments reveal the extent to which his commitment to easel painting in a specifically European sense made it impossible for him to abandon complexity of image, technique and pictorial language as a prerequisite for his art. While he recognized the strength to be derived from the singleminded pursuit of a particular method, such as that of screen-printing in Warhol's work or Lichtenstein's use of the Benday dot, he preferred to free himself from the vagaries of style and personal taste by using a multiplicity of systems including various mechanical ones but also methods of drawing and painting rooted in tradition.[43] In *Portrait of Hugh Gaitskell as a Famous Monster of Filmland* (1964), his first overtly satirical work, Hamilton used a photographic enlargement of a press photograph of the recently deceased Labour Party leader as a base on which to paint the sinister and distorted features conflated from a variety of cinematic and science fiction sources.[44]

Actual photographs collaged to the surface were also used by Hamilton in subsequent paintings based on images from the mass media, such as *My Marilyn* (1965). This must be numbered among the most open statements of his Pop aesthetic, and it is also one of the subjects he chose to reprocess into the more ruthlessly homogeneous surface of a limited edition screen-print on paper. Another painting appropriated from the mass media, *I'm dreaming of a white Christmas* (1967–8), was painted by hand from a film still of Bing Crosby, but it is presented as if it were purely a photographic enlargement of a colour negative; the ruse of a painstakingly hand-made rendering posing as an image instantly achieved by mechanical means was typical of Hamilton's highly conceptualized art. Equally elaborate in execution were a related screen-print of 1967, printed from twelve stencils produced from Hamilton's hand-made colour separations, a retouched dye-transfer in 1969 and a final return to the subject in 1971 in a print combining collotype and screen-print, *I'm dreaming of a black Christmas*.

The *Swingeing London 67* series of six pictures painted in 1968–9 are rare among Hamilton's paintings in being silk-screened directly from a photographic source, the newspaper photograph of his dealer Robert Fraser being arrested on a drugs charge with Mick Jagger. Unlike Warhol, however, who preferred to leave the screened image in its raw state, from the very first work in the series Hamilton used oil paint to colour the image in the manner of a photographic retoucher, updating a method of hand-tinting that has a history almost as long as that of photography itself. The last painted variation of the image, now in the Tate Gallery, tampered even further with the original source through the inclusion of collaged elements such as a landscape view glimpsed through a car window and a set of metallic handcuffs lifted in the air, calling attention to the ambiguous

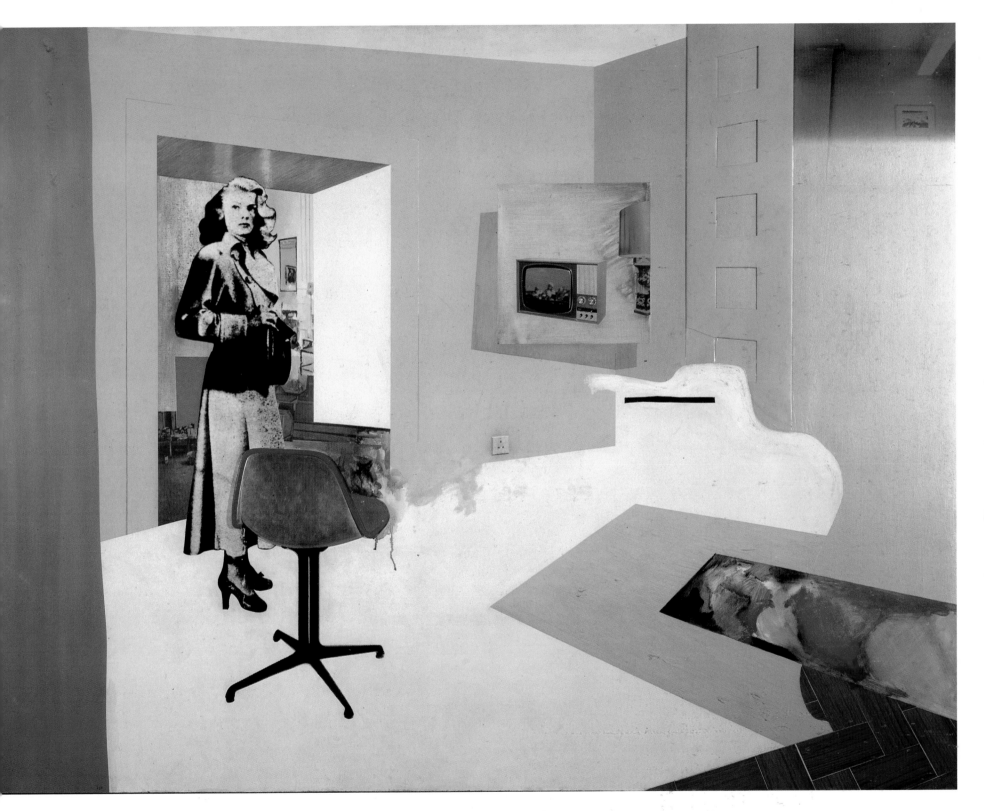

264 Richard Hamilton *Interior II* 1964

265 Richard Hamilton *Epiphany* 1964

266 Richard Hamilton *The Critic Laughs* 1971–2

gesture that could signify defiance or an unsuccessful attempt by the two celebrities to conceal their identities from the camera.

Hamilton's fascination with popular imagery, refined contemporary design and methods of presentation drawn from the most sophisticated forms of advertising continued to motivate his picture-making in the later 1960s and 1970s, for example in the *Fashion Plate (Cosmetic Study)* collages in 1969 and in a later group of paintings and prints derived from a 1960s advertising campaign for Andrex's new lines of coloured lavatory paper, such as *Soft Blue Landscape* (1973–80), which he presented both as a debasement of the *fête champêtre* tradition and as the evidence of its survival in mutated form. In the text accompanying the first exhibition of these works in 1975, Hamilton admitted, 'Sometimes advertisements make me wax quite poetical': 'A veil of soft focus vegetation screens the peeper from the sentinel. Poussin? Claude? No, more like Watteau in its magical ambiguity.'[45] He was later amused to be told by Bridget Riley that this advertising campaign, a ubiquitous feature of Sunday colour supplements and other magazines in Britain during the 1960s, was the product of her own work as a graphic designer just when she was beginning to establish her reputation as a painter.

A special category within Hamilton's later use of Pop imagery is his witty reworking in various media of domestic appliances made by the German manufacturer Braun. Having referred to such household objects in his paintings as early as 1958, and having also embarked in 1965 on a series of reliefs made of fibreglass and cellulose representing the facade of the Solomon R. Guggenheim Museum in New York, he began to examine appliances as suggestive signs of modern culture. *Toaster*, with his name in place of the Braun logo, was first made in 1966–7 as a chrome steel and perspex relief on a colour photograph; it was rephrased in 1967 in a deceptively simple print incorporating offset lithography, silkscreen and metalized acetate, the whole presented as an enlarged advertisement based on the publicity brochure for the toaster but used to convey all the vital statistics about the fabrication of the print itself. Another Braun appliance, an electric toothbrush, was paired with a set of false teeth made of dental plastic for his first fully sculptural work in 1968, *The Critic Laughs*, remade in 1971–2 as a limited edition multiple. It is a piece of typical and exquisite ambivalence on Hamilton's part. On one level it is a sincere form of homage, to Johns's sculpture *The Critic Smiles* (1959), a toothbrush in sculp-metal with the bristles replaced by four molars, and to the elegance and restrained beauty that represent modern industrial design and advertising at their best. It also represents, however, a form of censure: the typography that traces Hamilton's name on the implement, a self-mocking parody of the lettering on the original product, introduces a sardonic tone by reminding us of the speed with which the art market transforms the ideals and intellectual aspirations of artists into mere commodities, and of the careless talk with which the big mouths of critics can make or break an artist's reputation.

Hamilton's influence as a teacher in the fine art department at the University of Newcastle-upon-Tyne from 1953 to 1966 gave birth to an entire group of younger English artists touched by the Pop movement. Some of his students were later recognized as distinctive and thoughtful artists, including Rita Donagh, Mark Lancaster, Stephen Buckley, Tim Head and Tony Carter, as well as Bryan Ferry, who later found fame as lead singer with the pop group Roxy Music. Lancaster, who made contact with a number of the major American artists of that period, including Warhol, on his first visit to New York in 1964, was a particularly important figure both for his personal associations and for the information he brought back to England. Shortly before moving to America he made a small picture, *Postcard* (1962–3), in which he conflated the features of two film stars, James Dean and

267 Richard Hamilton *Soft Blue Landscape* 1973–80

268 Richard Hamilton *My Marilyn* 1965

269 Richard Hamilton *I'm dreaming of a black Christmas* 1971

270 Richard Hamilton *Swingeing London 67 (a)* 1968–9

Marlon Brando, derived from postcard photographs. The paintings he produced on his return, rigorous in their emphasis on systems and self-evident process, were influenced primarily by the work of American abstract artists such as Frank Stella, but he also painted a few pictures clearly marked by Pop. One of the largest, a four-panel painting called *Place* (1964), was the culmination of a group of pictures based on the design of paper napkins provided in the Howard Johnson chain of American restaurants; there is a clear debt both to the object paintings of Jasper Johns, for whom he was to work as personal secretary from 1974 to 1985, and to Richard Smith's formalized paintings of the early 1960s. He did not again involve himself so openly with Pop imagery and ideas until after Warhol's death in 1987.[46]

By and large, the work produced by Hamilton's students bore a tangential relationship to Pop. Donagh, who became Hamilton's second wife, engaged briefly with Pop sources and materials in works such as *Contour* (1967–8), in which she combined a screen-printed canvas with a sinuously shaped argon light tube as an abstraction from a *Life* magazine photograph of male homosexual prostitutes on New York's 42nd Street. Carter, throughout his later work, used ordinary objects as the basis of a highly cerebral and idiosyncratic form of Conceptual art. The room-sized installations with which Head established his reputation in the 1970s reveal a debt to Pop in their presentation of ordinary things both as sculptural objects and as images reprocessed photographically in the form of projected slides.

Of all the artists trained at Newcastle during Hamilton's tenure, however, Buckley was perhaps the most profoundly affected by the premises of Pop art, since by that time, as he later recalled, he was already interested in 'how environments reflected taste and style'.[47] Among the visiting lecturers with whom Buckley also made contact were Paolozzi, Tilson and Smith. Tilson and Smith, later close friends of Buckley, clearly affected his ideas about the painting as an object: Tilson for his wooden constructions decorated with colour, Smith for his essentially abstract statements based either on an ordinary thing or on an image from the mass media and presented emphatically as a shaped and three-dimensional object in its own right. Buckley saw little of Smith between 1963 and 1968, when Smith was in America, but worked as his assistant for about six months from the autumn of 1968, when Smith returned to Wiltshire in England. Smith had just completed the last of his paintings based on Pop ideas, such as a set of twelve shaped canvases *A Whole Year a half a day* (1966), in which he used the idea of a monthly calendar or the twelve hours of a clock face to establish a serial progression of form; in Smith's *Clairol Wall* (1967) an advertisement displaying the different shades of blonde hair dye again provided a cue for an essentially abstract statement bordering on Minimalist sculpture but still conceived within the terms of painting.

Many of Buckley's paintings of the 1960s and early 1970s take as their starting-point what might be described as Pop subjects – printed patterns and textile designs, board games (in his case, chess), references to restaurants or ballroom interiors, and a rich mixture of allusions to the work of admired artists such as van Gogh, Schwitters and the Cubists – all transformed by his highly personal, intuitive and spontaneous procedures. As with Smith, his work often appears to be abstract but has a strong referential root. Nowhere is this original synthesis of bold pattern and matter-of-factness more evident than in the *Crazy Paving* paintings of the late 1960s, based on the decorative interlocking shapes of paving stones common in the paths and patios of English suburban houses.

Pop ideas continued to be manipulated by artists in Britain during the later 1960s and 1970s, but in such a variety of forms that the term requires redefinition almost every time it

POP'S MATURITY

is used. For Tom Phillips, for example, who had come under the influence of Kitaj while still a student at Camberwell School of Art, London, from 1961 to 1963, found images painstakingly transcribed by hand were subjected to both iconographic and structural analysis; he particularly exploited the photographic imagery on colour postcards, as in *Benches* (1970–71), in which he broached themes of aging and mortality through found images of people passively seated on park benches as if awaiting their death.[48] Another painter and printmaker, David Oxtoby, who had known Hockney since they had been students together at Bradford College of Art in the mid-1950s, devoted himself exclusively through the 1970s to images of pop musicians from the rock'n'roll era through to later heroes such as David Bowie and Bruce Springsteen; working from photographs within a framework that could all too easily be dismissed as mere illustration, he captured the raucous spirit of this area of pop music through vibrant colour and a deliberate rawness of technique, as in his 1977 series of colour etchings depicting Elvis Presley.[49]

Some artists who had been instrumental in establishing the movement in the early 1960s drifted in and out of Pop in their later work. In the late 1970s and 1980s, for instance, Allen Jones continued to refer to popular entertainments in a series of paintings in which women were pictured as if on a stage, but his fundamental concern here, as in an inventive group of painted steel sculptures representing stylized dancing figures, was with the essentially abstract issues of colour, form and space that have provided the continuous thread throughout all his art. The paintings produced in Texas after 1980 by Derek Boshier likewise maintained a connection with the Pop subject-matter of his student work but rephrased his references from the mass media and current events in a heavily worked expressionist technique.[50]

In spite of his antipathy to the label, R. B. Kitaj continued to base many of the motifs in his paintings on photographs, on frame enlargements from films, on reproductions of works of art and on other images already processed into two dimensions; in his subject-matter, too, he occasionally referred to those aspects of popular culture that did appeal to him, as in a series of small paintings about baseball in 1967. Kitaj's work perhaps remained closest to Pop in paintings drawn in part from the cinema, such as *Walter Lippmann* (1966), a ruptured narrative that includes motifs familiar from films, such as the romantic scene in the distance in which a pretty girl standing under the glare of a street lamp is confronted by a man in a trench coat. 'Movies, and particularly frame-enlargements', Kitaj has written, 'have been in my work what engravings and such were for artists in the distant past, what printed illustrations were for painters like Manet and Van Gogh, what photographs were for Degas and Cézanne and later for Sickert and Bacon ... no more and no less.'[51] It was almost inevitable that an artist with as wide a frame of reference as Kitaj would occasionally use images drawn from the mass media, but the central role accorded drawing from life in his later work constitutes not just a distancing from Pop but an explicit rejection of some its basic premises about depersonalization, anonymity and mechanical methods of production. A similar process took place in Tilson's work, symbolized by his move in 1972 from London to the countryside at Christian Malford in Wiltshire and prompted in his case by political and ecological concerns and by a disenchantment with the technology that he had celebrated as an optimistic force in his Pop works of the 1960s. He returned to a hand-made look in his wooden constructions and oil paintings, still availing himself of the highly formalized grid structures and repeat patterns of his Pop work but applied now to his interest in alchemy and in man's relationship to nature, to ancient themes such as that of the four elements and to subjects drawn from pre-classical mythology.

271 Mark Lancaster *Postcard* 1962–3

272 Richard Smith *Clairol Wall* 1967

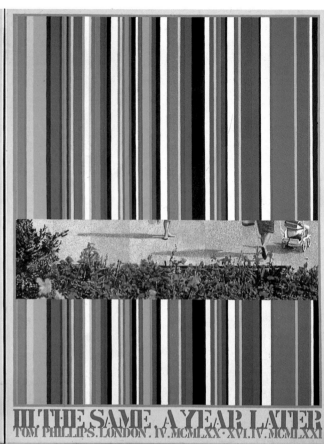

273 Tom Phillips *Benches* 1970–71

274 Stephen Buckley *Crazy Paving* 1968

One of the painters most resistant to his classification as a Pop artist, Patrick Caulfield, nevertheless remained faithful to the spirit of his early work both in his detached manipulation of style and in his choice of subjects that took an ironic but unpatronizing look at areas of popular taste generally considered low-brow, vulgar and kitsch. From the late 1960s he concentrated on large-scale paintings (many of them measuring around three metres in height) in which he depicted domestic interiors marked by a dull suburban conventionality or by the romantic escapism of cheap foreign restaurants, travel brochures, interior design magazines and mail-order catalogues, all of which represent equally doomed attempts to escape the stifling limitations of everyday routine. In paintings such as *Interior with Room Divider* (1971) he pursued a fiercely logical system in which every image is represented at the same size as the object it depicts, a typically Pop literalness by which he heightens the realism of the scene as a physical manifestation while avowing its artifice as a graphic invention on a flat surface.[52]

In the mid-1970s Caulfield began to elaborate this basic scheme by painting some of the elements in conflicting techniques, including a precisely rendered photorealism, *trompe-l'oeil* illusionism and even passages of broad pseudo-Expressionist brushwork. One of the first such works to present a fragment in an alien style in the guise of a picture within a picture was *After Lunch* (1975). His original intention had been to collage to the canvas a photo-mural of the Château de Chillon, cut to an eccentric shape to conform to the perspective of the imaginary restaurant interior. Like the fondue dish and the yoke-

POP'S MATURITY

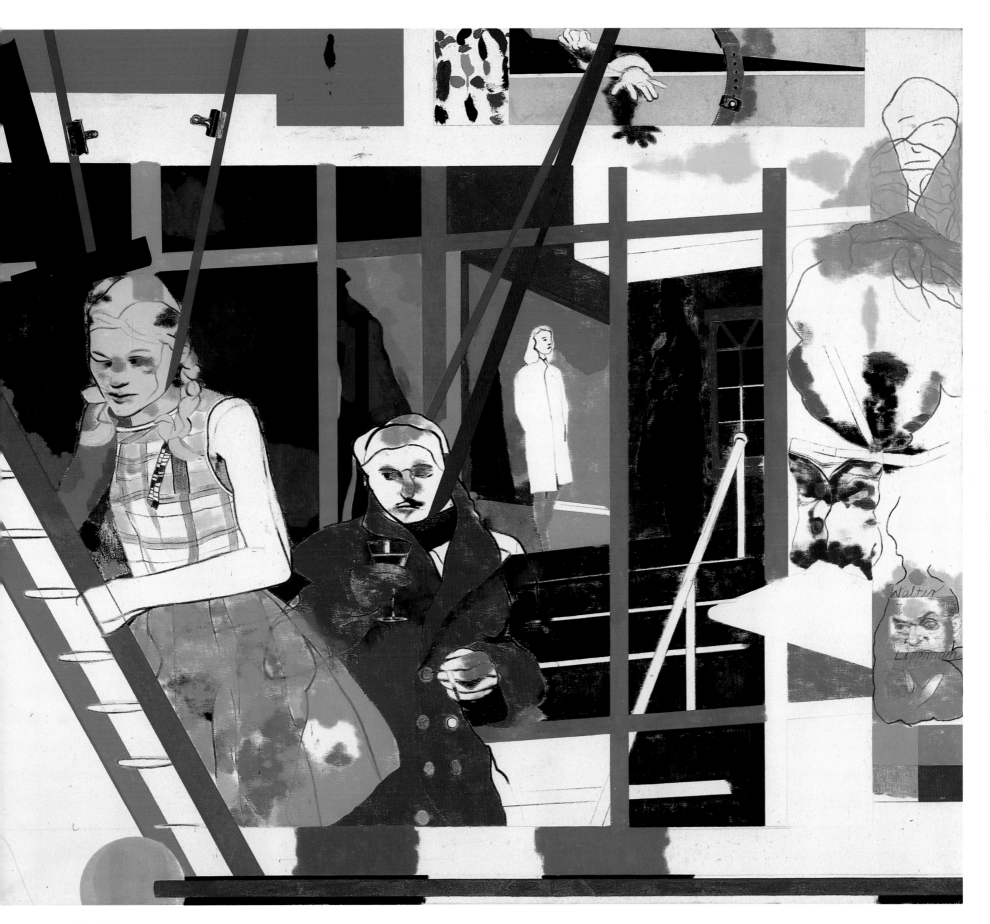

275 R. B. Kitaj *Walter Lippmann* 1966

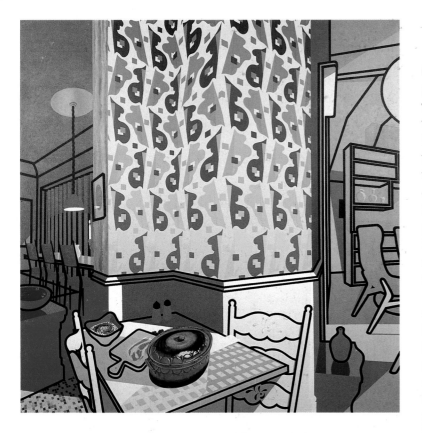

276 Patrick Caulfield *Dining/Kitchen/Living* 1980

278 Peter Phillips *Mosaikbild 5 x 4/La Doré* 1975

277 Peter Phillips *Repetition of a Night-time Safari* 1980

like object suspended from the ceiling, it was intended as a note of Swissness of such preposterous conventionality as to make it evident that the interior was located somewhere other than in Switzerland. When he found that the mural would not adhere properly to the surface, he decided to copy it laboriously in paint with such fidelity to the model that its very realism would give it away as a found image even more exaggerated in its artifice than the blatantly stylized room in which it is placed. In subsequent works he introduced further details and methods of paint application decidedly at odds with his own taste, excusing them by presenting them as found material even though in many cases he had invented them himself, as was the case with the vulgar colours and nauseous wallpaper pattern of *Dining/Kitchen/Living* (1980). By pitting one style against another and by making them all subservient to the overall surface design, Caulfield retained a characteristic detachment and horror of overt self-revelation that can still best be understood as an extension of Pop.

The British painter who perhaps more than any other demonstrated an unshakeable commitment to Pop as an aesthetic capable of great flexibility and resilience was Peter Phillips. In the space of only half a decade he moved from an extreme of airbrushed photographic perfection in paintings based on a grid system of interpenetrating images, such as *Mosaikbild 5 x 4/La Doré* (1975), to enigmatic colour fields with fragments of half-discernible motifs painted entirely by hand but with an equally exacting technique. The former series, with their sleek metallic surfaces and blatant contemporary imagery of pin-up sexuality, machinery and advertising, took to a logical conclusion a definition of Pop based on the technologically motivated presentation of motifs found ready-made or obtained by mechanical means; even the structure of these paintings was suggested by a newly introduced device called Multi-Vision, which consisted of a series of computer-guided back-projection units.[53] His paintings of the 1980s, such as *Repetition of a Night-time Safari* (1980), often sombre in colour, contemplative in mood and at first glance almost entirely abstract, look like a drastic departure but remain entirely consistent with his previous work. Each painting is transcribed from a smaller work on paper in which ready-made motifs, collaged from printed images in fashion magazines and books, were overpainted to intensify their physical presence while making their identity more mysterious and compelling. The source material, though altered, infiltrates our reading of the picture thanks to the clues provided by recognizable textures of fabrics, sequins and animal skins and by presentation that recalls the placement of models against coloured backgrounds in fashion photography.

The Dadaist Picabia prefigured a typical Pop attitude when he maintained that an artist should change style as often and with as little concern as he changed his shirt. In these new works Phillips has persuasively demonstrated that true Pop artists, no matter how they choose to clothe themselves, remain fundamentally unchanged under their skin.

EXTINGUISHED MATCH

American Pop, 1965 and after

The rapid acceptance of Pop as a codified movement with an entire phalanx of artists, admirers and promoters was without precedent in the history of American art. The Abstract Expressionists had worked for more than two decades before receiving general acceptance, only to see the Pop artists awarded similar accolades within three years of the naming of the movement. The first book on the subject, with text by John Rublowsky and photographs by Ken Hayman, came out in 1965. Andy Warhol, who had announced his intention to retire from painting on the occasion of his one-man show in Paris in May that year, was among those who greeted its publication as the death-knell of a development that seemed already to be suffering its last gasps: 'As I leafed through the pages and looked at the colorplates, I was completely satisfied with being retired: the basic Pop statements had already been made.'[1]

There was a grim satisfaction for some in heralding the rapid demise of a movement predicated on an acceptance of built-in obsolescence as a basic fact of modern life. New artistic trends now followed each other in quick succession; Hard-Edge Painting, Post-Painterly Abstraction, Op art, Minimal art, Conceptual art, Land art and Photorealism had all been labelled, discussed and heavily promoted by the beginning of the following decade. Yet these developments, while seeming to displace each other in rapid succession, also had a common thread, and in many respects they capitalized on attitudes, devices and strategies first systematically explored in Pop. The influence was so pervasive as to pass almost without notice, partly because Pop itself was largely misunderstood but also because the huge differences in appearance between one type of work and another obscured their shared concerns. With hindsight, and with the benefit of a clearer view of the role of Pop, one can recognize that essential aspects of the movement – literalism, anonymity of technique and surface, rejection of obvious expressiveness, the presentation of basic units and grids as Gestalts, and industrial or commercial methods of production – also came to characterize the extremes of both abstract (Minimal) and representational (Photorealist) art. The emphasis on flatness in Pop painting and on the duplication of existing objects in Pop sculpture, asserting the physical properties 'proper' to each medium, was in tune with the most stringent formal dictates of abstract art in that decade, while the use of mechanical processes for images derived from existing sources drew attention to the production of art as both a physical and intellectual operation, prefiguring developments such as Land art and Process art. The precedence of idea over execution or, more properly speaking, the presentation of the artefact as the embodiment of an idea, prepared the way for Conceptual art. In short, the developments that have altered our perception of art in the quarter century following the arrival of Pop would have been unthinkable without its example.

280 James Rosenquist *F-111* 1965, and detail

In spite of all the predictions, Pop itself stubbornly refused to go away. Only a few of its major practitioners made a decisive change of direction. Ruscha, for example, created an extremely personal and original form of Conceptual art that was witty and inventive in its visual use of language and in its exploitation of unconventional materials. D'Arcangelo, for his part, developed his landscapes towards a more extreme hard-edged abstraction around 1970 before returning more directly to the motif later in the decade using a cerebral but still highly formalized idiom reminiscent of Precisionist painters such as Charles Scheeler and of the work of Ralston Crawford, who was a friend and colleague.[2] Even in these cases, however, there remained a close link with their Pop origins, since similar sources were implicit in D'Arcangelo's early highway pictures and Ruscha remained faithful to the conception of an art of signs that he had formulated by the late 1950s.

By and large the originators of Pop, Warhol included, continued to expand on the logic of their early 1960s work, but increasingly drew attention to their different sensibilities rather than to the shared values and common purpose that had seemed so striking in the first half of the decade. The continued resilience of the basic tenets governing their work was most vividly illustrated, in the very year in which Warhol and others had pronounced Pop finished, in Rosenquist's largest and most accomplished painting to date: *F-111* (1965). Inspired in part by Duchamp's *The Bride Stripped Bare by her Bachelors, Even (The Large Glass)* (1915–23) – the subject of a lecture by Hamilton he had attended at the Guggenheim Museum in 1964 – Rosenquist wanted to produce a major work that looked both 'modern' and 'archaic'.[3]

Rosenquist's *F-111*, measuring more than 3 x 26 metres and wrapped round the four walls of a room at Leo Castelli's 77th Street gallery in April 1965, carried to an extreme both the enveloping scale and the references to technology of his most characteristic earlier pictures. As with all his works, images are seen in close-up: the actual F-111 bomber is about four metres shorter than its representation here. The relationships of the juxtaposed motifs continue to resist conventional narrative, but they are pulled together into the overtly political theme; one of the elements that seems most incongruous, for instance, the image of a smiling little girl under a hair-dryer, serves as a shocking reminder of the innocent lives sacrificed by military aggression and of the uncertain future facing

196

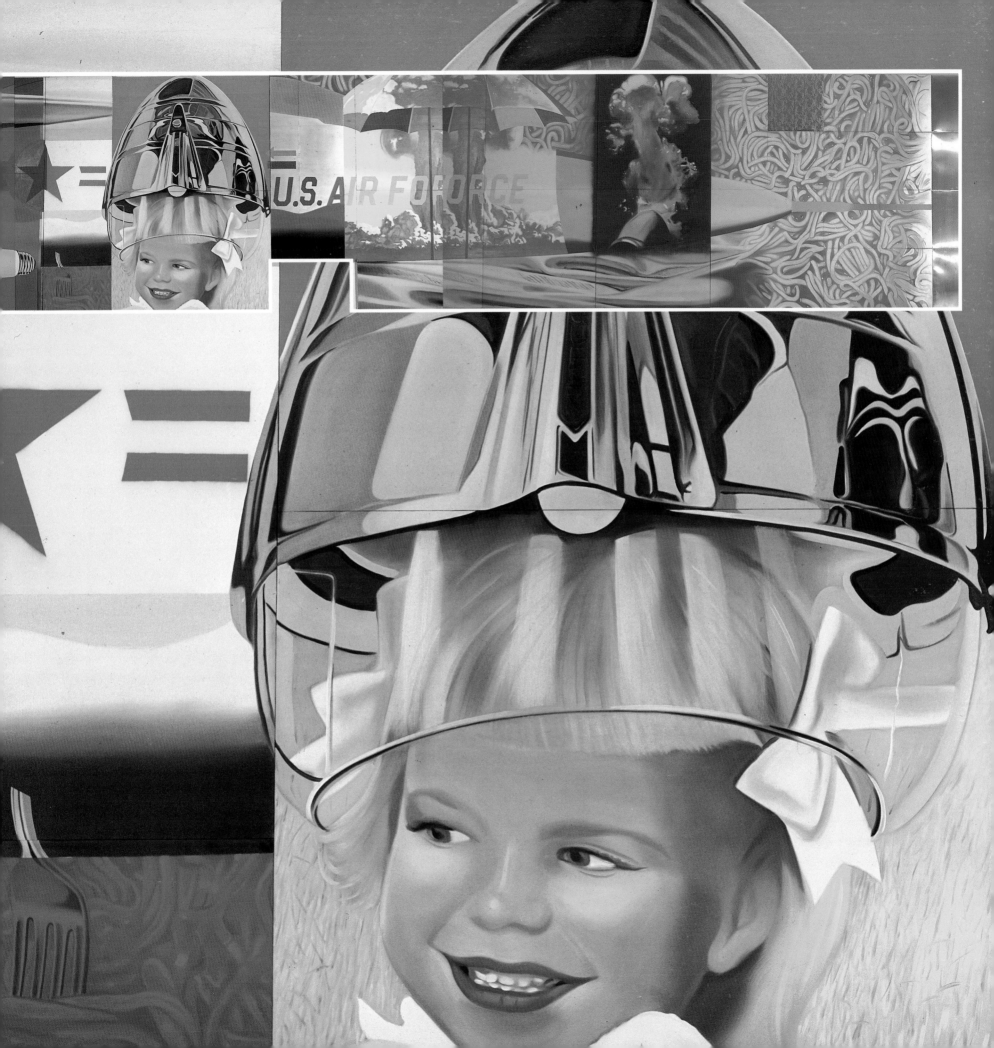

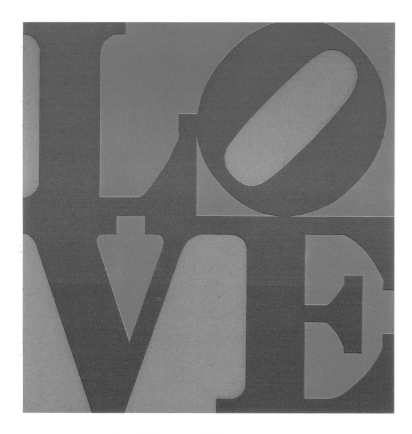

281 **Robert Indiana** *Love* 1966

282 **Jim Dine** *Poulenc* 1971

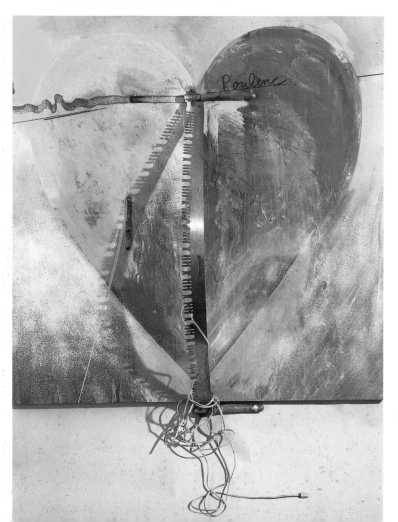

the new generation. The viewer is literally engulfed by interpenetrating images that are as violent and aggressive in their shrill colour as in what they represent; the surface is dominated from end to end by the profile of the American bomber, a controversially expensive military jet plane that was deemed obsolete before it had even left the drawing board. The sleekness of Rosenquist's painted surface here acquires an almost engineered perfection as well as a metallic sheen, not only in the form of reflective aluminium panels but in the illusionistic treatment of the hair-dryer.

The huge size of *F-111* and its display around a claustrophobically contained space subject the viewer to the image of uncontrolled power central to the picture's political message; the fact that we can see only a little of the picture at a time, but must rely on peripheral vision in order to begin to understand how one part connects with another, becomes a metaphor of the individual's powerlessness in the face of economic and political forces beyond one's control. The construction of the painting on 51 interlocking sections, 49 on canvas and the remaining 2 on aluminium, was a practical solution to producing such a huge work in the confined space of the artist's studio, but this too adds to the picture's meaning: Rosenquist was willing to entertain the idea of selling this impracticably large work piece by piece, a conceptual gesture by which the purchasers would be buying a souvenir of a technological white elephant that they had already helped pay for with their taxes.[4] If sold in this way, moreover, it would be as if the bomber had exploded into its separate fragments with the same finality as the nuclear fall-out of the atomic mushroom cloud pictured on its surface. In the event the entire work was purchased by one collector, Robert C. Scull, at the close of the show; as long as it is in private hands it remains a potential time-bomb that could be separated into its sections and dispersed uncontrollably around the world.

It was in the mid-1960s that Indiana also produced the works with which he remains most closely identified, in particular a series of paintings, sculptures and prints which spell out the word LOVE in an unchanging graphic formation. The first of these testaments to the idealism of the decade, such as *Imperial Love*, were produced in 1966, but they were followed by reworkings in different materials and to different scales, so that through its re-use the word became a sign for the artist himself. Dine similarly concentrated on a deliberately limited range of motifs – adding to the artist's palette and craftsman's tools his self-portrait bathrobe and a simple Valentine's heart, later supplemented by other images such as a tree, the Venus de Milo, an outstretched hand and a skull – as if they were containers that could be placed in different contexts and filled with a variety of emotions and meanings but still connected to him through familiarity. In a heart painting such as *Poulenc* (1971), named after the composer to whose music he had been listening, he continued to use strategies first devised for his Pop works: a simple, centrally placed image of an instantly recognizable motif, with real objects attached to the canvas as if physically acting on its surface. The increasingly private references, however, and the role accorded brushwork and atmospheric colour in conveying mood and personality, indicate the extent to which Dine had by this time left Pop behind. Among the last of his works that could be described as Pop were cast aluminium sculptures of 1965, such as *Large Boot Lying Down* and *A Boot Bench*, but even these demonstrate the extent to which common objects of everyday use still interested him not as signs of a culture based on the anonymity of mass production but, on the contrary, as resolutely human images.

The artists who constituted the core of American Pop painting – Wesselmann, Rosenquist, Warhol and Lichtenstein – showed no such signs of personalizing or toning down

the hardness of their aesthetic. The twin concerns with form and charged eroticism that had characterized Wesselmann's paintings from the early 1960s became more pronounced towards the end of the decade. He continued his quest for *The Great American Nude* with such urgent obsessiveness that he overtook the casual parody of the original title as a comment on the unattainable accolade of the Great American Novel. In works such as *Great American Nude # 92* (1967) the model displays her body with a shocking sexual openness: her legs are splayed wide to reveal her genitals, her breasts are picked out by their whiteness in contrast to the tanned skin around the bikini line, and her mouth has the openness of orgasmic ecstasy. Her vulnerable nudity is emphasized by a single stocking and by the representation of her pubic area with real hair; the sensual tactility of the picture as a whole is given one final but essential touch with the use of a fake animal fur as a collage element for the bed on which the woman lies. The intensity of sexual desire and the assertive physical presence of the pictorial means are inextricably entwined, mutually supporting the invented image.

A new development in Wesselmann's work around this time involved the representation of a grossly enlarged part of the female anatomy as a fragment whose contours are identical to those of the canvas on which the image is painted. Works such as *Seascape # 19* (1967), in which a pink-nippled breast is identified almost exclusively by its cut-out profile against a blue sky, or *Mouth # 18 (Smoker # 4)* (1968), one of a group of shaped canvases that depict female mouths covered in a layer of glossy red lipstick, are as explicitly formal in their exploration of shape and colour as a contemporaneous abstract painting by Ellsworth Kelly. There is, of course, one major difference, since Wesselmann's forms are directly dependent on their fetishistic identity as parts of female anatomy; the enlargement of a mouth to a height of more than two metres makes it look more abstract when viewed from close up, but it also exaggerates its sexual connotations, particularly as the lips enclose a cigarette suggestive of post-coital satisfaction.

When Warhol made his Duchampian pronouncement about retiring from painting in 1965 in order to devote more time to his 'underground' films, he had already achieved such a resolution both in his means and his subject-matter that it no longer seemed necessary to him to continue painting. His Castelli Gallery exhibition in November 1964, followed in May by a show at Ileana Sonnabend's in Paris, consisted of dozens of canvases, ranging in size from 10 x 10 centimetres to more than 2 x 4 metres, of a single image of Flowers adapted from a piece of a photograph found in a magazine. The first set of these paintings, for which the green background was painted by hand, was followed by another series printed from multiple screens to step up production, as Warhol wanted them to be hung close together almost like wallpaper; the areas of flat colour were printed in different colour combinations from the same screens before the final superimposition of the photographic image as a screen printed in black. Although at a glance they all looked much the same, each was in fact unique: a perfect example both of the efficiency of the assembly-line method and of the marketing strategy in which the uniqueness conferred by the smallest of changes makes an object more valuable and desirable.

Since shooting his first silent films with a 16mm camera in 1963 Warhol had found in the cinema a way of sidestepping his physical involvement in the production of images. It served him both as a mirror of the marginalized society of drug addicts, transvestites and drop-outs with whom he now associated and as a medium whose properties he could examine with the same dispassionate logic he had applied to painting. Starting with silent films, unscripted situations, a stationary camera and virtually static subjects, he gradually introduced sound, colour and narrative and his own roster of super-stars.

EXTINGUISHED MATCH

199

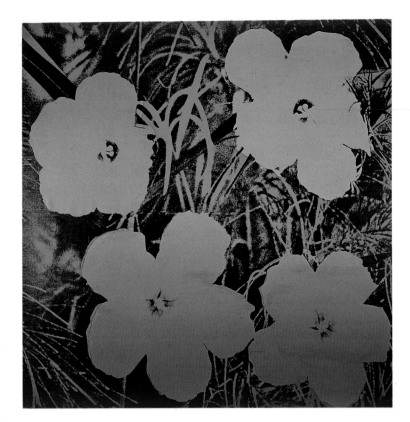

283 Andy Warhol *Flowers* 1964

284 Jime Dine *Large Boot Lying Down* 1965

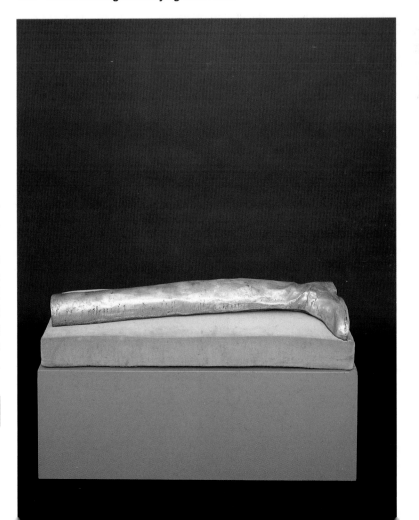

285 Tom Wesselmann *Mouth # 18 (Smoker # 4)* 1968

287 Tom Wesselmann
Great American Nude # 92 1967

286 Tom Wesselmann
Seascape # 19 1967

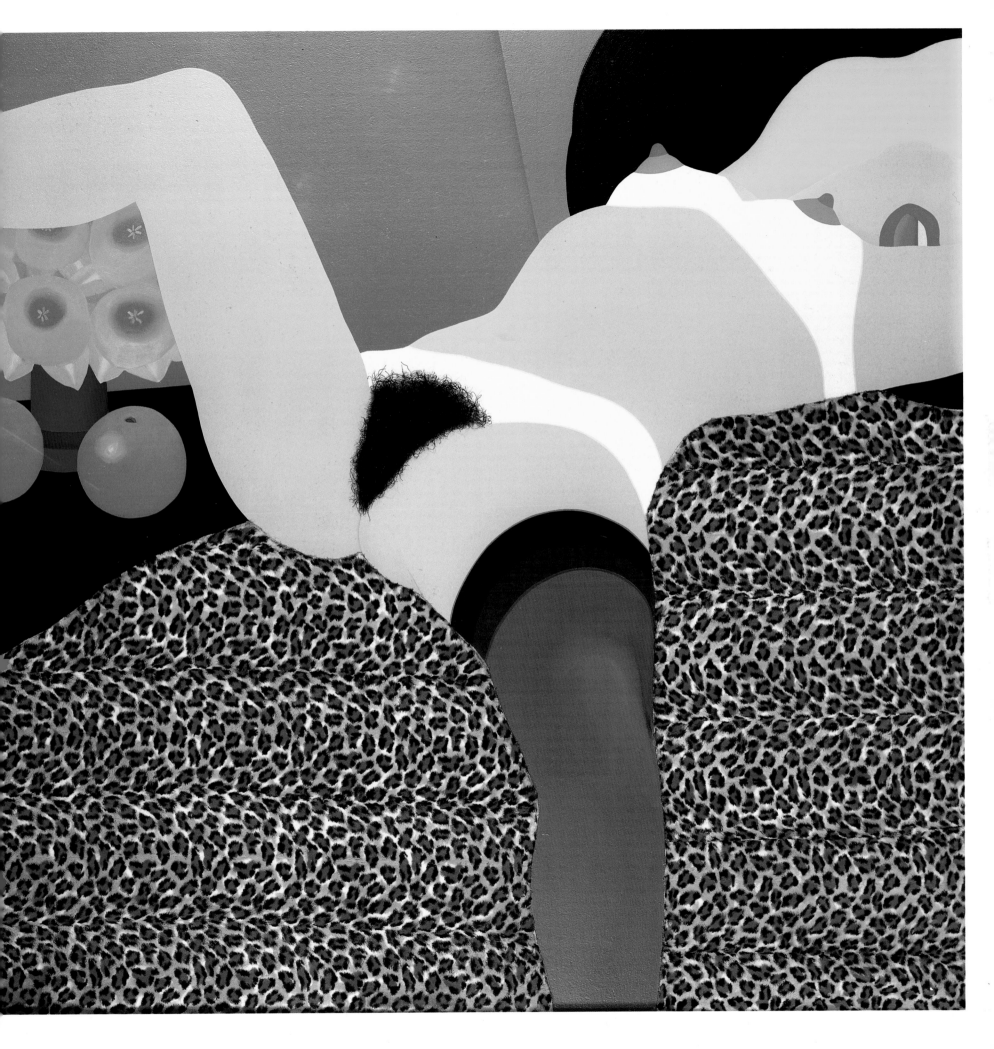

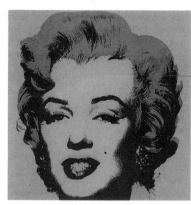
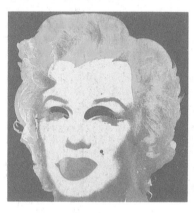
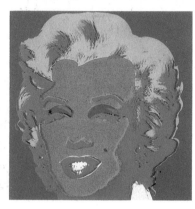

Thus he re-created in the space of a few years the entire history of the Hollywood industry. After the popular success of his best-known film, *The Chelsea Girls* (1966), Warhol removed himself even from his role of cameraman and director, soon handing over responsibility to his assistant Paul Morrissey but still keeping his name on the credits.

More than any other Pop artist, Warhol seemed to regard the removal of himself from his work as a real goal rather than just an idea that would focus attention on the nature of the creative act. He gave form to this final self-abnegation in the two rooms of his one-man show at Castelli's in April 1966: one consisted solely of the gallery wall covered in a continuous surface of wallpaper representing a cow's head in Day-Glo colours, while the other was an empty space containing nothing but a group of silver-coloured helium-filled pillow shapes that he called *Silver Clouds*.

Although Warhol never gave up painting, his professed retirement was not just a pose or a bid for sensationalist press coverage, since he was clearly content to leave much of the execution of his later works to others acting on his orders, particularly when it concerned purely mechanical tasks.[5] The *Marilyn* portfolio of screen-prints published in 1967, in which the same image of Monroe he had used in his paintings since 1962 was subjected to ten lurid colour variations, has come to be viewed as one of his best-known works, yet most of the decisions in this case were left to the project director David Whitney in Los Angeles, and Warhol was not even present when they were proofed. This comparatively late entry into the booming print market of the 1960s was consistent with his denial that the work of art's uniqueness was important, but his motivation seems largely to have been a commercial one: a readiness to embrace new ways of marketing art that was also entirely in line with the consumerist basis of his aesthetic.

In his paintings Warhol continued to recycle earlier images but gave them a new twist through changes of scale, cropping, colour and surface, as in *Big Electric Chair* (1967), one of several monumental variants of a striking photograph he had first used in his *Death and Disaster* series of 1963. He also found new ways of dealing with subjects already in his repertoire, notably in his 1967 *Self-Portraits*, which were far more sophisticated, both technically and conceptually, than the 1964 *Self-Portrait* screen-printed from four photo-booth portraits. The new series were all made from the same screens based

288 Andy Warhol, from the *Marilyn* portfolio, 1967

289 Andy Warhol *Electric Chair* 1967

290 Andy Warhol *Self-Portrait* 1967

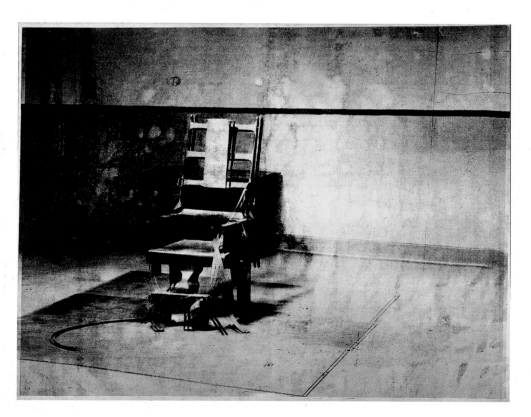

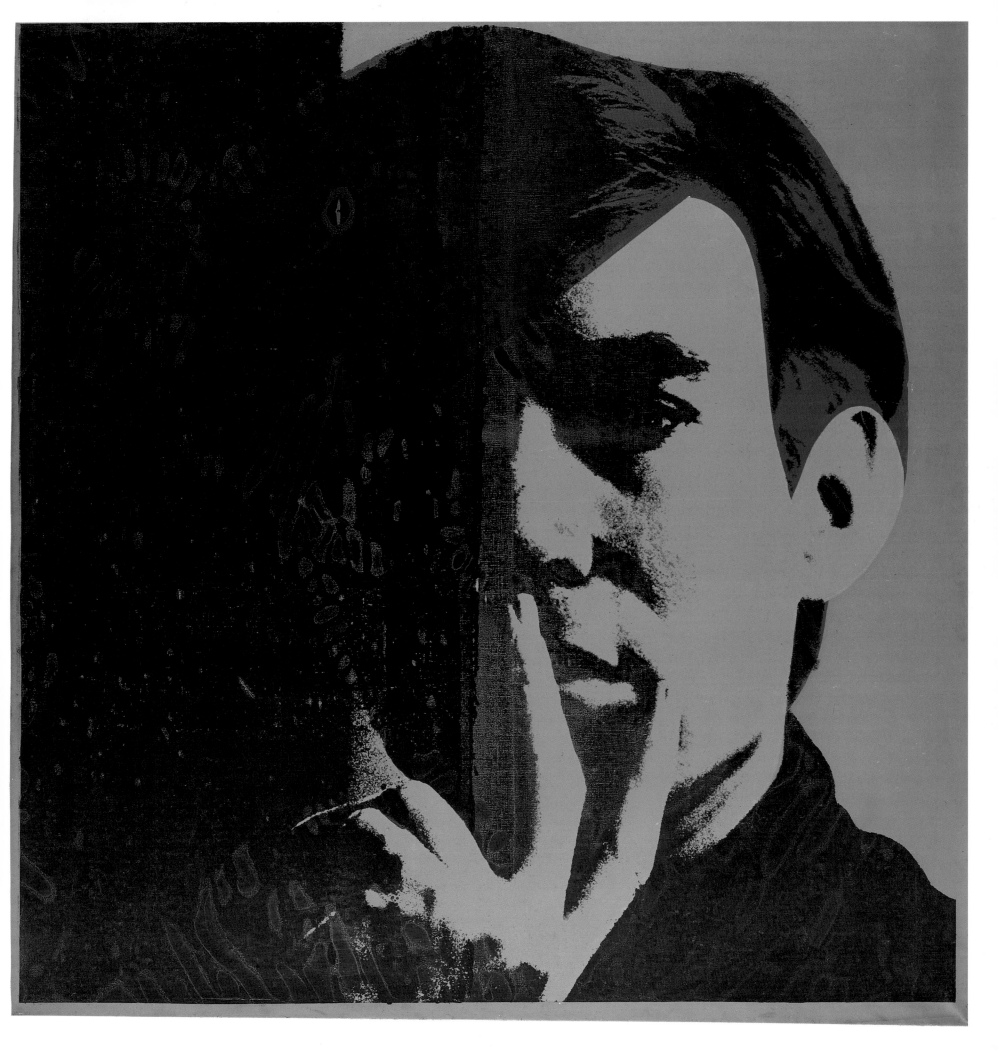

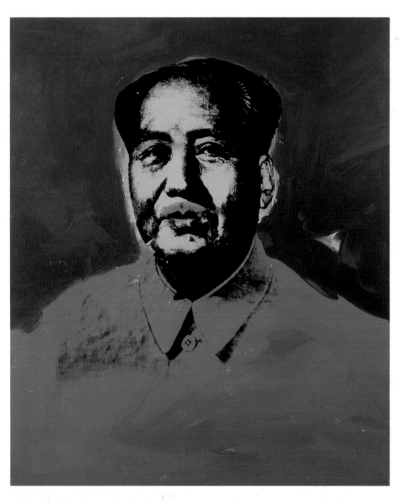

291 Andy Warhol *Mao 6* 1973

on a photograph taken by Rudy Burckhardt; this pensive image, by which he projected himself with the glamour and star quality he had earlier accorded Marilyn Monroe and Elizabeth Taylor, has since assumed a central position in Warhol's iconography. Few of the commissioned portraits that became the staple of his work as a painter during the 1970s even begin to rival the iconic power of these and earlier pictures. Nevertheless, Warhol's intuitive grasp of images that were arresting both in graphic terms and as signs of a particular historic moment continued to yield works that are among the greatest achievements of Pop, such as his *Mao* portraits of 1972–4, painted when President Nixon visited China and based on a photograph already well known as the frontispiece to the counter-culture bible of the 1960s, *Quotations from Chairman Mao*. The agitated brushwork in these and later paintings, such as the 1975 *Ladies and Gentlemen* series of transvestite portraits, anticipated the Neo-expressionist trend of the 1980s in their appropriation of a nominally expressive method as a mere surface style devoid of personal meaning.

Popular sources and methods had also been integrated with such conviction by Lichtenstein as early as 1963 that he could have succumbed to the temptation of simply repeating a proven formula. Instead he used the forcefulness of the standard elements of his pictorial language – the Benday dots, flat colours and black outlines – as a shield behind which he introduced substantial changes to his subject-matter and way of working. By 1964 he had abandoned his ready-made comic-strip images and had begun to invent his own, initially in a series of landscapes such as *White Cloud* that were conceived as pure abstractions rendered into a synthetic portrayal of an open vista through the suggestion of a horizon line, cloud shapes, sunset colours or the schematic rays of the sun. Lichtenstein stressed the artificiality of such images by using them not only in paintings but also in works made of enamel on steel, such as *Clouds and Sea* (1964), and in editioned prints on shimmering industrial materials such as Rowlux, as in his 1967 portfolio of screen-prints entitled *Ten Landscapes*. Our willingness to accept such simple representations as landscapes confirms the thesis that most people's experience of nature, particularly since the advent of the industrial and urban age, is largely culturally mediated. By such means Lichtenstein directs the viewer to questions of perception inherent not just to this particular genre but to all painting, whether it be the illusionism of traditional representational pictures or the effects of shimmering light and colour in the abstractions of Op art.

In 1965–6 Lichtenstein painted a series of large canvases, such as *Big Painting VI* (1965), in which he parodied the sweeping brushstrokes made by the Abstract Expressionists with house-painter's brushes. The double paradox was that of representing an apparently spontaneous mark by rendering it in a graphic language as a series of painstaking operations, but making the result look so effortless and mechanical that it might all have been printed at a single touch. As immediate in their impact, legibility of image and humour as any of his comic-strip paintings, these pictures pose serious questions about the artistic process and in particular about the interaction of idea, invention and execution. The same is true of the paintings in which Lichtenstein took as his starting-point a specific modern style, whether it be the Neo-Plasticist abstractions of Piet Mondrian, as in *Non-Objective I* (1964), the self-consciously modern machine aesthetic of Art Deco, which resulted in his *Modern Painting* series of 1967 and *Modular Paintings* of 1969, or the Impressionism of Claude Monet, as in his *Haystack* paintings of 1968–9. Our knowledge of the source to which he refers, and the associations it instils through its imagery and procedures, is treated as a nexus of assumptions against which we read Lichtenstein's pseudo-mechanistic treatment. *Rouen Cathedral*, rendered by a network of

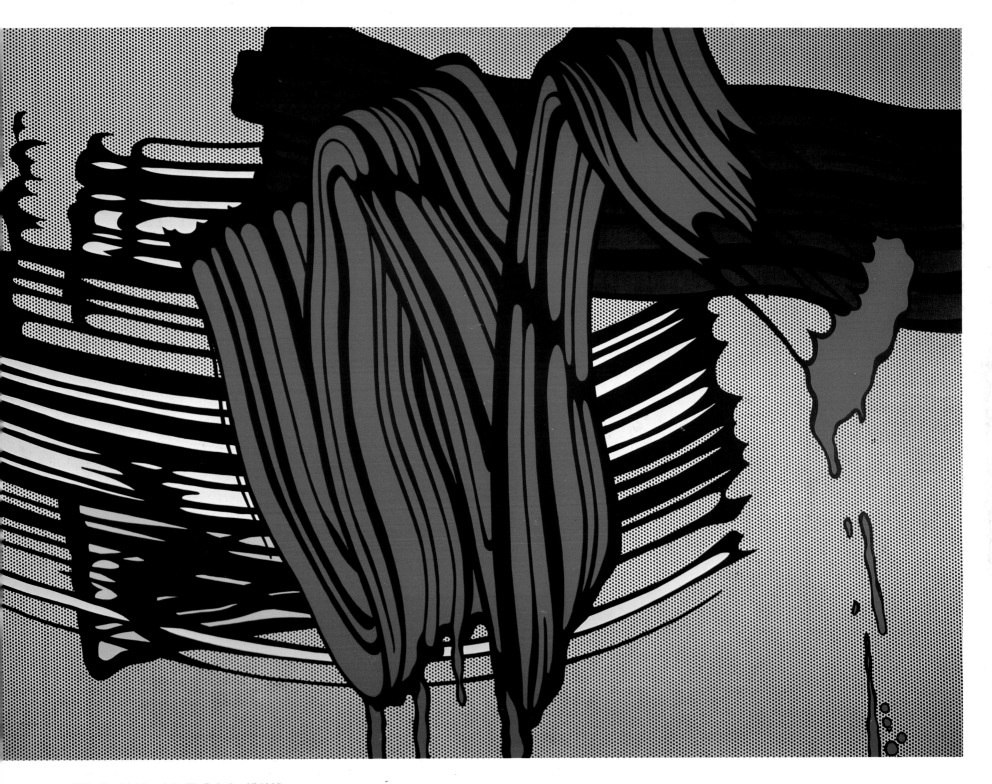

292　Roy Lichtenstein *Big Painting VI* 1965

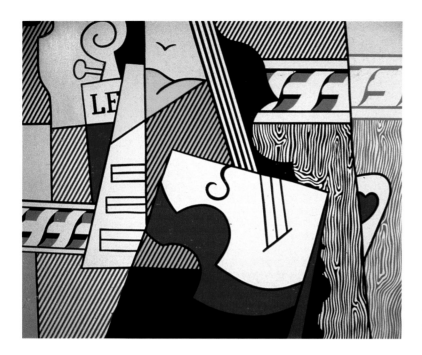

293 Roy Lichtenstein *Cubist Still Life* 1974

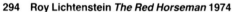

294 Roy Lichtenstein *The Red Horseman* 1974

coloured dots in specific configurations, results from a procedure as sophisticated and at least as laborious as the Impressionist spontaneity Monet had brought to the same subject nearly a century earlier. Yet both artists had made decisions about how to represent the motif by distributing paint in quantifiable amounts of colour across the flat surface, and both ultimately had to make subjective rather than rigorously scientific decisions in creating a substitute in paint for optical phenomena. Lichtenstein thus expresses both the specific historical condition by which he has produced his picture – presenting it, as in his earlier artistic parodies, as if it were a printed reproduction – and the questions of perception and method endemic to Western traditions of painting.

For each style Lichtenstein subjected the implicit intentions of the original to his intense scrutiny. *Cubist Still Life* (1974), for instance, tests the proposition that a three-dimensional object can be visualized as a succession of fragmentary planes reintegrated into a flat surface; while comparable to the later Cubism of Gris, it depends on our recognition of certain short-hand signs of the style (including the image of a guitar and the device of imitation wood-graining) rather than on any specific source. Similarly, Lichtenstein's parodies of Futurism employ its typical strategies, in particular that of representing motion through lines of force and the repetition of forms as if seen in quick succession, but he subverts their function; his own efforts, such as *The Red Horseman* (1974), are resolutely static, irredeemably fixed to the surface in comic acknowledgment of the logical impossibility of the task. His 'Surrealist' pictures of the late 1970s are intentionally cliché-ridden, offering an anthology of received ideas about dream imagery, including disembodied eyes and dripping forms reminiscent of the work of Salvador Dalí, as if to elicit our admission that even the most apparently subjective of styles follows a rigid set of rules and an iconography that depends on its familiarity for its success. His reinterpretation of German Expressionism, particularly in large woodcuts of the early 1980s, leads us to ponder on the genuineness of apparently impulsive marks as the direct result of emotion, given the checks on spontaneity effected by the planning process necessary to the production of any picture. There is much affection in all these works. Lichtenstein's intention is not to mock or dismiss the validity of these styles but to foster an understanding of the principles of modernist picture-making to which he, like earlier twentieth-century artists, is subject.

Paradox and witty reversals of expectations rebound as much in Lichtenstein's art as in Warhol's. For the latter this contrariness was concentrated on a dialogue between methods of printing and definitions of painting, between marks that were mechanical and reproducible and their subservience to the uniqueness of the work of art. Having spent most of the 1960s making paintings that were printed and thus implicitly deprived of their aura of uniqueness, in 1974 he produced a series of editioned prints, *Flowers*, that were coloured by hand and thus different in every case.[6] For Lichtenstein a similar interplay was effected by the relationship between two- and three-dimensional form. Having developed from comic strips a graphic system for representing mass and shadow on flat surfaces, in 1965 he produced glazed ceramic sculptures, including representations of stacked tea cups and of female heads such as *Blonde*, in which the same dots and black outlines were reapplied to three-dimensional objects, making redundant the intended function of the language. Two years later he began a series of free-standing but essentially flat *Modern Sculptures* that referred to the barriers in Art Deco cinema architecture in their elegant linear geometries and in their use of materials such as polished brass and velvet ropes; unlike the utilitarian objects they called to mind, of course, these derivations were deprived of their suggested function and also of much of their materiality,

since they were so thin that they could be seen properly from only one point of view.

This resolutely pictorial, and hence anti-sculptural, treatment of the medium was again employed by Lichtenstein in 1977 in a series of painted bronzes. In a typical work such as Cup and Saucer II he rendered not only the volume of the cup, but also the liquid it contains and the steam rising from its surface, in a unified graphic short-hand such as might have been used to represent such an image decades earlier on the walls of a diner or cafeteria. Customarily we expect sculpture to yield new information about its form as we walk around it, but we would learn little by that here, since they almost disappear when viewed from the side and display the same silhouette from the back as from the front. Our expectations are once again confounded, as also with the representation of the transience of steam in hard metallic outline: these sculptures, like all Lichtenstein's work, are witty and thought-provoking essays in the art of illusion proper to any representation.

Other artists, meanwhile, found new uses for such sources as the comic strip. The Hairy Who, a group based in Chicago that initially consisted of six members – James Falconer, Art Green, Gladys Nilsson, Jim Nutt, Suellen Rocca and Karl Wirsum – presented the catalogue of their first group show at the Hyde Park Art Center, Chicago, in 1966 in the form of an 'alternative' comic book. The imagery and text were all invented, but the subversiveness of the style and content were supported by the audience's recognition that the popular form they were using was that of the youth counter-culture of the time. Although they went their separate ways in 1968, the vulgarity, humour and provocative subject-matter of such sources continued to inform the work of these and other Chicago

EXTINGUISHED MATCH

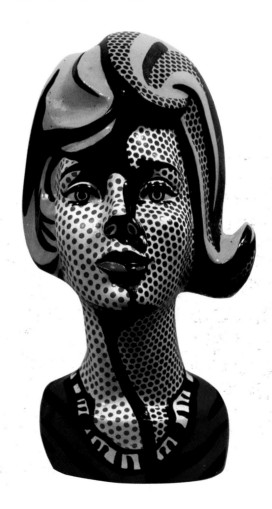

297 Red Grooms *Ruckus Manhattan: Subway* 1975–6

299 Malcolm Morley *On Deck* 1966

298 John Wesley *B's Town* 1973–4

artists such as Ed Paschke and Ray Yoshida, who became known as the Chicago Imagists.[7] The passionate and often quasi-Surrealist excesses of their inventions take them far from the premises of Pop, but the very proposition of an aesthetic rooted in the visual artefacts of street culture would have been unthinkable without Pop's example.

By the end of the 1960s even one of the Abstract Expressionist painters initially most hostile to Pop, Philip Guston, was developing a figurative art in a comic-strip idiom for his own, very different, expressive purposes. His sweaty and bumptious figures and clutter of ordinary objects, by turns hilarious and sinister, appear to be the progeny of another 'underground' comic-strip artist, R. Crumb, although in their impassioned handling and dedicatedly personal subject-matter of studio life and waking nightmares, Guston's pictures have little in common with Pop.

Pictorial languages derived from comic strips also continued to be investigated after the 1960s by a few of the artists associated with the early history of Pop. Red Grooms, for instance, developed the cartoon-like sculptural figures and settings he had introduced in 1963 into increasingly complex environmental tableaux such as *Ruckus Manhattan* (1975–6). The life-size figures have a physical immediacy that is intensified by the real space we spectators share with them, but their caricatured appearance also proclaims their identity as stereotypes of contemporary city life. John Wesley, while working largely with invented imagery in his later paintings, kept his dispassionate technique of black outline encasing flat areas of colour; he continued to use gentle humour, animal imagery, framing devices, symmetry and tactics of repetition as essential ingredients in the production of paintings that appear to be innocent in an almost childlike way but are, in fact, meditative in atmosphere and sophisticated in their formal construction. In 1974 he painted a series, Searching for Bumstead, that referred explicitly to a comic-strip source: the long-running serial 'Blondie' by Gig Young. As the series title suggests, Dagwood Bumstead is nowhere to be seen in paintings such as *B's Town*, in which his dog Daisy is shown looking forlornly into the empty distance.

One of the basic strategies of Pop, that of presenting a painting as a faithful replica of an existing image that has already been processed into two dimensions, was followed by a number of artists who came to be grouped together under the term Photorealism. The Englishman Malcolm Morley, who emigrated by sea to New York in 1958, began in 1965 to produce pictures of ocean liners such as SS Amsterdam in front of Rotterdam (1966) as hand-painted enlargements of publicity photographs found on postcards and travel brochures. The image was laboriously transcribed into paint in tiny sections according to a traditional squaring-up system, with the source material turned upside down so that every brushstroke would approximate as closely as possible the coloured marks of the photograph. By leaving a border of bare canvas round the image, Morley presented his paintings as grossly enlarged snapshots in order to portray deep space and effects of light while simultaneously destroying that illusion. A similar use of a bare canvas border to suggest the photographic origin of the painted image had been used by Hockney as early as 1964 in his pictures of buildings and swimming pools in Los Angeles.[8] Morley, however, went much further than Hockney in his exploitation of the photograph not just as an idea or a point of reference but as an artefact whose precision and surface gloss he wished to emulate. The synthetic colour he employed in paintings such as On Deck (1966), with the bluer than blue skies of holiday snapshots and tourist publicity, is as much a part of the picture's meaning as its subject-matter. The fantasy perpetual leisure can be experienced in brief doses and recalled with photographic souvenirs; or else it remains an ad-man's lie, a promise never to be fulfilled.

300 Chuck Close *Phil* 1969

301 Robert Bechtle *'60 T-Bird* 1967–8

The Photorealists acknowledged Pop as the precedent that made their work possible, and in essence their presentation of paintings as enlargements of photographs can be considered an extension of one of the basic practices of the movement.[9] The equivalence they established between an anonymity of technique and the mechanical nature of the source material, especially in the use of the airbrush by painters such as Chuck Close and Don Eddy, aligns them with the most rigorous definition of Pop as an art reflecting a materialistic and industrially based society. The airbrush had been used since the mid-1960s by at least one Pop artist, Peter Phillips, not only because it was capable of great precision but also because its association with commercial illustration took it outside the realm of art history.[10] Of all the new painters, Close made a particular point of the effects achieved by massively enlarging a photographic image: viewed from a distance or in reproduction, his painted portraits are endowed with an explicitly photographic definition, but when scrutinized from near the surface their legibility begins to break down into a surface pattern that looks virtually abstract. This acknowledgment of the properties of scale had also earlier been exploited by Pop artists and in particular by Rosenquist. The Photorealists' choice of subject-matter, too, encompassing Robert Bechtle's scenes of drab suburban life and the glittering city shopfronts of Richard Estes, demonstrated an involvement with the signs and symbols of contemporary American life that was even more literal than that featured in Pop earlier in the decade.

Just as Pop artists subjected similar sources to a variety of methods, so the Photorealists differed in the relationships they established between their paintings and their photographic models. The procedures they employed ranged from Bechtle's direct transcription of a single snapshot, which he projected to the required size in the form of a transparency, to the complex gathering of information from separate photographs for the paintings made by Richard Estes. Chuck Close, on moving from grey monochromatic paintings into colour in 1971, applied the hues in four separate airbrushed layers by a system derived from the commercial printing technique of four-colour separations, using as his guide actual photographic separations produced from the original transparency with the aid of filters. In spite of these procedural differences the Photorealists all shared an obsession with a perceptual illusionism explicitly identified with the vision of the camera, and however complex their methods they all sought to give the impression that their images were simply transcribed from photographic sources.

Similar methods were applied at this time to figurative sculpture by John de Andrea and Duane Hanson, both of whom developed in an explicitly illusionistic manner the literalism inherent to George Segal's environmental narratives of human figures cast from life. Segal continued to present his figures both as fragments of reality and as abstractions; to this end he continued to use white plaster as his basic material, from 1973 also recasting the plaster in bronze or painting the plaster figures in a coat of a single bright colour. The Photorealist sculptors, by contrast, exploited the shock of recognition achieved by *trompe-l'oeil* techniques previously used not in high art but in the precise rendering of life-size figures for waxwork effigies. Rather than relying on plaster, a traditional material associated with skilled handwork, they usually made their casts from newly available synthetic materials that had been developed for industry. De Andrea favoured polyvinyl, cast vinyl, polyester resin and polyester and fibreglass, all of which resulted in a smooth skin-like surface that he then coloured in flesh tones with oil paint; Hanson used plaster to reinforce moulds made by pouring silicone onto parts of the body, but he cast the figure in resilient synthetic materials such as fibreglass or polyvinyl acetate.

302 Richard Estes *Grand Luncheonette* 1970

304 Duane Hanson *Supermarket Shopper* 1970

Although de Andrea produced a number of figures that in their nudity were not of a specific time or place, even in these works he included sufficient detail to relate them to his own society, for example by seating the model on a real chair or by the choice of hair style. In their other works, moreover, both de Andrea and Hanson exaggerated the confusion between their sculptural inventions and reality by dressing their figures in store-bought clothing and by associating them with real objects that establish their identity. Hanson in particular thus portrayed immediately recognizable types encountered in daily life; *Bowery Derelicts* (1969), *Tourists* (1970), a construction worker (*Hard Hat*, 1970), a *Supermarket Shopper* (1970) and a garishly dressed *Florida Shopper* (1973), an *Old Man playing Solitaire* (1973), a *Bank Guard* (1975), a *Dockman* (1979) and *Queenie: Lady with Cleaning Cart* (1980) are among the ever growing cast of his composite portrait of contemporary American society. His choice of subject-matter as enumerated in such a listing, together with the humour and mixture of satire and social concern with which he examines his fellow citizens, places his work squarely in the Pop tradition.

The severity of the rules governing Photorealist painting and sculpture as a branch of Pop eventually proved their undoing, because Photorealism became a limited style incapable of any real development apart from one of technique or subject-matter. Pop, by contrast, was a movement predicated not on a single method but on a set of ideas, and it could thus continue to embrace a variety of styles ranging from the most literal representations to a formalism as rigorous as that governing any abstraction. The narrative sculptures fabricated by Segal and by Ed Kienholz, an artist who had been associated with Pop at an early date but who never aligned himself closely with the movement, continued to incorporate real objects or facsimiles of them without making such illusions or literal intrusions of the environment their primary appeal.

In some tableaux, such as *The Back Seat Dodge '38* (1964) or *Barney's Beanery* (1964–5), Kienholz alluded to objects and settings closely related to Pop, but he used

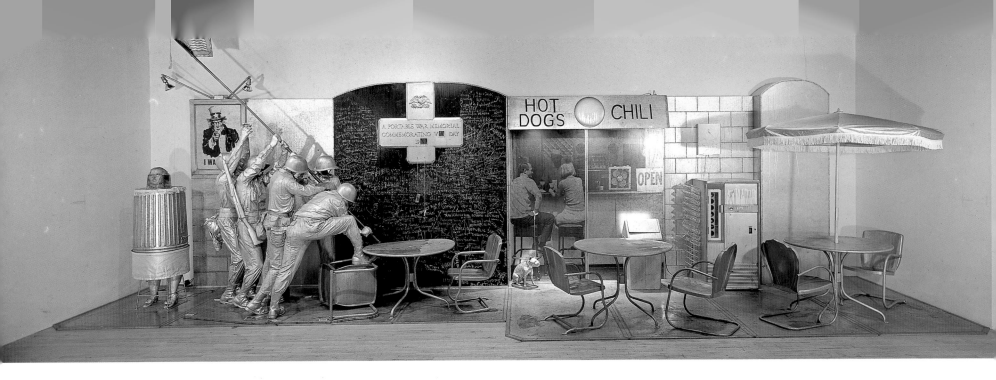

305 Ed Kienholz *The Portable War Memorial* 1968

306 Larry Rivers *I Like Olympia in Black Face* 1970

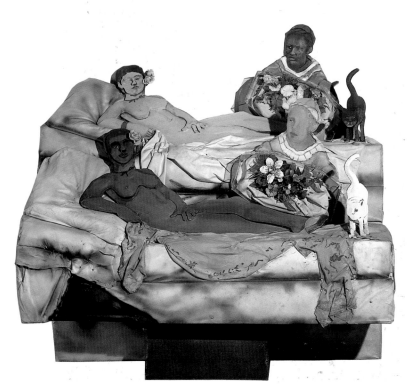

them not as ends in themselves but for explicitly social or political purposes and as props with which to develop a persuasive fiction. His works, like Segal's, remain tangential to the mainstream of Pop not just because of their narrative emphasis but also because they demand an emotional engagement with the subject-matter and an identification with (or reaction against) the figures portrayed. Nevertheless, some of his most powerful tableaux, such as *The Portable War Memorial* (1968), owe their effectiveness to the immediacy achieved through devices and methods derived from Pop. In this case, for example, the anti-war message is strengthened by the incorporation of a replica of the Iwo Jima memorial at Arlington Cemetery, by the sense of familiarity induced by the presence of a working Coca-Cola machine and an Uncle Sam recruiting poster, and by the official lettering of an inscription commemorating wars past, present and future through the sinister detail of a missing date to be inserted when the occasion arises.

The Photorealists were not alone in interpreting Pop primarily as a strategy for basing a painting on a ready-made image already processed into two dimensions. During the late 1960s and 1970s a number of other artists conceived works as reinterpretations, as parodies and even as *trompe-l'oeil* replicas of other works of art as seen in printed reproductions, re-using ideas already proposed as part of the basic fabric of Pop.[11] Such methods can be traced as far back as Rivers's *Washington crossing the Delaware* of 1953 and to his renditions during the early 1960s of a Rembrandt group portrait as seen on a cigar-box lid and of Cézanne's *Card Players* as pictured on a postage stamp.[12] Rivers continued to avail himself of such methods in his most overt engagements with Pop ideas, particularly in painted reliefs and sculptural objects such as *Webster and Cigars* (1966) and his double-take on Edouard Manet's *Olympia* of 1863, a mixed-media construction entitled *I like Olympia in Black Face* (1970), which he presented as an exposé of its implicit racism.

Prominent among the other precedents in Pop for such forays into the history of art were, as we have seen, the screen-printed reproductions of Old Master images by Rauschenberg and Warhol and the subjection by Lichtenstein of Picasso's Cubism and other

212

twentieth-century styles to a quasi-printed technique derived from comic books. Artists associated with Photorealism soon broached similar themes, as in two paintings of 1968, Morley's *Vermeer – Portrait of the Artist in his Studio* and John Clem Clarke's *Delacroix – Liberty leading the People,* both of which presented extremely well-known works from the history of art as if they were oversized reproductions. Others who had been associated with Pop at an early stage returned in the 1970s to some of its basic principles, particularly in relation to the use of ready-made images. Peter Saul, one of the first painters to have broached Pop subject-matter in his early 1960s work, again came close to the spirit of the movement in variations of masterpieces by other artists, such as *Liddul Gurnica* (1973), a paraphrase of Picasso's *Guernica* of 1937, *The Night Watch* (1974–6), after Rembrandt, and *De Kooning's Woman with Bicycle* (1976), each both a caricature of and a homage to its source. Jess, whose comic-strip paste-ups of the mid-1950s anticipated by several years the use of such imagery by the mainstream Pop painters, had returned in the 1960s to an essentially Surrealist collage idiom. In *Deranged Stereopticon* and other works of similar format begun in 1974, however, he introduced a technically novel twist on the use of an existing image as a found object by gluing fragments of a printed picture onto the pieces of a complete jigsaw puzzle; the interpenetration of two spatial illusions thus self-evidently takes place on a single flat surface, with the joins of the pieces encouraging the viewer to fill in the missing gaps of each image as an act of will, a conceptual game.

It was in the late 1960s, just as Photorealism was becoming an identifiable movement, that an American artist, Richard Pettibone, established the methodology he pursued in all his subsequent work: producing hand-painted transcriptions of colour reproductions of other artists' paintings. The tiny scale of his pictures has led to him being misleadingly called a miniaturist, but in fact he was a literalist in the most exacting Pop sense, since each painting is made from a tracing of a printed reproduction and is thus identical in size to its source. Although his models included the work of earlier painters such as Ingres, his prime sources were reproductions of pictures by three artists of the 1960s, Lichtenstein, Warhol and Stella. Sometimes two fragments were joined into a single config-

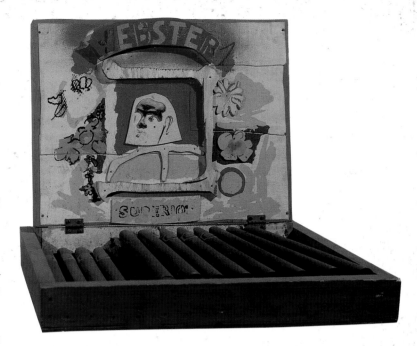

307 **Larry Rivers** *Webster and Cigars* **1966**

308 **Jess** *Deranged Stereopticon* **1974**

309 Richard Pettibone *Yazd V, Yazd II & Trigger Finger* 1969

311 Claes Oldenburg *Lipstick, Ascending, on Caterpillar Tracks* 1969

310 Claes Oldenburg *Lipsticks in Piccadilly Circus* 1966

uration, as in the marriage of works by Lichtenstein and Stella in *Yazd V, Yazd II & Trigger Finger* (1969). Other works were presented as faithful transcriptions of a single source, as in the set of thirty-two screen-printed *Campbell's Soup Cans* that replicate the hand-painted series shown by Warhol at the Ferus Gallery in 1962.[13] The preference shown by Pettibone for characteristic pictures by Warhol and Lichtenstein, and his reliance in each case on a technique derived from the source in question, stated unequivocally the extent to which his meditations on artistic originality were rooted in the concepts of Pop. His provocative equation between the 'original' and its 'copy' – of his own original work as a painted replica of a printed reproduction of another artist's original, which itself had been presented as a copy of a found image – rephrased one of the basic insights of Pop. Such ideas were to become endemic in art of the later 1970s and 1980s, for example in the work of Sherrie Levine, but were promoted under a new catchword: 'appropriation' (see Chapter 10).

The new lease of life given to the spirit and the ideas of Pop in the work of artists who emerged towards the end of the decade contradicts the often stated view that Pop was a spent force by 1970, if not earlier.[14] The purest American exponents of the movement, however, remained its originators, even when the artists subjected their work to major changes. As early as 1965, for instance, Oldenburg began to contemplate the possibility of taking his work out of art galleries and museums by presenting it instead on a much bigger public scale in the form of massive outdoor monuments. He was motivated partly by a desire to regain control of his work, for he wished to avoid both the speculation by which art objects become mere commodities and the frequent disregard for their intended conditions of display. It was on moving into a huge studio in 1965 that he began a series of drawings in which he imagined the unsettling effect of placing gargantuan enlargements of simple things like a baked potato or a banana into a real landscape. These soon developed into a genre in themselves, allowing full rein to his imagination and considerable virtuosity as a draughtsman.

Similar ideas were proposed by Oldenburg in a series of collages made from postcards and newspaper clippings during his first visit to London in 1966, usually based on a practical association between very small and very large things. Oldenburg was impressed by the monumentality of the city and found it a very good foil for his own ideas about scale and about the relationship of the present to the past. He allowed both his experience of driving around the city and the found images themselves to trigger associations that would free his fantasy in suggestive ways, but he wanted to picture his colossal versions of transplanted ordinary objects as realistically as possible, as if they were real sculptures. They were all intended to be realizable; only financial constraints and the impossibility of obtaining most of his chosen sites stopped them from being made. Among his proposals were two for Piccadilly Circus, the hub of the entertainment district bordering Soho, in which he impertinently suggested replacing the turn-of-the-century monument known as Eros with objects that played punningly on its sexual connotations but in a contemporary vernacular language: one plan called for a set of opened lipsticks, objects phallic in form but used to exaggerate the physical attractiveness of women; the other suggested monument was also determinedly phallic, a drill-bit presented as if half-submerged in the ground as a deliberately vulgar visualisation of 'screwing' in both the mechanical and sexual sense. Other such collages, which he referred to as Notebook Pages, included proposals to replace Nelson's Column in Trafalgar Square with a giant gearshift or rear-view mirror as a more appropriate symbol for the traffic congestion that seemed to him the most typical feature of that place and of London in general.

312 Claes Oldenburg *Extinguished Match* 1987

313 Claes Oldenburg *Giant Pool Balls* 1967

On returning to America Oldenburg produced some of his most monumental indoor sculptures, such as *Giant Pool Balls* (1967), a brilliantly economical equation between ordinary objects and huge sculptural forms that rivalled the simplicity and massive presence of the best Minimalist art of the period. As soon as the first opportunity presented itself for a commissioned work on a permanent outdoor site, however, Oldenburg showed no hesitation in abandoning his gallery objects in order to pursue a new career as a public sculptor. The tradition for public monuments that was so much a part of nineteenth-century civic pride and philanthropy had more or less died out with modernism; its resuscitation, especially in the 1980s in America, owes much to Oldenburg's trail-blazing example. His first such work, commissioned by a group of students at Yale School of Architecture, relates to his Piccadilly Circus collages in its use of motifs endowed with explicitly male and female associations combined here into a hybrid object of sublimated sexual aggression: *Lipstick, ascending, on Caterpillar Tracks*, in which a single lipstick stands upright on the platform of a tank that serves as its sculptural pedestal. Erected in 1969 at the height of student protests against the American military involvement in Vietnam, it was plainly intended as a focus for political protest. Objects, even when transformed into sculpture, were still to have a use: as originally envisaged, speakers were to mount the platform in order to address their audience, and the soft end of the lipstick was to be inflated into an erect form as they did so as a way of announcing their presence. Damage to the sculpture eventually caused it to be removed from its original site at Beinecke Plaza, Yale, to one less exposed, by Samuel Morse College, and its kinetic detumescent function had to be abandoned in favour of a more practical solution by which the lipstick was rigid at all times. Nevertheless, it was vital in convincing Oldenburg and potential patrons alike that his ideas for sculptural monuments, no matter how fantastic they seemed, were actually capable of being realized. It also provided him with his most useful experience to date of working with industrial technology, since it was only by transforming his creative role into that of a designer supervising the work of specialist fabricators that he could take his monumental ideas off the drawing board and into the real world.

The public commissions and projects made by Oldenburg in the 1970s and 1980s, conceived from 1976 as collaborative efforts with his second wife, Coosje van Bruggen, include such works as *Giant Trowel* (1976), now installed in the grounds of the Rijksmuseum Kröller-Müller in Otterlo, Netherlands; a *Batcolumn* (half-architecture, half-baseball bat) 33.5 metres high, sited in 1977 in front of the Social Security Administration Building, West Madison Street, Chicago; a painted steel *Flashlight* 11.73 metres high at the University of Nevada, Las Vegas, 1981; *Hat in Three Stages of Landing* (1982) in the grounds of the Community Center, Salinas, California; and *Stake Hitch* (1984) at the Dallas Museum of Art, Dallas, Texas. In terms both of their methods of manufacture and of the relationship between the site and the chosen image, these memorable and apposite insertions of stereotyped objects into specific locations, even in the case of large indoor works such as *Extinguished Match* (1987), succeed in extending Pop in one especially remarkable respect: that of re-imposing a transformed sign of an ordinary object back onto the environment from which it was drawn.[15]

Pop precepts also proved surprisingly fertile in the 1980s for Rosenquist, who set the tone for his work during the decade with *Star Thief* (1980), at more than 5 x 14 metres one of his largest and most elaborate paintings both in the formal complexity of its interpenetrating planes of illusion and in its elaboration of a contemporary iconography. Lichtenstein and Wesselmann found new ways of addressing themselves to the production

314　James Rosenquist *Star Thief* 1980

315 Tom Wesselmann *Steel Drawing/Still Life with Fruit and Goldfish* 1987

316 Andy Warhol *Dollar Signs* 1981

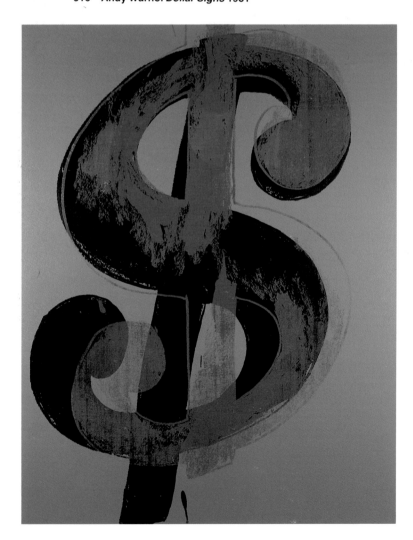

of marks that looked spontaneous and therefore 'expressive' while maintaining their characteristic aloofness. For Lichtenstein it was a matter of presenting smeared paint as an elaborate contrivance to be quoted at will as a cliché in its own right, that is to say as a graphic device in an ever-growing repertory. In Wesselmann's laser-cut *Steel Drawings* and related works of the late 1980s on cut-out aluminium, a hand-made drawing was mechanically replicated in enlarged form to preserve its sketchy quality in the very act of its production by machine; since the metal surface coincides entirely with the drawn line, its representational illusionism is presented as inseparable from its material identity.

Right until the moment that he was suddenly and sadly eliminated from the competition by his death early in 1987 after a routine operation, Warhol remained true to the spirit of Pop. Among his last works were large paintings in which he combined company logos and advertising symbols with religious imagery copied from masterpieces by Raphael and Leonardo. He had remained no stranger to controversy even when returning in the early 1980s to a theme he had proposed two decades earlier, that of money, this time presented not as a replica of an artefact (a dollar bill) but in the form of a sign or, more precisely, as *Dollar Signs*. The procedural complexity of these works, which involved multiple screenings of marks initially made by hand, was camouflaged, needless to say, as an act of supreme simplicity. Having long since announced his conversion from Commercial Art to Business Art, Warhol brought Pop full circle in these iconic homages to the Almighty Dollar. In the very act of rubbing our noses in the vastly increased commercialization of the art market, caustically but proudly presenting his own paintings as commodities for investment, Warhol celebrated the supremacy of Pop itself as a movement of incontrovertible and lasting value.

317 Roy Lichtenstein *Landscape with Figures* 1984

EAT DIRT ART HISTORY

Neo-Pop in the 1980s

Given the cyclical nature of artistic developments and the increasing speed with which one movement has given way to another by the sheer force of negative reaction, it was inevitable that after its heyday in the 1960s Pop appeared to go into an eclipse during the following decade. The flood of group exhibitions and books on Pop became a mere trickle after 1970. The hedonism and light-heartedness generally associated with the movement, together with the unabashed formalism and decorativeness of much of this work, were directly countered by the visual austerity and solemn, intellectual tone of the most vaunted forms of art during the 1970s – Minimalism, Arte Povera, Conceptual art and Land art – which, as suggested in the previous chapter, at first masked the debts owed to Pop even by these movements. The dedication of Pop artists to explicit and familiar imagery, the references to common objects and the insistent material presence of Pop paintings and sculptures were casually dismissed as evidence of the superficiality and consumerist values of the 'swinging 60s'; much of the art that followed in Pop's wake consequently sought to circumvent the art market, leading to a tendency called by the critic Lucy Lippard the 'dematerialization' of the object.[1]

When the reaction set in against what was perceived as the greyness and elitism of the art forms dominant in the 1970s, some of its first symptoms were made visible in the work of painters throughout Europe and America whose return to gestural brushwork – and to often extravagant imagery rooted in mythology or the artist's psychology – earned the epithet Neo-expressionist. The meteoric financial and critical success of many of these artists – of Americans such as Julian Schnabel, Germans such as Anselm Kiefer and Italians such as Enzo Cucchi – and of the network of ambitious dealers with whom they were associated in a sense replayed the ascendancy of Pop less than twenty years earlier but in an even more exaggerated way. The hyperbole and money lavished on these new developments brought artists face to face again with the status of their art as both a cultural and economic commodity.

Some of the young painters not closely connected to the Neo-expressionist trends, such as the American David Salle, began again to allude openly to consumer society (which now included a generation brought up on television) and to the vast fund of media images that had earlier attracted Pop artists. Others, again particularly in America, worked directly in the terms of street culture by using graffiti. Painters such as the Italian Sandro Chia made self-conscious references to historical modernist styles such as Futurism or moved disarmingly from one style to another, as in the case of the Czech-born German Jiři Georg Dokoupil, thus declaring an ironic distance from any single idiom and proposing that the entire history of painting was a kind of artistic shopper's paradise from which the individual could choose at will. Young sculptors, especially in Britain, based

221

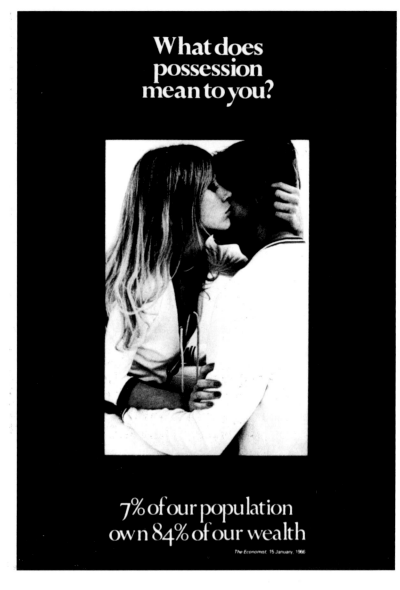

What does possession mean to you?

7% of our population own 84% of our wealth

The Economist, 15 January, 1966

319 Victor Burgin *Possession* 1976

their aesthetic on found objects that were explicitly the products of a late industrial society; whether recycling manufactured items which had outlived their use or buying things from the shops, they chose them with a view to the materials from which they were made and to their status as images and as objects intended for particular use.

The most conspicuous re-enactment of Pop strategies in the art of the 1980s was effected by American 'object-makers' and painters such as Jeff Koons, Haim Steinbach and Ashley Bickerton, who were among a number of artists shown in several high-profile group exhibitions beginning in 1986 and who were heavily promoted by dealers. The very terms in which their work was first presented as a reaction against their immediate Neo-expressionist predecessors were a precise echo of those used to explain Pop as a response to Abstract Expressionism a quarter of a century earlier: 'The smooth, clean surfaces and crisply defined motifs, the manufactured look, the eclectically borrowed geometric motifs are meant, on one level, to make the autobiographical posturing of the last generation seem slightly silly and quaint.'[2]

Pop's influence was so pervasive that the premises of almost every other movement from Minimalism onwards were transformed (as described in the previous chapter), but some tendencies in the 1980s were close enough to be labelled Neo-Pop. It was in terms of ideas, however, that Pop has perhaps most consistently affected the later course of art. Even politically motivated Conceptual art, made in direct opposition to the uncritical promotion of the capitalist system assumed by many to have been one of the salient characteristics of Pop, owed debts to the movement. The photo-conceptual work made in the 1970s by artists such as the German Hans Haacke and the Englishman Victor Burgin, for instance, was based in large measure on an explicit and subversive appropriation of the methods of mass advertising that would have been unthinkable without the precedent of Pop, although its origins are more usually assumed to have been in literary disciplines such as semiology and structuralism. In his series *US '77* Burgin paired photographs of commonplace advertisements with typeset messages that negate or parody their usual rhetorical language. He decided here and in his 1976 poster, *Possession,* to use the reproductive medium of his sources to expose their covert meanings, and to have the photographs printed on a large scale similar to that of public advertising hoardings. These strategies add to the reverberations of these media images in ways specifically derived from early Pop's mechanical processes and billboard scale, especially in America, but with the express intention of subverting their intended purpose.

Haacke's work, more bluntly political than Burgin's, also manipulated the language of sophisticated contemporary advertising with a slick professionalism to increase its subversive punch, and in so doing prepared the way for the work of younger artists who sought an increasingly fine line in their parody of media sources. From the mid-1970s, for instance, the American Barbara Kruger combined borrowed photographic images with printed slogans in such a way that at first glance they might be confused with the posters or printed advertisements whose implicit social messages about the distribution of power the artist was determined to decode and render impotent; the simplification of her means from the late 1970s, involving enlargement and often fragmentation and cropping of the processed image, was aimed at increasing the communicative potential of these works through the persuasiveness of their subliminal associations with the mass media. In Kruger's case this possibility was necessarily limited by the fact that her works were generally shown framed and exhibited as art in galleries and museums, or else printed on the pages of art magazines. Another American artist, Jenny Holzer, sought from 1978 to integrate her inversions of advertising into the public sphere by printing ambiguous or

320 Barbara Kruger *Untitled (I shop therefore I am)* 1987

321 Barbara Kruger *Untitled (The marriage of Murder and Suicide)* 1988

322 Jenny Holzer *The Survival Series: Turn Soft & Lovely Anytime You Have a Chance* 1987

323 Jenny Holzer *The Survival Series: Protect Me From What I Want* 1985–6

324 Cindy Sherman *Untitled No. 70* 1980

325 Sherrie Levine *Untitled (After Vasily Kandinsky)* 1985

provocative messages on sheets of paper that she fly-posted around the East Village, New York, where she lived. In 1983 she began to manipulate such texts in the high-technology medium of moving diode message boards, such as those used to relay information in public places. The hypnotic effect of these flashing texts, which from 1984 also incorporated emblematic images, was amplified by the opportunities soon presented to her for displaying these works, interspersed without warning or explanation, among sequences of real advertisements.[3]

Holzer's invention of phrases such as 'PROTECT ME FROM WHAT I WANT' conflated the directness of advertising language with the intimate air of ordinary speech, much as Ruscha had been doing in his word paintings since the early 1960s. Other young artists who used the imagery and presentation methods of advertising, rather than its specific linguistic messages, likewise reinterpreted and updated devices already familiar from Pop, but to completely different ends. From the late 1970s, for example, the Canadian Jeff Wall produced back-lit, high-resolution Cibachrome photographic images, which he called *Transparencies*, of the type one might find in the waiting areas of airports or in other public places; in place of the desirable commodities or supposedly enviable way of life usually shown in this medium, however, Wall used it for more commonplace situations and to dignify ordinary people, as in his *Young Workers* series of 1978.

In mimicking the techniques of advertising in a medium previously considered outside the limits of fine art, Wall continued the dialogue between artistic conventions and the mass media that had been initiated nearly twenty years before in the use by Pop artists of mechanical processes and depersonalized industrial surfaces. Notable among other artists who played on our knowledge of photographic and cinematic conventions was Cindy Sherman, who in 1977 began a series of works, generically known as *Untitled Film Stills*, in which she presented contrasting stereotypes of femininity as though they were images from Hollywood movies. Using only herself for a model, she harked back (perhaps subconsciously) to the performance origins of New York Pop and to the cult of the non-personality artist best exemplified by Warhol. In 1980, without deviating from her basic principles, Sherman began to work in colour and on a larger scale, suggesting increasingly extreme situations and emotions under the ever protective screen afforded by our awareness that each image is only the product of a play-acting fantasy.

Other artists working in the late 1970s and 1980s, such as the New Yorker Richard Prince, also followed systems established in Pop in their appropriation through photography of existing images. Like Sherman and similarly minded artists of that generation, including Robert Longo, Jack Goldstein and Sherrie Levine, Prince was associated with Metro Pictures, a New York gallery established in autumn 1980 with the aim of showing only representational work derived explicitly from the mass media. For his first solo show there in 1981 Prince exhibited photographs of people and ordinary goods taken directly from advertising images, which he subsequently elaborated: he wrenched motifs from their original context to deprive them of their intended purpose while laying bare their coded messages, for example stressing the stereotyped similarity of various excerpts by showing them together.

The camera served Levine as a tool for appropriating the work of other artists, carrying to its limits the dialogue begun by Pop artists between authenticity and spuriousness through their explicit reference to reproductions of works of art. Levine's first show at Metro Pictures in 1981 consisted entirely of images rephotographed from Walker Evans's Depression era Farm Security Administration photographs. Her decision to work in this case with well-known images that themselves had been originated by the camera

enabled her to produce pictures that looked virtually indistinguishable from the 'originals'. Only a specialist would be likely to notice the slight degradation of the crispness of the image resulting from the operation; in this act of artistic 'theft' the otherwise almost undetectable status of the pictures as 'fakes' might be known only with recourse to connoisseurship. The situation relies also on our understanding that photographic images are in theory indefinitely reproducible from a single negative, so that in a sense every print is at once an original and a copy. By turning Walker Evans's images of extreme poverty into a unique artistic artefact with a price tag dictated by market conditions, Levine has done no more than retrace the process that has already taken place, by which the original photographs themselves have been deemed to be worth large sums of money.

326 Richard Prince *Untitled (Sunsets)* 1981

Writing in 1981, Levine commented, 'The world is filled to suffocating . . . We can only imitate a gesture that is always anterior, never original. Succeeding the painter, the plagiarist no longer bears with him passions, humours, feelings, impressions, but rather this immense encyclopedia from which he draws.'[4] After turning her attention to the photographic reproduction of images from the history of painting, and especially from modernist painting, it was thus logical that she should begin to effect her copies by hand, using the same methods with which the originals had been made. The first such works, exhibited in December 1983 at Baskerville Watson, New York, were in pencil and watercolour after pictures by major European modernists such as Miró, Kandinsky, Matisse and Léger and after the Americans Stuart Davis and Arthur Dove; since a personal touch or idiosyncratic form of drawing were essential to the work of all these artists, the act of replicating their marks threw into particular relief Levine's willing sacrifice of such characteristics as evidence of her own personality. Like Pettibone, who was perhaps the most conspicuous of the painters involved with such issues from the end of the 1960s, she copied her images to the same dimensions as the reproductions in books from which she worked; in this way the pictures were relentless in their fidelity both to the techniques of the original and to the size of the printed image that was her source, but they also avowed their identity as copies through the change of dimensions inevitably effected in the printed reproduction of the original.

For another American painter, Mike Bidlo, copying acknowledged masterpieces of modern art with as great a fidelity as possible was presented, paradoxically, as perhaps the most authentic act open to an artist working at a time when originality and invention had come to seem only futile hopes. His first solo show at the Castelli Gallery (9 – 31 January 1988) consisted of a selection of *Picasso's Women*, but he appears to have set himself the task of remaking every great icon of modernism without taking into account his own preferences or taste; any sense of his personal identity as an artist is thus not only completely subjugated to the model but fundamentally negated, since in principle he eliminated even the question of choice. Among his other works are a recreation of Warhol's early Pop paintings shown in a window display at the Bonwit Teller department store in 1961, which was commissioned from him on the occasion of an exhibition of Warhol's early work in 1989, and even a reproduction of Duchamp's most famous found object, the urinal called *Fountain*.[5] Bidlo's enterprise, however strong its conceptual basis, remains unsettling not only because he has willingly sacrificed both the creative role long considered to be the centre of art and the quest for originality so relentlessly pursued by modernists for the past hundred years, but also because there is a sense that the idea could exist on its own without the artefacts even having to be made. Because he is a consummate and clever technician, the suspicion also remains that the market to which he is

327 Richard Prince *Untitled (Sunsets)* 1981

EAT DIRT ART HISTORY

328 Mike Bidlo *Not Warhol (Superman 1960)* 1989

329 Shinro Ohtake *Mexico (Misprinted in N.Y.C.)* 1983

really addressing himself, under the protective veneer of conceptual respectability, is precisely that of the copyist, since those purchasing Bidlo's pictures will inevitably be tempted to do so as a cheap substitute for modern masterpieces they could not otherwise afford. Yet this, too, becomes part of the meaning. Like much Neo-Pop, Bidlo's work disarms criticism by acknowledging such interpretations as inherent to its intentions.

Together with other American painters who established themselves in the late 1970s and 1980s, such as Ross Bleckner, Eric Fischl and Jack Goldstein, David Salle studied under the Photo-conceptual artist John Baldessari in the early 1970s at the new California Institute of the Arts at Valencia, near Los Angeles. Salle's student work in photography was strongly influenced by his teacher's general principles and also by his introduction of humour into a mode generally characterized by intense seriousness. In 1979 Salle began to produce paintings in which images derived from photographs, comic strips, other works of art, old-fashioned furniture and decoration were layered and juxtaposed in a seemingly random way. They were structured so that each motif could function as cultural sign open to interpretation, as evidence of types of human interaction or experience, or as triggers for emotional states; they were built in part on his Conceptualist origins but were related even more closely to Pop precedents, particularly the work of Rosenquist and to a lesser extent that of Rauschenberg.

Although the importance of Pop in relation to Salle's paintings has been consistently noted by commentators, the rhetorical language of semiology and structuralism that has often been employed in his support has tried to distance him from such sources and to intellectualize very similar devices employed by Pop artists nearly two decades earlier. Stripped of its 1980s jargon, the points made about Salle's work are not basically different from those used to explicate the similar methods devised by Rosenquist in the early 1960s.[6] The use of extreme close-ups and enlargements, the apparently illogical juxtapositions and interpenetration of fragmented imagery, the abrupt shifts in style and mode of representation, and the reliance on procedures from the mass media (particularly photography and the cinema) are among the many fundamental features that directly link the work of the two artists. There are elements, too, reminiscent of those employed by other artists associated with Pop in the 1960s: the use of printed fabric as a decorative base on which to apply an image in a painting such as *Muscular Paper* (1985) has a clear precedent in the *Stoffbildungen* painted by the German Sigmar Polke as early as 1964 (see Chapter 7).[7]

To insist on these precedents is not to belittle Salle's achievement nor to deny the very strong individual identity he has forged using processed images and recycled styles within terms already familiar from Pop. The artist himself most clearly articulated the essential paradox underlying his work when he remarked in 1984: 'I think the current debate over "the end of originality" is sophistic. Originality is still the only thing that matters in the end. My point is that originality had to be located outside the question of personal "style" ... Put simply, the originality is in what you choose. What you choose and how you choose to present it.'[8] Rather than suggest that copying an existing image was a conceptual gesture complete in itself, as Levine and Bidlo did, Salle thus makes it a starting-point for a sifting process comparable to that enacted by each and every one of us in responding to and interpreting the ever more complex and vast amount of material thrust towards us on a daily basis.

Among artists working in the 1980s Salle and other Americans were not alone in reacting to such visual and cultural overload with Pop tactics. From the late 1970s, for instance, the Japanese painter Shinro Ohtake, then in his mid-twenties, set himself on a

course of voracious assimilation of contemporary Western styles that jostled against each other with increasing urgency. The strongest presence in these first paintings and etchings was that of Hockney's graffiti pictures of the early 1960s but Ohtake soon added to his repertoire features from the work of many other artists, including Blake, Paolozzi and Rauschenberg. Oil paintings alternate with assemblages and collages, invented scenes with images based on photographs and found ephemera, all conveyed by techniques borrowed not only from Pop but also from a variety of conflicting styles and methods of depiction. Avowing no apparent hierarchy of importance, Ohtake criticized and reinterpreted historical styles of painting and the latest stars of the art world as openly as he did the lowliest mass-produced reproduction. Every borrowed style implicitly carries with it a value judgment, a measure on the one hand of his allegiances and sympathies

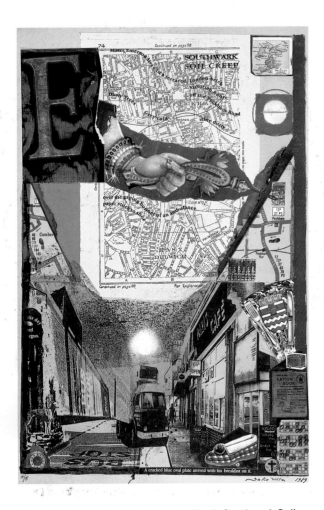

331 Jake Tilson *Breakfast Special, No. 5: Southwark Soil Creep* 1988–89

332 *CRASH Margie* 1986

and on the other of his emotional distance or need to reformulate an idiom that he finds debased or unfulfilled. Seen in quantity, Ohtake's prolific production provides an extraordinary panorama of the history of modernism, filtered through the critical faculties and explicit vantage point of an artist determined to transcend the marginalization of his national origins by addressing himself to every option available.

A sense that the speed of present-day international travel and communications makes it possible now for elements from any culture to be borrowed, appropriated or mimicked, if never fully assimilated, also underlies the work made since 1983 by the Englishman Jake Tilson, the son of Joe Tilson. Using collage and assemblage for sculptural 'dioramas' representing shabby shopfronts and interiors and for paintings and prints composed of found images recycled with the aid of colour photocopiers, Tilson was intent above all in capturing a sense of place in our late twentieth-century 'global village'. Fragments and souvenirs amassed during trips to cities such as New York and Barcelona are reassembled in dizzying profusion as enigmatic facts, but his work acknowledges that even without leaving our front door we are all now theoretically capable of this kind of wide-ranging cultural tourism. In Tilson's collage-based books and magazines, too, such as the appropriately named *Atlas*, which he began designing, editing and publishing in 1985, the impression is of a head filled to overflowing with sensations and experiences from a multiplicity of sources.

For a group of painters working in New York in the early 1980s, such as Keith Haring, Jean-Michel Basquiat, Lee Quinones and CRASH (the pseudonym used by John Matos), the appropriated language was explicitly that of the city's street culture: of the graffiti drawn, painted or sprayed on the walls of public buildings or on the corridors and trains of the subway system. Although their meteoric success led them very quickly to the transference of these techniques to paper, panel or canvas so that they could be bought and sold like conventional pictures, their initial decision to place their work in the public arena from which it was drawn was essential both in capturing a transient moment and in effecting a genuine convergence between their images as art and as signs of popular culture. The dilemma facing these artists, of course, was that as soon as they sought to make a living from their pictures by turning them into commodities their work risked being fatally compromised. Those working more or less exclusively with spray paint, such as Quinones and CRASH, particularly suffered from the transfer to a gallery context. CRASH produced clever revisions of Lichtenstein's early Pop subjects, including female heads seen in close-up, fighter planes and explosions, often with the letters of his pseudonym spelt out as in Lichtenstein's pictures derived from war comics; his techniques and formal strategies, including brutally cropped images, flat areas of vivid colour outlined in black and the use of patterns of Benday dots to suggest tonal modulation, were also blatantly from the same source. On the street, such strategies had an element of surprise and subversion, in that a popular form that had been turned into fine art was being redirected to the mass audience for which the original images had been intended; but, as more conventional pictures in a fine art context, in spite of their wit and formal punch they seemed to lack purpose, and they suffered by comparison with the more considered and timeless work they sought to reinterpret.

With the instincts of a survivor, Haring developed his cartoon-like pictographic mode into a style that looked anonymous but actually functioned paradoxically as his personal signature. The graphic simplicity of his linear motifs, the boldness of his marks and of his (often fluorescent) colour, his reliance on humour to offset the threatening quality of sometimes violent and sexually provocative subject-matter, and – by no means least –

his astuteness in adapting his own work to badges, T-shirts and a variety of ephemeral objects sold in his own East Village shop all ensured a continuing future for his art throughout the 1980s. Warhol, who purchased work by Haring and became a friend, had declared in 1975 that 'making money is art and working is art and good business is the best art.'[9] It was in pursuing the relentless commercialization of his work, perhaps more than in any other single respect, that Haring turned himself into a Pop artist of the 1980s.

Basquiat, too, got to know Warhol well. Three of his most Pop-oriented early works, *Dos Cabezas* (1982), *All Beef* (1983) and *In Italian* (1983), all painted by the time he was twenty-three, were acquired directly from him by Warhol.[10] The earliest of these, a self-portait of cartoon-like stylization paired with a larger image of Warhol's bewigged head with his finger poised as if about to pick his nose, suggests that Basquiat was well acquainted even with Warhol's pre-Pop work; it brings to mind the uncouth humour of a then virtually unknown youthful self-portrait, *The Broad Gave Me My Face, But I Can Pick My Own Nose* (*c*. 1948), in which Warhol had represented himself with his finger up his nostril.[11] *All Beef*, painted on both sides of a canvas mounted on two wooden supports as if it were an actual advertising display intended to attract customers into a cheap hot dog restaurant, brings to mind early Pop pictures by Rivers such as *Cedar Bar Menu I* (1959) in its casual approximation of a found object, complete with hand-scrawled texts and images of ostentatious crudeness and simplicity. Of the works owned by Warhol, however, the most typical of Basquiat's later development is *In Italian*, in which a variety of impulsively drawn motifs – some invented, some copied from coins and diagrams – jostle wildly against one another and compete for attention with written inscriptions and copyright symbols declaiming Basquiat's authorship.

Warhol himself was much affected by the Pop-influenced work made by younger artists in the 1980s, comparing its vitality, humour and spirit of fun to that produced by his

EAT DIRT ART HISTORY

336 Ronnie Cutrone *Sunday Painter* 1985

337 Ronnie Cutrone *Stress* 1984

own generation in the 1960s. The garish fluorescent colours employed by Haring and other artists involved with cartoon imagery or the spray-paint techniques of graffiti, such as Kenny Scharf and Warhol's former assistant Ronnie Cutrone, encouraged his own return to such hues of heightened artificiality. More important still was his collaboration with Basquiat in 1984–5 on two groups of paintings, the first also involving the Italian Francesco Clemente and the second made as a sort of tug-of-war between two egos in friendly competition with each other. It was in these works, in which each artist partly obliterated the marks and images painted by his collaborator, that Warhol returned to methods of hand painting for the first time since the early 1960s, relying again on found images such as company logos or the labels of consumer products projected to the desired size and reformulated in deft strokes of the brush. Sadly, Warhol, who died in 1987, had little opportunity to pursue this revitalization of his work; Basquiat himself died of a drug overdose in the following year.

In their reference to familiar comic-strip figures such as Felix the Cat and Woody Woodpecker placed in new and incongruous situations, American painters such as Scharf and Cutrone rephrased themes of originality and authorship, and of low-brow taste and fine art, in ways clearly indebted to Pop of the early 1960s. Cutrone's use in

338 Kenny Scharf *Felix on a Pedestal* 1982

339 Robert Combas *Le Dieu à six têtes* 1984

340 Graham Crowley *Sound of the City* 1983

Sunday Painter (1984–5) of hand-painted formulaic landscapes as a kitsch ready-made surface on which to overlay such borrowed motifs, recalling (probably coincidentally) the Danish artist Asger Jorn's methods in his *Modifications* of 1959, brought Pop back to its origins.

Outside America the imagery and language of comic strips was also enjoying a revival, but to rather different ends. In France, in particular, where a huge market had developed for comic books aimed at adults, it was largely a question of capitalizing on what had become the most widely familiar form of narrative figuration. Rather than using established characters or found images, artists played their inventions against the viewer's knowledge of the popular art form in general. Among those working in this idiom were François Boisrond, who painted his flatly outlined motifs not only on canvas but on cardboard as a way of highlighting their spontaneous and ephemeral look, and Jean-Charles Blais, whose repertoire of stocky and often headless figures were painted on the tattered surfaces of posters torn from public walls: a deliberate renegotiation with the methods employed as early as the 1950s by European *affichistes* such as Hains, Villeglé, Vostell and Rotella. The most extreme of the new generation of French artists making paintings conceived as enlarged episodes of *bandes dessinées*, however, were Robert Combas and Hervé di Rosa, both of whom pursued the limits of tastelessness and vulgarity in their often provocative choice of subjects as well as in their deliberately slapdash drawing and the shrillness of their colour schemes.

As with most of the American graffiti artists, much of the work made by these French artists soon appeared tired and repetitive; having established such narrow terms for themselves, once their basic points were made there was little room for development. Only Blais, whose generalized drawing style was as deeply rooted in fine art (for example, in Malevich and Léger) as in the conventions of comic strips, was able to suggest that his art was potentially something more than just a gimmick or one-liner; his devotion to a series of object-types and to a cast of emblematic figures shown in enigmatic poses and recurring situations allowed him gradually to enact a personal mythology of everyday human behaviour and experience.

Among younger painters working in Britain in the 1980s it is possible to speak of isolated examples of Pop influence but not of a united movement as such. The cartoon-like drawing and areas of flat colour employed by Graham Crowley, for instance, during the early 1980s in paintings of ordinary objects in domestic situations soon gave way in works such as *Sound of the City* (1983) to a reliance on exaggerated tonal modelling to convey a sensation of deep recessive space. Densely packed with mundane objects pictured with alarming disregard for relative scale, these paintings induce sensations both of claustrophobia and vertigo; bilious colour adds still more to a sense of nausea traceable to the congestion of modern city life and to the suffocating demands of domestic existence. Yet the debt to Pop displayed in Crowley's paintings, rooted as much in their reference to vernacular contemporary styles of drawing as to their portrayal of familiar mass-produced objects, also carries with it an implicit rejection of some of Pop's basic assumptions about authorship, invention and depersonalization. Crowley's objects are blatantly anthropomorphic: they are not only clearly intended for human use, but have the fleshy and sweaty countenance of living and breathing beings. Nothing seems innocent; even the bulbous arm of the old-fashioned record player in *Sound of the City* looks like a human tongue lolling in lascivious anticipation. Ultimately it is to questions of human psychology that these paintings are addressed, couched in modern life but in the faded terms of a distantly recalled childhood.

The paintings of Stephen Farthing, a friend and fellow student of Crowley's from the late 1960s, likewise developed in rather tangential ways from their Pop origins. Among his earliest surviving works are two paintings made in 1973, *Piano Box* and *Harpsichord Box*, in which the flat shapes of musical instruments are starkly and frontally presented against an expanse of bare canvas. Subsequent works such as *Flat Pack* (1975), in which a grossly enlarged cigarette packet is shown flattened out and surrounded by images of scissors on a canvas measuring more than two metres in height, were consciously influenced by Dine's suggestive treatment of objects and by Rauschenberg's use of photo-silkscreen, with which Farthing briefly experimented; a series of gouaches of architectural mouldings drawn in Italy in 1976–7, which he then used for paintings of architectural fragments such as *Sistina* (1977–8), may on the artist's own admission have been subconsciously prompted in part by Lichtenstein's *Entablature* series of 1974–6.[12]

It was in two paintings and related studies made while a student in London in 1975, however, that the roots in Pop of Farthing's subsequent investigation of pictorial conventions are most evident. In these works, based on portraits of Louis XIV and Louis XV by the early eighteenth-century painter Hyacinthe Rigaud, Farthing extended his interest in packaging to the presentation techniques and encoded signs by which the importance of the figure portrayed could be conveyed without the need for representing his features.[13] Only a few of Farthing's later pictures relate so closely to Pop both in spirit and method, yet various Pop aspects of this early work – the reinterpretation of another work of art, the sense of humour, the juxtaposition of contrasting styles and modes of representation – remained fundamental to his subsequent development of an ever shifting figurative style rooted in tradition but conscious of its contemporaneity.

Following Warhol's death in early 1987 another English painter, Mark Lancaster, who had worked briefly as an assistant to Warhol in 1964, decided to pay tribute to him by tracing onto a 12 x 10 inch canvas the image of Marilyn Monroe from the cover of Warhol's 1971 Tate Gallery exhibition catalogue. Once he had filled in the outlines with flat areas of colour, he had a hand-painted replica of a printed reproduction of a silkscreen painting that was itself a half-tone reproduction of a photograph. This commemorative picture led Lancaster to produce nearly two hundred paintings collectively entitled *Post-Warhol Souvenirs*, in which he subjected Warhol's enduring image of Monroe to permutations involving references to other art, a wide variety of techniques, and his own memories from a transatlantic perspective. He decided to make do with the ordinary painting materials he had to hand and consequently did not use Warhol's silkscreen method in any of the paintings. However, his superimpositions and transformations of imagery – while referring to, or commenting on, Warhol's methods – help to unravel layers of subconscious motivation and conscious intention. Marilyn is made to assume other identities, merging into the image of Elizabeth Taylor or into Warhol's pensive self-portrait, half-obscured by women's shoes or by his *Flowers* of 1964, or juxtaposed surrealistically with his *Cow* wallpaper of 1966. There are many references to the work of other artists, for example in images of Marilyn as the Mona Lisa, as Dalí's melting pocket-watch, as Matisse's Fauve-period *Portrait of Madame Matisse* of 1905, as Magritte's *The Rape* or as Picasso's *Weeping Woman* of 1937. Apart from Warhol himself the single painter most often called to mind is Jasper Johns, for whom Lancaster worked (see Chapter 8), not only in specific references but in the very idea of exploring the changing meanings and uses of a single image.[14]

Of the paintings produced in England during the 1980s, the most consistently Pop in aspect were those made by the Canadian Lisa Milroy. Each canvas is conceived as an

341 Jean-Charles Blais *Untitled* 1984

342 Stephen Farthing *Louis XIV Rigaud* 1975

arrangement of seductively painted images of objects, usually laid out simply in rows according to a grid system or in a subtly displaced variation of such a regular pattern, but occasionally composed in a more apparently random manner. In some works the objects appear to be identical: a set of twenty open fans of simple design, twenty-five sailors' caps laid out in five rows, twelve pairs of women's black shoes. More usually, however, it is a particular class of object to which we are asked to direct our gaze: manufactured items such as various types of metal hinges, rows of otherwise identical gramophone records with different labels, and postage stamps; individually crafted or mass-produced cultural artefacts from other times or places, including shards of ancient Greek pottery, Roman coins and nineteenth-century Japanese woodblock prints; and occasionally even natural things bearing the mark of human use or handling, such as a series of melons with the label of a single producer.

In a number of Milroy's paintings the objects are shown to cast strong shadows from a consistent light source, suggesting that they have been painted from real objects rather than from flat images or simply from the imagination; yet the luscious brushstrokes with which the images are coaxed into existence as immediately recognizable and consequently generalized signs, together with the pattern of exaggerated highlights with which their glamorous presence is defined, is as reminiscent of correspondence school methods of painting as it is of the impasto technique of a master of life painting such as Manet. As in Thiebaud's paintings of the early 1960s, which they resemble in both placement and painterliness, Milroy turns ordinary objects into sublime and mysterious presences; as in Warhol's work, she uses strategies of repetition to direct us towards subtle variations, as if on each occasion we were seeing these things for the first time. As with earlier Pop works, Milroy's paintings are thus concerned as much with the act of looking as with the systematic tabulation of images redolent of late twentieth-century society and of the cultural references by which we continue to define ourselves.

Julian Opie, who like his wife Lisa Milroy studied at Goldsmiths' College, London, from 1979 to 1982, also favoured decorative colour schemes, blandly attractive brushwork and a straightforward representation of familiar objects in the hand-painted welded steel sculptures with which he established his reputation within a year of completing his studies. One of the youngest of a group of sculptors influenced in one way or another by Pop to emerge at this time in Britain – including Tony Cragg, Bill Woodrow, Edward Allington, Richard Wentworth, Kate Blacker, David Mach and the Frenchman Jean-Luc Vilmouth – Opie in his early work was also the most unashamedly pictorial in his deployment of overt images best seen from a single angle. The jocular tone and simple forms of representation, both of which masked the technical complexity of the structure by directing the viewer's attention to a surface handled with apparent nonchalance, were clearly intended to entice a mass audience in much the same way as the most exuberant forms of Pop had done twenty years earlier.

The familiar objects rendered in some of Opie's works of this period allude to methods of communication, as in *Call Me* (1984), in which the words of the title (also the title and refrain of a popular song associated with Aretha Franklin) are attached to the old six London telephone directories (including the *Yellow Pages*); another work of the same year, *A to B*, which consists of the two cut-out letters joined by a straight line of force, calls to mind the title of the book of Andy Warhol's 'philosophy' published nearly a decade earlier[15]. Other favoured images include the packaging of ordinary food items, as in *Abstract Composition with Pilchards* (1984) and *Sweet Composition* of the same year, in which representations of three chocolate bars and two packages of fruit gums are joined to-

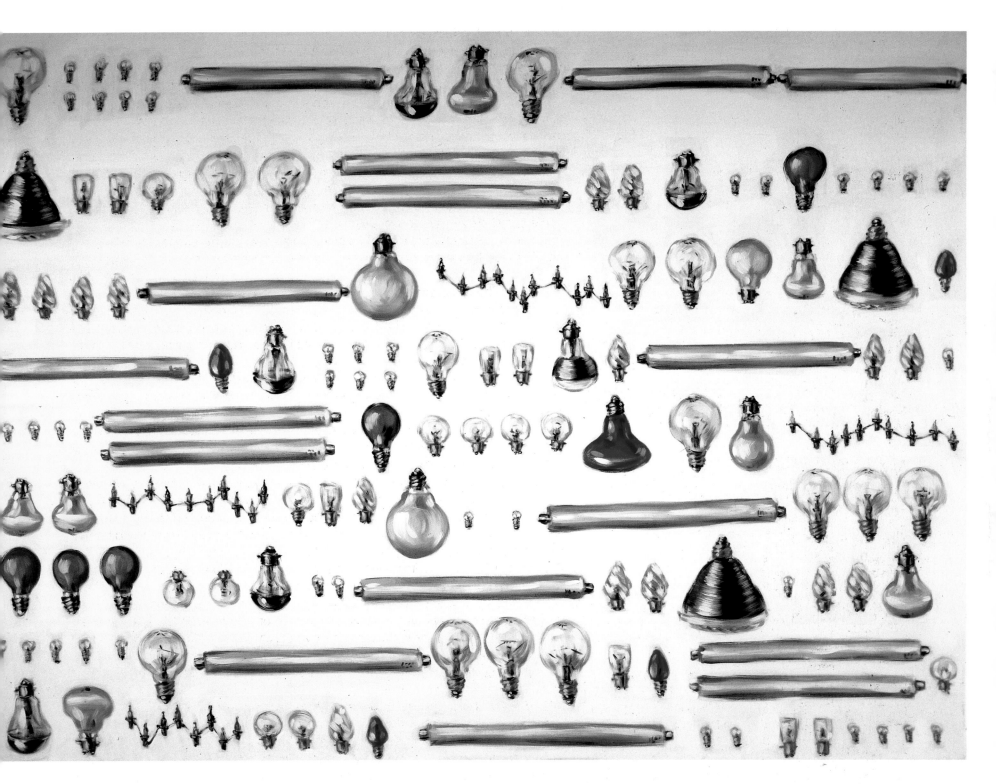

344 Lisa Milroy *Light Bulbs* 1987

345 Julian Opie *Eat Dirt Art History* 1982

346 Julian Opie *Night Light* 1989

gether in the manner of an abstract sculptural composition. There are also explicit references to signs of commerce and material success – as in *Personal Effects* (1984), which features not only an addressed envelope and a passport but also a cheque-book and a credit card – to painters' brushes and to other tools used by artists and craft workers.

These last two themes had interacted in *Making It* (1983), in which a hammer, a saw, a screwdriver, an electric drill and a chisel are poised incongruously in mid-air over several clearly fake 'wooden' planks; the punning title could be taken to refer both to the process of construction and to a bravado proclamation of career success, one that could well have served as a slogan for the equivalence between artistic ambition and commercial value to which Pop artists had uncomfortably drawn attention in the 1960s. The use of an exaggerated comic-strip style to represent each of the elements adds an almost sneering note to an image already conceived as a bare-faced lie, for the viewer needs only to walk around the sculpture, which is unpainted on the other side, to realize that none of the tools pictured could possibly have been of any service in its construction.

In other works by Opie, such as *Eat Dirt Art History* (1983), *Cultural Baggage* (1983) and *A Pile of Old Masters* (1984), hand-painted reproductions of famous works of art – conceived explicitly as pages torn from books in the first case and in the latter two as blatant copies on fake (metal) canvases – seem to have been thrown to the wind or casually scattered across the floor like so much flotsam. As with Neo-Pop, as with Pop itself and even Dada earlier in the century, it is as though the weight of the past had become so unbearable that the artist could declare his freedom only by sweeping away all the work made before him or by casually accepting it as raw material for his own production. In the event, this proved to be only one way out of the dilemma. For his 1986 exhibition at the Lisson Gallery, London, Opie abruptly abandoned conspicuous imagery and with it the style that had proved popular with critics and especially with collectors; nevertheless, the machine-like perfection of his subsequent works and the identification of their minimal forms with display cases and high-tech architectural details, revealed the extent to which aspects of Pop continued to suggest the way forward for him.

Among the older artists working in Britain to have taken Pop as a reference point for a sculptural investigation of ordinary objects was the American-trained Irishman Michael Craig-Martin, whose influence as a teacher can be measured by the fact that his former students have included not only Milroy and Opie but many others who have since become well known. He moved to England in 1966 after studying at Yale University and for the following decade explored ideas that were grounded mainly in Minimalism and in Conceptual art, for example in a series of constructed boxes or in subsequent works involving store-bought buckets and balances; even in these sculptures, however, his reference to utilitarian objects and materials, including household paint, formica and new mass-produced items as ready-made elements, demonstrated a predisposition to certain aspects of Pop.

In 1976 Craig-Martin made a series of *Untitled Paintings* each of which consisted of a found canvas, purchased in street markets and antique shops, set flush into the upper left-hand corner of a bare canvas; the found paintings, which he had intended to be primarily of still-life subjects, were mostly of landscapes, the most popular genre among amateur painters in England. The questions raised in these works not only about popular stereotyped conceptions of art but also about authorship, originality and appropriation – all themes that had been articulated in Pop – were most acutely posed in *Untitled Painting No. 4*, in which the found painting was a faked and aged version of Monet's *Gare Saint-Lazare*, complete with false documentation.

347 Michael Craig-Martin *Untitled* 1989

348 Michael Craig-Martin *Night Life* 1984

With his first exhibition of wall drawings in 1978 Craig-Martin moved closer to the appearance of Pop, arranging simple images oulined by self-adhesive tape directly on the wall. In the first of these, unrelated representations of standard objects – including domestic tools, pieces of furniture, open books, eyeglasses and single shoes – were superimposed over each other as if they were transparent, alluding to the process by which they had been transferred from paper onto acetate, photographed as 35mm slides and then enlarged by projection so that their outlines could be reconstituted in thin black tape.[16] In later works, such as *Reading with Globe* (1980), the same types of motifs are made to appear volumetric through the simple strategy of showing some as foreground objects partly obscuring the view of other items 'behind' them, even though every element plainly exists only as a graphic sign on the flat surface of the wall.

On his return from a year in America in 1981, Craig-Martin began to render such outlined images in solid form as shaped black steel rods either hung directly on the wall or welded onto painted aluminium panels that function both as independent abstract devices and as a base that literally holds the image. Although these works make use of sculptural methods, they are displayed like pictures and generally allowed to project only slightly into space as overlapping planes. Their representations of such ordinary items as a light bulb, a pistol, a pair of headphones and a piano, since they consist mainly of empty space circumscribed by a continuous line in metal, declare their status not as real things but as stereotyped renderings of them. In 1989 Craig-Martin returned such

349 Tony Cragg *Blue Bottle* 1982, installation view

351 Bill Woodrow *Twin-Tub with Guitar* 1981

350 Edward Allington *The Fruit of Oblivion* 1982

motifs to a flat canvas surface in enormous diptychs of contrasting colour, in each case placing a single life-size outlined image of an ordinary object – a television set, an empty drawer, a pull-out shaving mirror – on the centre of each of the two canvases. By his own admission these paintings, in which our attention oscillates between the emblematic motifs and the saturated colour that fills our field of vision, are among the most overtly Pop of all his works.

The return to favour of assemblage as a sculptural method in Britain owes much to the example of Tony Cragg, who in the early 1980s adapted Pop methods to the Duchampian found object with industrial materials and ordinary objects and with allusions to modern technology and themes drawn from the mass media. The Pop overtones are particularly strong in wall works such as *5 Bottles* (1982), in which a number of discrete elements, each a fragment of a brightly coloured mass-produced plastic object, are formed into a simple, decoratively appealing and easily recognizable shape; in this case each silhouetted motif on the wall takes its outline from the found plastic bottle on the floor in front of it, so that the flat image is presented as a hugely magnified shadow cast by a three-dimensional artefact. The sense of transience introduced by Cragg in his reliance on discarded materials, brought into a self-evidently temporary and changeable relationship to each other, distinguishes the work of his generation from mainstream American and British Pop. The methods can be linked to those of the Nouveaux Réalistes, a relationship, however, which these British sculptors have not acknowledged.

Until the mid-1980s Cragg chose the pieces for his sculptures with a view to the fact that they were the refuse of a modern industrial society, often preferring non-biodegradable synthetic materials such as plastic. Similarly Bill Woodrow from the early 1980s took as his starting-point discarded domestic appliances which functioned as both image and medium. *Twin-Tub with Guitar* (1981) is typical in effecting a transformation from a found image – an old-fashioned and obsolete washing machine – into an equally recognizable emblem of contemporary culture. Woodrow's work is in a logical and direct line from the tradition of metamorphic sculpture exemplified by Picasso, although he achieves a particularly modern alchemy of industrial cast-offs into objects of beauty, poetry and a retrieved social function. His mutations of the cut-out planes of one object into a new three-dimensional form unquestionably involve great ingenuity and an extraordinary ability to conceive images in volume and space.

It is a great strength of the current generation that the best artists have each brought to their assemblages a highly individual feeling for materials, images and subject-matter. In works by Edward Allington such as *The Fruit of Oblivion* (1982) kitsch and classicism come together in the representation of a cornucopia of plastic fruits: while making humorous reference to the abundance of modern mass-production, a more sinister reading is also suggested by the parallel drawn between organic and synthetic matter and the freezing of the flow of movement into a static shape that disturbingly contradicts our experience of gravity. This sense of the natural order being subjected to mutations as strange and alarming as those effected by scientific progress – in the form, for example, of the atom bomb – underlies the disquieting presence of other works using similar methods, such as *The Argo Unmanned* (1984), in which a static wave is represented by dozens of plastic fish attached together as if asphixiated by the lack of water.

The galvanized steel buckets and tubs, tubular steel furniture and other industrial ready-made objects deployed in the sculptures of Richard Wentworth, who like Craig-Martin taught for many years at Goldsmiths' College, are altogether more austere. Yet there is a quiet sense of humour at work in his art, too, for example in the transformation in

LEGACIES OF POP

352 **Richard Wentworth** *Place* **1984**

353 **Bertrand Lavier** *Formica Red* **1983**

Place (1984) of a rather ineffectual looking chair into a stand-in for an aggressively sexual male nude through the addition of two testicle-like spheres suspended with cable from the soft seat. As in sculptures by artists as diverse as Oldenburg and Paolozzi, there is a strong suggestion of the ways in which each of us is formed by an accumulation of random experiences, observations and perceptions. For Wentworth this has been expressed only occasionally by overt references to human forms assembled from found objects; it has motivated him and other artists more generally in the emphatic reliance on both metaphor and metamorphosis when such objects become in their hands not simply sculptural material but a second layer of imagery.[17]

References to Duchamp have usually loomed larger than those to Pop in Wentworth's art: *Algebra* (1986–7), in which a wooden crutch is attached high on the wall next to a tall ladder whose pointed shape is like its enlarged reversed image, specifically recalls Duchamp's ready-made using a snow shovel, *In Advance of the Broken Arm* (1915), in its suggestion of the threatening potential of ordinary objects. Yet Wentworth's particular way of treating mass-produced items intended for domestic use was clearly modified not only by the example of Pop object sculptors such as Barker in the 1960s, but also by the transforming power of scale that was one of the basic operating principles of Oldenburg's work;[18] in *Toy* (1983), for instance, an opened and conspicuously empty sardine tin inserted into the flat metal surface representing the water level inside a steel tub also allows it to be viewed as a ship in a sea devoid of both water and fish.[19]

The ephemeral installations made by Cragg from large quantities of worthless objects of a particular type provided a point of departure for David Mach, who carried these methods to an extreme. Mach often worked on an enormous scale – as in the *Polaris* submarine, more than fifty metres in length, constructed out of rubber tyres outside the Hayward Gallery, London, in 1983 – with an earthiness and simplicity of vision. Even before completing his studies at the RCA in 1982, he had begun to make sculpture by stacking or layering large numbers of identical recycled objects such as books, magazines and bottles. As with certain Pop artists before him, the procedures he chose were directly related to his own experience with methods of production outside fine art. Mach had sometimes supported himself with factory work, including spells in a Scottish whisky distillers and a cannery in Milton Keynes. Through such experiences he became acutely aware of the gap between a mechanical and monotonous mode of production, and the personal and social connotations inherent in purchasing and consuming such products.

Mach's work in the early 1980s, including sculptures assembled from rows of bottles filled with varying quantities of colour dyes, displays an overt Pop aspect in the direct relationship between the found objects used and the emblematic images to which they give rise. For *Thinking of England* (1983) he took his patriotic cue for the Union Jack from the image of the Houses of Parliament featured on the labels of the 2160 HP sauce bottles displayed in grid formation; the diagonal red forms also double as a nude woman lying on her back with her legs splayed out in a sexually provocative fashion, alluding punningly to the British embarrassment at experiencing sexual pleasure, as summed up in the expression 'close your eyes and think of England'.

The performance element involved in erecting huge temporary structures was itself a vital part of Mach's work, particularly for the opportunities it presented for communicating his ideas to a non-art audience. The critique of consumer society and of its notions of built-in obsolescence involved in the making of a huge installation such as *Adding Fuel to the Fire* (1987), in which many tons of unsold magazines appear relentlessly to sweep along ever larger man-made objects, including furniture and an automobile, gives

LEGACIES OF POP

354 David Mach *Thinking of England* 1983

355 Rosemarie Trockel *Untitled* 1986

356 Komar and Melamid *The Origin of Socialist Realism* 1982–3

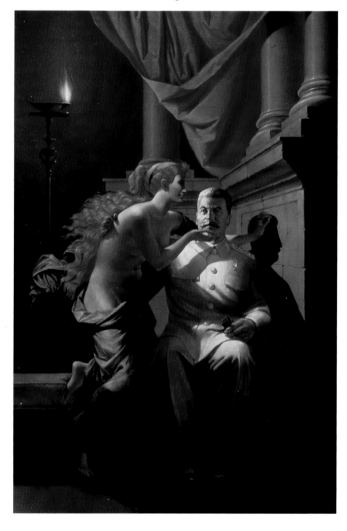

Mach's art a broader satirical edge than was generally the case with first-generation Pop. His use of modern technology for a frame of reference, however, along with his sense of humour and insistence on a visual vocabulary readily accessible to everyone, continued to bring him very much into Pop's orbit.

Pop strategies and attitudes resurfaced in the 1980s in myriad forms. At the beginning of the decade young German painters such as Rainer Fetting and Helmut Middendorf were among those who used the language of early twentieth-century German Expressionism in a particulaly detached way, spreading poster paints over large surfaces with a deliberate hastiness as if to disavow the usual sense of the style as evidence of a personal Angst. Among the favoured subjects of their early paintings were images of rock singers onstage in Berlin nightclubs, re-establishing an equivalence between painting and popular music that was as appropriate to the era of punk rock as images by Blake or Warhol had been to the rock'n'roll period. In the United States, Eric Fischl reinterpreted contemporary American culture in ways similar to those initiated in Pop and extended in Photorealism so that he brought to the surface the sense of suburban ennui only hinted at in those earlier movements. Although his over-life-size figures are executed in a broad painterly technique, much of the imagery is obviously based on photographs, adding to the voyeuristic quality of his often embarrassingly intimate subject-matter and of his use of scale and viewpoint to suggest our intrusion as spectators into the lives of others.

The found object continued to serve artists as a springboard in a variety of ways, as with the items of furniture coated in an unctuous surface of translucent paint by the Frenchman Bertrand Lavier. Other artists extended Pop ideas about depersonalization by presenting their inventions in the guise of manufactured items, as in the case of the German Rosemarie Trockel's woven wool fabric designs; these featured simple repeat patterns that sometimes represented mutations of symbolically loaded motifs such as the swastika or the hammer and sickle, and at other times simply copied well-known commercial trademarks such as the Playboy bunny or the Woolmark. Pop attitudes towards style as a cultural sign that can be appropriated at will were evident in work as diverse in form as the parodies of Soviet Socialist Realism painted by the Russian team of Komar and Melamid on settling in America and in the ironic rephrasing of a largely unfashionable style of painting, Op art, by the Americans Ross Bleckner and Philip Taaffe. Even the English conceptual team known as Art and Language, who during the 1970s had devoted themselves primarily to linguistic rather than purely visual concerns, produced stylistic and cultural hybrids such as *Portrait of a Man (V.I. Lenin) in the Style of Jackson Pollock II* (1980), playing the connotations of familiar idioms and images against each other.

Of all the work produced in the mid- to late 1980s, however, it was that of a group of young artists working in New York that constituted the most extreme return to Pop. Catapulted to controversial fame and fortune with a speed unusual even by the increasingly panic-stricken atmosphere of the New York art world, there is a sense in which they can be said to have replayed all the strategies of the original Pop artists at high speed. In place of the relative innocence with which artists in the 1950s and 1960s formulated their aesthetic, this new breed of artist, surveying the immediate past, tended to be knowing and sophisticated to the point of cynicism. The best-known and most successful of them all, Jeff Koons, supported his early art production by working as a commodities broker, that perfect symbol of 1980s affluence and worldly success. It says much about the current commercial art situation that Koons was able to give up his financial career because he had amassed a considerably greater fortune through his sculpture alone.

As with any movement, each of the New York artists in the mid-1980s had a distinct personality and set of interests, and the interviews published with them at the very time they were devising their terms of reference indicate a remarkably consistent level of articulateness and clarity of thought. Nevertheless, to describe the work of these artists very briefly does not seem to lead to as dangerous an oversimplification as it might when applied to others, given the extent to which such programmatic intentions appear to have been built into their aesthetic. Before he was known as an artist Peter Halley, one of a group of painters sometimes bracketed under the label Neo-Geo, had helped define the current situation as a critic. When his work was first noticed in the mid-1980s, like that of his colleagues it already looked complete, resolved and extreme, with no outward sign of a struggle towards maturity. As with many of these artists, however, such singlemindedness also carried with it the necessity for a clear and unambiguous statement that could most easily be achieved by the pursuit of a sometimes very limited idea that risked being exhausted very quickly. Halley's solution, for instance, was to produce paraphrases of Minimalism whose apparent purity was corrupted by the identification of the geometric forms with electronic circuitry, by the use of vulgar fluorescent colours and by the application of a synthetic stucco, Roll-a-Tex, to create a resolutely impersonal textured surface redolent of the worst excesses of suburban do-it-yourself pastimes. By contrast, Robert Gober used traditional materials such as plaster and wood to fashion austere sculptural shapes. These could be interpreted both as a parody of Minimalism, in that they transposed basic forms into objects identified with sinks or with items of furniture such as a play-pen or a bed, and of consumer culture, since the resulting objects were all blatantly removed from their implicit function.

Just as the furniture sculptures in formica made by Artschwager in the 1960s provide a point of reference for these works by Gober, so his procedures of simulation of one ma-

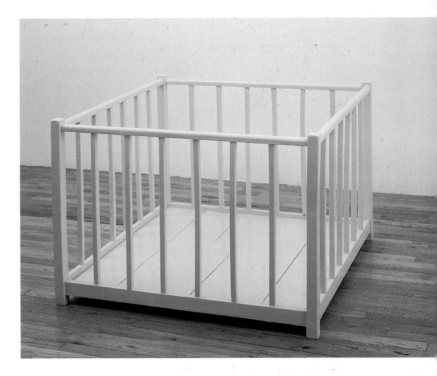

357 Robert Gober *Play Pen* 1986

358 Peter Halley *Yellow and Black Cells with Conduit* 1985

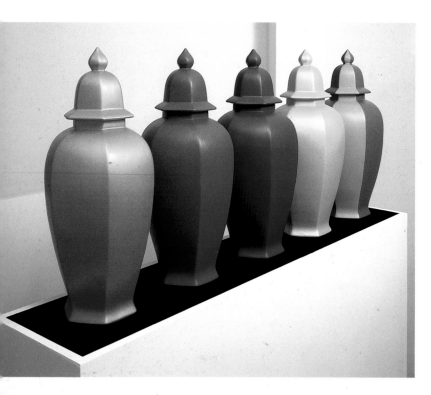

359 Allan McCollum *Five Perfect Vehicles* 1985–7

terial by another can be said to lie behind the elaborate subterfuges practised by Meyer Vaisman who, like many of these artists, was motivated by a conviction that 'Deceit . . . is what art does best.'[20] Allan McCollum produced numerous cast plaster imitations of conventionally framed pictures, which he labelled *Surrogates*, and bland sculptural arrangements of identically shaped vessels, *Perfect Vehicles*, as part of a larger examination of the status of the art object within the commercial market.[21] Jon Kessler devised a new form of kinetic construction in which mass-produced plastic figures and toys, lit from behind, endlessly revolve so that they present picturesque and exotic spectacles while frustrating our expectations of a completed narrative event.

In this generation the three artists whose work has most aggressively recharged the terms of Pop – Ashley Bickerton, Haim Steinbach and Jeff Koons – have all produced or manipulated objects whose manufactured quality gives them a bright and cheerful look that only partly masks a deep despair and even cynicism. Interviewed in 1987, Bickerton articulated the cultural and social malaise he appears to have felt his work was duty-bound to express: 'I decided that I wanted to make paintings that were utterly bleak, utterly without hope. But I realized, too, that in order to say this, they couldn't make it too obvious in their stylistic appearance – that, indeed, some of the bleakest commentary is often dandified and celebratory. . . . I want to create objects that are shamelessly beautiful at the same time that they invest in the utter bankruptcy of all possibility. But then again, I think that this is a possibility that creates its own poetic dynamic, that is capable of producing its own optimism.'[22]

The paradoxical impulses of which Bickerton speaks are clearly manifest in the uneasy allure of the works themselves. The ambivalence extends even to their most basic characteristics. They can be called paintings, in that they hang on the wall and present flat painted images on a planar surface, or sculptural constructions, since this frontal plane, often held out by more than thirty centimetres from the wall, is only one of a set of flat elements screwed together into box-like forms with the precision of a high-tech artefact. Unrelieved in their flatness, frontality and clean edges, unashamedly decorative in their pure bright colours and formalized designs, and with machine-like surfaces of pristine and soulless perfection, they seduce the eye only to deliver their desperate verdict on their own (literal) hollowness. On Bickerton's own admission, they speak of the death of the individual 'constructed through an elaborate and ritualized system of cultural codes.'[23] In works such as *Le Art (Composition with Logos, 2)* (1987) he presents his own exaggerated signature, repeated with the mechanical insistency of advertising, as simply another corporate logo, avowing the fact that for consumers and investors, whether in art or in industry, it is only the brand name that really counts. Bickerton's works, like those of his colleagues, are disturbing because of their apparent refusal to countenance emotion or any of the higher ideals of which artists used to speak. In some works he went so far as to incorporate an electronic meter, similar to those in taxis, that displayed its current monetary value.

This insistent and blatant sense of the work of art as a commodity is perhaps even more brutally evident in the assemblages of the Israeli-born Haim Steinbach, whose typical production consists of ready-made manufactured objects displayed on wedge-shaped formica-covered plinths fixed to the wall. In a more extreme form than that devised by Pop artists of an earlier generation such as Warhol, the production of a finished work seems to be limited to two basic acts: selection and presentation. The shelves themselves not only suggest shop display but bring to these works an 'art quotient' that will be recognized and appreciated by the specialized but growing audience for contemporary

360 Ashley Bickerton *Le Art (Composition with Logos, 2)* **1987**

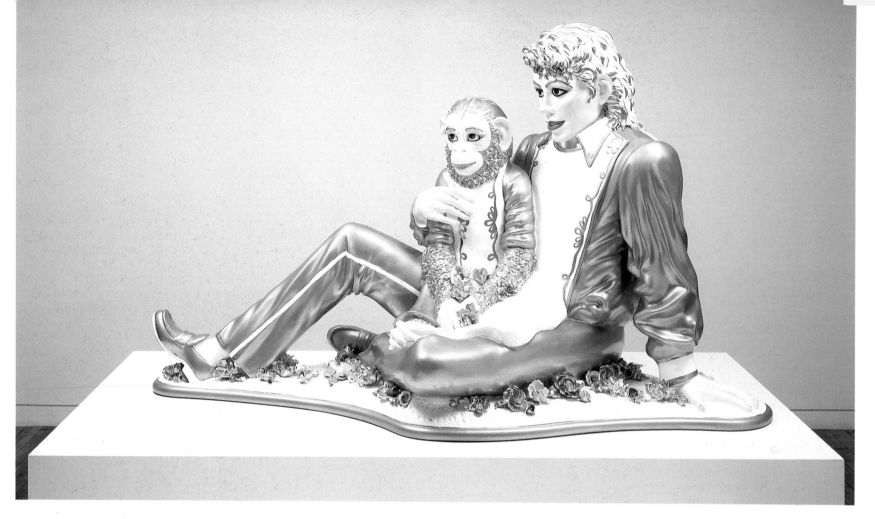

364 Jeff Koons *Michael Jackson and Bubbles* 1988

polychromed wood. Among these works were a gilded porcelain life-size rendering of a white-faced *Michael Jackson and Bubbles*, a tastelessly neo-Baroque gilded mirror representing *Christ with Lamb* and a wooden pig guided by sickly sweet cherubs, provocatively titled *Ushering in Banality*. As with much of the Pop art before it, this exhibition was both heavily derided and lavished with exaggerated praise and was thus successful in attracting attention. Yet the harshness of its humour, pointed with a kind of cruelty not only towards the popular taste it satirizes but also towards the almost masochistic obedience with which the art world asks to be taunted, demonstrates unequivocally the final loss of innocence that had allowed Pop artists to steer a course between genuine popular appeal and artistic integrity. And yet there is always a possibility that, like most Pop artists, Koons without cynicism is demonstrating essentially conceptual concerns.

In these works of the late 1980s Pop has enjoyed another flowering that suggests its life is far from exhausted. Methods of seriality and repetition, the deployment of industrial and synthetic materials, the use of media images as icons of modern mass culture, the presentation of ready-made objects as art and of art objects as commodities, and the insistent references to mass production have once again become standard elements of an art that seeks to define its place as much in its society at large as in the terms of an enclosed philosophical or conceptual enquiry. Faking, copying, appropriating and simulating one thing for another, artists have continued to meditate on concepts of originality and authenticity in ways that display the lasting inspiration of the Pop movement more than a quarter of a century after its inception.

Notes

Introduction

1 The pioneering study of Courbet's reliance on such sources, Meyer Schapiro's 'Courbet and Popular Imagery', *Journal of the Warburg and Courtauld Institutes* (1940–41), pp. 164–91, indicated a shift in appreciating the specific meaning of the artist's modernity only a decade before Larry Rivers painted *The Burial* (1951), loosely based on Courbet.

2 In very rare cases, these collages by Schwitters prominently show excerpts from comic strips, as in a late work, *For Käte* (1947), reproduced in Lucy Lippard, ed., *Pop Art* (London, Thames and Hudson, and New York, Praeger, 1966), p. 12, fig. 1, and Michael Compton, *Pop Art* (London, Hamlyn, 1970), p. 21. It is very misleading, however, to propose such untypical and little-known works as a direct influence on Pop.

3 On the death of Walter Arensberg in 1954, the collection of modern art he and his wife Louise had accumulated, including major works by Duchamp, was bequeathed to the Philadelphia Museum of Art, where it went on permanent display as a special section. A collection of Duchamp's writings edited by Michel Sanouillet, *Marchand du Sel*, was published in 1958 (Paris, Le Terrain Vague), followed by a monograph by Robert Lebel, *Sur Marcel Duchamp* (Paris and London, Trianon, 1959), English transl. George Heard Hamilton. In England Richard Hamilton prepared *The Bride Stripped Bare by her Bachelors, Even: a typographic version by Richard Hamilton of Marcel Duchamp's Green Box translated by George Heard Hamilton* (London and Bradford, Lund, Humphries, and New York, Wittenborn, 1960). The apotheosis of Duchamp's status as one of the most influential of all 20th-century artists was marked in a retrospective held at the Pasadena Art Museum in 1963, 'of or by Marcel Duchamp or Rrose Sélavy', the opening attended by several Pop artists including Hamilton, Ed Ruscha and Andy Warhol (at the time of his own one-man show in Los Angeles), and in 1966 by a retrospective at the Tate Gallery, 'The almost complete works of Marcel Duchamp' (see Ch. 8, n. 41).

4 'Apropos of "Readymades" ', published in *Art and Artists*, 1, no. 4 (July 1966), p. 47, reprinted in Michel Sanouillet and Elmer Peterson, *The Essential Writings of Marcel Duchamp* (New York, Oxford University Press, 1973 and London, Thames and Hudson, 1975), p. 141.

5 Both *Apolinère Enameled* and *The Bride Stripped Bare* were in the collection of the Philadelphia Museum of Art and thus readily accessible to American artists. The latter, of which a replica was made under the guidance of Hamilton for the 1966 Tate exhibition, was acknowledged by James Rosenquist as an inspiration for his major work, *F–111* (1965, see Ch. 9).

6 In *Made in USA: An Americanization in Modern Art, the '50s and '60s* (Berkeley and Los Angeles, University of California Press, 1987) Sidra Stich brilliantly integrates a great variety of Pop subject-matter with information on world events and statistics about such matters as mass production, consumerism, the growth of supermarkets, the mass exodus to the suburbs, automation and computerization, television, marketing, packaging and advertising. Similar connections could usefully be made with the situation during the same period in Great Britain and the rest of Europe but no such studies have yet been published.

Chapter 1

1 Alan Solomon, *Jasper Johns: paintings, drawings and sculpture 1954–1964* (exh. cat., Whitechapel Gallery, London, Dec. 1964), p. 7.

2 Hilton Kramer, 'Art and the Found Object', *Arts* (Feb. 1959), p. 49, and Harold Rosenberg, 'The Audience as Subject', in *Out of the Ordinary* (exh. cat., The Contemporary Arts Association, Houston, 1959), both quoted in Leo Steinberg, *Jasper Johns* (New York, Wittenborn, 1963), p. 8.

3 Interview with David Sylvester recorded in spring 1965 and first broadcast on the BBC, 10 Oct. 1965, quoted in *Jasper Johns Drawings* (exh. cat., Arts Council of Great Britain, London, 1974), pp. 12–13.

4 Max Kozloff, *Jasper Johns* (New York, Abrams, 1967), p. 36, notes similarities between Cornell's work and certain painted constructions of the mid–1950s by Johns but discounts the possibility of a direct connection.

5 I am grateful to Professor Kenneth Silver of New York University for proposing this.

6 A very similar work, *Target with Four Faces*, was printed on the cover of *Artnews*, 56, no. 9 (Jan. 1958). It was through this conspicuous reproduction in an art magazine until then identified with Abstract Expressionism that Johns first reached a wide public.

7 Both Picabia (e.g. in a watercolour of *c.* 1922, *Octophone*) and Duchamp (in kinetic works such as *Rotary Glass Plate [Precision Optics]* 1920 and *Rotorelief [Optical Disk]* 1935) had used targets in their work but for very different purposes; see William S. Rubin, *Dada, Surrealism and their Heritage* (exh. cat., Museum of Modern Art, New York, 27 March – 9 June 1968), pp. 21, 23, 27, 29, 185. Johns's interest in Duchamp seems to have developed only in 1959 on the publication of Robert Lebel's monograph on the artist; that year Johns went to Philadelphia to see the works by Duchamp in the Arensberg collection and met Duchamp who was brought to his studio by the critic Nicolas Calas. See Kozloff, *Jasper Johns*, pp. 23–4, and Michael Crichton, *Jasper Johns* (London, Thames and Hudson, 1977), p. 40.

8 Steinberg, *Jasper Johns*, p. 12. He elaborated: 'The street and the sky – they can only be simulated on canvas; but a flag, a target, a 7 – these can be made, and the completed painting will represent no more than what it actually is. For no likeness of a thing is paintable, only the thing itself.'

9 The importance of such imagery to the development of Pop can be shown, for example, in Warhol's purchase of one of Johns's drawings of a light bulb from the Castelli Gallery in 1960. See Victor Bockris, *Warhol: The Biography* (London, Frederick Muller, 1989), p. 136. According to Warhol's own account, written with Pat Hackett, in *POPism: The Warhol '60s* (New York and London, Harcourt Brace Jovanovich, 1980), p. 6, it was his friend Ted Carey who purchased the drawing, but it was among the works from Warhol's collection auctioned after his death (*The Andy Warhol Collection*, vol. VI: *Contemporary Art*, Sotheby's, New York, 2 and 3 May 1988, cat. no. 3353).

10 Quoted in Crichton, *Jasper Johns*, pp. 42–3.

11 See Stich, *Made in USA*, pp. 92–6, for a discussion of Coca-Cola's marketing success and the use of the image in works by Rauschenberg and other American artists.

12 See Thomas B. Hess, *Willem de Kooning* (exh. cat., Museum of Modern Art, New York, 1958), pp. 77–8. A subsequent work in the *Woman* series, *Marilyn Monroe* (1954), is now identified as a portrait of the star who became the Pop artists' favourite pin-up; as its title seems not to have been de Kooning's own, however, and as the facial features would not have been explicitly identifiable as hers, it seems very improbable that it would be directly linked to any of the images of the early 1960s. See Stich, *Made in USA*, fig. 130, p. 133 and p. 161, n. 23.

13 When Sidney Janis was preparing for the opening of his gallery's 'The New Realists' (31 Oct. – 1 Dec. 1962), the first to include the work of Pop artists, a protest meeting

was held by the Abstract Expressionists under contract to him. Guston, Gottlieb, Motherwell and Rothko all resigned from the gallery; only de Kooning elected to stay, apparently offering no opposition to the new arrivals and even attending the opening. See Janis's account in Laura de Coppet and Alan Jones, *The Art Dealers* (New York, Clarkson Potter, 1984), pp. 39–40, and Bockris, *Warhol*, p. 155. De Kooning was reported, however, to have turned on Warhol at a party in 1969 and told him, 'You're a killer of art, you're a killer of beauty, and you're even a killer of laughter. I can't bear your work!' Warhol is said to have reacted only by saying 'Oh, well, I always loved his work': Bockris, *Warhol*, p. 320.

14 Rivers passed through London in autumn 1961 (see Ch. 5, n. 8) and first exhibited his work there in a one-man show at Gimpel Fils in May 1962, but among the few paintings by him known to British artists from reproductions were *Buick Painting with P*, 1960 (*Artnews*, Dec. 1960, p. 38) and *The Next to Last Confederate Soldier*, 1959 (pl. 4 and cover of *Evergreen Review*, March – April 1960); the latter was also the subject of an essay by the poet Frank O'Hara, 'Larry Rivers: The Next to Last Confederate Soldier', in B. H. Friedman, *School of New York: Some Younger Artists* (New York, Grove Press, 1959), pp. 64ff, which included chapters on Johns and Rauschenberg. The same issue of *Evergreen Review*, a copy of which was owned by Allen Jones, included a colour reproduction of Johns's *Large Target with Plaster Casts* (1955) and Rauschenberg's combine *The Eagle* (1959) as part of an article by John Bernard Myers, 'The impact of Surrealism on the New York School'. In conversation with me on 15 March 1976, Jones recalled having been impressed by these reproductions of Rivers's paintings: 'Here was someone who was *using* the language of Abstract Expressionist painting, just painting a soldier or something. And I thought that was all terrific, it was very exhilarating. It didn't influence me in the sense that I then painted motorcars or anything, but that's what *I* consider an influence.'

15 Rivers initiated his *French Money* series while living in Paris in the winter of 1961–2 (see Ch. 5, n. 8).

16 Johnson and Warhol were friends by the beginning of the 1960s, when Warhol was introduced by Johnson to Billy Linich (later known as Billy Name), who was to become one of the stalwarts of the Factory.

17 Quoted in Michael Auping, *Jess: Paste-Ups (and Assemblies) 1951–1983* (exh. cat., John and Mable Ringling Museum of Art, Sarasota, Florida, 9 Dec. 1983 – 5 Feb. 1984), p. 10. See also Stich, *Made in USA*, pp. 147–8.

18 Pearlstein and Warhol had moved together from Pittsburgh to New York in summer 1949 and had briefly shared a flat. Warhol established himself as a successful commercial artist with a new set of friends, but the possibility of his having seen Pearlstein's one-off experiment with a comic strip character cannot be discounted.

19 See Intro., n. 2.

20 See *Picasso* (exh. cat., Arts Council of Great Britain, London, 6 July – 18 Sept. 1960), cat. no. 202. These and other works in the exhibition, held at the Tate Gallery, exerted a strong influence on the young David Hockney.

Chapter 2

1 Their first meetings were held as the Young Group at the ICA in spring 1952, under the direction of a young gallery assistant there, Richard Lannoy. The first recorded use of the Independent Group as their name was in a meeting on 12 Nov. 1952 of the ICA Managing Committee. For an account of their formation and early history, see Anne Massey, 'The Independent Group: towards a redefinition', *Burlington Magazine*, 129, no. 1009 (April 1987), pp. 232–42.

2 Lawrence Alloway, 'The Arts and the Mass Media', *Architectural Design*, 28, no. 2 (Feb. 1958).

3 The records of the spring 1955 season, for instance, indicate that the attendance of the nine seminars varied from 14 to 22 people; see *This is Tomorrow Today: The Independent Group and British Pop Art* (exh. cat., The Clocktower Gallery, New York, 22 Oct. – 13 Dec. 1987), pp. 87–8. 'Parallel of Life and Art' was organized and designed by Henderson, Paolozzi and the Smithsons and shown at the ICA 11 Sept. – 18 Oct. 1953; 'Man, Machine and Motion' was organized by Hamilton and shown at the Hatton Gallery, King's College, Newcastle upon Tyne, in May 1955 and at the ICA 6 – 30 July 1955 (with a text by Reyner Banham in the catalogue). 'This is Tomorrow', shown at the Whitechapel Art Gallery, London, 8 Aug. – 12 Sept. 1956, consisted of installations by twelve teams drawn from the Independent Group. The last joint show to be staged by them was 'An Exhibit', organized and designed by Alloway, Hamilton and Pasmore and shown at the Hatton Gallery in July and at the ICA 13 – 27 Aug. 1957 (with an essay by Alloway in the brochure). For a discussion of these exhibitions and a bibliography of publications by Independent Group members, see *Modern Dreams: The Rise and Fall and Rise of Pop* (Cambridge, Mass., MIT Press, in association with The Institute for Contemporary Art, The Clocktower Gallery, New York, 1988), which includes an almost complete reprint of *This is Tomorrow Today*.

4 They were first displayed as framed collages in Paolozzi's retrospective at the Tate Gallery, London, 22 Sept. – 31 Oct. 1971.

5 For example, the large two-panel *Collage Mural* (1952) reproduced in Diane Kirkpatrick, *Eduardo Paolozzi* (London, Studio Vista, 1970), p. 41.

6 See, e.g., Lawrence Alloway, 'Technology and Sex in Science Fiction: A Note on Cover Art', *Ark: Journal of the Royal College of Art*, 17 (summer 1956), pp. 19–23, and 'The Robot & the Arts', *Art News and Review*, 8, no. 16 (1 Sept. 1956), pp. 1, 6. Alloway lectured on 'Science Fiction' at the ICA in Jan. 1954 and on 'Monster Engineering' in a 'Mass Communications' session there in Oct. 1958. For further discussion, see Eugenie Tsai, 'The Sci-Fi Connection: the IG, J. G. Ballard, and Robert Smithson', in *Modern Dreams*, pp. 71–5.

7 It was reproduced, for instance, in Mario Amaya, *Pop as Art: A Survey on the New Super-Realism* (London, Studio Vista, and New York, Viking, 1965), p. 35, and Lippard, *Pop Art*, p. 38, and it was included as the first work in 'Richard Hamilton: Paintings etc. '56–'64' (Hanover Gallery, London, 20 Oct. – 20 Nov. 1964 and exh. cat.), his first one-man show in London since 1955.

8 Alison and Peter Smithson, 'But Today We Collect Ads', *Ark*, 18(Nov. 1956), pp. 49–50, reprinted in *Modern Dreams*, p. 53.

9 According to Richard Morphet, *Richard Hamilton* (exh. cat., Tate Gallery, London, 12 March – 19 April 1970), p. 31, 'the feel of this work [by McHale] was, however, perhaps closer to Dubuffet than to its artificial and elegant sources.'

10 Lawrence Alloway, 'The Long Front of Culture', *Cambridge Opinion*, no. 17 (1959), reprinted in *Modern Dreams*, p. 33.

11 Reyner Banham, 'Vehicles of Desire', *Art*, no. 1 (1 Sept. 1955), reprinted in *Modern Dreams*, p. 69.

12 Hamilton's article, 'An exposition of $he', originally published in *Architectural Design* (Oct. 1962), pp. 485–6, is reprinted in full with corrections in Richard Hamilton, *Collected Words 1953–1982* (London, Thames and Hudson, 1982), pp. 35–9.

13 Semiology or semiotics, the study of signs and symbols, as developed by Barthes in the 1950s, originated in the linguistic investigations of the Swiss philologist Ferdinand de Saussure early in the 20th century. The most pertinent of Barthes's early collections of criticism, *Le Degré zéro de l'écriture* (Paris, Seuil, 1953) and *Mythologies* (Paris, Seuil, 1957), were not made available in English until long after the advent of Pop, as *Writing Degree Zero [and] Elements of Semiology* (London, Cape, 1967 and New York, Hill and Wang, 1968) and *Mythologies* (London, Cape, 1972 and New York, Hill and Wang, 1973); the latter, consisting of selections from the original publication, includes essays of particular relevance to Pop subject-matter, such as 'The World of Wrestling', 'The Romans in Films' and 'Soap-powders and Detergents'. Closely related to these methods of decoding were publications in English by such theorists as Marshall McLuhan and Vance Packard; see Ch. 5, n. 16.

14 In his notes to this picture in *Richard Hamilton: Paintings etc.*, cat. 11, he wrote: 'Girlie pictures were the source of Pin-up; not only the sophisticated and often exquisite photographs in *Playboy* magazine, but also the most vulgar and unattractive to be found in such pulp equivalents as *Beauty Parade*. All the paintings have references to fine art sources as well as pop – in this case there are passages which bear the marks of a close look at Renoir.'

15 Enid Marx and M. Lambert wrote *English Popular Art* (London, Batsford, 1951).

16 Of these only Coleman was in Blake's year. Smith and Denny, whose work of the 1950s was already primarily abstract, were part of the 1954 intake. Tilson had arrived at the College a year before Blake. Also in Tilson's year were

other painters who later enjoyed international success: Bridget Riley and Frank Auerbach. Another 'serious' painter, Leon Kossoff, was in Blake's year. Tilson and Smith came to be associated with Pop, but only in 1960–61 after undergoing other influences, notably that of American colour field painting; Tilson worked at first in an expressionist style, which he applied to subjects such as London low life and the pigeons in Trafalgar Square. Malcolm Morley, who gained fame in the mid-1960s as a pioneer of Photorealism after his move to the United States, was also a student at the RCA from 1954 to 1957, but the landscapes he was painting then bear little relation to his later work and even less to early Pop. One such student work, *Richmond Hill below the Wick* (1954), is reproduced in colour in Paul Huxley, ed., *Exhibition Road: Painters at the Royal College of Art* (Oxford, Phaidon, with Christie's and the Royal College of Art, London, 1988), p. 120.

17 The editorial in *Ark*, 1 (Oct. 1950), p. 2, was by Jack Stafford. In his editorial to *Ark*, 3 (Oct. 1951), p. 8, John E. Blake (no relation) wrote, 'To be a Social Realist, whether one accepts the label or not, is to draw not only on the danger and beauty of our time within a wide range of representational media; but to maintain a lively attitude toward life itself, challenging poverty and social injustice.' Four Social Realist painters from the RCA, grouped together by critics as the Kitchen Sink School because of their preference for domestic subject-matter drawn from ordinary working-class life, were already enjoying considerable success by the time Blake arrived: Derrick Greaves (a student at the RCA from 1948 to 1952), Edward Middleditch (1949–52), Jack Smith (1950–53) and John Bratby (1951–54). Such painters, Bratby in particular, sometimes included contemporary consumer products as part of the paraphernalia of daily life. A typical example was a picture painted by Bratby during Blake's first year at the College, *Jean and Tabletop (girl in a yellow jumper)* (1953–4), which prominently displays such items as a Kellogg's Corn Flakes packet and a box of Daz soap powder; the deep recessive space, the gloomy and angst-ridden atmosphere and the expressionist use of thick paint, however, were all antipathetic to Blake and to the spirit of what was soon identified as Pop.

18 *Ark*, 4 (Feb. 1952). The vogue for Victoriana was noted by John E. Blake in his editorial. Among the articles in this issue was one on barge decoration, 'The Spiritsail Sailing Barge' by Jim Lovegrove.

19 Advertising was first made the subject of extensive comment in a series of articles in *Ark*, 5 (summer 1952), notably in Raymond Hawkey's 'ADVERTISING: the skeleton in the consumers' cupboard'; this attack on the sinister implications of modern advertising methods, which were compared to propaganda, reveals that Marshall McLuhan's *The Mechanical Bride* (first published in 1951) was reaching a circle wider than that of the Independent Group. The IG's sociological examinations of advertising were also given an airing during Coleman's period as editor, particularly Alison and Peter Smithson, 'But Today We Collect Ads', see n. 8; this appeared in the same issue as Coleman's articles on city backgrounds and realism in current American cinema ('... and on the Shady') and 'A Romantic Naturalist: Some Notes on the Paintings of Peter Blake', and as Richard Smith's 'On the Sunny Side of the Street', pp. 54–5, a celebration of Hollywood musicals in which 'The mass-produced known environment can be re-seen in a heightened form.' Lawrence Alloway's 'Technology and Sex in Science Fiction', see n. 6, appeared in summer 1956. A special issue was devoted after Blake left to 'aspects of the popular arts' (*Ark*, 19, spring 1957), with articles by Smith ('Film Backgrounds: 2', pp. 13–15, on the symbolic overtones of Hollywood and 'home magazines', which together 'can give some public reality to an essential unvoiced communal fantasy'), Coleman ('Dream Worlds, assorted', pp. 30–32, in which he wrote of 'the expensive fashion magazines like *Vogue* and *Harper's* as a 'compelling world of glossy excitement') and Alloway (a 'Personal Statement', p. 28, in which he emphasized the critical importance of the mass media in overcoming 'the lingering prestige of aestheticism and fine art snobbism'). Comics were the object of persistent study in the pages of *Ark* as early as spring 1954 (Rosalind Dease and Len Deighton, 'Funnies Ha Ha', *Ark*, 10, pp. 52–8), and Blake contributed actual comic strips on two occasions long after completing his course: 'Funnies', *Ark*, 24 (autumn 1959, with work by T. Ungerer and Don Mason) and the full-page 'Only Sixteen', *Ark*, 25 (spring 1960), p. 29.

20 The ICA exhibition, 'Symbolic Realism in American Painting 1940–1950' (18 July – 18 Aug. 1950), with a catalogue introduction by Lincoln Kirstein, was followed by a more general survey of American painting at the Tate Gallery, 'Modern Art in the United States: Selections from the collections of the Museum of Modern Art, New York' (5 Jan. – 12 Feb. 1956), accompanied by a catalogue with essays by René d'Harnoncourt and Homer Cahill. Blake was particularly fond of a painting by Bernard Perlin, *Orthodox Boys* (1948), which had entered the Tate in 1950 and was on more or less permanent display there for some years.

21 Interview with me, 10 July 1989.

22 According to Blake, such grants had previously been made only for more traditional academic study, and this was the first year in which art subjects were even allowed for consideration.

23 Among the paintings were *Portrait of Joe in Spain*, *Guardia Civil*, *Goldfish* and *Shoe on the Beach at Nice*, all included in Michael Compton, *Peter Blake* (exh. cat., Tate Gallery, London, 9 Feb. – 20 March 1983), cat. nos 11–14; see also cat. nos 189–93 for some of the surviving drawings. Blake sent a few drawings back to the RCA, including some of Paris and Rome that were reproduced in *Ark*, but a large group were lent to a publisher some years later and never returned.

24 According to Compton's note on this painting in *Peter Blake*, p. 78, 'The prototype for his treatment was a painting by the social realist Honoré Sharrer in the Museum of Modern Art, New York. This painting, "Workers and their Pictures", showed contemporary workers holding masterpieces of modern art that they could never possess as individuals. It came to London for the 1955 exhibition of American art at the Tate but was not hung. Blake made an appointment to see it in storage at the American Embassy.' Among the other art references only one, to Manet's *The Balcony* (1865), is immediately recognizable as from the mainstream of art history; other pictures allude to the styles of his colleagues Smith, Denny and Kossoff, and the small still life in the lower left corner was meant as a sarcastic allusion to the Kitchen Sink painters. The portrait photograph worn by the boy on the far right is of the English Neo-Romantic painter John Minton, a much loved tutor at the College who had committed suicide in January 1957.

25 The woman on the tie appears to be based on the same still of Marilyn Monroe in *The Seven Year Itch* that Hamilton had incorporated into his installation at 'This is Tomorrow'.

26 In conversation, 10 July 1989, he recalled buying a girls' magazine which included a glossy reproduction of a sloppily painted portrait of the English pop singer Cliff Richard; he realized that the style of this image, and the imitation canvas on which it was printed, corresponded to a common expectation of what art should look like in a way that his own work did not. 'So to present that public with a picture painted in hard enamels with photographs stuck on was never going to get through. It got through to very few people anyway, so it didn't work on that level.' Nevertheless, he did eventually reach a surprisingly wide audience for a contemporary artist, not only through his occasional work as a graphic artist – notably the design of the Beatles' *Sergeant Pepper's Lonely Hearts Club Band* album in 1967 (see also Ch. 8, n. 14) – but through the art itself. His retrospective exhibition at the Tate Gallery in 1983 broke all previous attendance records for the work of a living artist.

27 See the catalogue entry on *The Fine Art Bit* in *The Tate Gallery 1968–70* (Tate Gallery, London, 1970), pp. 72–3. The six postcards, selected from those he already owned, are of works by Fra Angelico, Hans Memling, two of Indian art, Paulus Potter and the Black Madonna in the Abbey of Montserrat in Catalonia.

28 Blake's *Gold Paintings* were shown at the New Vision Centre, London, 18 Jan. – 6 Feb. 1960 in a two-man exhibition, 'Peter Blake and Tony Gifford: Grass and Gold'; Gifford's paintings represented sections of football pitches. One of the *Gold Paintings* is illustrated in Compton, *Peter Blake*, p. 81, cat. no. 28.

29 Although the best-known of the American hard-edge painters, Ellsworth Kelly, did not have a one-man show in England until 1962 (at Arthur Tooth & Sons, London), the new development was already becoming known in Britain. The exhibition 'West Coast Hard-edge: Four Abstract Classicists' was held at the ICA in March – April 1960; it included the work of Karl Benjamin, Lorser Feitelson, Frederick Hammersley and John McLaughlin, who are now largely forgotten. Blake, in conversation with me, on 10 July 1989, explained that his use of a pattern of diagonal stripes

in alternating colours was derived from the decorative border of a sculpture by H. C. Westermann, *Mysterious Yellow Mausoleum* (1958), which he knew from a black-and-white reproduction in *H. C. Westermann: recent work* (exh. cat., Allan Frumkin Gallery, Chicago, 1958), cat. 4; the catalogue had been given him by Alloway, who had become something of a mentor to Blake and was a good source of such information and material. The red and yellow diagonal used in some of Blake's pictures was taken directly from British railway rubbish bins; he imagines that the pattern signified some kind of warning.

Chapter 3

1 The exhibition was held in a specially hired space, see Ch. 1, n. 13; the catalogue contains essays by John Ashbery and Pierre Restany. The formation of the Nouveaux Réalistes was announced in a handwritten declaration signed by Restany, Klein, Raysse, Spoerri, Arman, Tinguely, Villeglé, Hains and Dufrêne, dated 27 October 1960. The text is brief: 'Les nouveaux réalistes ont pris conscience de leur singularité collective. Nouveau Réalisme = nouvelles approches perceptives du réel' (The new realists have become aware of their collective oddness. New Realism = new perceptual approaches to reality). It is reproduced in *1960: Les Nouveaux Réalistes* (exh. cat., Musée d'Art Moderne de la Ville de Paris, 15 May – 7 Sept. 1986), p. 216.

2 Restany's manifesto, 'Les Nouveaux Réalistes', 16 April 1960, was published as the preface for an exhibition of works by Arman, Dufrêne, Klein (Yves le Monochrome), Tinguely and Villeglé at the Galerie Apollinaire, Milan, in May 1960; it is reprinted in *1960: Les Nouveaux Réalistes*, pp. 264–5. Restany, the group's champion, also provided a preface for *A 40° au-dessus de Dada* (exh. cat., Galerie J, Paris, 17 May – 10 June 1961), reprinted in *1960: Les Nouveaux Réalistes*, pp. 266–7.

3 The performance, *Anthropométries de l'époque bleue*, took place at the Galerie Internationale d'Art Contemporain, Paris.

4 'Yves Klein the Monochrome', his first one-man show in America, was held at the Leo Castelli Gallery, New York, from 11–29 April 1961, and consisted exclusively of blue monochromes; among the visitors to the show was Andy Warhol. It was followed from 29 May – 29 June by another one-man show with the same title at the Dwan Gallery, Los Angeles, which included some *Sponges*, *Obelisks* and the first of his *Anthropométries*. During his visit to the city he met Edward Kienholz, to whom he gave a 'zone of immaterial pictorial sensibility' and who in turn dedicated an assemblage to him shortly afterwards; for a reproduction of this work, *Homage to Yves Klein* (c. 1961), see *Yves Klein* (exh. cat., Centre Georges Pompidou, Paris, 3 March – 23 May 1983), p. 372.

5 Quoted in Guy Atkins, *Asger Jorn: The crucial years, 1954–1964* (London, Lund Humphries, 1977), p. 65.

6 See *The Situationist International 1957–1972* (exh. cat., Institute of Contemporary Arts, London, 23 June – 13 Aug 1989, co-published with Verso).

Chapter 4

1 See Carol Anne Mahsun, *Pop Art and the Critics* (Ann Arbor, U.M.I. Research Press, 1987), pp. 5–11, for a discussion of the origins of the term and its first official acceptance at a symposium held on 13 Dec. 1962 at the Museum of Modern Art, moderated by Peter Selz. Among the terms rejected after consideration were New Realism and neo-Dada. Of the major museum exhibitions of the movement in 1963 only one, 'Pop Art USA' (Oakland Museum, CA) used the term on its own. The others, following 'The New Painting of Common Objects' (Pasadena Art Museum, CA, 1962), included 'Six Painters and the Object' (Guggenheim Museum, New York), 'Popular Art: Artistic Projection of Common American Symbols' (Nelson Gallery and Atkins Museum, Kansas City, MS), 'Pop! Goes the Easel' (Contemporary Art Museum, Houston), 'The Popular Image' (Washington Gallery of Modern Art, Washington, DC), 'Mixed Media and Pop Art' (Albright-Knox Art Gallery, Buffalo, NY) and 'Six More' (Los Angeles County Museum of Art).

2 Clement Greenberg, the most prominent and dogmatic of the critics who championed Abstract Expressionism and the formalist abstraction that emerged in its wake during the 1960s, was understandably one of the least sympathetic in his assessment of Pop. The polarity he had established between genuine 'high culture' and the supposedly synthetic emotion of mass taste in his influential article 'Avant-Garde and Kitsch' (*Partisan Review* 6, Fall 1939, pp. 34–9), was implicit to the wariness expressed towards contemporary mass culture in a symposium, 'Our Country and Our Culture', organized by the *Partisan Review* in 1952 (*Partisan Review* 19, May-June 1952, pp. 282–326, July-Aug., pp. 420–50, Sept.-Oct., pp. 562–97); reprinted as *America and the Intellectuals*, New York, Partisan Review Press, 1953). For a précis of the discussion see Stich, *Made in USA*, pp. 8–9.

3 The shift of sensibility was evident not just in Pop but in other artistic developments of the 1960s such as Post-Painterly Abstraction, Op Art and Minimalism. Another critic identified with the Abstract Expressionists, Irving Sandler, in 'The New Cool-Art', *Art in America* 1 (1965), pp. 96–101, discussed Warhol and Lichtenstein with reference to Frank Stella, Larry Poons, Morris Louis, Donald Judd and Ad Reinhardt.

4 Harold Rosenberg, 'The American Action Painters', in *The Tradition of the New* (New York, Horizon Press, 1959 and London, Thames and Hudson, 1962), p. 25.

5 Allan Kaprow, 'The Legacy of Jackson Pollock', *Artnews*, 57 (Oct. 1958), pp. 56–7, quoted in Barbara Haskell's account of the origins of Pop in junk aesthetics and Happenings, *Blam! The Explosion of Pop, Minimalism, and Performance 1958–1964* (exh. cat., Whitney Museum of American Art, New York, in association with W. W. Norton, New York, 1984), p. 18.

6 Kaprow, like Brecht, regularly attended the class on experimental music composition given by Cage at the New School for Social Research in 1958–9 and was greatly affected by his ideas about allowing the real world into the fabric of one's art, unjudgmentally and without mediation. Segal and Dine were among those who visited the class at Kaprow's invitation.

7 Grooms's performances also included *The Walking Man* (at the Sun Gallery, Provincetown, MA, Sept. 1959), and *The Burning Building* (Delancey Street Museum, New York, Dec. 1959).

8 At the end of his article on Pollock, see n. 5, p. 57, Kaprow looked forward to his sense of 'the alchemies of the 1960's': 'Not only will these bold creators show us as if for the first time the world we have always had about us, but ignored, but they will disclose entirely unheard of happenings and events found in garbage cans, police files, hotel lobbies, seen in store windows and on the streets, and sensed in dreams and horrible accidents ... All of life will be open to him. ... But out of nothing he will devise the extraordinary, and then maybe' nothingness as well.' Among those who acknowledge a direct debt to Kaprow is Roy Lichtenstein, who taught with him at Rutgers University, 1960–64.

9 Performances of *Snapshots from the City* took place on 29 Feb. and 1 and 2 March 1960. The comic books were printed on the Judson Memorial Church's stencil machine; see Haskell, *Blam!*, p. 27 and p. 110, n. 38.

10 A retrospective of 77 works by Dubuffet had just taken place at the Pierre Matisse Gallery, New York, Nov. 1959.

11 'Environments, Situations, Spaces', Martha Jackson Gallery, 25 May – 23 June 1961. Oldenburg's one-man show, 'The Store', 1 Dec. 1961 – Jan. 1962.

12 Quoted in John Rublowsky, *Pop Art* (New York, Basic Books, 1965), p. 65.

13 Grooms had effectively isolated himself from the developments that led to Pop by living in Europe from June 1960 to Sept. 1961. His first sculptural works of 1963, including a life-size portrait, *Alex Katz*, seated on an office chair, and a mixed-media construction, *Le Banquet pour le Douanier Rousseau*, marked the beginning of his re-engagement with subject-matter allied to Pop.

14 One of the earliest paintings reflecting this shift in Katz's work is *The Red Smile* (1963), a canvas 2 m high and nearly 3 m wide. For a discussion of his formal reliance on such popular forms as billboard advertising and film stills, see Richard Marshall, *Alex Katz* (Whitney Museum of American Art, New York, in association with Rizzoli, 1986), pp. 20–22. In conversation with me on 25 Sept. 1989, Gerard Malanga, Warhol's assistant during the 1960s, commented on the similarity between the flat areas of colour in his Marilyn Monroe paintings (before the superimposition of the screen-printed image) and those employed in Katz's schematic portraits.

15 For an account of their history and antecedents see George Maciunas's *Diagram of historical development of Fluxus and other 4 dimensional, aural, optic, olfactory, epithelial and tactile art forms* (1973), reproduced in Charles Dreyfus, *Happenings & Fluxus* (exh. cat., Galerie 1900–2000, Paris, 7 June – 29 July 1989, with Galerie du Génie and Galerie de Poche, Paris), cat. no. 279.

16 Brecht, for example, was among those not shown in the 'New Realists' on the rather tenuous grounds that there was insufficient space, although he did take part in other major early surveys of Pop.

17 *The Art of Assemblage* (exh. cat., Museum of Modern Art, New York, 2 Oct. – 12 Nov. 1961), text by William C. Seitz. Among the younger of the 142 artists in the exhibition only a few were associated with the development of Pop, such as Johns and Rauschenberg, Lucas Samaras (a participant in Happenings by Oldenburg and others) and Brecht.

18 It is unclear when Warhol acquired *Jackpot*, first shown in 'An Exhibition in Progress', Leo Castelli Gallery, New York, Sept. – Oct. 1961, and donated by him in 1975 to the Whitney Museum. It must be the piece referred to as 'a sculpture of a car crash by John Chamberlain' in a much later account of a visit to Warhol in the early 1960s by Castelli's assistant Ivan Karp, but the date of this visit is rather nebulous; see Bockris, *Warhol*, p. 137.

19 The Johns work was *Target with Four Faces* (1955), reproduced in *Print Magazine*; although Ruscha was already studying painting and working in an Abstract Expressionist manner, he cited Johns as his reason for becoming an artist. See *The Works of Edward Ruscha* (New York, Hudson Hills Press, 1982, in association with the San Francisco Museum of Modern Art), p. 157.

20 Ruscha's first books were all self-published, beginning with *Twenty-six Gasoline Stations* (Jan. 1963) and followed by numerous others such as *Various Small Fires and Milk* (1964), *Some Los Angeles Apartments* (1965), *Every Building on the Sunset Strip* (1966), *Thirty-four Parking Lots in Los Angeles* (1967), *Nine Swimming Pools and a Broken Glass* (1968) and *Real Estate Opportunities* (1970). Working as Eddie Russia, Ruscha was credited with 'production' on *Artforum* from Oct. 1965 (vol. 4 no. 2) through to summer 1969 (vol. 7, no. 10), by which time the editorial offices had moved from Los Angeles to New York.

21 *Dublin* takes its title not from the Irish capital but from a town in Georgia through which Ruscha had passed in 1952 when hitchhiking to Florida. The 1959 collage (34.5 x 33 cm) is reproduced in *The Works of Edward Ruscha*, p. 42.

22 Among the works on paper painted by Ruscha in Europe in 1961 are *Boulangerie*, consisting of nothing but this word against a coloured background, and *Bicycle Sign*, a representation of a bicycle silhouette against a dark circular background. According to Peter Schjeldahl, in 'Ed Ruscha: Traffic and Laughter', *Edward Ruscha* (exh. cat., Octobre des Arts, Lyon, 1985), pp. 45–8, 'The public use of graphic images, such as that of a bicycle to denote a bi-

cycle route, was still rare in America in 1961, and it plainly excited Ruscha.' The two items are reproduced on pp. 19 and 22 respectively.

23 A major retrospective of Hopper's work had been held by the Whitney Museum of American Art in New York in 1950, and in 1960 he was presented with the Art in America Annual Award.

24 Quoted in John Coplans, *Wayne Thiebaud* (exh. cat., Pasadena Art Museum, 1968), p. 26.

25 Quoted in Elizabeth Claridge, *The Girls of Mel Ramos* (London, Mathews Miller Dunbar, 1975), p. 28.

26 See Ernst A. Busche, *Roy Lichtenstein: Das Frühwerk 1942–1960* (Berlin, Gebr. Mann Verlag, 1988). Lichtenstein made two versions of *Washington crossing the Delaware*, reproduced on pp. 94 and 95, and around the same time tackled another history subject, *The Death of General Wolfe* (p. 97), previously treated by Benjamin West.

27 For reproductions of such works by Lichtenstein of *c.* 1959–60, some of which are known as *Ribbon Paintings*, see Busche, *Lichtenstein*, pp. 208–22. These paintings vary in size from about 40 x 55 to 178 x 229 cm.

28 Busche, *Lichtenstein*, reproduces *Ten Dollar Bill* on p. 112 and the drawings of comic-strip characters on pp. 224–7.

29 Richard Bellamy ran the Green Gallery, New York, from 1960 until it closed in 1965, showing a number of Pop artists such as Oldenburg, Rosenquist, Wesselmann and Segal; the gallery was subsidized by Robert Scull, one of the major collectors of Pop art. In the year he painted this picture, Lichtenstein signed with the Leo Castelli Gallery, where he has remained.

30 Reproduced in Rublowsky, *Pop Art*, p. 183.

31 Erle Loran, *Cézanne's Composition* (Berkeley and Los Angeles, University of California Press, 1946).

32 Warhol's interest in Johns's work is well documented; see Ch. 1, n. 9, and Bockris, *Warhol*, pp. 128–9.

33 There is some confusion from the separate accounts by Warhol and Karp as to which Lichtenstein painting he was shown, but it may have been *Girl with Ball* (1961). According to Karp, quoted in Jean Stein with George Plimpton, *Edie: An American Biography* (New York, Knopf, 1982), pp. 194–5, the incident occurred just after Warhol had purchased a drawing of a light bulb by Johns: 'He asked me if there was anything else of unusual interest in the gallery. I took out a painting by Roy Lichtenstein to show him. It was a painting of a girl with a beach ball held over her head. . . . Andy, looking at it, said in shock, "ohhh, I'm doing work just like that myself".' Warhol himself, in *POPism*, pp. 6–7, referred to it as 'a painting of a man in a rocket ship with a girl in the background'.

34 See Bockris, *Warhol*, p. 125, for an account of Warhol's nose job, which he dates to 1956. According to the chronology by Marjorie Frankel Nathanson in Kynaston McShine, ed., *Andy Warhol: A Retrospective* (exh. cat., Museum of Modern Art, New York, 6 Feb – 2 May 1989), p. 406, the operation took place in 1957.

35 Karp visited Warhol's studio on the same day that he had shown him the painting by Lichtenstein, and after looking at Warhol's paintings told him: 'These blunt, straightforward works are the only ones of any consequence. The others are all homage to Abstract Expressionism and are not.' De Antonio, whose close friends included Johns and Rauschenberg, was of the same opinion: 'One of these is a piece of shit, simply a little bit of everything. The other is remarkable – it's our society, it's who we are, it's absolutely beautiful and naked, and you ought to destroy the first one and show the other.' See Warhol and Hackett, *POPism*, pp. 6–7.

36 Quoted in 'New Talent U.S.A.', *Art in America*, 50, no. 1 (1960), p. 42.

37 Road signs were alluded to not only by Indiana, but also by Rauschenberg, D'Arcangelo and other artists as well as in a great range of American photography dating back at least to the 1930s. Concern with the urban environment went far beyond Pop: in March 1954 the Museum of Modern Art presented an exhibition on its first-floor gallery and garden terrace entitled 'Signs in the Street', which according to Mary Anne Staniszewski, 'Capital Pictures', in Paul Taylor, ed., *Post-Pop Art* (Cambridge, MA, MIT Press, 1989), p. 164, consisted of 'signs and photographs of signs from highways, bus stops, gas stations and buildings'. This is not to suggest, however, a direct influence: Indiana would not have been able to see the exhibition, as he was studying in Edinburgh during 1953–4 and did not move to New York until the end of summer 1954.

38 In *Allan D'Arcangelo: Paintings of the Early Sixties* (exh. cat., Neuberger Museum, State University of New York College at Purchase, 4 June – 10 Sept. 1978), unpaginated.

39 In an early interview Rosenquist explained: 'I use images from old magazines – when I say old, I mean 1945 to 1955 – a time we haven't started to ferret out as history yet. If it was the front end of a new car there would be people who would be passionate about it, and the front end of an old car might make some people nostalgic. The images are like no-images. There is a freedom there. If it were abstract, people might make it into something. If you paint Franco-American spaghetti, they won't make a crucifixion out of it, and also who could possibly be nostalgic about canned spaghetti? They'll bring their reactions but, probably, they won't have as many irrelevant ones.' Quoted in G. R. Swenson, 'What is Pop Art? Part II: Stephen Durkee, Jasper Johns, James Rosenquist, Tom Wesselmann', *Artnews*, 62 (Feb. 1964), p. 41.

40 Lucy Lippard, in 'James Rosenquist: Aspects of a Multiple Art', *Artforum*, (Dec. 1965), p. 41, states that 'Rosenquist's work is often compared to that of René Magritte. Although he admires the Belgian Surrealist, the similarity is superficial. They share a knowledge of the mystery inherent in common images. Yet Magritte's remote and deadpan approach is closer to that of the other Pop artists than to Rosenquist's.'

41 Jim Dine interviewed by me, July 1986, in *Rise Up,*

Solitude!: Prints 1985–86 (exh. cat., Waddington Graphics, London, 1986), p. 20.

42 *Ibid.*, p. 16.

43 *Portrait Collage # 2* (1959) was modelled directly on a reproduction of a painting by Memling, *Portrait of a Young Man*, which Wesselmann had on his kitchen wall. *Little Bathtub Collage # 2* (1960) relates closely to one of Bonnard's favourite subjects even in the adoption of a high point of view, while *Judy trimming Toenails, Yellow Wall* (1960) includes a reproduction of Matisse's *Grande robe bleue, fond noir* (1937). See Constance W. Glenn, *Tom Wesselmann: The Early Years, collages 1959–1962* (exh. cat., The Art Galleries, California State University, Long Beach, 10 Nov. – 8 Dec. 1974), unpaginated.

44 In the monograph written under his pseudonym Slim Stealingworth, *Tom Wesselmann* (New York, Abbeville, 1980), p. 23, Wesselmann wrote: 'It is pertinent to remember that in the early sixties nudity in American media was still rare and demure. There were not yet magazines publicly available that showed women openly displaying their genitals. Such magazines were, in fact, illegal; and it wasn't until around 1965 or 1966 that Wesselmann even saw one. Wesselmann took his spread leg nudes as an aggressive image and also as an expression of his joy at rediscovering sex, following the breakup of his first marriage. He was irritated with critics that spoke of the nudes as girly magazine material. The nudes were an expression of his delight at realizing that his girl friend would make such gestures and poses naturally, as a part of sexual pleasure and communication.' Whatever the circumstances that prompted Wesselmann's choice of subject-matter, however, the fact remains that the first issue of the most successful mass-circulation erotic magazine for men, *Playboy*, had appeared in 1953.

Chapter 5

1 In an interview with me, on 10 July 1989, Blake recalled that at the opening of 'Young Contemporaries' Pauline Fordham, a former girlfriend of Richard Smith, introduced him to her new boyfriend, Derek Boshier, because he was interested in Blake's work; she asked him at that time to visit the RCA to see what Boshier and the others were doing. He soon became especially friendly not only with Boshier but also with Phillips, whose work was closest to his own; when Blake was invited with another painter from the RCA, Pauline Boty, to take part in a film directed by Ken Russell for BBC Television, *Pop Goes the Easel* (first televised 25 March 1962), he recommended that Boshier and Phillips be included. Blake and Boshier even shared a room in the house on Addison Road where Boty and Celia Birtwell (later a close friend of Hockney's) were lodgers; in the end Blake used the room only for storage, while Boshier used it as a studio. See Ch. 1, n. 14, for some of the works by Rivers, Johns and Rauschenberg known to the RCA students through reproductions.

2 Hamilton taught one day a week at the RCA from 1957 to 1961, but in the Interior Design rather than in the Painting department, and as he did not have a one-man exhibition in London until 1964 the students had no opportunity to see work with which they would plainly have been in sympathy. Hockney, in *David Hockney by David Hockney* (London, Thames and Hudson, 1976), pp. 42–3, cites a studio visit by Hamilton as important in confirming the direction of his work: 'The students used to organize what they called sketch clubs: they'd put up one or two paintings and they'd get somebody from outside, an artist, to come in and talk about the work. And I remember Richard Hamilton was invited. Nobody knew much about him, although he was actually teaching in the College, in the school of interior design. . . . He gave a prize to Ron [Kitaj] and a prize to me, and from that moment on the staff of the College never said a word to me about my work being awful. . . . Richard was quite a boost for students.'

3 Lawrence Alloway, introduction to *Young Contemporaries 1961* (exh. cat., RCA, London, 8 – 25 Feb. 1961), unpaginated. He added that in their work, 'The impact of popular art is present, but checked by puzzles and paradoxes about the play of signs at different levels of signification in their work, which combines real objects, same size representation, sketchy notation, printing, and writing.'

4 J. Huizinga, *Erasmus of Rotterdam* (London, Phaidon, 1952), pl. V, reproduced in my *R. B. Kitaj* (Oxford, Phaidon, 1985), p. 14, fig. 2.

5 Garrick Mallery, 'Picture-Writing of the American Indians', *Tenth Annual Report of the Bureau of Ethnology, 1888–89* (Washington, Smithsonian Institution, 1893), pp. 25 ff. Kitaj acknowledged this source in the catalogue of his one-man show at the Marlborough-Gerson Gallery, New York, Feb. 1965, cat. no. 5, and in a note on the surface of his painting *Reflections on Violence*.

6 Rauschenberg used a similar grid-like construction in paintings such as *Charlene* (1954) and *Small Rebus* (1956). Kitaj found the diagram and learned about Lull in two articles by Frances A. Yates, 'The Art of Ramón Lull: An Approach to it through Lull's Theory of the Elements', *Journal of the Warburg and Courtauld Institutes*, 17, pp. 115 –73, and 'Ramón Lull and John Scotus Erigena', *Journal of the Warburg and Courtauld Institutes*, 18, pp. 1–44 (Jan. – June 1960). For further discussion of Kitaj's use of scholarly journals see my 'Iconology as Theme in the Early Work of R. B. Kitaj', *Burlington Magazine*, 122, no. 928 (July 1980), pp. 488–97, and my book, *R. B. Kitaj*, pp. 11–18.

7 Hockney's playing-card paintings were based on reproductions in a book on the history of playing cards owned by another student, Mark Berger. Although Hockney was aware of Rivers's work (see n. 8), there is no evidence that he would have known his contemporaneous paintings of similar subjects when he began his own series. It is not surprising, however, that they should both have thought of using such material as readily available, flat, heraldic images once the idea had been proposed of basing an entire painting on a single ready-made object.

8 Rivers visited London with his girlfriend Clarisse Price in 1961, marrying her there in October before moving on to Paris, where they remained until July 1962 and where he held a one-man show at the Galerie Rive Droite, 10 April – 7 May 1962. According to Peter Webb, *Portrait of David Hockney* (London, Chatto and Windus, 1988), p. 20, Rivers was among the established painters who visited the RCA painting studios at the principal's invitation when Hockney was a student there, presumably in autumn 1961. Hockney himself, in *David Hockney by David Hockney*, p. 42, later recalled: 'Someone who was an influence on a lot of students was Larry Rivers; he had come to England and a lot of people were very interested in his work, which was a kind of seminal pop art.' See also Larry Rivers and David Hockney, 'Beautiful or interesting', *Art and Literature*, 5 (summer 1964), pp. 94–117.

9 Hockney made several visits to the 'Picasso' exhibition (6 July – 18 Sept. 1960), which included among its 268 works of all periods the 1957 series of 58 variations on Velásquez's *Las Meninas*.

10 *Jean Dubuffet: Paintings, gouaches and lithographs* (exh. cat., Hanover Gallery, London, 3 May – 3 June 1960).

11 Phillips, like many English artists of his generation, first became aware of Abstract Expressionism through an exhibition, 'The New American Painting' (Tate Gallery, London, 24 Feb. – 22 March 1959), which he visited while still studying at Birmingham. Although few artists at the RCA made any attempt to come to terms with Abstract Expressionism then, Phillips recalled in an interview with me, on 2 Feb. 1982, that elsewhere in London the style was 'all the rage', particularly among painting students at the Royal Academy Schools. He shared a flat with several such students, including Michael Upton and David Willetts.

12 Phillips recalls being very impressed by reproductions of works by Johns and Rauschenberg in magazines brought to him by a girlfriend who had just visited New York, but he is convinced that he knew only Johns's target paintings then and not the flags. Flag paintings were, however, among the works reproduced in Friedman, *School of New York*, which he could have seen. See Ch. 1, n. 14.

13 An exhibition held at the ICA, London, in October 1959, 'Place', as a collaborative venture by three British abstract painters influenced by American Abstract Expressionism, had been consciously concerned with the relationship between the painting and the spectator in ways that were relevant to Pop and to Phillips's large-scale paintings in particular. Two of those participating were Richard Smith and Robyn Denny; the third artist was Ralph Rumney. The author of the catalogue introduction, Roger Coleman, also a former RCA student, wrote both of the importance of the mass media in their work, specifically in their adoption of Cinemascope scale, and of their interest in 'The Game Environment' – notably in their hanging of the paintings in the form of a maze – as a way of encouraging the viewer's active participation. Coleman's introduction to another exhibition, 'Situation' (RBA Galleries, London, Sept. 1960), which included work by Denny, Bernard Co-

hen, John Hoyland and others, again hinted at similarities of intention and reference between the work of these abstract painters and the nascent Pop Art, particularly in the preoccupation with the painting as a 'real object'. Cohen's use of concentric circles in works such as *Painting 96* (1960) provides further evidence of the general currency of the target motif in British art of this time. Works by Smith were also to be included in this exhibition, but they did not arrive in time from America, where he was then living.

14 Although these no longer exist, two of them can be glimpsed in a photograph by Geoffrey Reeves of Boshier and Hockney in their studio at the RCA in early 1961; reproduced in Webb, *Portrait of David Hockney*, pl. 42.

15 See the discussion of Smith's New York paintings in Ch. 4. *Airmail Letter* bears comparison with paintings by him such as *Billboard*, reproduced in *Richard Smith: Seven Exhibitions 1961–75* (exh. cat., Tate Gallery, London, 13 Aug. – 28 Sept. 1975), fig. 8, which consists almost entirely of an abstract flat coloured surface surrounded at the canvas edges by a simple pattern of alternating strips of colour, and particularly with *After Six* (1960), in which a central colour wheel is surrounded by a framing device of thick diagonal stripes very similar to those used in Boshier's painting. *After Six* and *Wado* (1961), exhibited at 'New London Situation' (Marlborough New London Gallery, London, Aug – Sept. 1961), are reproduced in *Richard Smith: paintings 1958–1966* (Whitechapel Gallery, London, May 1966), cat. nos 8 and 9. Boshier would have been well informed about Smith's work through Fordham by early 1961 (see n. 1); he met Smith on the latter's return from New York in summer 1961 and even worked as an assistant for him at his Bath Street studio before Smith's one-man show there in 1962. Boshier's sensuous handling of paint in his works of early 1962 owes much to Smith.

16 Boshier's reading at this time included McLuhan's *The Mechanical Bride: Folklore of Industrial Man* (New York, Vanguard, 1951), Packard's *The Hidden Persuaders* (London, Longmans, Green, 1957) and *Status Seekers: An Exploration of Class Behaviour in America* (London, Longmans 1960), Galbraith's *The Affluent Society* (Boston, Houghton Mifflin, and London, Hamish Hamilton, 1958) and D. J. Boorstin's *The Image: or, What Happened to the American Dream* (London, Weidenfeld and Nicolson, 1962).

17 Quoted in 'MONITOR: Pop Art – whimsical and impudent', *Radio Times*, 22 March 1962.

18 Oil on canvas, 30.5 x 40.7 cm, destroyed. Chessman was an American who had been convicted for rape in 1948 and who was executed at San Quentin prison, May 1960, after appealing against his sentence for 12 years and obtaining 8 stays of execution. His case aroused global coverage: the *Times* reported his execution and burial, 4 and 5 May, and featured 12 major articles on his case, the last of them on 12 August 1960. Chessman himself published not only an autobiography, *Cell 2455, Death Row* (1954) and a novel, *The Kid was a Killer* (1960), but two non-fiction works, *Duel by Ordeal* (1955) and *The Face of Justice* (1957).

19 Vance Packard, *The Hidden Persuaders* (Harmondsworth, Penguin, 1962), p. 15, and Marshall McLuhan, *The Mechanical Bride* (London, Routledge & Kegan Paul, 1967), pp. 118ff and p. v (see n. 16 for the original edns).

20 Boshier's interest in market research may have been strengthened by the fact that his friend and flatmate Brian Rice was supporting himself through such part-time work.

21 Boshier lived in India for a year, on an Indian government scholarship, immediately after leaving the RCA in summer 1962. The paintings he produced there, similar in style to his last College paintings but incorporating references to Hindu symbolism and mythology, were accidentally destroyed just before his return to England. In 1964–5 he produced a series of paintings, many of them on shaped canvases, in which the language of geometric abstraction was used to convey ideas about architectural structures and urban environments in a very general way. From the mid-1960s Boshier experimented with a form of Minimalist sculpture, and then with film and photography, before turning in the mid-1970s to collages made from contemporary magazine advertisements in a critical spirit reminiscent of his examination of such material in the early 1960s. He returned to painting in 1979, devoting himself to the figure and to the invention of a new personal iconography after moving to Houston, Texas, to take up a professorship in painting in summer 1980.

22 *My Colouring Book*, now in the collection of the Muzeum Sztuki w Lodzi, Poland, is reproduced in *Connoisseur*, 154 (1963), p. 256.

23 The only recent research on Boty is an M.A. Report by Gwyneth King (Sussex University, 1979).

24 For reference he used a photograph taken by Man Ray in 1922, reproduced as the frontispiece to James Thrall Soby, *Juan Gris* (Museum of Modern Art, New York, 1958). *Portrait of Juan Gris* (1963) is reproduced in my *Patrick Caulfield: Paintings 1963–81* (exh. cat., Tate Gallery, London, 27 Oct. 1981 – 3 Jan. 1982), cat. no. 5.

25 Caulfield visited Crete in 1961 and 1963, on both occasions buying postcards of Minoan frescoes, which he enjoyed for their decorative qualities; the postcards, redrawn versions of such images rather than photographs, employed black outlines and areas of bright flat colour such as Caulfield began to use then in his own paintings.

26 Pertinent works by Léger include *Le Siphon* (1924) and *The Mirror* (1925), reproduced in Katharine Kuh, *Léger* (Urbana, The University of Illinois Press, 1953), pp. 38–40; see also Léger's statements on pp. 42–3 and Kuh's comments on p. 103.

27 Paintings based on similar sources include two of 1964, *Still Life with Necklace* and *Still Life on a Table*, reproduced in my *Patrick Caulfield*, cat. nos 8 and 10.

28 *Captain Webb Matchbox* is interesting to compare with Warhol's *Brillo Boxes* and other sculptures of 1964, although Warhol could not have known this work by Blake; there are important distinctions, too, between Blake's piece, which involved the enlargement of the source and its incomplete transcription by hand in a painterly tech-

nique, and Warhol's screen-printed actual-size facsimiles that duplicate their source as literally as possible. For background information about Blake's *Toy Shop*, see the entry in *The Tate Gallery 1968–70* (Tate Gallery, London, 1970), pp. 73–4.

29 The other participants are: Frank Auerbach (the bottom half of A), Bernard Cohen (the top half of C), the photographer Robert Freeman (F), John Latham (L), Tony Messenger (M), Tony Caro (T), Brian Wall (W), Brian Young (X and Y), Tilson's wife Jos (the bottom right section of J) and his young children Jake and Anna (the top right section of J and the top of A).

Chapter 6

1 See Ellen H. Johnson, 'Image Duplicators – Lichtenstein, Rauschenberg, and Warhol', *Canadian Art*, 23 (Jan. 1966), p. 16; John Coplans, 'Early Warhol: The Systematic Evolution of the Impersonal Style', *Artforum*, 8 (March 1970), p. 54; and Warhol and Hackett, *POPism*, p. 23.

2 See his comments in G. R. Swenson, 'What is Pop Art? Interviews with eight painters, Part I', *Artnews*, 62, (Nov. 1963), p. 26, and in Warhol and Hackett, *POPism*, p. 22.

3 Bockris, *Warhol*, p. 151.

4 Just as Warhol was influenced by Duchamp, so Duchamp recognized the importance of Warhol's work, commenting that, 'If a man takes fifty Campbell's soup cans and puts them on a canvas, it is not the retinal image that concerns us. What concerns us is the concept that wants to put fifty Campbell's soup cans on a canvas' (quoted in Bockris, *Warhol*, p. 159). In 1965 the Milan-based art dealer Arturo Schwarz produced eight limited edition sets of replicas of Duchamp's early ready-mades with the artist's consent; the idea of remaking manufactured objects in this way, especially to such blatantly commercial ends, may have been prompted in part by the example of Warhol's 1964 box sculptures.

5 For a detailed discussion of Warhol's processes see my 'Do It Yourself: Notes on Warhol's Techniques', in McShine, *Andy Warhol: A Retrospective*, pp. 63–78.

6 Janis Hendrickson, *Roy Lichtenstein* (Cologne, Taschen, 1988), p. 29, quotes him: 'A minor purpose of my war paintings is to put military aggressiveness in an absurd light. My personal opinion is that much of our foreign policy has been unbelievably terrifying, but this is not what my work is about and I don't want to capitalize on this popular position. My work is more about our American definition of images and visual communication.' For a political reading of Lichtenstein's war pictures against the background of the Cold War, see Stich, *Made in U.S.A.*, p. 158.

7 In John Coplans, 'Talking with Roy Lichtenstein', *Artforum*, 5, May 1967, reprinted in Coplans, ed., *Roy Lichtenstein* (New York, Praeger, 1972), p. 89, the artist recalled that the two groups of pictures were similarly motivated: 'At that time I was interested in anything I could use as a subject that was emotionally strong – usually love, war, or

something that was highly charged and emotional subject matter to be opposite to the removed and deliberate painting techniques. Cartooning itself usually consists of very highly charged subject matter carried out in standard, obvious, and removed techniques.'

8 The postcard is reproduced in Claridge, *The Girls of Mel Ramos*, p. 61, and the paintings on pp. 64–7.

9 Wesselmann wrote of this series, in *Tom Wesselmann*, p. 40: 'His prime goal in the interiors was to compress many mechanical and real elements into a given space, and still have the sense of a rational piece of environment. The first interior was a part of the Still Life series, but was such an obviously different involvement and emphasis that its title was changed to *Interior # 1*, beginning the Interior Series. The series began when Ivan Karp gave Wesselmann the unwanted control panel section of his new stove. That started the buying of many appliances and parts – fluorescent lights, wall clocks, radios, fans, fan covers, refrigerator and stove doors, stove back panels, air conditioner grills, etc. Wesselmann felt these object-works needed to be hard, metallic, unyielding … to expand the object's intensity into the rest of the image.'

10 See Ch. 4, n. 1, for a list of the major early group exhibitions of Pop art.

11 See Stich, *Made in U.S.A.*, pp. 59–60.

12 See Ch. 4, note 20, for details of Ruscha's other books.

13 See Stich, *Made in U.S.A.*, p. 69, for a discussion of Ruscha's road imagery in relation to the popular song 'Route 66' and Jack Kerouac's 1957 novel *On the Road*.

14 These observations by Oldenburg on the anthropomorphic quality of his work were made in a talk at the ICA, London, 6 July 1988.

15 Quoted in Jan McDevitt, 'The Object: Still Life', *Craft Horizons*, 25, no. 5 (Sept. – Oct. 1965), p. 30.

Chapter 7

1 See, for instance, José Pierre, *Dictionnaire de poche: Le pop art* (Paris, Hazan, 1975), which contains some very odd assessments of the work of individual artists but usefully details the major Pop figures in a number of countries not usually covered.

2 The other artists in 'Dylaby' were Tinguely, Saint Phalle, Spoerri, the Swede Per-Olof Ultvedt and Rauschenberg. For details of installations by Dine, Oldenburg and other American artists, see Ch. 4; for 'This is Tomorrow', see Ch. 2; for 'Place', see Ch. 5, n. 13.

3 'Raysse Beach', Alexander Iolas Gallery, New York; introduction to the accompanying catalogue by the poet and critic John Ashbery.

4 *Suddenly Last Summer*, directed by Joseph L. Mankiewicz, starred Elizabeth Taylor, Montgomery Clift and Katherine Hepburn; Gore Vidal's screenplay was based on Tennessee Williams's play of the same title.

5 Raysse used the Louvre version of 1859–63 but some of the appeal of the image – apart from the voluptuous sensuality of its nudes, the 19th-century equivalent of his explicitly contemporary icons of feminine sexiness – may have resided in the fact that Ingres himself had reworked the image more than once in response to its popularity.

6 The same painting was parodied by Ramos in *Regard Gérard* (1974), one of his series of *Salutes to Art History*, which also included versions of nudes by Boucher, David, Ingres, Manet and Modigliani.

7 There was a strong RCA contingent at the '3e Biennale des Jeunes' (Musée d'Art Moderne de la Ville de Paris, 28 Sept. – 3 Nov. 1963), with 2 works by Hockney and 3 each by Boshier, Jones and Phillips. Both Johns and Rauschenberg had one-man shows in Paris in 1961, at the Galerie Rive Droite and Galerie Daniel Cordier respectively, followed by a Rivers exhibition at the Galerie Rive Droite in 1962. From 1963 the Galerie Ileana Sonnabend hosted one-man shows by the major American Pop artists including Rauschenberg and Dine, 1963; Warhol and Oldenburg, 1964; Lichtenstein, Rosenquist and D'Arcangelo, 1965; and Wesselmann, 1967.

8 The models were Pierre Restany, Jeannine de Goldschmidt, Mario Schifano (an Italian painter whose work bore a strong relation to Pop at that time) and Jacqueline Lafon; the colour photographs were taken under Jacquet's direction by Jacques Montagnac, 31 May 1964, in a suburb of Paris aptly named Plaisir. For a recent account, see Restany, *Alain Jacquet: Le Déjeuner sur l'herbe, 1964 – 1989 – 25e anniversaire* (Paris, L'Autre Musée/Grandes Monographies aux Editions de la Différence, 1989).

9 *Parquet* and *Sacs de jute* strikingly resemble works of 1969 by 2 British artists: *Photopath* by Victor Burgin, consisting of photographs of a wooden floor printed actual size and then stapled to the same floor; and *light on light on white on white*, an installation by Barry Flanagan consisting of a stack of real sacks onto which a sliver of light is projected. Burgin's work is reproduced in Ursula Meyer, ed., *Conceptual Art* (New York, Dutton, 1972), p. 78, and Flanagan's in Anne Seymour, *The New Art* (exh. cat., Hayward Gallery, London, 17 Aug. – 24 Sept. 1972), p. 31. Although the site-specific quality of these British works is quite different from Jacquet's concern with one material posing as another, the similarities in the choice of image with which to broach themes of illusion and factuality suggest a direct influence from Jacquet. Jacquet recalls visiting Flanagan in his studio during a visit to London in 1969 or 1970.

10 Jacquet had been aware since the 1970s of this system of printing colour photographs onto fabric by computer, but he did not use it until a new generation of computers arrived that provided much better definition. By 1988 he was aware of the work in this medium by the English artist John Hilliard; see *John Hilliard* (exh. cat., ICA, London, 2 Nov. – 9 Dec. 1984).

11 'Mythologies Quotidiennes', July 1964, Musée d'Art Moderne de la Ville de Paris; 'La Figuration narrative dans l'art contemporain', organized by Gérald Gassiot-Talabot, Galerie Europe and the Galerie Creuze, Paris, October 1965; and 'Bande dessinée et figuration narrative', with a book of the same title by Pierre Couperie and others, Musée des Arts Décoratifs, Paris, April 1967. For an overview of these exhibitions and the developments encompassed by them, see Gérald Gassiot-Talabot, 'Everyday Mythologies, Narrative Figuration, Political Painting', in *Figurative Art since 1945* (London, Thames and Hudson, 1971), pp. 272–302.

12 A number of artists in the 1980s, such as the Czech-born Jiři Dokoupil, made a virtue of using a variety of styles but paying allegiance to none of them, mocking preconceptions of artistic consistency. Such irony was foreign to Richter's approach: in exhibitions such as 'Gerhard Richter: The London Paintings', Anthony d'Offay Gallery, London, 11 March – 16 April 1988, he showed his landscapes and abstracts side by side as equivalents, stressing their conceptual unity over their apparent differences of style, which emerge simply as those of subject-matter.

13 Quoted in G. R. Swenson, 'What is Pop Art? Interviews with eight painters, Part I: Jim Dine, Robert Indiana, Roy Lichtenstein, Andy Warhol', *Artnews* 62 (Nov. 1963), p. 24, reprinted in John Russell and Suzi Gablik, *Pop Art Redefined* (London, Thames and Hudson, and New York, Praeger, 1969), p. 92.

14 Stämpfli's work is closer to Salvador Dalí's famous *Mae West's Lips* (c. 1936), a satin-covered sofa in the shape of the film star's voluptuous mouth, which may well have been a source.

15 For the Venice Biennale in 1970 Stämpfli created an installation of paintings of car tyres in hugely magnified form, so that the regular patterns of their treads became abstract designs; the idea was elaborated in his 1970 solo show at the Galerie Rive Droite, Paris, where the entire floor was covered with what appeared to be the print of a gigantic tyre; and in the Paris Biennale in 1971, for which he produced a painting of a tyre nearly 8 m high preceded by a pattern 30 m long of its 'tracks' along the floor, as if the painting were a real tyre that had simply been rolled into place.

16 See Michael Compton, *Marcel Broodthaers* (exh. cat., Tate Gallery, London, 16 April – 26 May 1980), p. 14 and the entry on *Casserole et moules fermées* (1964) in *The Tate Gallery 1974–6: Illustrated Catalogue of Acquisitions* (Tate Gallery, London, 1978), p. 62. Broodthaers discussed Segal and Dine's work in an article written at the time, 'Gare au défi: Pop Art, Jim Dine and the Influence of René Magritte', reprinted in translation in Benjamin H. D. Buchloh, ed., *Broodthaers: Writings, Interviews, Photographs* (Cambridge, Mass, MIT Press, 1988), pp. 33–4.

17 Quoted in Compton, *Marcel Broodthaers*, p. 13.

Chapter 8

1 The biomorphic design, from an advertisement for a bedspread made by Lee Wah Weaving Factory Ltd, could easily have been invented, but Caulfield recalled in an

interview with me, 22 and 29 Dec. 1980, that he liked it as an extreme example of 'surrealist kitsch' and as 'a commercial artist's idea of modern art design'. The jar was transcribed from a black-and-white photograph in a booklet, *Turkish Pottery* (Victoria and Albert Museum, London, 1955), pl. 1.

2 Letter to me, 1 Dec. 1987. For the links between British art schools and pop music in the 1960s, see Simon Frith and Howard Horne, *Art into Pop* (London and New York, Methuen, 1987), ch. 2, 'The Art School Context', pp. 27–70, and John A. Walker, *Cross-overs: Art into Pop/Pop into Art* (London and New York, Methuen, 1987), ch. 1, 'The Art School Connection', pp. 15–36.

3 In a letter to me, 23 Sept. 1987, Self explained: 'I spent my teenage years . . . having been psychologically devastated by the preachings of Bertrand Russell and thought Armageddon would have exploded its nuclear end when he predicted. By 1967 or 8. For seven years I worked towards that end, thinking the most civilised thing one could do (with what time was left) would be a "record" of "how come" the world ended?'

4 Although such direct references to pop music are rare in Self's work, this was one area of popular culture with which he felt a strong affinity. While working intensively on a group of highly finished *Garden* drawings at home in Norwich in the late 1960s, he found it helped him concentrate to listen to records by Dylan, the Beatles, the Rolling Stones, Love, the Mothers of Invention and Captain Beefheart and his Magic Band. See *The Tate Gallery Illustrated Catalogue of Acquisitions 1978–80* (Tate Gallery, London, 1981), p. 153.

5 Piccadilly Gallery, London, Nov. – Dec. 1965.

6 In a letter to me, 1 Dec. 1987, Self refers to a film of 1959, *The Savage Eye* (written, edited and directed by Ben Maddow, Joseph Strick and Sidney Meyers), as having particularly impressed him. He describes it as the story of a woman betrayed in love, rendered cold by her emotional crisis and divorce, which he interpreted in a wider philosophical context. In retrospect he thinks the film may have led him in the *Cinema* drawings to concentrate always on a single individual, 'a strangely attractive but cold, model type of woman'. His enthusiasm about his Los Angeles visit, part of an extensive tour of America in 1962, may have prompted Blake to visit the city in 1963 (on commission from the *Sunday Times Magazine*) and Hockney to settle there in early 1964. Self again travelled around America in 1965, this time with Hockney and another painter, Norman Stevens; among the places they visited was Disneyland, spiritual home of the cartoon characters such as Pluto and Mickey Mouse that featured in Self's drawings of this period.

7 This and the following quotations are taken from a letter to me, 23 Sept. 1987.

8 See Self's introductory text to *Colin Self's Colin Selfs* (exh. cat., ICA, London, 16 July – 31 Aug. 1986).

9 The materials of this period included bronze, gunmetal, brass and aluminium. One work, *Solo* (1962), was chrome-plated in 1964. For a discussion of Paolozzi's industrial procedures in these works, made in collaboration with 2 specialist firms (W. L. Shepherd, London, a maker of industrial patterns and operator of a non-ferrous foundry, and C. W. Juby Ltd, Ipswich, a precision engineering works), see Kirkpatrick, *Eduardo Paolozzi*, pp. 47–9.

10 Letter to me, 28 Sept. 1987. In the same letter Monro elaborated: 'Multiples, as you may remember, were very much in at the time. They could be sold in shops, or off a barrow in Petticoat Lane. . . . Get your martians here, luvly martians, fresh green martians, Get your martians here!'

11 See, for example, *Betsy Ross, look what they've done to the flag you made with such care* (1966), *The Camera's Eyes* (1966) and *Confedspread* (1967), reproduced in *Joyce Wieland* (exh. cat., Art Gallery of Ontario, Toronto, 1987), b/w pl. 16, col. pls 44 and 47 respectively. Wieland's paintings and especially her assemblages of the early 1960s are also very pertinent to Pop: e.g., *Young Woman's Blues* (1964, col. pl. 41 of the same catalogue), with its found objects and transparent heart through which a young woman can be glimpsed.

12 *Four Young Painters* (ICA, London, 1963).

13 Haworth and Blake separated in 1979 and were divorced in 1981.

14 The photograph of the staged scene was taken by Michael Cooper, who was also regularly employed by Haworth's and Blake's dealer Robert Fraser. Fraser, on close terms with the Beatles, the Rolling Stones and other musicians then at the height of their fame, was undoubtedly the single most important figure in the crossover between the otherwise largely separate worlds of British Pop art and pop music. The 1967 *Sergeant Pepper* commission stemmed from his suggestion to Paul McCartney.

15 Barker was encouraged by his uncle, regional manager of Vauxhall Motors in Luton, to work there as a short-term measure; his father, brothers and cousins were all employed by Vauxhall. After a spell of office work, he moved to the shop floor working on the track, initially on the leather section, stuffing seat cushions into their casing, and then on bumpers.

16 The screen-printing was by his friend Gordon House, a painter and graphic designer who had produced his own limited edition screen-prints as early as his 1961 portfolio *Five Screenprints*, working with the master printer Christopher Prater at Kelpra Studio, London. See Gordon House, 'Spring 1959: My first visit to Kelpra Studio', in Pat Gilmour, *Kelpra Studio: an exhibition to commemorate the Rose and Chris Prater Gift* (exh. cat., Tate Gallery, London, 9 July – 25 Aug. 1980), pp. 57–8.

17 In conversation with me, 10 July 1989, Barker was uncertain whether the idea of using words in this way was related to Blake's work, but he recalled going to Woolworth's with Blake to buy the letters for Blake's painting *Tuesday* (1961); as they had run out of the letter A, Blake decided to buy a V and to use this inverted in its place.

18 He stayed in New York with the British painter Gerald Laing, who was at that time collaborating with Peter Phillips on the sculptural project *Hybrid*, but Barker does not recall seeing much of either artist, particularly as Laing was getting a divorce and was rarely at home.

19 *Clive Barker: Recent Works* (exh. cat., Robert Fraser Gallery, London, 17 Jan. 1968) and *Clive Barker* (exh. cat., Hanover Gallery, London, Oct. – Nov. 1969). Fraser closed his gallery after his arrest and subsequently spent many years in India, re-opening for business in London only for a short period in the 1980s before his death in 1986.

20 For further information on the genesis and manufacture of this work, see the entry on *Splash* in *The Tate Gallery 1970–72* (Tate Gallery, London, 1972), in which Barker's comments, 13 March 1972, are quoted.

21 See, for example, Carl Gustav Jung, *Two Essays on Analytical Psychology* (London, Routledge & Kegan Paul, 1966), transl. by R. F. C. Hull, pp. 199 and 210 (originally published 1928 and 1943), and Friedrich Nietzsche, *Thus Spoke Zarathustra* (Harmondsworth, Penguin, 1961), transl. by R. J. Hollingdale, pp. 68–9 and 95. For further discussion see my *Allen Jones: Retrospective of Paintings 1957–1978* (exh. cat., Walker Art Gallery, Liverpool, 17 March – 20 April 1979), essays accompanying cat. nos 13, 14 and 17, and my *Sheer Magic by Allen Jones* (New York, Congreve, and London, Thames and Hudson, 1979), pp. 36–44.

22 The title was borrowed from a painting by Klee representing a man and woman meeting in a boat against a harbour wall.

23 Interview, *The Image*, 9 (1973).

24 Among Atomage's other clients during this period, apart from their regular fetishists, were the producers of the television programme *The Avengers*, who had them make leatherware for Diana Rigg as Mrs Peel. They were again employed by Jones for some of the leather costumes used in 'a television video fantasy', *Männer, Wir Kommen*, designed by Jones, directed by Bob Royans, for Westdeutsche Rundfunk; see *Allen Jones Projects* (London, Mathews Miller Dunbar, 1971), pp. 45–96.

25 *Peter Phillips* (exh. cat., Westfälischer Kunstverein, Münster, 4 Nov. – 10 Dec. 1972), p. 99.

26 Gerald Laing, undated letter to me, Feb. 1982.

27 See my *Peter Phillips retroVISION: paintings 1960–1982* (exh. cat., Walker Art Gallery, Liverpool, 26 June – 1 Aug. 1982), pp. 49–50.

28 *Gerald Laing: Paintings & Sculpture 1963–1983* (exh. cat., Herbert Art Gallery, Coventry, 10 Sept. – 9 Oct. 1983), entry to cat. no. 2.

29 See the detailed entry on *Masked Zebra Kid* in *The Tate Gallery 1974–6*, pp. 54–6.

30 There are parallels with the box constructions of the American Joseph Cornell, which Blake greatly admires but thinks he may not have known by 1965.

31 Among Blake's best-known commercial designs are other record covers such as *Streetchild* by The Pentangle (1968) and *Face Dances* by The Who (1981), for which he enlisted painters such as Hockney, Jones, Kitaj and Caulfield to paint miniature portraits of the group. For a brief ac-

NOTES

count of Blake's work in this field see Nicholas Usherwood's brochure for the exhibition 'Commercial Art by Peter Blake' (Watermans Arts Centre, Brentford, Middlesex, 1986). Blake set a precedent for such work: Hamilton designed the cover and enclosed poster for the Beatles untitled double 'white' album (1968), designs by Jones and Paolozzi were included as part of the packaging of McCartney's *Red Rose Speedway* (1973), Boshier designed the cover for David Bowie's *Lodger* (1979) and produced a drawing for the back cover of his *Let's Dance* (1983), and Phillips used his painting *Art-O-Matic Loop di Loop* (1972) for his design for The Cars's *Heartbeat City* (1984). Warhol had designed record covers commercially in the 1950s and continued to do so sporadically, most famously in his peeling banana cover for *Velvet Underground and Nico* (1967) and for the Rolling Stones's *Sticky Fingers*, with its life-size unzippable jeans (1971).

Blake's *Babe Rainbow* was printed in an edition of 10,000; the company who commissioned the work, Dodo Designs, specialists in nostalgic enamelled signs, planned Blake's image in enamel but the results were unsatisfactory and it was therefore printed on tin. In conversation with me, 10 July 1989, Blake recalled that it was intended as the only genuine multiple at the time (most printed images were still produced in very limited editions available only to the select few) and was widely stocked on Carnaby Street, London. His wish that it be popularly accessible, however, was not entirely fulfilled, since the purchaser was still likely to be 'a certain kind of person ... usually someone who was interested in art, not a street-wise kid'.

32 See *Peter Blake: Souvenirs and Samples* (exh. cat., Waddington and Tooth Galleries I, London, 26 April – 21 May 1977), and Compton, *Peter Blake*, pp. 106–8.

33 The other members of the Brotherhood of Ruralists were Haworth, Ann and Graham Arnold, David Inshaw, and Annie and Graham Ovenden. They first exhibited their work together as part of a room selected by Blake at the Royal Academy Summer Exhibition, 1976. For further information see Nicholas Usherwood's introduction, *The Ruralists: an exhibition of works by the Brotherhood of Ruralists and their circle* (exh. cat., Arnolfini Gallery, Bristol, April – May 1981) and his essay, 'Peter Blake & the Ruralists', in Compton, *Peter Blake*, pp. 31–4.

34 See *Peter Blake: Déjà vu* (exh. cat., Nishimura Gallery, Tokyo, 9 – 31 May 1988). The works were all produced from 1986 to 1988 specifically for the exhibition. In his catalogue introduction, Blake explained that he wanted to show new work that commented on his past: 'We had first talked about the exhibition about two years ago, this seemed a very eccentric idea then, but since then we have seen "Post-Modernism", with its looking back to earlier styles, and had the young artists of New York unashamedly stealing other artists' motifs. Better to have ripped myself off, than to have been "ripped-off". Part of the reasoning behind the exhibition was that I felt that some of the American Pop-Artists had had only one idea in the early 1960's, then repeated that idea over and over again, mainly for

commercial reasons, whereas I had often only painted one picture from an idea, and it would sometimes have been worth further paintings.'

35 The rest were Gillian Ayres, Bernard Cohen, Harold Cohen, Robyn Denny, Adrian Heath, Howard Hodgkin, Gwyther Irwin, Henry Mundy, Victor Pasmore, Bridget Riley and William Turnbull. See Gilmour, *Kelpra Studio*, pp. 17 and 68–9.

36 For more information about American prints and print workshops of the 1960s, see Riva Castleman, *American Impressions: Prints since Pollock* (exh. cat., Museum of Modern Art, New York, 1986); Virginia Allen, *Tamarind: Homage to lithography* (exh. cat., Museum of Modern Art, New York, 1969); Maurice E. Bloch, *Tamarind: A renaissance in lithography* (exh. cat., International Exhibitions Foundation, Washington DC, 1971); Marjorie Devon and others, *Tamarind: 25 years, 1960–1985* (exh. cat., University of New Mexico Art Museum, Albuquerque, 1985); Bloch, *Words and Images: Universal Limited Art Editions* (exh. cat., Frederick S. Wight Art Gallery, University of California at Los Angeles, 1978); Castleman, *Technics and Creativity: Gemini G.E.L.* (exh. cat., Museum of Modern Art, New York, 1971); Ruth E. Fine, *Gemini G.E.L.: Art and Collaboration* (exh. cat., National Gallery of Art, Washington DC, 1984); and Pat Gilmour, *Ken Tyler – Master Printer, and the American Print Renaissance* (exh. cat., Australian National Gallery, Canberra, 1986). A comprehensive bibliography can be found in Gilmour, ed., *Lasting Impressions: Lithography as Art* (London, Alexandria Press, 1988), which includes an essay by Fine, 'Bigger, Brighter, Bolder: American Lithography since the Second World War', pp. 257–82.

37 Caulfield's friend Monro was among the few English artists who used screen-printing for similiar purposes, often adapting images from his sculpture, as in *Sheep* (1970).

38 See my *R. B. Kitaj*, p. 26.

39 See Rosemary Miles, *The complete prints of Eduardo Paolozzi: Prints drawings collages 1944–77* (exh. cat., Victoria and Albert Museum, London, 1977), pp. 23–5.

40 For a detailed discussion of these works see Morphet, *Richard Hamilton*, pp. 50–53, and Hamilton, *Collected Words*, pp. 61–2.

41 Hamilton had a longstanding interest in Duchamp's work and was closely involved in the rehabilitation of his reputation in the late 1950s and 1960s. He organized a small exhibition, 'Homage to Marcel Duchamp', at the library of the ICA, London, 18 Sept. – Oct. 1959, with readymades, reproductions and some objects borrowed from France (no catalogue) and published a limited edition book, *The Bride Stripped Bare by her Bachelors, Even*. He organized a major exhibition, 'The almost complete works of Marcel Duchamp' (Arts Council of Great Britain, Tate Gallery, London, 1966), and constructed for it a replica (1965–6, now in the Tate's collection) of *The Bride Stripped Bare by her Bachelors, Even (The Large Glass)* with his students at the University of Newcastle-upon-Tyne. For

reprints of various texts by Hamilton on Duchamp, see *Collected Words*, pp. 183–238.

42 Quoted in *Richard Hamilton: Paintings etc.*, caption accompanying cat. no. 26, *A little bit of Roy Lichtenstein for ...* (1964), a screen-print in which he presented 'an enlarged detail of a weeping girl's head' as a way to 'take the serial process to its logical conclusion and make an art work from a piece of a Lichtenstein art work from a piece of comic strip'. Hamilton cited Warhol, Lichtenstein, Dine, Rosenquist and Oldenburg as the American Pop artists whose work he saw at first hand on this visit. Although he did not mention Ruscha, who also attended the Duchamp opening at Pasadena, Hamilton's use of words in *Epiphany*, particularly in the form of slang, strongly resembles the characteristic reliance on language that Ruscha had only recently initiated in his own pictures such as *Annie* (1962) and *Large Trademark with Eight Spotlights* (1962), among the works in his first one-man show, Ferus Gallery, Los Angeles, May 1963.

43 Hamilton paid tribute to Lichtenstein's 'marvellously extreme' art in one of the most considered early studies of his work, 'Roy Lichtenstein', *Studio International*, 175, no. 896 (Jan. 1968), pp. 20–24, reprinted in Hamilton, *Collected Words*, pp. 249–54. See also *Roy Lichtenstein & Richard Hamilton in conversation with Marco Livingstone*, taped interview, Museum of Modern Art, Oxford, 23 May 1988, published in cassette form, *Audio Arts Magazine*, 9, no. 2 (1988).

44 Among the sources were stills from *Jack the Ripper* (1959), *The Creature from the Black Lagoon* (1954), *The Creature with the Atom Brain* and *The Phantom of the Opera* (1943), the latter from the cover of an issue of the magazine *Famous Monsters of Filmland*. All reproduced in *Collected Words*, pp. 56–60.

45 Quoted in *Hamilton: Paintings, Pastels, Prints* (exh. brochure, Serpentine Gallery, London, 4 Oct. – 2 Nov. 1975), unpaginated.

46 See the discussion of Lancaster's *Post-Warhol Souvenirs* in Ch. 10.

47 Stephen Buckley, in conversation with me, 18 Jan. 1985, quoted in my *Stephen Buckley: Many Angles* (exh. cat., Museum of Modern Art, Oxford, 14 April – 2 June 1985), p. 29, which also cites him on his avowed debt to Pop.

48 For a detailed discussion of this painting, see *The Tate Gallery 1970–72*, pp. 171–4, and the artist's own account in *Tom Phillips: Works. Texts. To 1974* (Stuttgart, Hansjörg Mayer, 1975), pp. 141–57.

49 Oxtoby's willingness to submit his artistic identity to that of the musicians whose work he idolized, exceeding even that of Blake in his treatment of similar subjects, is clearly documented in the only monograph on his work, David Sandison's *Oxtoby's Rockers* (Oxford, Phaidon, 1978), in which the extended captions deal at great length not with the production of the pictures but with the life and work of the musicians portrayed.

50 Boshier had returned to painting in 1979, while still in

London, in such works as *The Culture of Narcissism*, in which a bald and nude male figure appears to be assaulted by a barrage of magazine covers and fashion photographs transcribed into paint; the title was taken from that of a book then much in vogue, following his own practice of the early 1960s. Among subsequent paintings that refer to popular imagery and media figures are *David Bowie as the Elephant Man* (1980), in which the pop star is painted in the theatrical role with which he was then having great success on Broadway, and *The Idealist: A Future President* (1982), in which a MacDonald's hamburger restaurant and an equestrian figure reminiscent of Paul Revere can be spied in the distance behind a broadly grinning man wearing nothing but an absurd patriotic hat. See *Derek Boshier Texas Works* (exh. cat., ICA, London, 25 Nov. 1982 – 9 Jan. 1983), with an introduction by David Brauer and an edited transcript of a public talk held by Boshier, 3 April 1982.

51 Letter to me, postmarked 29 Sept. 1983, quoted in my *R. B. Kitaj*, p. 22, which includes further discussion of *Walter Lippmann* and of cinematic references in his work. See also Kitaj's brief essay about this picture on p. 148 of the same book, and his letter about it dated July 1968, quoted in *Contemporary Art 1942–72: Collection of the Albright-Knox Art Gallery* (New York, Praeger, in association with the Albright-Knox Art Gallery, Buffalo, New York, 1973), p. 149.

52 For a discussion of Caulfield's treatment of such subjects and of his references from slightly out-of-date books in interior design, see my *Patrick Caulfield: Paintings 1963–81*, p. 23 and p. 34, n. 39.

53 See my *Peter Phillips retroVISION*, p. 63.

Chapter 9

1 Warhol and Hackett, *POPism*, p. 115. Rublowsky's book, *Pop Art*, covered only American Pop, devoting separate chapters to Lichtenstein, Oldenburg, Rosenquist, Warhol and Wesselmann, dealing in passing with Ramos, Watts, D'Arcangelo, Artschwager, Mary Inman, Bob Stanley and Gerald Foyster in a section on 'The New Wave'. Three other books on the movement followed within a year: Amaya's *Pop as Art* (1965); Rolf-Günter Dienst's *Pop-Art: Eine Kritische Information* (Wiesbaden, Limes Verlag, 1965); and the collection of essays edited by Lippard, *Pop Art* (1966), all of which included British and European as well as American artists.

2 D'Arcangelo and Crawford got to know each other when they were both visiting artists at the Memphis Academy of Art, Memphis, Tennessee, in 1975.

3 See Judith Goldman, *James Rosenquist* (New York, Penguin, 1985), p. 41; his comments about the lecture, particularly his interest in the relationship between the fragments of Duchamp's *Large Glass* and the modern appearance of the work as a whole, are in Jeanne Siegel, 'An Interview with James Rosenquist', *Artforum*, 10, no. 10 (June 1972), p. 34; see Ch. 8, n. 43, for Hamilton's reminiscences in a taped public interview with me.

4 The idea of painting a large work on numerous panels to be sold separately was prefigured in Jacquet's *Peinture-Souvenir* (1963); see Ch. 7.

5 The story circulated by Warhol at this time that one of the Factory stalwarts, Brigid Polk, was painting his pictures for him was retracted when it became evident that the price and saleability of his work was being affected; collectors and dealers may have approved of the principle that his work could be made by anyone, but they insisted that the works in their possession be incontrovertibly by his own hand. Warhol must have enjoyed the irony, but he was also serious about his financial success and later staunchly maintained that his remarks were simply a joke that had gone too far. See Phyllis Tuchman, 'Pop! Interviews with George Segal, Andy Warhol, Roy Lichtenstein, James Rosenquist, and Robert Indiana', *Artnews*, 73 (May 1974), p. 26, and Barry Blinderman, '"Modern Myths": An Interview with Andy Warhol', *Arts Magazine*, 56 (Oct. 1981), p. 146. Apart from Malanga, who worked briefly again as Warhol's screen-printer after Warhol's near-fatal shooting (3 June 1968), he employed several others who helped produce much of his later work until his death in 1987: Ronnie Cutrone (from 1972), Jay Shriver (who more or less took Cutrone's place in 1980 so that Cutrone could concentrate on his own painting), and Rupert Smith (as his screen-printer from Feb. 1977).

6 In 1972 Warhol had produced a series of *Sunset* screenprints (commissioned by the architect Philip Johnson for the Marquette Inn, Minneapolis) in which he subjected a single, almost abstract, image of a sun-shaped truncated disc to 632 colour variations. The 'personalizing' of each of the coloured versions of *Flowers* was effected, however, in a characteristically paradoxical manner, as the hand-colouring was done largely by assistants. He had used a similar system in the 1950s, when working as an illustrator, for hand-colouring the printed flyers that he sent out to prospective clients; friends were invited to his house for 'colouring parties' and instructed to fill in the outlines of drawings (reproduced by offset lithography) with Dr Martin's aniline watercolour dyes.

7 See *Who Chicago?: An exhibition of contemporary imagists* (exh. cat., Ceolfrith Gallery, Sunderland Arts Centre, 1980).

8 *Wilshire Boulevard, Los Angeles* (1964), e.g., was among the 13 works in Hockney's show at the Charles Alan Gallery, New York, in Sept. – Oct. 1964. A later work by Morley, *Rhine Chateau* (1969), was painted from a postcard sent by Hockney; see Lawrence Alloway, *Photo-Realism: Paintings, sculpture and prints from the Ludwig Collection and others* (exh. cat., Serpentine Gallery, London, 4 April – 6 May 1973), unpaginated.

9 See the statements by Robert Bechtle, Chuck Close, Robert Dottingham, Don Eddy, Richard Estes, Richard McLean and John Salt in 'The Photo-Realists: 12 Interviews', *Art in America* (Nov. – Dec. 1972), pp. 73–89, quoted in Alloway, *Photo-Realism*, introduction and n. 10. The relationship between the two movements was recognized early: Morley and another painter associated with Photorealism, John Clem Clarke, were each represented by one painting in 'Pop Art' Hayward Gallery, London, 1969 (see n. 14).

10 Phillips bought an airbrush while in New York from 1964 to 1966, and he used it almost exclusively for more than a decade to produce a uniform surface plainly mechanical in appearance. The surfaces of Rosenquist's paintings, particularly after 1964, contain transitional passages of such deftness as to look airbrushed, but they were painted mainly by hand (in his *F-111* industrial spraying, machine paint and fluorescent colour were used over certain hand-brushed areas, but there was no airbrushing); later he did occasionally use the airbrush but only for very small details. A few of his early paintings, however, e.g., *Untitled (Two Chairs)* (1963) and *Dishes* (1964), prefigure Photorealism in their prosaic domestic subject-matter, the sleek precision of their surfaces and their presentation as transcriptions of a single photographic source rather than as juxtapositions of disparate images.

11 For a survey of these developments in American art of the 1960s and 1970s, see Jean Lipman and Richard Marshall, *Art about Art* (New York, Dutton, in association with the Whitney Museum of American Art, 1978).

12 Rivers painted *Cézanne Stamp* in 1963, a year after the first of several *Dutch Masters*, in which he reinterpreted Rembrandt's *Syndics of the Drapers' Guild*.

13 Pettibone's undated set of 32 canvases, each 17.4 x 13 cm, were conceived as a single work and sold to his dealer Castelli, who had missed buying the Warhol set by failing to take him on until 1964. Pettibone's is reproduced in *Leo Castelli y sus artistas* (exh. cat., Centro Cultural Arte Contemporáneo, Mexico City, June – Oct. 1987), p. 164.

14 The 'Pop Art' exhibition selected by John Russell and Suzi Gablik for the Hayward Gallery, London, 9 July – 3 Sept. 1969, documented in their book *Pop Art Redefined*, had a pronounced retrospective tone, as if Pop were already a historically complete phenomenon. The largest recent survey, selected by Henry Geldzahler for an Australian touring exhibition organized under the auspices of the International Council of the Museum of Modern Art, New York, took 1970 as its cut-off point (*Pop Art 1955–70*, exh. cat., International Cultural Corporation of Australia, 1985). *Pop Art U.S.A. – U.K.* (exh. cat., Brain Trust Inc., Tokyo, 1987), an exhibition of 12 American and 15 British artists selected respectively by Alloway and me, represented each artist with at least one 1960s and one recent work, a premise established by the organizers.

15 See Oldenburg, *Proposals for Monuments and Buildings 1965–69* (Chicago, Big Table, 1969), Barbara Haskell, *Claes Oldenburg: Object into Monument* (exh. cat., Pasadena Art Museum, 1971), and Germano Celant, *A Bottle of Notes and Some Voyages. Claes Oldenburg: Drawings, Sculptures and Large-Scale Projects with Coosje van Bruggen* (New York, Rizzoli, 1988).

Chapter 10

1 Lucy Lippard, *Six Years: The Dematerialization of the Art Object* (New York, Praeger, 1973).

2 Thomas Crow, 'The Return of Hank Herron', in *Endgame: Reference and Simulation in Recent Painting and Sculpture* (exh. cat., Institute of Contemporary Art, Boston, 25 Nov. – 30 Nov. 1986), p. 20.

3 For example at Waterloo Station and Piccadilly Circus, London, Jan. 1989, invited by the Artangel Trust; in connection with this project, similar messages were included on till receipts at all Virgin Records shops in London.

4 Quoted in *Origins Originality + Beyond: The Sixth Biennale of Sydney* (exh. cat., Art Gallery of New South Wales, Sydney, 16 May – 6 July 1986), p. 180.

5 The Warhol display, which included the remake of a lost painting, The Little King, was commissioned by the Grey Art Gallery and Study Center, New York, in connection with their exhibition '"Success is a job in New York...": The Early Art and Business of Andy Warhol' (14 March – 29 April 1989); it was shown in one of their outside windows and was recreated in an even more appropriate context, Liberty's department store, London (4 – 20 Sept. 1989), tied to the same exhibition then on view at the Serpentine Gallery. The decision to remake a Duchamp ready-made, however absurd, had its precedent in Duchamp's work, since in 1965 he allowed the Galleria Schwarz to produce editioned copies of some of his most famous ready-mades in response to commercial demand; see also Ch. 6, n. 4.

6 Lisa Phillips, 'His Equivocal Touch in the Vicinity of History', in *David Salle* (exh. cat., Institute of Contemporary Art, University of Pennsylvania, Philadelphia, 9 Oct. – 30 Nov. 1986), p. 22, wrote, 'More than any other artist of his generation, David Salle is a painter of postmodern life ... he presents us with the paradoxical and equivocal nature of contemporary life – that the old reality of direct, firsthand experience is slipping away, increasingly supplanted by a vicarious reality of signifiers.' On p. 23 she observed, 'Salle's art is one of eruptive focus, where disparity, dissonance, and distance constitute significance. His deliberate breakup and isolation of forms focus our attention on what an image is, how it is made, and how it gets used – on the process of representation itself.' In an earlier essay, 'David Salle and the New York School', in *David Salle* (exh. cat., Boymans-van Beuningen Museum, Rotterdam, 26 Feb. – 17 April 1983), p. 38, Carter Ratcliff noted, 'The Pop artists, especially Andy Warhol, are his predecessors ... though Salle ranges more widely than they did' for stylistic and iconographic references. Nevertheless, Ratcliff's conclusion is hardly different from that suggested by first-generation Pop: 'We live immersed in imagistic plenitude. Salle evokes this vast repertoire, this culture, with precise selections.' The reference to Warhol, the most frequently cited Pop artist in relation to work produced in the 1980s, says less about the actual lines of influence than about general agreement on Warhol's pre-eminent stature in this circle of critics and artists.

7 W. L. Beeren's essay, 'David Salle my view', in the Rotterdam *David Salle*, acknowledges Polke among Pop sources for Salle. As for Polke, Picabia's late paintings seem to have been a model; the chronology in the Philadelphia *David Salle*, p. 85, states that Salle first saw such works at the 'Westkunst' exhibition, Cologne, 1981, but he could of course have known them earlier from reproductions.

8 Quoted in Dan Cameron, *Art and its Double: A New York Perspective* (exh. cat., Centre Cultural de la Fundació Caixa de Pensions, Barcelona, 27 Nov. 1986 – 11 Jan. 1987), p. 24.

9 Andy Warhol, *The Philosophy of Andy Warhol: From A to B and Back Again* (New York, Harcourt Brace Jovanovich, and London, Michael Dempsey in association with Cassell, 1975), p. 92. Two sets of prints and 2 unique works by Haring were among the effects auctioned after Warhol's death: see *The Andy Warhol Collection*, vol. V: *Americana and European and American Paintings, Drawings and Prints* (Sotheby's, New York, 29 and 30 April 1988), cat. nos 2981 and 2982, and vol. VI: *Contemporary Art* (Sotheby's, New York, 2 and 3 May 1988), cat. nos 3427 and 3428.

10 They were all auctioned after Warhol's death; see *The Andy Warhol Collection*, vol. VI, cat. nos 3371, 3429 and 3423 respectively.

11 This painting on masonite, in the family collection of Warhol's brother Paul Warhola, was exhibited in Pittsburgh (with some controversy) shortly after it was painted, but it was not shown again until after his death, in the exhibition '"Success is a job in New York..."'; the cat. (no. 3) listed it as *Nosepicker* (1946); reproduced in McShine, *Andy Warhol: A Retrospective*, p. 402.

12 In conversation with me, 18 Sept. 1989, Farthing explained that he had seen some of Lichtenstein's drawings for this series while in Paris as a student, at the exhibition 'Lichtenstein: Dessins sans bande' (Centre National d'Art Contemporain, Paris, 1975), but that he did not know the paintings to which they related. His own drawings of architectural details, while they may thus have been subconsciously influenced by Lichtenstein, seemed at the time to be a direct response to elements that attracted him in Italian Renaissance architecture.

13 In the conversation cited above, Farthing noted that in retrospect the *Louis XIV* and *Louis XV* paintings may be connected to Dine's self-portrait bathrobe images, but that again these had not been consciously on his mind at the time.

14 For more information about this series, see my 'Mark Lancaster: Unmasking Andy's Marilyn', *Art & Design*, 4, no. 3-4 (1988), pp. 65-9.

15 See n. 9.

16 It is pertinent to these grossly enlarged fragments of ordinary images that in discussing his interest in Pop with me, 16 Sept. 1989, Craig-Martin said that Rosenquist was the American Pop artist whose paintings he most enjoyed.

17 Wentworth remarked in an interview with Paul Bonaventura (first published 1987, reprinted in *Richard Wentworth*, exh. cat., Sala Parpalló, Diputación Provincial de Valencia, 1988), p. 156: 'I could talk at great length about the constituent parts of the mass-produced forms with which I work (and their anthropomorphic associations) but I do not want to overdignify the objects themselves. The things I'm interested in working with seem to me to be symbolic of rather primitive industrialised modes of production. I have selected them because they no longer relate to a specific origin. That is, they represent certain formal expressive values which for me delineate all objects of that genre....'

18 At Oldenburg's exhibition 'A Bottle of Notes and Some Voyages', Serpentine Gallery, London (9 July – 29 Aug. 1988), Wentworth gave a talk, 16 July, on the influence of Oldenburg's early work on British sculpture. Wentworth also attended the lecture given by Oldenburg at the ICA on 6 July and there likewise acknowledged the direct impact Oldenburg's work had had on him. See also Wentworth's interview with Milena Kalinovska, in *Richard Wentworth: Sculpture* (exh. cat., Riverside Studios, London, 18 March – 12 April 1987), p. 10, and the analysis in Greg Hilty, 'Recognition', same cat., p. 23.

19 When first shown, *Toy* was interpreted in the popular press as a metaphor of the sinking of the Argentinian *Belgrano* by the British Navy during the Falklands War, but this was not part of Wentworth's conscious intention; the fact that the work had been purchased by a government-funded body, the Arts Council of Great Britain, clearly encouraged this reading of the piece as political satire.

20 Quoted in Dan Cameron, *NY Art Now* (London, Saatchi Collection, undated [1987]), p. 44. Vaisman went on: 'It involves you in the illusion of objectivity and it can show you a slice of life that you never actually saw before, something you have managed to ignore because it's strange to look at. What I feel the closest affinity to are forms that don't pass judgement, like Andy Warhol's work or Stanley Kubrick's movies. The best art intersects the culture it exists in, rather than critique it.'

21 In Cameron, *NY Art Now*, p. 24, McCollum is quoted as saying: 'In modern industry, the physical "product" is really just one factor in a much larger system which includes not only production, but also market research, finance, packaging, advertising, sales, distribution, customer relations, and so on. In the industrial system, the market itself is produced by producing desire in the consumer. Now, the art world is no different than any other modern economic community in that it models itself after this industrial system. But the artists consider themselves to be so exaggeratedly unique and heroically independent that they never notice the role they play in this mimicry.'

22 Interview with Cameron, *NY Art Now*, pp. 19 and 32.

23 *Ibid.*, p. 36.

24 See his comments in an interview with Matthew Collings, 'You are a White Man, Jeff ...', in *Modern Painters*, 2, no. 2 (summer 1989), p. 63.

Select Bibliography

General surveys

BONY, Anne. *Années 60's*. Paris, 1984.
CALAS, Nicolas. *Art in the Age of Risk and Other Essays*. New York, 1968.
CALAS, Nicolas and Elena. *Icons and Images of the Sixties*. New York, 1971.
HANSEN, Al. *A Primer of Happenings & Time/Space Art*. New York, 1965.
HENDRICKS, Jon. *Fluxus Codex*. New York, 1988.
HENRI, Adrian. *Environments and Happenings*. London, 1974.
KAPROW, Allan. *Assemblage, Environments and Happenings*. New York, 1966.
KIRBY, Michael. *Happenings*. New York, 1965.
SANDLER, Irving. *American Art of the 1960s*. New York, 1988. *The New York School: The Painters & Sculptors of the Fifties*. New York, 1978.
STICH, Sidra. *Made in U.S.A.: An Americanization in Modern Art, the '50s and '60s*. Berkeley, 1987.
TOMKINS, Calvin. *The Bride and the Bachelors: The heretical courtship in modern art*. New York and London, 1965.

Books on Pop

ALLOWAY, Lawrence. *American Pop Art*. New York and London, 1974.
AMAYA, Mario. *Pop as Art: a Survey of the New Super-Realism*. London and New York, 1965.
BAILEY, Elizabeth. *Pop Art*. London, 1976.
BOATTO, Alberto. *Pop Art*. Rome, 1983. [Dine, Johns, Lichtenstein, Oldenburg, Rauschenberg, Rosenquist, Segal, Warhol]
CODOGNATO, Attilio, ed. *Pop Art: Evoluzione di una Generazione*. Milan, 1980. Texts by Roland Barthes, Achille Bonito Oliva, David Bourdon, Germano Celant and David Shapiro. [Dine, Lichtenstein, Oldenburg, Rosenquist, Segal, Warhol, Wesselmann]
COMPTON, Michael. *Pop Art*. London, 1970.
CRISPOLTI, Enrico. *La pop art*. Milan, 1966.
DIENST, Rolf-Gunter. *Pop-Art: Eine Kritische Information*. Wiesbaden, 1965.
DUBREUIL-BLONDIN, Nicole. *La Fonction critique dans le Pop Art.américain*. Montreal, 1980.
FINCH, Christopher. *Image as Language – Aspects of British Art 1950–1968*. Harmondsworth, Middlesex, 1969. [Blake, Caulfield, Hamilton, Hockney, Jones, Kitaj, Monro, Phillips, Smith and Tilson] *Pop Art: Object and Image*. London and New York, 1968.
FRANCBLIN, Catherine. *Les Nouveaux Réalistes*. Paris, 1997.
FRITH, Simon. *Art into Pop*. London and New York, 1987.
HASKELL, Barbara. *Blam! The Explosion of Pop, Minimalism, and Performance 1958–1964*. New York and London, 1984.
HERMAND, Jost, *Pop International: Eine Kritische Analyse*. Frankfurt, 1971.
HERZKA, D. *Pop art one*. New York, 1965.
KELLER, Jean-Pierre. *Pop Art et évidence du quotidien: pour une sociologie du regard ésthetique*. Lausanne, 1979.

LEFFINGWELL, Edward, and Marta, Karen, eds. *Modern Dreams: The Rise and Fall and Rise of Pop*. Cambridge, MA, 1988.
LIPPARD, Lucy. *Pop Art*. London and New York, 1966, rev. 1970. With contributions by Lawrence Alloway, Nicolas Calas and Nancy Marmer.
MADOFF, Steven Henry, ed. *Pop: A Critical History*. Berkeley, 1997.
MAHSUN, Carol Anne. *Pop Art and the Critics*. Ann Arbor, 1987. Ed. *Pop Art: The Critical Dialogue* (Art Criticism, no. 29). Ann Arbor, 1988.
OHFF, Heins. *Pop und die Folgen*. Düsseldorf, 1969.
OSTERWOLD, Tilman. *Pop Art*. Cologne, 1989.
PAPADAKIS, Andreas C., ed. *Pop Art*. London, 1992.
PIERRE, José. *An Illustrated Dictionary of Pop Art*. Paris, 1975, Eng edn London, 1977, and Woodbury, CT, 1978.
RESTANY, Pierre. *Les Nouveaux Réalistes*. Paris, 1968. Rev. as *Le Nouveau Réalisme*. Paris, 1978.
ROBBINS, David, ed. *The Independent Group: Postwar Britain and the Aesthetics of Plenty*. Cambridge, MA, and London, 1990. Essays by Lawrence Alloway *et al.*, chronology by Graham Whitham. Pub. to accompany the exhibition, Institute of Contemporary Arts, London, 1 Feb.–1 April 1990 and tour.
RUBLOWSKY, John. *Pop Art: Images of the American Dream*. New York, 1965.
RUSSELL, John, and Gablik, Suzi. *Pop Art Redefined*. London and New York, 1969.
TAYLOR, Paul, ed. *Post-Pop Art*. Cambridge, MA, 1989. [essays by Roland Barthes, Jean Baudrillard *et al.*]
TONO, Yoshiaki. *The Pop Image of Man* (Art Now, 4). Tokyo, 1971.
WALKER, John. *Cross-overs: Art into Pop, Pop into Art*. London and New York, 1987.
WEBER, Jürgen. *Pop-Art, Happenings und Neue Realisten*. Munich, 1970.
WHITELEY, Nigel. *Pop Design from Modernism to Mod: Theory and Design in Britain 1955–72*. London, 1987.
WHITING, Cécile. *A Taste for Pop: Pop Art, Gender and Consumer Culture*. Cambridge, England, 1997.
WILSON, Simon. *Pop*. London, 1974. Republished in Britt, David, ed. *Modern Art: Impressionism to Post-Modernism*. London, 1989.

Exhibition Catalogues

Environments, Situations, Places. Martha Jackson Gallery, New York. 1961. [statements by Dine and Oldenburg].
Image in Progress. Grabowski Gallery, London. 15 Aug.–8 Sept. 1962. [Boshier, Hockney, Jones, Phillips, Shepherd, Toynton].
My Country 'Tis of Thee. Dwan Gallery, Los Angeles. 1962. Text by Gerald Nordland.
New Paintings of Common Objects. Pasadena Art Museum. 1962. Text by John Coplans.
New Realists. Sidney Janis Gallery, New York. 1962. Texts by John Ashbery, Pierre Restany, Sidney Janis.
Americans 1963. Museum of Modern Art, New York. 1963. Selected by Dorothy Miller. [incl. Indiana, Oldenburg, Rosenquist].

Pop Art USA. Oakland Art Museum, 7–29 Sept. 1963. Intro. by John Coplans.
The Popular Image. Washington Gallery of Modern Art, Washington, D.C. 1963. Text by Alan Solomon.
Six More. Los Angeles County Museum of Art. 1963. Text by Lawrence Alloway. [companion to *6 Painters and the Object*: Bengston, Goode, Hefferton, Ramos, Ruscha, Thiebaud].
6 Painters and the Object. Solomon R. Guggenheim Museum, New York. 1963. Text by Lawrence Alloway. [Dine, Lichtenstein, Oldenburg, Rauschenberg, Rosenquist, Warhol].
Amerikanste Pop-Kunst. Moderna Museet, Stockholm. 1964. Texts by Alan Solomon and Billy Kluver.
Neue Realisten & Pop Art. Akademie der Künste, Berlin. 1964. Intro. by Werner Hofmann.
Nieuwe Realisten. Gemeentemuseum, The Hague. 1964.
The New Generation: 1964. Whitechapel Art Gallery, London. March–May 1964. [incl. Boshier, Caulfield, Hockney, Jones, Phillips].
New York, The Second Breakthrough, 1959–1964. Art Gallery, University of California at Irvine. 1965. Text by Alan Solomon.
The New American Realism. Worcester Art Museum, Worcester, MA. 1965. Texts by Daniel Catton Rich and Martin Carey.
Pop Art and the American Tradition. Milwaukee Art Center. 1965. Text by Tracy Atkinson.
Kompass, Paintings after 1945 in New York. Kunstverein, Frankfurt. 1967. Text by J. Leering.
Information: Joe Tilson, Peter Phillips, Allen Jones, Eduardo Paolozzi, Ronald B. Kitaj, Richard Hamilton. Badischer Kunstverein, Karlsruhe. 1 Aug.–14 Sept. 1969. Text by Peter F. Althews.
Pop Art. Hayward Gallery, London. 9 July–3 Sept. 1969. Intro. by John Russell and Suzi Gablik.
Pop art: nieuwe figuratie/nouveau réalisme. Casino Communal, Knokke-le Zoute. June–Sept. 1970. Essays by John Russell, Geert Bekaert and Pierre Restany.
Multiples. The First Decade. Philadelphia Museum of Art. 1971. Text by John L. Tancock.
American Pop Art and the Culture of the Sixties. New Gallery of Contemporary Art, Cleveland, OH. 1976.
Pop Art in England: Beginnings of a New Figuration 1947–63. Kunstverein, Hamburg. 7 Feb.–21 March 1976. Texts by Uwe Schneede and Frank Whitford.
Paris–New York. Centre national d'art et de culture Georges Pompidou, Paris. 1 June–19 Sept. 1977. Text by Alfred Pacquement and Pontus Hultén incl. 'New Realism and Pop Art: The Beginnings of the 1960s'.
Il Pop art e l'Italia. Castello Visconteo, Pavia. June–Sept. 1983. Texts by Rossana Bossaglia and Suzanna Zatti.
Pop Art 1955–70. International Cultural Corporation of Australia Ltd, under the auspices of the International Council of the Museum of Modern Art, New York. Art Gallery of New South Wales, Sydney. 27 Feb.–14 April 1985 and tour. Text by Henry Geldzahler.
Les Nouveaux Réalistes 1960. Musée d'Art Moderne de la Ville de Paris, 15 May–7 Sept. 1986. Ed. Bernadette Cotensou. Interview and poems by Pierre Restany. Chronology by Aude Bodet and Sylvain Lecombre.

British Art in the 20th Century: The Modern Movement. Royal Academy of Arts, London. 15 Jan.–5 April 1987. Incl. Susan Compton, 'Pop Art – New Figuration'.

Pop Art America Europa dalla Collezione Ludwig. Forte di Belvedere, Florence. 4 July–4 Oct. 1987.

Pop Art U.S.A.–U.K.: American and British artists of the '60s in the '80s. Odakyu Grand Gallery, Tokyo. 24 July–18 Aug. 1987 and tour. Organized by Brain Trust Inc., Tokyo. Text by Lawrence Alloway and Marco Livingstone.

Pop Art. Royal Academy of Arts, London. 13 Sept.–15 Dec. 1991. Edited by Marco Livingstone.

Hand-Painted Pop: American Art in Transition 1965–62. Museum of Contemporary Art, Los Angeles. 6 Dec. 1992–7 March 1993, and tour. Edited by Russell Ferguson.

Pop '60s: Transatlantic Crossing. Centro Cultural de Belém, Lisbon. 11 Sept.–17 Nov. 1997. Edited by Marco Livingstone.

Articles

ALLOWAY, Lawrence, '"Pop Art" since 1949'. The Listener (27 Dec. 1962), pp. 1085–7. 'Popular Culture and Pop Art'. Studio International (July/August 1969), pp. 17–21.

GABLIK, Suzi, 'Protagonists of Pop: Five Interviews Conducted by Suzi Gablik'. Studio International (July/August 1969), pp. 9–16. [Leo Castelli, Richard Bellamy, Robert C. Scull, Dr Hubert Peeters, Robert Fraser].

JOHNSON, Ellen H. 'The Image Duplicators – Lichtenstein, Rauschenberg and Warhol'. Canadian Art (Jan. 1966), pp. 12–18.

LIVINGSTONE, Marco. 'Pop Art, Nouveau Réalisme, and Related Developments'. The Berardo Collection. Sintra, 1996, pp. 35–64.

MASSEY, Anne. 'The Independent Group: towards a redefinition'. Burlington Magazine, 129, no. 1009 (April 1987), pp. 232–42.

MELVILLE, Robert. 'English Pop Art'. Quadrum (Brussels), no. 17 (1964), pp. 23–38, 182–3.

RESTANY, Pierre. 'Le Noveau Réalisme à la Conquête de New York'. Art International, 7, no. 1 (Jan. 1963), pp. 29–36.

ROSENBLUM, Robert. 'Pop Art and Non-Pop Art'. Art and Literature (summer 1965), pp. 80–93.

SECKLER, Dorothy Gees. 'Folklore of the Banal'. Art in America, 50 (winter 1962), pp. 52–61.

SELZ, Peter. 'A Symposium on Pop Art'. Arts Magazine, 37 (April 1963), pp. 36–45. [documentation of symposium held at the Museum of Modern Art, New York, 13 Dec. 1962, with Dore Ashton, Henry Geldzahler, Hilton Kramer, Stanley Kunitz, Leo Steinberg and Peter Selz].

SMITH, Richard. 'New Readers start here . . .' Ark, 32 (Royal College of Art, summer 1962). [Hockney, Boshier, Phillips].

SWENSON, G. R. 'The New American Sign Painters'. Artnews, 61 (Sept. 1962), pp. 45–7, 61–2. 'What is Pop Art?' Artnews, 62 (Nov. 1963), pp. 24–7, 61–5, and Artnews, 62 (Feb. 1964), pp. 40–43, 62–7. [interviews with Dine, Steven Durkee, Indiana, Johns, Lichtenstein, Rosenquist, Warhol and Wesselmann].

SYLVESTER, David. 'Art in a Coke Climate'. Sunday Times Magazine, 26 Jan. 1964, pp. 14–23.

TUCHMAN, Phyllis. 'Pop! Interviews with George Segal, Andy Warhol, Roy Lichtenstein, James Rosenquist and Robert Indiana'. Artnews, 73 (May 1974), pp. 24–9.

WHITELEY, Nigel. 'Throw-Away Culture in the 1950s and 1960s'. Oxford Art Journal, 10, no. 2 (1987), pp. 3–27.

Artists

Exhibition catalogues are listed by the title first

Adami, Valerio: Damisch, Hubert, and Martin, Henry, Adami. New York and Paris, 1974. Valerio Adami. Paris, Centre Pompidou, 1985.

Arman: Martin, Henry. Arman. New York, 1973. Van der Marck, Jan. Arman. New York, 1984.

Arroyo, Eduardo: Eduardo Arroyo. Paris, Centre Pompidou, 1982. Essays by Gérald Gassiot-Talabot, Bernard Pautrat, Gilles Aillaud and Christian Derouet. Arroyo. Madrid, Museo Nacional Centro de Arte Reina Sofia, 1998.

Artschwager, Richard: Armstrong, Richard. Richard Artschwager. New York, Whitney Museum of American Art, 1988.

Baj, Enrico: Crispolti, Enrico, ed. The Catalogue Raisonné for Baj's Complete Works. Turin, 1973.

Barker, Clive: Clive Barker Portraits. London, National Portrait Gallery, 1987. Intro. by Norbert Lynton.

Basquiat, Jean-Michel: Jean-Michel Basquiat: Paintings 1981–1984. Edinburgh, Fruitmarket Gallery, 1984. Preface by Mark Francis.

Bengston, Billy Al: Billy Al Bengston: Motel Dracula. San Francisco Museum of Art, 1968. Text by James Monte.

Berman, Wallace: Wallace Berman Retrospective. Los Angeles, Otis Art Institute Gallery, 1978. Interview with Walter Hopps, essays by Robert Duncan and David Meltzer.

Bidlo, Mike: Mike Bidlo Masterpieces. Zürich, 1989.

Blais, Jean-Charles: Jean-Charles Blais. Bordeaux, capcMusée d'art contemporain, 1985. Essays by Jean-Louis Froment, Jean-Christophe Ammann and Catherine Francblanc.

Blake, Peter: Peter Blake. London, Tate Gallery, 1983. Text by Michael Compton. Vaizey, Marina. Peter Blake. London, 1986.

Boshier, Derek: Derek Boshier: Selected Drawings 1960–1982. Liverpool, Bluecoat Gallery, 1983. Text by Marco Livingstone.

Boty, Pauline: Pauline Boty. London, Whitford Fine Art and Mayor Gallery, 1998. Texts by Sue Watling and David Alan Mellor.

Brecht, George. Martin, Henry. An Introduction to George Brecht's Book of the Tumbler on Fire. Milan, 1978.

Broodthaers, Marcel: Broodthaers, Marcel. Writings, Interviews, Photographs. Cambridge, MA, 1988. Essays by Raine Borgemeister et al. Marcel Broodthaers. Minneapolis, Walker Art Center, and New York, 1989. Intro. by Marge Goldwater, essays by Michael Compton, Douglas Crimp, Bruce Jenkins and Martin Mosebach.

Buckley, Stephen: Stephen Buckley: Many Angles. Oxford, Museum of Modern Art, 1985. Text by Marco Livingstone.

Carter, Tony: Tony Carter: Images of subject/object duality 1968–82. London, Serpentine Gallery, 1982. Intro. by Fenella Crichton.

Caulfield, Patrick: Finch, Christopher. Patrick Caulfield. Harmondsworth, Middlesex, 1971. Patrick Caulfield: Paintings 1963–1981. Liverpool, Walker Art Gallery, and London, Tate Gallery, 1981. Text by Marco Livingstone. Patrick Caulfield. Hayward Gallery, London, and tour, 1999. Introduction by Marco Livingstone, interview with Bryan Robertson.

César: Restany, Pierre. César. Paris, 1975.

Chamberlain, John: Syvester, Julie. John Chamberlain: A Catalogue Raisonné of the Sculpture 1954–1985. New York, 1986. Essay by Klaus Kertess.

Christo: Bourdon, David. Christo. New York, 1970. Jorg

Schellmann and Josephine Benecke, eds. Christo: Prints and Objects, 1963–1987. Catalogue raisonné. Munich and New York, 1988. Intro. by Werner Spies.

Combas, Robert: Robert Combas, rétrospective. Les Sables d'Olonne, Musée de l'Abbaye Sainte-Croix, Cahier no. 50, 1985. Essays by Didier Semin, Roland Recht, Rainer Michael Mason, interview with Françoise Brutsch and Didier Moiselet.

Cragg, Tony: Tony Cragg. London, Hayward Gallery, 1987. Text by and interview with Lynne Cooke.

Craig-Martin, Michael: Michael Craig-Martin: A Retrospective 1968–1989. London, Whitechapel Art Gallery, 1989. Essay by Lynne Cooke, interview with Robert Rosenblum.

Crowley, Graham: Graham Crowley: Home Comforts. Oxford, Museum of Modern Art, 1983. Text by Marco Livingstone.

D'Arcangelo, Allan: Allan D'Arcangelo: Paintings 1963–1970. Philadelphia, Institute of Contemporary Art, 1971. Essay by Tony Towle and interview with Stephen Prokopoff. Allan D'Arcangelo: Paintings of the Early Sixties. Purchase, NY, Neuberger Museum, 1978. Intro. by the artist.

Deschamps, Gérard: Deschamps et le rose de la vie. Paris, Galerie J., 1962.

Dine, Jim: Shapiro, David. Jim Dine: Painting What One Is. New York, 1981. Beal, Graham W. J. Jim Dine: Five Themes. New York, 1984. Livingstone, Marco. Jim Dine: The Alchemy of Images. New York, 1998.

Donagh, Rita: Rita Donagh: Paintings and Drawings. Manchester, Whitworth Art Gallery, 1977.

Donaldson. Anthony: Anthony Donaldson. Paris, Galerie du Luxembourg, 1975. Intro. by William Packer.

Equipo Crónica: Equipo Crónica. Valencia, IVAM Centre Julio González, 1989. Texts by Equipo Crónica, Valeriano Bozal, Tomás Llorens and Michèle Dalmace.

Errò: Errò: Catalogue Général. Milan and Paris, 1976: Errò 1974–1986: Catalogue Général. Paris, 1986.

Estes, Richard: Meisel, Louis K. Richard Estes: The Complete Paintings 1966–1985. New York, 1986.

Fahlström, Oyvind: Oyvind Fahström. Paris, Centre national d'art et de culture Georges Pompidou, 1980. Oyvind Fahström. New York, Solomon R. Guggenheim Museum, 1982.

Farthing, Stephen: Stephen Farthing: Mute Accomplices. Oxford, Museum of Modern Art, 1987. Text by Marco Livingstone.

Goode, Joe: Joe Goode: Work until Now. Fort Worth Art Center, 1973. Text by Henry Hopkins.

Grooms, Red: Ratcliff, Carter. Red Grooms. New York, 1984. Red Grooms: A Retrospective 1956–1984. Philadelphia, Pennsylvania Academy of the Fine Arts, 1985. Essays by Judith E. Stein, John Ashbery and Janet K. Cutler.

Hains, Raymond: Raymond Hains. Paris, Centre national d'art et de culture Georges Pompidou, 1976.

Hairy Who: Schulze, Franz. Fantastic Images: Chicago Art Since 1945. Chicago, 1972. Who Chicago?: An exhibition of contemporary imagists. Sunderland Arts Centre, Ceolfrith Gallery, 1981. Essays by Victor Musgrave, Dennis Adrian, Russell Bowman and Roger Brown.

Halley, Peter: Peter Halley. London, Institute of Contemporary Arts, 1989.

Hamilton, Richard: Richard Hamilton. London, Tate Gallery, 1970. Text by Richard Morphet. Hamilton, Richard. Collected Words 1953–1982. London, 1982. Richard Hamilton: Prints 1939–83. Stuttgart and London, 1984. Richard Hamilton. Tate Gallery, London, 1992. Texts by Richard Morphet and others.

Hanson, Duane: Varnedoe, Kirk. Duane Hanson. New York, 1985.

Duane Hanson. Montreal Museum of Fine Arts, 1994. Text by Marco Livingstone.

Haring, Keith: *Keith Haring: Peintures, sculptures et dessins.* Bordeaux, capcMusée d'art contemporain, 1986. Essays by Brion Gysin and Sylvie Couderc.

Haworth, Jann: *Jann Haworth.* New York, Sidney Janis Gallery, 1971. Intro. by Robert Melville.

Henderson, Nigel: *Nigel Henderson: Heads Eye Win.* Norwich School of Art, 1982. Essays by Chris Mullen and the artist.

Hilliard, John: *John Hilliard.* London, Institute of Contemporary Arts, 1984. Intro. by Michael Newman.

Hockney, David: Stangos, Nikos, ed. *David Hockney.* London and New York, 1976. Livingstone, Marco. *David Hockney.* London and New York, 1981, rev. 1987, 1996. *David Hockney: A Retrospective.* Los Angeles County Museum of Art and London, 1988. Essays by R. B. Kitaj, Henry Geldzahler, Christopher Knight, Gert Schiff, Anne Hoy, Kenneth E. Silver and Lawrence Weschler.

Holzer, Jenny: *Jenny Holzer: Signs.* London, Institute of Contemporary Arts, 1988. Essay by Joan Simon, interview with Bruce Ferguson.

Indiana, Robert: *Robert Indiana.* Philadelphia, Institute of Contemporary Art, 1968. Intro. by John W. McCoubrey, statements by the artist. *Wood Works: Constructions by Robert Indiana.* Washington, D.C., National Museum of American Art, 1984. Text by Virginia M. Mecklenburg. *Robert Indiana.* Nice, Musée d'Art Moderne et d'Art Contemporain, 1998. Texts by Joachim Pissarro and Hélène Depotte.

Jacquet, Alain: *Alain Jacquet: donut flight 6078.* Musée d'Art Moderne de la Ville de Paris, 1978. *Alain Jacquet oeuvres de 1951 à 1998.* Amiens, Musée de Picardie, 1998. Texts by Catherine Millet and others.

Jess: *Translations, Salvages, Paste-Ups by Jess.* Dallas Museum of Fine Arts, 1977. Intro. by Robert Duncan. *Jess: A Grand Collage 1951–1993.* Buffalo, Albright-Knox Art Gallery, 1993. Texts by Michael Auping and others.

Johns, Jasper: Steinberg, Leo. *Jasper Johns.* New York, 1963. Kozloff, Max. *Jasper Johns.* New York, 1969. Crichton, Michael. *Jasper Johns.* New York and London, 1977. *Jasper Johns: A Retrospective.* New York, Museum of Modern Art, 1996. Texts by Kirk Varnedoe and Roberta Bernstein.

Johnson, Ray: *Correspondence: An Exhibition of the Letters of Ray Johnson.* Raleigh, North Carolina Museum of Art, 1976. *Works by Ray Johnson.* Roslyn Harbor, NY, Nassau County Museum of Art, 1984. Intro. by David Bourdon.

Jones, Allen: *Allen Jones: retrospective of paintings 1957–1978.* Liverpool, Walker Art Gallery, 1979. Text by Marco Livingstone. Livingstone, Marco. *Sheer Magic by Allen Jones.* New York and London, 1979. *Allen Jones Prints.* Munich, 1995. Essay by Marco Livingstone, catalogue by Richard Lloyd.

Kaprow, Allan: *Allan Kaprow.* Dortmund, Museum am Ostwall, 1986. Text by the artist.

Katz, Alex: Marshall, Richard. *Alex Katz.* New York, 1986.

Kienholz, Ed: *Ed Kienholz.* Los Angeles County Museum of Art, 1966. Intro. by Maurice Tuchman. *Ed Kienhoz: 11+11 Tableaux.* Stockholm, Moderna Museet, 1970. Eds. K. G. P. Hultén and Katja Waldén. Kienholz. *Kienholz: A Retrospective.* New York, Whitney Museum of American Art, 1996. Text by Walter Hopps.

Kitaj, R. B.: Livingstone, Marco. *R. B. Kitaj.* Oxford and New York, 1985, 1999. *R. B. Kitaj: A Retrospective.* London, Tate Gallery, 1994. Edited by Richard Morphet.

Klapheck, Konrad: *Konrad Klapheck: Retrospektive 1955–1985.* Hamburger Kunsthalle, 1985.

Klein, Yves: Restany, Pierre. *Yves Klein, le monochrome.* Paris, 1974. *Yves Klein.* Paris, Centre national d'art et de culture Georges Pompidou, 1983. Ed. Jean-Yves Mock.

Komar and Melamid: *Komar and Melamid.* Edinburgh, Fruitmarket Gallery, and Oxford, Museum of Modern Art, 1985. Essay by Peter Wollen.

Koons, Jeff: *Parkett* (Zurich), no. 19 (1989). Essays by Klaus Kertess, Jean-Christophe Ammann, Glenn O'Brien, interview with Burke & Hare.

Kruger, Barbara: *Barbara Kruger.* Wellington, New Zealand, National Art Gallery, 1988. Essays by Jenny Harper and Lita Barrie.

Laing, Gerald: *Gerald Laing: A Retrospective.* Edinburgh, Fruitmarket Gallery, 1993. Texts by Ian Carr and David Alan Mellor.

Lancaster, Mark: *Mark Lancaster Paintings: Cambridge/New York.* Liverpool. Walker Art Gallery, 1973. Text by David Shapiro. Livingstone, Marco. 'Mark Lancaster: Unmasking Andy's Marilyn', *Art & Design*, 4, no. 3–4 (1988), pp. 65–9.

Lavier, Bertrand: *Bertrand Lavier.* Dijon, Athenéum–Le Consortium, and Grenoble, Musée de peinture et de sculpture, 1986–7. Essays by Germano Celant and Xavier Douroux, interview with Bernard Marcadé.

Levine, Sherrie: *Sherrie Levine.* Vienna, Galerie Nächst St. Stephan/Rosemarie Schwarzwälder, 1988. Essays by Dieter Schwarz and the artist.

Lichtenstein, Roy: Waldman, Diane, *Roy Lichtenstein.* New York and London, 1971. Coplans, John, ed. *Roy Lichtenstein.* New York, 1972. Cowart, Jack. *Roy Lichtenstein 1970–1980.* New York and St Louis, 1982. Alloway, Lawrence. *Roy Lichtenstein.* New York, 1983. *Roy Lichtenstein.* New York, Guggenheim Museum, 1993. Text by Diane Waldman.

Lindner, Richard: Ashton, Dore. *Richard Lindner.* New York, 1969.

McCollum, Allan: *Allan McCollum.* Eindhoven, Stedelijk Van Abbemuseum, 1989. Essays by Anne Romier, Lynne Cooke and Selma Klein Essink.

Mach, David: Livingstone, Marco, ed. *David Mach.* Kyoto, 1990.

Marisol: *Marisol.* Worcester, MA, Worcester Art Museum, 1971. Intro. by Leon Shulman.

Milroy, Lisa: *Lisa Milroy.* Glasgow, Third Eye Centre, and Southampton City Art Gallery, 1989. Essays by David Plante and Lynne Cooke.

Monory, Jacques: Gaudibert, Pierre, and Jouffroy, Alain. *Monory.* Paris, 1972. Bailly, Jean-Christophe. *Monory.* Paris, 1979.

Monro, Nicholas. Article in *Ark, Journal of the Royal College of Art*, 39 (1965), pp. 16–23.

Morley, Malcolm: *Malcolm Morley.* London, Whitechapel Art Gallery, 1983. Text by Michael Compton.

Ohtake, Shinro: *Shinro Ohtake.* Tokyo, Galerie Watari, 1982. *Shinro Ohtake 1983–1984.* Tokyo, Galerie Watari, 1984.

Oldenburg, Claes: Oldenburg, Claes. *Store Days.* New York, 1967. Baro, Gene. *Claes Oldenburg: Drawings and Prints.* London and New York, 1969, repr. Secaucus, NJ, 1988. *Claes Oldenburg.* New York, Museum of Modern Art, 1970. Text by Barbara Rose. *Claes Oldenburg: Mouse Museum/Ray Gun Wing.* Otterlo, Rijksmuseum Kröller-Müller, 1979. Text by Coosje van Bruggen. *Claes Oldenburg: An Anthology.* Washington, D.C., National Gallery of Art, 1995. Texts by Marla Prather and others.

Opie, Julian: Cooke, Lynne and others. *Julian Opie.* London, 1993.

Oxtoby, David: Sandison, David. *Oxtoby's Rockers.* Oxford, 1978.

Paolozzi, Eduardo: Kirkpatrick, Diane. *Eduardo Paolozzi.* London, 1970. Spencer, Robin, with contributions from Rudolf Seitz and Christopher Frayling. *Eduardo Paolozzi: Recurring Themes.* London, 1984. Konnertz, Winfried. *Eduardo Paolozzi.* Cologne, 1984.

Phillips, Peter: Crispolti, Enrico. *Peter Phillips: Works 1960–1974.* London, Milan and Paris, 1977. *RetroVISION Peter Phillips: paintings 1960–1982.* Liverpool, Walker Art Gallery, 1982. Intro. by John McEwen, text by Marco Livingstone.

Phillips, Tom: *Tom Phillips: Works. Texts. To 1974.* Stuttgart, 1975.

Pistoletto, Michelangelo: *Michelangelo Pistoletto.* Genoa, Galleria la Bertesca, 1966. Ed. Germano Celant.

Polke, Sigmar: *Sigmar Polke.* Musée d'Art Moderne da la Ville de Paris, 1988. *Sigmar Polke.* San Francisco Museum of Modern Art, 1991. Texts by John Caldwell and others.

Ramos, Mel: Claridge, Elizabeth. *The Girls of Mel Ramos.* London, 1975. Rosenblum, Robert. *Mel Ramos: Pop Art Images.* Cologne, 1994.

Rancillac, Bernard: Fauchereau, Serge. *Rancillac.* Paris, 1991.

Rauschenberg, Robert: *Robert Rauschenberg.* New York, Jewish Museum, 1963. Text by Alan Solomon. Forge, Andrew. *Robert Rauschenberg.* New York, 1969. Kotz, Mary Lynn. *Rauschenberg/Art and Life.* New York, 1990. *Robert Rauschenberg: A Retrospective.* New York, Guggenheim Museum, 1997. Edited by Walter Hopps and Susan Davidson.

Raysse, Martial: *Martial Raysse ou l'hygiène de la vision.* Brussels, Palais des Beaux-Arts, 1967. Intro. by Pierre Restany. *Martial Raysse.* Vienna, Museum Moderner Kunst Stiftung Ludwig Wien, 1993. Introduction by Didier Semin.

Richter, Gerhard: *Gerhard Richter: Bilder/Paintings 1962–1985.* Düsseldorf, Städtische Kunsthalle, 1986. Ed. Jürgen Harten. *Gerhard Richter.* Bonn, Kunst- und Austellungshalle dem Bundesrepublik Deutschland, 1993. Essays by Benjamin H. D. Buchloh.

Rivers, Larry: Hunter, Sam. *Larry Rivers.* New York, 1969. Rivers, with Carol Brightman. *Drawings and Digressions.* New York, 1979. *Larry Riverts Retrospektive.* 2 vols, Hannover, Kestner-Gesellschaft, 1980. Harrison, Helen A. *Larry Rivers.* New York, 1984.

Rosenquist, James: *James Rosenquist: Gemälde, Räume, Graphik.* Cologne, Kunsthalle, 1972. Text by Evelyn Weiss. *James Rosenquist.* New York, Whitney Museum of American Art, 1972. Text by Marcia Tucker Goldman, Judith *James Rosenquist.* New York, 1985 [cat. for retrospective organized by Denver Art Museum].

Rotella. Mimmo *Rotella: Décollages 1954–1964.* Milan, 1986. Intro. by Sam Hunter.

Ruscha, Edward: *Guacamole Airlines and Other Drawings by Edward Ruscha.* New York, 1980. *The Works of Edward Ruscha.* New York and San Francisco, 1982. Foreword by Henry T. Hopkins, intro. by Anne Livet, essays by Dave Hickey and Peter Plagens. *Edward Ruscha.* Paris. Centre national d'art et de culture Georges Pompidou. 1989. *Edward Ruscha: Editions 1959–1999.* 2 vols. Minneapolis, 1999. Essays by Siri Engberg and Clive Phillpot.

Saint Phalle, Niki de: *Niki de Saint Phalie: Werke, 1962–68.* Düsseldorf, Kunstverein für die Rheinlande und Westfalen, 1968. Schulz-Hoffmann. Carla, ed. *Niki de Saint Phalle: Bilder – Figuren – Phantastische Garten.* Munich, 1987.

Salle, David: *David Salle.* Philadelphia. Institute of Contemporary Art, 1986. Essays by Janet Kardon and Lisa Phillips.

Saul, Peter: *Peter Saul Retrospective Exhibition.* De Kalb, IL,

Swen Parson Gallery, 1980. Text by E. Michael Flanagan and the artist.

Scharf, Kenny: *Kenny Scharf*. New York. Tony Shafrazi Gallery, 1983. Interview with Tony Shafrazi and Bruno Schmidt.

Segal, George: Van der Marck, Jan. *George Segal*. New York, 1977. Tuchman. Phyllis. *George Segal*. New York, 1983. Hunter, Sam. *George Segal*. New York, 1984. *George Segal: A Retrospective*. Montreal Museum of Fine Arts, 1997. Text by Marco Livingstone.

Self, Colin: Finch, Christopher. 'Colin Self'. *Art International*, 11, no. 4 (20 April 1967), pp. 27–31. *Colin Self's Colin Selfs*. London, Institute of Contemporary Arts, 1986. Text by the artist.

Sherman, Cindy, *Cindy Sherman*. Munich, 1982. Intro. by Els Barents. *Cindy Sherman*. New York. Whitney Museum of American Art, 1987. Essays by Peter Schjeidahl and Lisa Phillips.

Smith, Richard: *Richard Smith: paintings 1958–1966*. London, Whitechapel Art Gallery, 1966. Intro. by and interview with Bryan Robertson. *Richard Smith: Seven Exhibitions 1961–75*. London, Tate Gallery, 1975. Text by Barbara Rose.

Spoerri, Daniel: *Daniel Spoerri*. Amsterdam, Stedelijk Museum, 1971. *Daniel Spoerri*. Paris, Centre National d'Art Contemporain, 1972.

Stämpfli, Peter: Abadie, Daniel. *Peter Stämpfli*. Geneva, 1991. *Peter Stämpfli*. Fribourg, Musée d'Art et d'Histoire, 1999. Texts by Marco Livingstone and Yvonne Lehnherr.

Stankiewicz, Richard: *Richard Stankiewicz: Thirty years of sculpture 1952–1982*. New York, Zabriskie, 1984. Intro. by Virginia M. Zabriskie.

Steinbach, Haim: *Haim Steinbach: Recent Works*. Bordeaux, capcMusée d'art contemporain, 1988. Essays by Germano Celant, Elisabeth Lebovici and John Miller, interview with John Miller.

Taaffe, Philip: *Philip Taaffe*. New York, Pat Hearn Gallery, 1989. Intro. by Gore Vidal.

Télémaque, Hervé: *Télémaque*. Valencia, IVAM Centre Julio González, 1998. Text by Juan Manuel Bonet and others. *Hervé Télémaque: des Modes et Travaux 1959–1999*. Tanlay, Centre d'art de Tanlay, 1999. Text by Marco Livingstone.

Thiebaud, Wayne. *Wayne Thiebaud*. Pasadena Art Museum, 1968. Text by John Coplans. Tsujimoto, Karen. *Wayne Thiebaud*. Seattle and San Francisco, 1985.

Tilson, Jake: Livingstone, Marco, ed. *Jake Tilson*. Kyoto, 1989.

Tilson, Joe: *Tilson*. Rotterdam, Museum Boymans-van Beuningen, 1973. Intro. by R. Hammacher-van den Brande, text by the artist. Quintavalle, Arturo Carlo. *Tilson*. Milan, 1977. Preface by Pierre Restany. Tilson, Joe. *'Alchera' 1970–1976*. Pollenza-Macerata, Italy, 1977.

Trockel, Rosemarie: *Rosemarie Trockel*. London, Institute of Contemporary Arts, 1988.

Vaisman, Meyer: *Meyer Vaisman*. Cologne, Jablonka Galerie, 1989. Intro. by Isabelle Graw.

Villeglé, Jacques de la: *Villegié, Retrospektivt 1949–1971*. Stockholm, Moderna Museet, 1971. Intro. by Otto Hahn, essay by the artist.

Vostell, Wolf: *Wolf Vostell*. Berlin, Galerie René Block. 1969. *Décoll/agen. verwischungen, Schichtenbilder, Bleibilder, Objektbilder 1955–1979*. Kunstverein Braunschweig, 1980.

Warhol, Andy: *Andy Warhol*. Stockholm, Moderna Museet, 1968. Ed. Kasper König. Pontus Hultén and Olle Granath. Crone, Rainer. *Andy Warhol*. New York, London and Frankfurt, 1970. Warhol, Andy, with Pat Hackett. *POPism: The Warhol '60s*. New York 1980. Smith, Patrick, S. *Andy Warhol's Art and Films*. Ann Arbor 1986. *Andy Warhol: A Retrospective*. New York, Museum of Modern Art, 1989. Essays by Kynaston McShine, Robert Rosenblum,

Benjamin H. D. Buchloh and Marco Livingstone. Bockris, Victor, *Warhol: The Biography*. London, 1989. Bourdon, David. *Warhol*. New York, 1989. *The Andy Warhol Museum*. Essays by Callie Angell and others. Pittsburgh, 1994.

Wentworth, Richard: *Richard Wentworth*. Valencia, Sala Parpalló, 1988. Essay by Juan Vicente Aliaga and interview with Paul Bonaventura.

Wesley, John: *John Wesley*. Frankfurt, Portikus, 1993. Texts by Martin Hentschell and others.

Wesselmann, Tom: *Tom Wesselmann: The Early Years. Collages 1959–1962*. Long Beach, California State University Art Galleries. 1974. Text by Constance Glenn. Stealingworth, Slim. *Tom Wesselmann*. New York, 1981. *Tom Wesselmann: Paintings 1962–1986*. London, Mayor Gallery, 1988. Intro. by John McEwen. *Tom Wesselmann: A Retrospective Survey 1959–1992*. Tokyo, Isetan Museum of Art, Shinjuku, 1993. Text by Marco Livingstone. Hunter, Sam. *Tom Wesselmann*. New York, 1994.

Westermann, H. C.: *H. C. Westermann*. New York, Witney. Museum of American Art, 1978. Text by Barbara Haskell. *H. C. Westermann*. London, Serpentine Gallery, 1981.

Whitman, Robert: *Palisade: Robert Whitman*. Yonkers, NY, Hudson River Museum, 1979. Compiled by Billy Klüver and Julie Marten, interview with Barbara Rose.

Wieland, Joyce: *Joyce Wieland*. Toronto, Art Gallery of Ontario, 1987. Essays by Lucy Lippard, Marie Fleming and Lauren Rabinovitz.

Woodrow, Bill: *Bill Woodrow: Sculpture 1960–86*. Edinburgh, Fruitmarket Gallery, 1986. Intro. by Lynne Cooke.

Yokoo, Tadanori: Haizuka, Kizo, ed. *Tadanori Yokoo's Posters*. Kyoto, 1974. Intro. by Milton Glazer.

List of Illustrations

Measurements are in centimetres before inches, height before width before depth

ADAMI, Valerio (1935–)
207 *Gli omosessuali – Privacy* 1966. Acrylic on canvas, 200 × 300 (78¼ × 118). Collection Eduardo Arroyo

ALLINGTON, Edward (1951–)
350 *The Fruit of Oblivion* 1982. Plaster, steel and plastic fruit. 123 × 90 × 120 (48⅜ × 35⅜ × 47¼). Private collection. Courtesy Lisson Gallery, London. Photo Edward Woodman, London.

ANDREA, John de (1941–)
303 *Clothed Artist and Model* 1976. Oil on polyvinyl, lifesize. Courtesy of ACA Galleries, New York. Photo Eric Pollitzer.

ARMAN (1928–)
55 *Cachets* 1955. Rubber stamping of ink on paper, 111.8 × 94 (44 × 37). Private collection.
56 *Petits Déchets bourgeois* 1959. Accumulation of refuse in a wood and plexiglass box, 60 × 40 × 12 (23⅝ × 15¾ × 4¾). Courtesy the artist.
58 *Boum boum, ça fait mal* 1960. Assemblage of plastic water-pistols in plexiglass case, 21 × 59 × 11.2 (8¼ × 23¼ × 4½). Collection,

The Museum of Modern Art, New York. Gift of Philip Johnson.
66 *Chopin's Waterloo* 1962. Smashed piano on wood panel, 186 × 300 × 48 (73¼ × 118 × 19). Musée National d'Art Moderne, Centre Georges Pompidou, Paris.
222 *Vénu$, Poupée dollars* 1970. Dollar bills embedded in polyester mannequin form, 92 × 31 × 27 (36¼ × 12¼ × 10⅝). Galerie Sonnabend, Paris. Photo Georges Borgontier.

ARROYO, Eduardo (1937–)
217 *With Deference to Traditions* 1965. Oil on canvas, 142 × 184 (56 × 72½). Collection the

artist.

ARTSCHWAGER, Richard (1924–)
188 *Untitled (Tract Home)* 1964. Acrylic on celotex with formica frame, 122.6 × 174 (48¼ × 68½). Private collection.
190 *Table with Pink Tablecloth* 1964. Formica on wood, 64 × 111.8 × 111.8 (25½ × 44 × 44) Saatchi Collection, London.

BAJ, Enrico (1924–)
74 *Comode de style* 1961. Collage, inlay and veneering on panel, 96 × 130 (37¾ × 51⅛). Collection Roberta Cerini di Castegnate. Courtesy Studio Marconi.

canvas, 182.9 × 182.9 (72 × 72). Tate Gallery, London.

139 *Second Bus* 1962. Oil on canvas (3 parts), 121.9 × 155 (48 × 61), plus 2 canvases 30.5 × 30.5 (12 × 12). Collection Granada Television, Manchester.

140 *The Artist Thinks* 1960. Oil on canvas, 121.9 × 121.9 (48 × 48). Collection the artist.

244 *Wunderbare Landung* 1963. Oil on canvas, 121.9 × 76 (48 × 29¹/₂). Ferens Art Gallery, Hull City Museums and Art Galleries.

245 *Sheer Magic* 1967. Oil on canvas plus shelf (wood faced with plastic), 91.4 × 91.4 (36 × 36). Private collection.

246 *Maid to Order III* 1973. Oil on canvas, 152.4 × 184 (60 × 72). Private collection.

247 *Chair* 1969. Fibreglass and various materials, 77.5 × 57.1 × 99.1 (30¹/₂ × 22¹/₂ × 39). Tate Gallery, London.

JORN, Asger (1914–73)

75 *Le Canard inquiétant* 1959. Oil on canvas, 53 × 64.5 (20⁷/₈ × 25³/₈). Silkeborg Kunstmuseum, Denmark. Photo Lars Bay.

KAPROW, Allan (1927–)

80 *Yard* 1961. Environment, New York City. Photo Robert McElroy.

KATZ, Alex (1927–)

85 *Washington crossing the Delaware* 1961. Cutouts for Kenneth Koch's one-act play *George Washington Crossing the Delaware*. Acrylic and oil on wood, china. National Museum of American Art, Smithsonian Institution, Washington, D. C. Gift of Mr and Mrs David K. Anderson. Martha Jackson Memorial Collection.

KIENHOLZ, Edward (1927–)

87 *George Warshington in Drag* 1957. Painted wood on polywood, 82.5 × 91.4 × 7.6 (32¹/₂ × 36 × 3). Collection Walter Hopps.

305 *The Portable War Memorial* 1968. Environmental construction with operating Coke machine, 289 × 243.8 × 975.4 (114 × 96 × 384). Museum Ludwig, Cologne.

KITAJ, R. B. (1932–)

130 *Erasmus Variations* 1958. Oil on canvas, 104.2 × 84.2 (41 × 33¹/₈). Private collection. Courtesy Marlborough Fine Art (London) Ltd.

131 *Specimen Musings of a Democrat* 1961. Oil and collage on canvas, 102 × 127.5 (40¹/₂ × 50¹/₂). Collection Colin St John Wilson. Courtesy Marlborough Fine Art (London) Ltd.

263 *In Our Time: Four in America* 1969. Screen-print, printed in colour, 78.3 × 57.5 (30⁵/₈ × 22⁵/₈).

275 *Walter Lippmann* 1966. Oil on canvas, 182.9 × 213.4 (72 × 84). Albright-Knox Art Gallery, Buffalo, New York. Gift of Seymour H. Knox, 1967.

KLAPHECK, Konrad (1938–)

76 *Schreibmaschine* 1955. Oil on canvas, 68 × 74 (27 × 29). Collection the artist. Photo courtesy the artist.

KLEIN, Yves (1928–62)

67 *Victory of Samothrace* 1962. Plaster, resin and pigment mounted on stone, 49.5 (19¹/₂) high. Private collection. Photo Christian Larrieu.

68 *Portrait-relief d'Arman* 1962. Blue painted bronze on leaf-gilded panel, edition of 6, 175 × 95 × 26 (68⁷/₈ × 37³/₈ × 10³/₄). Private collection.

KOMAR, Vitaly (1943–), and MELAMID, Aleksander (1945–)

356 *The Origin of Socialist Realism* 1982–3. Oil on canvas, 182.9 × 121.9 (72 × 48). Courtesy of The Fruitmarket Gallery, Edinburgh, Photo D. James Dee

KOONING, Willem de (1904–97)

18 *Woman and Bicycle* 1952–3. Oil on canvas, 194.3 × 124.5 (76¹/₂ × 49). Collection of Whitney Museum of American Art, New York. Purchase 55.35.

KOONS, Jeff (1955–)

318 *New Hoover Celebrity IV, New Hoover Quik-Broom* 1980–86. Acrylic, fluorescent lights, 2 vacuum cleaners, 142.2 × 55.9 × 50.8 (56 × 22 × 20). Saatchi Collection, London.

362 *Travel Bar* 1986. Cast stainless steel, 35.5 × 50.8 × 30.5 (14 × 20 × 12). Saatchi Collection, London.

364 *Michael Jackson and Bubbles* 1988. Porcelain, edition of 3, 106.7 × 179 × 81.3 (42 × 70¹/₂ × 32). Sonnabend Gallery, New York.

KRUGER, Barbara (1945–)

320 *Untitled (I shop therefore I am)* 1987. Photographic silkscreen on vinyl, 282 × 287 (111 × 113). Courtesy Mary Boone Gallery, New York.

321 *Untitled (The marriage of Murder and Suicide)* 1988. Photographic silkscreen on vinyl, 205.8 × 259 (81 × 102). Courtesy Mary Boone Gallery, New York.

LAING, Gerald (1936–)

253 *Anna Karina* 1963. Oil on canvas, 213.4 × 365.8 (84 × 144) in 9 sections. Collection the artist. Photo courtesy the artist.

254 *Deceleration I* 1964. Oil on canvas (top section), oil on woven aluminized cloth (lower section), 188 × 180.3 (74 × 71). Nagaoka Museum, Japan. Photo courtesy the artist.

LANCASTER, Mark (1938–)

271 *Postcard* 1962–3. Oil on canvas, 45.8 × 35.5 (18 × 14). Collection Richard Hamilton. Photo Eileen Tweedy.

343 *From the series Post Warhol Souvenirs* 1987–8. From top left to right: *Dec. 7–8, Dec. 31, Oct. 5–9, Nov. 29–Dec. 3, Aug. 19, Dec. 5–6, Oct. 24–26, Oct. 13–15.* Each oil on canvas, 30.5 × 25.4 (12 × 10). Private collection. Photo John Webb.

LAVIER, Bertrand (1949–)

353 *Formica Red* 1983. Acrylic paint on object, 76 × 72 × 82 (30 × 28³/₄ × 32¹/₂). Courtesy Lisson Gallery, London.

LEGER, Fernand (1881–1955)

15 *Le Siphon* 1924. Oil on canvas, 65.1 × 46 (25⁵/₈ × 18¹/₈). Albright-Knox Art Gallery, Buffalo, New York. Gift of Mr and Mrs Gordon Bunshaft.

LEVINE, Sherrie (1947–)

325 *Untitled (After Vasily Kandinsky)* 1985. Watercolour on paper, 35.5 × 28 (14 × 11). Courtesy Mary Boone Gallery, New York.

LICHTENSTEIN, Roy (1923–97)

97 *Popeye* 1961. Oil on canvas, 106.7 × 142.2 (42 × 56). Private collection. Photo courtesy Leo Castelli Gallery, New York.

98 *Girl with Ball* 1961. Oil on canvas, 153.7 × 92.7 (60¹/₂ × 36¹/₂). Collection, The Museum of Modern Art, New York. Gift of Philip Johnson. Photo Leo Castelli Gallery, New York.

99 *Engagement Ring* 1961. Oil on canvas. 172 × 202 (67³/₄ × 79¹/₂). Collection Ronnie and Samuel Heyman, New York.

100 *Step-on Can with Leg* 1961. Oil on canvas, 2 panels, 82.5 × 67.3 (32¹/₂ × 26¹/₂). Lauffs Collection at Kaiser Wilhelm Museum, Krefeld. Photo Leo Castelli Gallery, New York.

101 *Look Mickey* 1961. Oil on canvas, 121.9 × 175.3 (48 × 69). Partial and promised gift to the National Gallery of Art, Washington, D.C. Photo Leo Castelli Gallery, New York.

102 *Roto-Broil* 1961. Oil on canvas, 174 × 174 (68¹/₂ × 68¹/₂). Private collection.

103 *Mr Bellamy* 1961. Oil on canvas, 143.5 × 107.9 (56¹/₂ × 42¹/₂). Fort Worth Art Museum. The Benjamin J. Tillar Memorial Trust. Acquired from the Collection Vernon Nikkel, Clovis, New Mexico.

104 *Portrait of Madame Cézanne* 1962. Magna on canvas, 172.7 × 142.2 (68 × 56). Private collection.

105 *Femme au Chapeau* 162. Oil and magna on canvas, 172.7 × 142.2 (68 × 56). Private collection. Photo Leo Castelli Gallery, New York.

168 *Hopeless* 1963. Oil on canvas, 112 × 112 (44 × 44). Collection Peter and Irene Ludwig, on loan to Kuntsmuseum, Öffentliche Kunstsammlung Basel.

169 *Whaam!* 1963. Oil and magna on canvas. 172.7 × 406.4 (68 × 160). Tate Gallery, London. Photo courtesy Leo Castelli Gallery, New York.

279 *Cup and Saucer II* 1977. Painted bronze, 111.1 × 65.4 × 25.4 (43³/₄ × 25³/₄ × 10). Private collection. Photo Leo Castelli Gallery, New York.

292 *Big Painting VI* 1965. Oil and magna on canvas, 234.9 × 327.7 (92¹/₂ × 129). Kuntsammlung Nordrhein-Westfalen, Dusseldorf. Photo Leo Castelli Gallery, New York.

293 *Cubist Still Life* 1974. Oil and magna on canvas, 152.4 × 188 (60 × 74). Art Moderne La Gradelle, Geneva. Photo courtesy Leo Castelli Gallery, New York.

294 *The Red Horseman* 1974. Oil and magna on canvas, 213.3 × 284.5 (84 × 112). Museum Moderner Kunst, Vienna, on deposit from Sammlung Ludwig, Aachen. Photo courtesy Leo Castelli Gallery, New York.

296 *Blonde* 1965. Glazed ceramic, 38.1 (15) high. Wallraf-Richartz Museum, Cologne. Photo courtesy Leo Castelli Gallery, New York.

317 *Landscape with Figures* 1984. Oil and magna on canvas, 127 × 177.8 (50 × 70). Private collection. Photo courtesy Leo Castelli Gallery, New York.

LINDNER, Richard (1901–78)

35 *Stranger No. 2* 1958. Oil on canvas, 92.1 × 60.3 (36¹/₄ × 23³/₄). Tate Gallery, London.

McCOLLUM, Allan (1944–)

359 *Five Perfect Vehicles* 1985–7. Acrylic on hydrocal, 127 × 55.9 (50 × 22). Private collection. Courtesy Lisson Gallery, London.

MACH, David (1956–)

354 *Thinking of England* 1983. 2160 HP sauce bottles with liquid dyes, area 183 × 246 (72 × 96). Tate Gallery, London.

MAGRITTE, René (1898–1967)

12 *L'usage de la parole I* 1928–9. Oil on canvas, 54.5 × 72.5 (21¹/₂ × 28¹/₂). Collection William N. Copley. Photo Geoffrey Clements, New York.

MARISOL (Marisol Escobar, 1930–)

192 *Love* 1962. Plaster and glass (Coca-cola bottle), 15.8 × 10.5 × 20.6 (6¹/₄ × 4¹/₈ × 8¹/₈). Collection, The Museum of Modern Art, New York. Gift of Claire and Tom Wesselmann.

MILROY, Lisa (1959–)

344 *Light Bulbs* 1987. Oil on canvas, 203 × 284.5 (80 × 112). Private collection. Courtesy Nicola Jacobs Gallery, London.

MONRO, Nicholas (1936–)

233 *Martians* 1965. Painted fibreglass, 4 figures approx. 110 × 75 (43³/₈ × 29¹/₂) each. Collection Rupert E. G. Power.

235 *Sand Castles* 1966. Painted fibreglass, 109.3 × 116.7 × 76.5 (43 × 46 × 30). Private collection. Photo Eileen Tweedy.

MORLEY, Malcolm (1931–)

299 *On Deck* 1966. Acrylic on canvas, 212.7 × 161.9 (83³/₄ × 63³/₄). Metropolitan Museum of Art, New York. Gift of Mr and Mrs S. Brooks Barron. Photo The Pace Gallery, New York.

MURPHY, Gerald (1888–1964)

13 *Razor* 1922. Oil on canvas, 81.3 × 91.4 (32 × 36). Dallas Museum of Fine Arts, Foundation for the Arts Collection, Gift of Gerald Murphy.

OHTAKE, Shinro (1955–)

329 *Mexico (Misprinted in N. Y. C.)* 1983. Oil, mixed media on canvas, 162 × 162 (63³/₄ × 63³/₄). Courtesy the artist.

OLDENBURG, Claes (1929–)

79 *White Shirt and Blue Tie* 1961. Fabric soaked in plaster over wire armature, painted, 121.9 × 81.3 × 30.5 (48 × 32 × 12). Museum Ludwig, Cologne.

81 *The Street* 1960. Judson Gallery, Judson Memorial Church, 1960; later at the Reuben Gallery, New York, 1961. Photo courtesy Leo Castelli Gallery, New York.

86 *Pastry Case I* 1961–2. Enamel paint on 9 plaster sculptures in glass showcase, 52.7 × 76.5 × 37.3 (20³/₄ × 30¹/₈ × 14³/₄). Collection, The Museum of Modern Art, New

LIST OF ILLUSTRATIONS

Illustration Credits

Index

Figures in italics refer to illustration numbers